The Lamp of Beauty

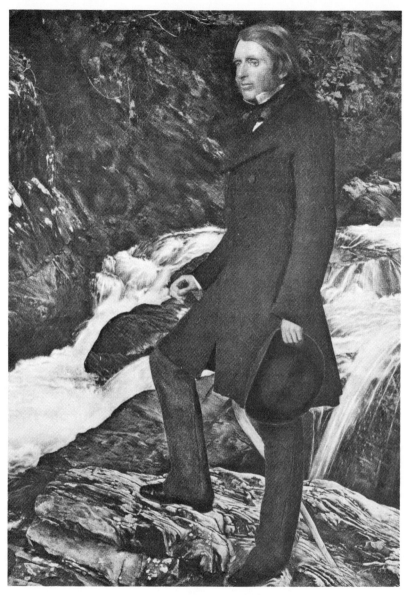

PORTRAIT OF RUSKIN AT THE WATERFALL. Detail of the painting by Millais.
Coll. Sir William Acland, Bt.

The Lamp of Beauty

Writings on Art by
JOHN RUSKIN

Selected and edited by Joan Evans

A Phaidon Book

Cornell University Press
ITHACA, NEW YORK

First published 1959
First published, Cornell Paperbacks, 1980

International Standard Book Number 0-8014-9197-5
Library of Congress Catalog Card Number 80-66414

Printed in Great Britain by The Pitman Press, Bath

CONTENTS

PUBLISHER'S NOTE

This volume has been photographically reprinted from the first edition, published in 1959. The six colour plates in the earlier edition (frontispiece, and plates facing pages 46, 82, 98, 114 and 130) are here reproduced in black and white, although they are still referred to as 'colour-plates' in some footnotes and in the list of plates. For production reasons, their blank verso pages have been retained in this edition. Like the black and white plates, they are unpaginated.

The locations of some of the works reproduced have changed during the past twenty years; in particular, the painting reproduced in the plate facing page 82 is now in the Tate Gallery, the picture in Plate 48 now belongs to Roy Miles Fine Paintings, London, and some of the works listed as belonging to private owners have changed hands.

INTRODUCTION

WHEN RUSKIN DIED IN 1900 his friends E. T. Cook and Alexander Wedderburn embarked upon the preparation of a great Library Edition of his works. It is admirably edited and splendidly produced; yet its very completeness has made it less a memorial than a tombstone. Few people nowadays will read through thirty-eight massive volumes, or even consult an index that occupies 688 pages in double columns.

It is partly for this reason that Ruskin's writings on art are now little read. That fact is the justification for the present volume of selections:[1] a volume from which much has necessarily had to be omitted, and in which a single colour of Ruskin's portrayal of life is torn from its web; yet one which may help to remind its readers that much that we still take for granted in our view of art is derived from Ruskin. A strictly chronological arrangement, with three broad divisions of subject, will, I hope, show the development of his mind and of his taste.

John Ruskin[2] was born on February 18, 1819, the only child of two people who had married late in life. His father was a man of taste, who had risen from his father's shop in Edinburgh to become a partner in a firm of sherry merchants. He used to take his wife and child with him on his summer journeys in search of orders round the country houses of England, and so introduced the boy to private galleries which held the pictures brought from Grand Tours in Italy by their owners or their ancestors. Ruskin *père* had tried his hand at drawing as a boy, and encouraged his son in the same pursuit, as in the composition of endless prose and verse, which emerged from the boy's mind in facile and undistinguished quantities.

[1] As early as 1891 W. G. Collingwood published *The Art Teaching of John Ruskin* with the same intention; he endeavoured, however, to take a synoptic rather than a chronological view, and for reasons of copyright did not quote at length. Recent studies, apart from the biographies cited below, include R. Ironside, 'The Art Criticism of Ruskin', in *Horizon*, Vol. VIII, July 1943, p. 8, and Graham Hough, 'Ruskin and Roger Fry: two Aesthetic Theories', in *Cambridge Journal*, Vol. I, October 1947, p. 14.

[2] Several biographies have appeared comparatively recently, by A. Williams-Ellis (1928); R. H. Wilenski (1933); Peter Quennell (1949); D. Leon (1949) and Joan Evans (1954). Each includes an adequate bibliography.

The Ruskins lived near to the Dulwich Gallery, and it was from the pictures there exhibited that the boy learned to distinguish styles and to appreciate technique.

In 1837, when he was just beginning his second year at Oxford, John Ruskin began to publish, under the pseudonym of *Kataphusin*, a series of articles in the *Architectural Magazine* under the title of 'The Poetry of Architecture'. In them he tried to explain the beauties and defects of the cottage architecture of the European countries he had visited in relation to the scenery in which they were set and the people who had built them. The articles show a superficial shrewdness of observation, but it is the observation of a sketcher who has drawn the houses he describes, rather than of a man with any real sense of the fundamentals of architecture. The articles were, indeed, illustrated from his own drawings, reproduced in notably inadequate woodcuts. It is not unfair to say that Ruskin's appreciation and description of scenery was at this time, and perhaps always, sounder and more mature than his perception of architecture. What was original, and what was to bear riper fruit in later years, is his vision of architecture as essentially a part of landscape.

It was the sharpness of his aesthetic perception, both of painting and of architecture, combined as it was with literary facility, that made it natural for him to write on art. His father was both wealthy and generous; there was no reason for the young writer to earn his living, nor any but his own honourable dislike of idleness why he should work at all. When he set himself to work, there was no reason but his own restlessness why he should ever feel hurried or pressed for time. It was no practical necessity, but disinterested anger, that turned him into a critic. He had a particular passion for the paintings, and especially the water colours, of J. M. W. Turner, a man personally unknown to him and forty-four years older than himself. In October 1836, just before he went to Oxford, *Blackwood's Magazine* had published a criticism of some of Turner's later pictures which enraged the boy of seventeen. He wrote an indignant reply to it, to send to *Blackwood*, but his father insisted on his first obtaining Turner's permission to publish. The old artist replied kindly enough, but did not encourage his youthful admirer to rush into print.

The wish to vindicate Turner remained in Ruskin's mind, and provided the impetus to the writing of *Modern Painters:* though as each of its five volumes was completed it proved to contain less and less about Turner and more and more of general criticism of art and life as Ruskin saw them. Since the publication of the book extended over seventeen years Ruskin's

views naturally changed and developed in the course of its publication, and I have set the excerpts from it that I have chosen according to the year in which the volume in which they appeared was published, so that they should take their place in the record of his developing taste.

The unexpected success of the first volume of *Modern Painters* was in part due to its freshness of observation and its literary grace, and in part to the fact that it was a book of a new kind that met a new need. The Napoleonic Wars had broken the tradition of the Grand Tour and the traditional culture of the men who had followed it by further travel; and now a cultivated bourgeois class was beginning to travel in greater numbers if less far afield. To go by Abbeville and Amiens to Paris, or to visit the Belgian battlefields and then perhaps to travel down the valley of the Rhine, might be exceptional events in the lives of business men and their families, but they were far from unusual in their class as a whole. Such travellers were aware that they knew little of art and architecture, and Ruskin provided the needed guidance. He, too, belonged to that same class, and like them did not take a vast background of experience and knowledge for granted.

His more academic friends, too, had welcomed the book, if rather more critically. The Rev. H. G. Liddell, then Greek Reader in Christ Church, had criticized Ruskin's style as being youthful in its over-confidence. Ruskin replied,[1] in October 1844: 'It is only eagerness and strong feeling which have given so overbearing a tone to much of what I have written. . . . But it seems to me that the pamphleteer manner . . . is ingrained throughout. There is a nasty, snappish, impatient, half-familiar, half-claptrap web of young-mannishness everywhere. This was, perhaps, to be expected from the haste in which I wrote. I am going to try for better things; for a serious, quiet, earnest and simple manner, like the execution I want in art.'

The second volume, Ruskin declared,[2] had not been meant to be in the least like what it is. In fact the wider experience gained in more extensive travel had turned his interests to include not only Turner but also the Old Masters; not only landscape but also religious paintings; not only the mature classical painters but also the primitives. He owed a good deal to the study of Rio's book on Christian Art,[3] and a good deal to his own greater knowledge of the technique of painting. The reception of his first volume had given him a clearer idea of the public he was addressing, and

[1] Library Edition edn. Cook and Wedderburn, Vol. III, p. 668.
[2] *Praeterita*, Vol. II, Ch. IV, p. 682.
[3] *De la poésie chrétienne dans son principe, dans sa matière et dans ses formes.*

its success, and his own development—notably in the course of his long tour in Italy in 1845, when for the first time he travelled without his parents —had given him a calmer confidence.

By the time the second volume of *Modern Painters* appeared in 1846, Ruskin was established in the public mind as a critic of distinction with an unrivalled intensity of aesthetic feeling and a polished and indeed rhetorical style in which to express it. His particularity of observation—a minute and almost scientific way of vision—made a natural link between him and the Pre-Raphaelites, though they were not, as is sometimes supposed, indebted to him for their inspiration. In 1851 he was among the first to break a lance for them when their early pictures, exhibited in the Academy of that year, were unfavourably received. His championship brought him the acquaintance of most of the Brotherhood, and a closer intimacy with Millais, Rossetti and Burne Jones. His friendship with Millais ended when his wife left him in 1854 and married the artist as soon as she had secured the annulment of her marriage with Ruskin; but it is noteworthy that in the 'Academy Notes' which Ruskin began to publish in 1855 he continues to take a detached and fair view of the work of the man who had been his friend.

Meanwhile Ruskin had established a second and perhaps more distinguished reputation as a historian and critic of architecture. *The Seven Lamps of Architecture*, published in 1849, lighted the way for many. It was a far better organized book than *Modern Painters*; it had a subject and a plan and pursues them. To people who knew little of architecture the very small number of buildings that the author had studied was no matter for complaint; they were little likely, either, to notice and regret the absence of any technical discussions of such things as systems of vaulting. The book owed much to the recent more detailed work on the subject by men such as Rickman, Whewell, Willis and Pugin; and was more directly indebted in outlook and even in style to two books by Lord Lindsay— *Progression by Antagonism*, published in 1846, and *Sketches of the History of Christian Art*, which appeared in 1847.

Ruskin, however, had a characteristic quality of directness of approach that was all his own. He 'saw' his buildings in great detail; he was learning to relate them to the particular society which had produced them, and to the events which influenced that society at the moment of their building. He admitted and exploited his own predilection for minute and delicate decoration, and his own inclination to admit a moral element into the assessment of artistic values. Such idiosyncrasies were congenial to his public, and the book had a great success.

The Seven Lamps was followed by *The Stones of Venice*, published between 1851 and 1853, which helped to make architecture visible to men who were more accustomed to historical research than to the study of visible remains. Ruskin on the whole found the study of the history of art antipathetic, and justified his antipathy by declaring that such study weakened the aesthetic sensibilities of the student. Yet in *The Stones of Venice* he made a genuine and original contribution to such studies. He spent long months in Venice itself, working much harder than usual, until all its beauties seemed to be reduced to 'mouldings and mud'; for the first time in his life he ventured on the study of early printed and even manuscript sources, and found the work a good deal more difficult than he had anticipated; and for the first time he attempted a truly chronological study of material that was in great part unpublished. Here too he was able for the first time to use daguerrotypes of the Venetian palaces for comparative study, though such mechanical reproductions took a secondary place—as in all Ruskin's work, up to the end of his life—beside drawings made by himself on the spot. *The Stones of Venice* is more factual and less personal than the preceding books; fewer pages from it appear in this selection than might be expected, because fewer are about Ruskin's own view of art. Yet the book is chiefly memorable for one very personal discovery. In the second section of the second volume Ruskin defines 'The Nature of Gothic', and includes among the tests of beauty of art the well-being of the workman. 'Now, in the make and nature of every man, however rude and simple, whom we employ in manual labour, there are some powers for better things: some tardy imagination, torpid capacity of emotion, tottering steps of thought, there are even in the worst, and in most cases it is all our own fault that they *are* tardy or torpid. But they cannot be strengthened, unless we are content to take them in their feebleness, and unless we prize and honour them in their imperfections above the best and most perfect manual skill. And this is what we have to do with all our labourers; to look for the *thoughtful* part of them, and get that out of them, whatever faults and errors we are obliged to take with it. For the best that is in them cannot manifest itself, but in company with much error. . . . And observe, you are put to stern choice in this matter. You must either make a tool of the creature, or a man of him. You cannot make both. . . . Let him but begin to imagine, to think, to try to do anything worth doing; and the engine-turned precision is lost at once. Out come all his roughness, all his dullness, all his incapability; shame upon shame, failure upon failure, pause after pause: but out comes the whole majesty of him also;

and we know the height of it only when we see the clouds settling upon him. And, whether the clouds be bright or dark, there will be transfiguration behind and within them.'

Turner died on December 19, 1851. His will appointed Ruskin one of a number of executors, but because of the legal complications which it involved he refused to act. In 1856 the Chancery case concerning the will ended in a compromise and Ruskin offered to arrange and catalogue the vast number of works that by this compromise became the property of the National Gallery. He first catalogued thirty-four oil paintings that were exhibited at Marlborough House in the quarters of the Science and Art Department, and then went on to tackle the rest. The laborious work of sorting and mounting a vast mass of drawings, the unwonted responsibility of dealing with material not in his own possession, and, it may be, mere satiation, prevented him from receiving any fresh inspiration from Turner's work. Instead he became more conscious of its conventions and its weaknesses; and his fatigue found expression in a measure of criticism of the master's work on irrelevant moral grounds.

In 1855 he had begun to publish *Academy Notes*: very personal commentaries on the current Academy Exhibitions which told people unequivocally what he liked on the tacit assumption that they should like it too. This rather dictatorial note was sustained in the many public lectures he gave in these years, many of which were later printed. His great discovery at this time—made during a six weeks' stay in Turin in 1858—was of the splendid beauty of the pictures of Veronese: a discovery that linked itself with his recognition that he had altogether broken away from the barrenness of the Evangelical religion in which he had been brought up.

His profounder knowledge of Turner's work and his new enthusiasm for Veronese are both reflected in the later volumes of *Modern Painters*; yet in fact fewer and fewer of their pages are filled by the discussion of art, and more and more by descriptions of natural beauty in clouds and leaves and mountains, and by dissertations on the author's view of life. Even in his study of pictures that he liked a fundamental weakness became increasingly manifest. He could never so far forget himself as to think of what the artist had intended to create within the limits of his own time and his own temperament; all that interested Ruskin was the impact of the picture upon his own sensibility. For this reason Ruskin is usually the most indifferent of critics in the interpretation of an artist's work; yet out of the impression of that work upon his own mind he could achieve a new creation.

Most of the fifth volume of *Modern Painters* was written while Ruskin's mind was slowly losing its balance. His own pathetic sense of this disequilibrium is evident in a letter which he wrote to his American friend Charles Eliot Norton at Christmas 1858.[1]

'Indeed I rather want good wishes just now for I am tormented by what I cannot get said, nor done. I want to get all the Titians, Tintorets, Paul Veroneses, Turners and Sir Joshuas in the world into one great fireproof Gothic gallery of marble and serpentine. I want to get them all perfectly engraved. I want to go and draw all the subjects of Turner's 19,000 sketches in Switzerland and Italy, elaborated by myself. I want to get everybody a dinner who hasn't got one. I want to macadamize some new roads to Heaven with broken fools' heads. . . . I want to play all day long and arrange my cabinet of minerals with new white wool. I want Turner's pictures not to fade—I want to be able to draw clouds . . . and I can't do anything and don't understand what I was born for. . . .'

The pure pleasure of aesthetic perception was becoming dimmed for him. In 1857 he delivered two lectures at Manchester on the Political Economy of Art—later printed under the title *A Joy for Ever*—which are the finest expression of his thought at this time. They are hardly about art at all, but are concerned with the training and employment of workmen, and about the preservation of existing monuments. 'Here in England', he declared, 'we are making enormous and expensive efforts to produce new art of all kinds, knowing and confessing all the while that the greater part of it is bad, but struggling still to produce new patterns of wall-papers, and new shapes of tea-pots, and architecture; and pluming and cackling if ever a tea-pot or a picture has the least good in it—all the while taking no thought whatever of the best possible pictures and statues and wall patterns already in existence, which require nothing but to be taken common care of, and kept from damp and dust; but we let the walls fall that Giotto patterned, and the canvases rot that Tintoret painted, and the architecture be dashed to pieces that St. Louis built, while we are furnishing our drawing rooms with prize upholstery, and writing accounts of our handsome warehouses to the country papers.'[2]

Ruskin's father died in 1864, leaving his son master of a large fortune. In 1869 he was elected as the first holder of the Slade Professorship in Fine Art at Oxford. His new freedom and his new honour were clouded for him by endless frustrations in a love affair with Rose La Touche, a morbid-minded

[1] *Letters of John Ruskin to Charles Eliot Norton*, Boston and New York, 1905, Vol. I, p. 75.
[2] Vol. XVI, p. 75.

girl nearly thirty years younger than himself. The inevitable mental breakdown struck him early in 1871. During his convalescence he bought —unseen—the house called Brantwood on Coniston Water, that was to be his home for the rest of his life. After his mother's death at the end of the year he divided his time between Brantwood and Oxford, and spent less and less time in London.

His thoughts went back to the past, and in anger and disgust at the sight of an industrial England he endeavoured to recreate a minute feudal society with himself as ruler, by the foundation of the Company or Guild of St. George: an institution not strong enough to affect the course of history, but one, thanks to his benefactions, still rich enough to survive.

The first mental breakdown was followed by others, that left him intellectually diminished. Yet for short times and on familiar subjects he could still be worth listening to, and a number of extracts from papers and lectures written between 1871 and 1883 are included in these selections. His interest in architecture was less easily stimulated, but in these years he wrote some memorable passages on the mediaeval architecture of Northern France. Already, however, his influence was chiefly exerted through the pupils and followers who believed in the artistic doctrines he had preached in happier days: doctrines that are not yet forgotten, though many have ceased to remember that we owe them to John Ruskin.

Ruskin's own footnotes to his text are here marked by asterisks. The numbered footnotes have been added by the Editor. Ruskin's numbering of paragraphs in the original text is here indicated by paragraph signs ¶.

PAINTING

PART ONE

PAINTING

MODERN PAINTERS

THEIR SUPERIORITY IN THE ART OF LANDSCAPE PAINTING TO THE
ANCIENT MASTERS, PROVED BY EXAMPLES OF THE TRUE, THE
BEAUTIFUL AND THE INTELLECTUAL, FROM THE WORKS OF MODERN
ARTISTS, ESPECIALLY FROM THOSE OF J. M. W. TURNER, ESQ., R.A.,
BY A GRADUATE OF OXFORD, 1843.[1]

Painting as Language

PAINTING, or art generally, as such, with all its technicalities, diffi-
culties, and particular ends, is nothing but a noble and expressive language,
invaluable as the vehicle of thought, but by itself nothing. . . . Speaking
with strict propriety, therefore, we should call a man a great painter only as
he excelled in precision and force in the language of lines, and a great versifier,
as he excelled in precision and force in the language of words. A great poet
would then be a term strictly and in precisely the same sense, applicable to
both, if warranted by the character of the images or thoughts which each
in their respective languages conveyed.

Take, for instance, one of the most perfect poems or pictures (I use the
words as synonymous) which in modern times have been seen: the 'Old
Shepherd's Chief-mourner'.[2] Here the exquisite execution of the glossy
and crisp hair of the dog, the bright sharp touching of the green bough
beside it, the clever[3] painting of the wood of the coffin and the folds
of the blanket are language—language clear and expressive in the highest
degree. But the close pressure of the dog's breast against the wood, the

[1] The five volumes of *Modern Painters* were published over so long a stretch of time—between
1843 and 1860—that each must be considered separately in any consideration of Ruskin's develop-
ment as a critic.

[2] By Landseer; Ill. 1 facing page 18.

[3] So in manuscript; 'clear' in printed editions. See Cook and Wedderburn, Library Edition
of the Works of John Ruskin, Vol. III, p. 88, n. 3. (This will hereafter be referred to by volume
and page only.)

convulsive clinging of the paws which has dragged the blanket off the trestle, the total powerlessness of the head laid close and motionless, upon its folds, the fixed and fearful fall of the eye in its utter hopelessness, the rigidity of repose which marks that there has been no motion or change in the trance of agony since the last blow was struck on the coffin-lid, the quietness and gloom of the chamber, the spectacles marking the place where the Bible was last closed, indicating how lonely has been the life, how unwatched the departure, of him who is now laid solitary in his sleep— these are all thoughts—thoughts by which the picture is separated at once from hundreds of equal merit, as far as mere painting goes, by which it ranks as a work of high art, and stamps its author, not as the neat imitator of the texture of a skin, or the fold of a drapery, but as the Man of Mind.

From *Modern Painters*, Vol. I, Part I, Sec. I, Ch. II, ¶ I.

MOST pictures of the Dutch School, for instance, excepting always those of Rubens, Vandyke, and Rembrandt, are ostentatious exhibitions of the artist's power of speech, the clear and vigorous elocution of useless and senseless words; while the early efforts of Cimabue and Giotto are the burning messages of prophecy, delivered by the stammering lips of infants. . . . The picture which has the nobler and more numerous ideas, however awkwardly expressed, is a greater and better picture than that which has the less noble and less numerous ideas, however beautifully expressed. No weight, nor mass nor beauty of execution, can outweigh one grain or fragment of thought. Three penstrokes of Raffaelle are a greater and better picture than the most finished work that ever Carlo Dolci polished into inanity. A pencil scratch of Wilkie's on the back of a letter is a great and a better picture—and I use the word picture in its full sense—than the most laboured and luminous canvas that ever left the easel of Gerard Dow. A finished work of a great artist is only better than its sketch, if the sources of pleasure belonging to colour and realization— valuable in themselves—are so employed as to increase the impressiveness of the thought. But if one atom of thought has vanished, all colour, all finish, all execution, all ornament, are too dearly bought.

From *Modern Painters*, Vol. I, Part I, Sec. I, Ch. II, ¶ 7.

Power

THERE are . . . two modes in which we receive the conception of power; one the more just, when by a perfect knowledge of the difficulty to be

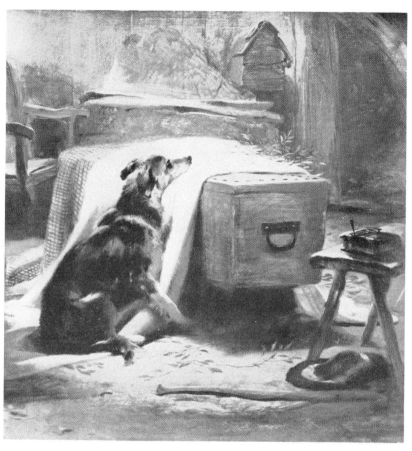

I. THE OLD SHEPHERD'S CHIEF MOURNER

Detail of a painting by Sir Edwin Landseer. *London, Victoria and Albert Museum*

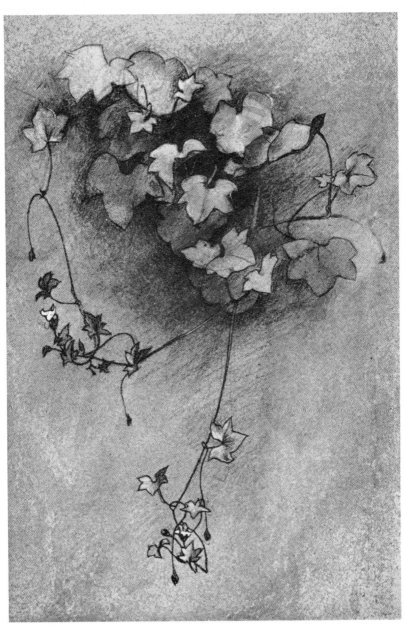

2. OXFORD IVY. Drawing by Ruskin. *Oxford, Ashmolean Museum*

overcome, and the means employed, we form a right estimate of the facul-
ties exerted; the other, when without possessing such intimate and accurate
knowledge, we are impressed by a sensation of power in visible action. If
these two modes of receiving the impression agree in the result, and if the
sensation be equal to the estimate, we receive the utmost possible idea of
power. But this is the case, perhaps, with the works of only one man out
of the whole circle of the fathers of art . . . Michael Angelo. . . .

There are few drawings of the present day that involve greater sensa-
tions of power than those of Frederick Tayler.[1] Every dash tells, and the
quantity of effect obtained is enormous, in proportion to the apparent
means. But the effect obtained is not complete. Brilliant, beautiful, and
right, as a sketch, the work is still far from perfection, as a drawing. On the
contrary, there are few drawings of the present day that bear evidence of
more labour bestowed, or more complicated means employed, than those
of John Lewis.[2] The result does not, at first, so much convey an impression
of inherent power as of prolonged exertion: but the result is complete.
Water-colour drawings can be carried no farther; nothing has been left
unfinished or untold. And on examination of the means employed, it is
found and felt that not one touch out of the thousands employed has been
thrown away; that not one dot or dash could be spared without loss of
effect; and that the exertion has been as swift as it has been prolonged—
as bold as it has been persevering. The power involved in such a picture, and
the ideas and pleasures following on the estimate of it, are unquestionably
far higher than can legitimately be traced in, or received from the works of
any other mere water-colour master now living.

From *Modern Painters*, Vol. i, Part i, Sec. ii, Ch. i, ¶ 4.

. . . The first merit of manipulation . . . is that delicate and ceaseless ex-
pression of refined truth which is carried out to the last touch, and shadow
of a touch, and which makes every hair's breadth of importance, and every
gradation full of meaning. It is not, properly speaking, execution; but it
is the only source of difference between the execution of a commonplace
and that of a perfect artist. . . .

The second quality of execution is simplicity. The more unpretending,
quiet, and retiring the means, the more impressive their effect. Any osten-
tation, brilliancy, or pretension of touch,—any exhibition of power or
quickness, merely as such—above all, any attempt to render hues attractive
at the expense of their meaning, is vice.

[1] 1802-89; President of the (Old) Water Colour Society, 1858-71.
[2] John Frederick Lewis, R.A., 1804-76.

The third is mystery. Nature is always mysterious and secret in her use of means; and art is always likest her when it is most inexplicable. That execution which is least comprehensible and which therefore defies imitation (other qualities being supposed alike), is the best.

The fourth is inadequacy. The less sufficient the means appear to the end, the greater . . . will be the sensation of power.

The fifth is decision; the appearance, that is, that whatever is done, has been done fearlessly and at once; because this gives us the impression that both the fact to be represented, and the means necessary to its representation, were perfectly known.

The sixth is velocity. Not only is velocity, or the appearance of it, agreeable as decision is, because it gives ideas of power and knowledge; but of two touches, as nearly as possible the same in other respects, the quickest will invariably be the best. . . .

These six qualities are the only perfectly legitimate sources of pleasure in execution, but I might have added a seventh—strangeness, which in many cases is productive of a pleasure not altogether mean or degrading, though scarcely right. Supposing the other higher qualities first secured, it adds in no small degree to our impression of the artist's knowledge, if the means used be such as we should never have thought of, or should have thought, adapted to a contrary effect. Let us, for instance, compare the execution of the bull's head in the left-hand lowest corner of the Adoration of the Magi,[1] in the Museum at Antwerp, with that in Berghem's landscape, No. 132, in the Dulwich Gallery. Rubens first scratches horizontally over his canvas a thin greyish brown, transparent and even, very much the colour of light wainscot, the horizontal strokes of the bristles being left so evident that the whole might be taken for an imitation of wood, were it not for its transparency. On this ground the eye, nostril, and outline of the cheek are given with two or three rude brown touches (about three or four minutes' work in all), though the head is colossal. The background is then laid in with thick solid, warm white, actually projecting all round the head, leaving it in dark intaglio. Finally, five thin and scratchy strokes of very cold bluish white are struck for the highlight on the forehead and nose, and the head is complete. Seen within a yard of the canvas, it looks actually transparent—a flimsy, meaningless, distant shadow, while the background looks solid, projecting and near. From the right distance (ten or twelve yards off, whence alone the whole of the picture can be seen), it is a complete, rich, substantial, and living realization of the projecting head of the animal; while the background falls far behind. Now there is no slight or mean pleasure in perceiving such a result attained by means so strange. By Berghem, on the other hand, a dark background is first laid in

[1] By Rubens.

with exquisite delicacy and transparency, and on this the cow's head is actually modelled in luminous white, the separate locks of hair projecting from the canvas. No surprise, nor much pleasure of any kind, would be attendant on this execution, even were the result equally successful; and what little pleasure we have in it vanishes, when on retiring from the picture, we find the head shining like a distant lantern, instead of seeming substantial or near.

From *Modern Painters*, Vol. I, Part I, Sec. II, Ch. II, ¶ I.

Fact

THE representation of facts . . . is the foundation of all art; like real foundations, it may be little thought of when a brilliant fabric is raised on it; but it must be there. And as few buildings are beautiful unless every line and column of their mass have reference to their foundation, and be suggestive of its existence and strength, so nothing can be beautiful in art which does not in all its parts suggest and guide to the foundation, even where no undecorated portion of it is visible; while the noblest edifices of art are built of such pure and fine crystal that the foundation may all be seen through them. . . . And thus, though we want the thoughts and feelings of the artist as well as the truth, yet they must be thoughts arising out of the knowledge of truth, and feelings arising out of the contemplation of truth. We do not want his mind to be like a badly blown glass, that distorts what we see through it, but like a glass of sweet and strange colour, that gives new tones to what we see through it; and a glass of rare strength and clearness too, to let us see more than we could ourselves, and bring nature up to us and near to us. Nothing can atone for the want of truth, not the most brilliant imagination, the most playful fancy, the most pure feeling (supposing that feeling *could* be pure and false at the same time); not the most exalted conception, nor the most comprehensive grasp of intellect, can make amends for the want of truth, and that for two reasons: first, because falsehood is in itself revolting and degrading; and secondly, because nature is so immeasurably superior to all that the human mind can conceive, that every departure from her is a fall beneath her, so that there can be no such thing as an ornamental falsehood. All falsehood must be a blot as well as a sin, an injury as well as a deception.

From *Modern Painters*, Vol. I, Part II, Sec. I, Ch. I, ¶ 7.

IT ought farther to be observed respecting truths in general, that those are always most valuable which are most historical; that is, which tell us most

about the past and future states of the object to which they belong. In a tree, for instance, it is more important to give the appearance of energy and elasticity in the limbs which is indicative of growth and life, than any particular character of leaf, or texture of bough. It is more important that we should feel that the uppermost sprays are creeping higher and higher into the sky, and be impressed with the current of life and motion which is animating every fibre, than that we should know the exact pitch of relief with which those fibres are thrown out against the sky.[1] For the first truths tell us tales about the tree, about what it has been, and will be, while the last are characteristic of it only in its present state, and are in no way talkative about themselves. Talkative facts are always more interesting and more important than silent ones. So again the lines in a crag which mark its stratification, and how it has been washed and rounded by water, or twisted and drawn out in fire, are more important, because they tell more than the stains of the lichens which change year by year, and the accidental fissures of frost or decomposition; not but that both of these are historical, but historical in a less distinct manner, and for shorter periods. . . .

We thus find painters ranging themselves into two great classes: one aiming at the development of the exquisite truths of specific form, refined colour, and ethereal space, and content with the clear and impressive suggestion of any of these, by whatsoever means obtained; and the other casting all these aside, to attain those particular truths of tone and chiaroscuro, which may trick the spectator into a belief of reality. The first class, if they have to paint a tree, are intent upon giving the exquisite designs of intersecting undulation in its boughs, the grace of its leafage, the intricacy of its organization, and all those qualities which make it lovely or affecting of its kind. The second endeavour only to make you believe that you are looking at wood. They are totally regardless of truths or beauties of form; a stump is as good as a trunk for all their purposes, so that they can only deceive the eye into the supposition that it *is* a stump and not canvas.

From *Modern Painters*, Vol. I, Part II, Sec. I, Ch. VI, ¶ I.

Landscape

CLAUDE had, if it had been cultivated, a fine feeling for beauty of form, and is seldom ungraceful in his foliage; but his picture, when examined with reference to essential truth, is one mass of error from beginning to end. Cuyp, on the other hand, could paint close truth of everything except ground and water, with decision and success, but then he has not the slightest idea of the meaning of the word 'beautiful'. Gaspar Poussin, more

[1] Ill. 6 facing page 34.

ignorant of truth than Claude, and almost as dead to beauty as Cuyp, has yet a perception of the feeling and moral truth of nature, which often redeems the picture; but yet in all of them, everything that they can do is done for deception and nothing for the sake or love of what they are painting.

Modern landscape painters have looked at nature with totally different eyes, seeking not for what is easier to imitate, but for what is most important to tell. Rejecting at once all idea of *bona fide* imitation, they think only of conveying the impression of nature into the mind of the spectator, and chiefly of forcing upon his feelings those delicate and refined truths of specific form, which are just what the careless eye can least detect or enjoy, because they are intended by the Deïty to be the constant objects of our investigation that they may be the constant sources of our pleasure.

From *Modern Painters*, Vol. I, Part II, Sec. I, Ch. VII, ¶ 3.

WHO, that has one spark of feeling for what is beautiful or true, would not turn to be refreshed by the pure and extended realizations of modern art! How many have we—how various in their aim and sphere—embracing one by one every feeling and lesson of the creation! David Cox, whose pencil never falls but in dew—simple-minded as a child, gentle, and loving all things that are pure and lowly—content to be quiet among the rustling leaves, and sparkling grass, and purple-cushioned heather, only to watch the soft white clouds melting with their own motion, and the dewy blue dropping through them like rain, so that he may but cast from him as pollution all that is proud, and artificial, and unquiet, and worldly, and possess his spirit in humility and peace. Copley Fielding, casting his whole soul into space—exulting like a wild deer in the motion of the swift mists, and the free far surfaces of the untrodden hills—now wandering with the quick, pale, fitful sun-gleams over the dim swells and sweeps of grey downs and shadowy dingles, until, lost half in light and half in vapour, they melt into the blue of the plain as the cloud does into the sky—now climbing with the purple sunset along the aërial slopes of the quiet mountains, only known from the red clouds by their stillness—now flying with the wild wind and sifted spray along the white, driving, desolate sea; but always with the passion for nature's freedom burning in his heart, so that every leaf in his foreground is a wild one, and every line of his hills is limitless. J. D. Harding, brilliant and vigorous, and clear in light as nature's own sunshine—deep in knowledge, exquisite in feeling of every form that nature falls into—following with his quick, keen dash the sunlight into the crannies of the rocks, and the wind into the tangling of the grass, and the bright colour into the fall of the sea-foam—various, universal in his aim—

master alike of all form and feature of crag, or torrent, or forest, or cloud; but English, all English at his heart, returning still to rest under the shade of some spreading elm, where the fallow deer butt among the bending fern, and the quiet river glides noiselessly by its reedy shore, and the yellow corn sheaves glow along the flanks of the sloping hills. Clarkson Stanfield, firm and fearless, and unerring in his knowledge—stern and decisive in his truth—perfect and certain in composition—shunning nothing, concealing nothing, and falsifying nothing—never affected, never morbid, never failing —conscious of his strength, but never ostentatious of it—acquainted with every line and hue of the *deep* sea—chiselling his waves with unhesitating knowledge of every curve of their anatomy, and every moment of their motion—building his mountains rock by rock, with wind in every fissure and weight in every stone—and modelling the masses of his sky with the strength of tempest in their every fold. And Turner—glorious in conception —unfathomable in knowledge—solitary in power—with the elements waiting upon his will, and the night and the morning obedient to his call, sent as a prophet of God to reveal to men the mysteries of His universe, standing, like the great angel of the Apocalypse, clothed with a cloud, and with a rainbow upon his head, and with the sun and stars given into his hand.

From *Modern Painters*, First and Second Editions, Vol. i, Part ii, Sec. i, Ch. vii, ¶ 6.

Canaletti

THE effect of a fine Canaletti is, in its first impression, dioramic. We fancy we are in our beloved Venice again, with one foot, by mistake, in the clear, invisible film of water lapping over the marble steps of the foreground. Every house has its proper relief against the sky—every brick and stone its proper hue of sunlight and shade—and every degree of distance its proper tone of retiring air. Presently, however, we begin to feel that it is lurid and gloomy, and that the painter, compelled by the lowness of the utmost light at his disposal to deepen the shadows, in order to get the right relation, has lost the flashing, dazzling, exulting light, which was one of our chief sources of Venetian happiness. But we pardon this, knowing it to be un-avoidable, and begin to look for something of that in which Venice differs from Rotterdam, or any other city built beside canals. We know that house, certainly; we never passed it without stopping our gondolier, for its arabesques were as rich as a bank of flowers in spring, and as beautiful as a dream. What has Canaletti given us for them? Five black dots. Well; take the next house. We remember that too; it was mouldering inch by inch into the canal, and the bricks had fallen away from its shattered marble

shafts, and left them white and skeleton-like; yet, with their fretwork of cold flowers wreathed about them still, untouched by time, and through the rents of the wall behind them there used to come long sunbeams, greened by the weeds through which they pierced, which flitted and fell, one by one, round those grey and quiet shafts, catching here a leaf and there a leaf and gliding over the illumined edges and delicate fissures, until they sank into the deep dark hollow between the marble blocks of the sunk foundation, lighting every other moment one isolated emerald lamp on the crest of the intermittent waves, when the wild seaweeds and crimson lichens drifted and crawled with their thousand colours and fine branches over its decay, and the black, clogging, accumulated limpets hung in ropy clusters from the dripping and tinkling stone. What has Canaletti given us for this? One square red mass, composed of—let me count—five-and-fifty, no; six-and-fifty, no; I was right at first—five-and-fifty bricks, of precisely the same size, shape, and colour, one great black line for the shadow of the roof at the top, and six similar ripples in a row at the bottom! And this is what people call 'painting nature'! It is, indeed, painting nature—as she appears to the most unfeeling and untaught of mankind. The bargeman and the bricklayer probably see no more in Venice than Canaletti gives— heaps of earth and mortar, with water between—and are just as capable of appreciating the facts of sunlight and shadow, by which he deceives us as the most educated of us all. But what more there is in Venice than brick and stone—what there is of mystery and death, and memory and beauty— what there is to be learned or lamented, to be loved or wept—we look for to Canaletti in vain.

From *Modern Painters*, First and Second Editions, Vol. I, Part II, Sec. I, Ch. VII, ¶ 7.

Turner

. . . Let us take, with Turner, the last and greatest step of all. Thank heaven, we are in sunshine again,—and what sunshine! Not the lurid, gloomy, plague-like oppression of Canaletti, but white, flashing fulness of dazzling light, which the waves drink and the clouds breathe, bounding and burning in intensity of joy. That sky,—it is a very visible infinity,—liquid, measure- less, unfathomable, panting and melting through the chasms in the long fields of snow-white, flaked, slow-moving vapour, that guide the eye along their multitudinous waves down to the islanded rest of the Euganean hills. Do we dream, or does the white forked sail drift nearer, and nearer yet, diminishing the blue sea between us with the fulness of its wings? It pauses now; but the quivering of its bright reflection troubles the shadows of the

sea, those azure, fathomless depths of crystal mystery, on which the swift-ness of the poised gondola floats double, its black beak lifted like the crest of a dark ocean bird, its scarlet draperies flashed back from the kindling surface, and its bent oar breaking the radiant water into a dust of gold. Dreamlike and dim, but glorious, the unnumbered palaces lift their shafts out of the hollow sea,—pale ranks of motionless flame,—their mighty towers sent up to heaven like tongues of more eager fire,—their grey domes looming vast and dark, like eclipsed worlds,—their sculptured arabesques and purple marble fading farther and fainter, league beyond league, lost in the light of distance. Detail after detail, thought beyond thought, you find and feel them through the radiant mystery, inexhaustible as indistinct, beautiful, but never all revealed; secret in fulness, confused in symmetry, as nature herself is to the bewildered and foiled glance, giving out of that indistinctness, and through that confusion, the perpetual newness of the infinite, and the beautiful.

Yes, Mr. Turner, we are in Venice now.

From *Modern Painters*, First and Second Editions, Vol. I, Part II, Sec. I, Ch. VII, ¶ 10.

Poussin and Turner

TAKE, for instance, one of the finest landscapes that ancient art has pro-duced—the work of a really great and intellectual mind, the quiet Nicholas Poussin in our own National Gallery, with the traveller washing his feet.[1] The first idea we receive from this picture is that it is evening, and all the light coming from the horizon. Not so. It is full noon, the light coming steep from the left, as is shown by the shadow of the stick on the right-hand pedestal; for if the sun were not very high, that shadow could not lose itself half-way down, and if it were not lateral, the shadow would slope, instead of being vertical. Now ask yourself, and answer candidly, if those black masses of foliage, in which scarcely any form is seen but the outline, be a true representation of trees under noon-day sunlight, sloping from the left, bringing out, as it necessarily would do, their masses into golden green, and marking every leaf and bough with sharp shadow and sparkling light. The only truth in the picture is the exact pitch of relief against the sky of both trees and hills; and to this the organization of the hills, the intricacy of the foliage, and everything indicative either of the nature of the light, or the character of the objects, are unhesitatingly sacrificed. So much false-hood does it cost to obtain two apparent truths of tone! . . .

Compare with [this], Turner's treatment of his materials in the Mercury and Argus.[2] He has here his light actually coming from a distance, the sun

[1] Ill. 4 between pages 26 and 27. [2] Ill. 3 facing this page.

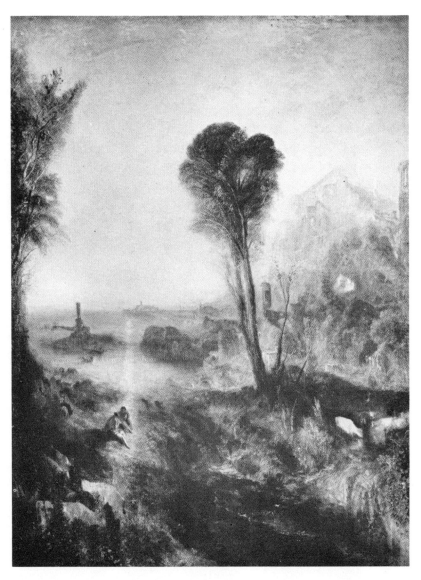

3. MERCURY AND ARGUS. Painting by Turner. *Ottawa, National Gallery of Canada*

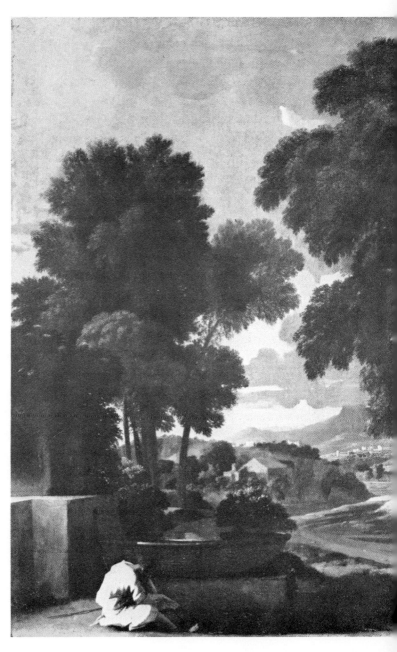

4. LANDSCAPE WITH TRAVELLER WASHING HIS FEET

Painting by Nicolas Poussin. *London, National Gallery*

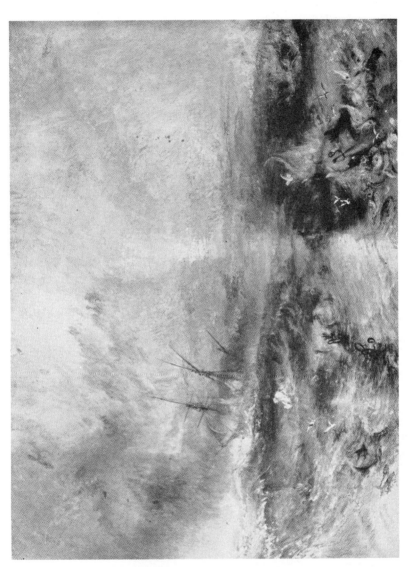

5. THE SLAVE SHIP. Painting by Turner. *Boston, Museum of Fine Arts*

being nearly in the centre of the picture, and a violent relief of objects against it would be far more justifiable than in Poussin's case. But this dark relief is used in its full force only with the nearest *leaves* of the nearest group of foliage overhanging the foreground from the left; and between these and the more distant members of the same group, though only three or four yards separate, distinct aërial perspective and intervening mist and light are shown; while the large tree in the centre, though very dark, as being very near, compared with all the distance, is much diminished in intensity of shade from this nearest group of leaves, and is faint compared with all the foreground. It is true that this tree has not, in consequence, the actual pitch of shade against the sky which it would have in nature; but it has precisely as much as it possibly can have, to leave it in the same proportionate relation to the objects near at hand. And it cannot but be evident to the thoughtful reader, that whatever trickery or deception may be the result of a contrary mode of treatment, this is the only scientific or essentially truthful system, and that what it loses in tone it gains in aërial perspective.

From *Modern Painters*, Vol. I, Part II, Sec. II, Ch. I, ¶ 8.

Light

LIGHT, with reference to the tone it induces on objects, is either to be considered as neutral and white, bringing out local colours with fidelity; or coloured, and consequently modifying these local tints with its own. But the power of pure white light to exhibit local colour is strangely variable. The morning light of about nine or ten is usually very pure; but the difference of its effect on different days, independently of mere brilliancy, is as inconceivable as it is inexplicable. Every one knows how capriciously the colours of a fine opal vary from day to day, and how rare the lights are which bring them fully out. Now the expression of the strange, penetrating, deep, neutral light, which, while it *alters* no colour, brings every colour up to the highest possible pitch and key of pure harmonious intensity, is the chief attribute of finely toned pictures by the great *colourists*, as opposed to pictures of equally high tone, by masters who, careless of colour, are content, like Cuyp, to lose local tints in the golden blaze of absorbing light. . . .

. . . It is only the white light, the perfect unmodified group of rays, which will bring out local colour perfectly; and if the picture, therefore, is to be complete in its system of colour, that is, if it is to have each of the three primitives in their purity, it *must* have white for its highest light,

otherwise the purity of one of them at least will be impossible. And this leads us to notice the second and more frequent quality of light (which is assumed if we make our highest representative of it yellow), the positive hue, namely, which it may itself possess, of course modifying whatever local tints it exhibits, and thereby rendering certain colours necessary, and certain impossible. Under the direct yellow light of a descending sun, for instance, pure white and pure blue are both impossible; because the purest whites and blues that nature could produce would be turned in some degree into gold by it; and when the sun is within half a degree of the horizon, if the sky be clear, a rose light supersedes the golden one, still more over-whelming in its effect on local colour. I have seen the pale fresh green of spring vegetation in the gardens of Venice, on the Lido side, turned pure russet, or between that and crimson, by a vivid sunset of this kind, every particle of green colour being absolutely annihilated. And so under all coloured lights (and there are few, from dawn to twilight, which are not slightly tinted by some accident of atmosphere), there is a change of local colour which, when in a picture it is so exactly proportioned that we feel at once both what the local colours are in themselves, and what are the colour and strength of the light upon them, gives us truth of tone.

From *Modern Painters*, Vol. I, Part II, Sec. II, Ch. I, ¶ 14.

Turner

IN THE whole range of Turner's works, recent or of old date, you will not find an instance of anything near enough to have details visible, painted in sky blue. Wherever Turner gives blue, there he gives atmosphere; it is air, not object. Blue he is, in his sea; so is nature;—blue he is, as a sapphire, in his extreme distance; so is nature;—blue he is, in the misty shadows and hollows of his hills; so is nature; but blue he is *not*, where detail and illumi-nated surface are visible; as he comes into light and character, so he breaks into warmth and varied hue; nor is there in one of his works—and I speak of his Academy pictures especially—one touch of cold colour which is not to be accounted for, and proved right and full of meaning.

From *Modern Painters*, Vol. I, Part II, Sec. II, Ch. II, ¶ 4.

THROUGHOUT the works of Turner, the same truthful principle of delicate and subdued colour is carried out with a care and labour of which it is difficult to form a conception. He gives a dash of pure white for his highest light; but all the other whites of his picture are pearled down with grey or

gold. He gives a fold of pure crimson to the drapery of his nearest figure, but all his other crimsons will be deepened with black, or warmed with yellow. In one deep reflection of his distant sea, we catch a trace of the purest blue, but all the rest is palpitating with a varied and delicate gradation of harmonized tint, which indeed looks vivid blue as a mass, but is only so by opposition. It is the most difficult, the most rare thing, to find in his works a definite space, however small, of unconnected colour; that is, either of a blue which has nothing to connect it with the warmth, or of a warm colour, which has nothing to connect it with the greys of the whole; and the result is, that there is a general system and under-current of grey pervading the whole of his colour, out of which his highest lights, and those local touches of pure colour, which are . . . the keynotes of the picture, flash with the peculiar brilliancy, and intensity in which he stands alone.

From *Modern Painters*, Vol. I, Part II, Sec. II, Ch. II, ¶ 14.

Purple and Yellow

I THINK the first approach to viciousness in any master is commonly indicated chiefly by a prevalence of purple, and an absence of yellow. I think nature mixes yellow with almost every one of her hues, never, or very rarely, using red without it, but frequently using yellow with scarcely any red; and I believe it will be in consequence found that her favourite opposition, that which generally characterizes and gives tone to her colour, is yellow and black, passing, as it retires, into white and blue. It is beyond dispute that the great fundamental opposition of Rubens is yellow and black; and that on this, concentrated in one part of the picture, and modified in various greys throughout, chiefly depend the tones of all his finest works. And in Titian, though there is a far greater tendency to purple than in Rubens, I believe no red is ever mixed with the pure blue, or glazed over it, which has not in it a modifying quantity of yellow. At all events I am nearly certain that whatever rich and pure purples are introduced locally, by the great colourists, nothing is so destructive of all fine colour as the slightest tendency to purple in general tone; and I am equally certain that Turner is distinguished from all the vicious colourists of the present day, by the foundation of all his tones being black, yellow, and the intermediate greys, while the tendency of our common glare-seekers is invariably to cold, impossible purples.

From *Modern Painters*, Vol. I, Part II, Sec. II, Ch. II, ¶ 17.

Turner's 'Slave Ship'

BEYOND dispute the noblest sea that Turner has ever painted, and if so, the noblest certainly ever painted by man, is that of the Slave Ship,[1] the chief Academy picture of the Exhibition of 1840. It is a sunset on the Atlantic, after prolonged storm; but the storm is partially lulled, and the torn and streaming rain-clouds are moving in scarlet lines to lose themselves in the hollow of the night. The whole surface of sea included in the picture is divided into two ridges of enormous swell, not high, nor local, but a low broad heaving of the whole ocean, like the lifting of its bosom by deep-drawn breath after the torture of the storm. Between these two ridges the fire of the sunset falls along the trough of the sea, dyeing it with an awful but glorious light, the intense and lurid splendour which burns like gold, and bathes like blood. Along this fiery path and valley, the tossing waves by which the swell of the sea is restlessly divided, lift themselves in dark, indefinite, fantastic forms, each casting a faint and ghastly shadow behind it along the illumined foam. They do not rise everywhere, but three or four together in wild groups, fitfully and furiously, as the under strength of the swell compels or permits them; leaving between them treacherous spaces of level and whirling water, now lighted with green and lamp-like fire, now flashing the gold of the declining sun, now fearfully dyed from above with the undistinguishable images of the burning clouds, which fall upon them in flakes of crimson and scarlet, and give to the reckless waver the added motion of their own fiery flying. Purple and blue, the lurid shadows of the hollow breakers are cast upon the mist of night, which gathers cold and low, advancing like the shadow of death upon the guilty[*] ship as it labours amid the lightning of the sea, its thin masts written upon the sky, in lines of blood, girded with condemnation in that fearful hue which signs the sky with horror, and mixes its flaming flood with the sunlight, and, cast far along the desolate heave of the sepulchral waves, incardines the multitudinous sea.

I believe, if I were reduced to rest Turner's immortality upon any single work, I should choose this. Its daring conception, ideal in the highest sense of the word, is based on the purest truth, and wrought out with the concentrated knowledge of a life; its colour is absolutely perfect, not one false or morbid hue in any part or line, and so modulated that every square inch of canvas is a perfect composition; its drawing as accurate as fearless; the ship buoyant, bending, and full of motion; its tones as true as they are wonderful; and the whole picture dedicated to the most sublime of subjects

[1] Catalogued as ' Slavers throwing overboard the dead and dying—Typhoon coming on'. The picture was once in Ruskin's own collection. Ill. 5 facing page 27.

[*] She is a slaver, throwing her slaves overboard. The near sea is encumbered with corpses.

and impressions . . .—the power, majesty and deathfulness of the open, deep, illimitable sea.

<div align="center">From Modern Painters, Vol. I, Part II, Sec. v, Ch. III, ¶ 39.</div>

Infinity

THE absolute necessity, for such I indeed consider it, [for infinity in art], is of no more than such a mere luminous distant point as may give to the feelings a species of escape from all the finite objects about them. There is a spectral etching of Rembrandt, a Presentation of Christ in the Temple, where the figure of a robed priest stands glaring by its gems out of the gloom, holding a crozier. Behind it there is a subdued window-light, seen in the opening between two columns, without which the impressiveness of the whole subject would, I think, be incalculably brought down. I cannot tell whether I am allowing too much weight to my own fancies and pre-dilections, but without so much escape into the outer air and open heaven as this, I can take permanent pleasure in no picture.

<div align="center">From Modern Painters, Vol. II, Part III, Sec. I, Ch. v, ¶ 7.</div>

Primitives

. . . The ornaments used by Angelico, Giotto, and Perugino, but especially by Angelico, are always of a *generic* and *abstract* character. They are not diamonds, nor brocades, nor velvets, nor gold embroideries; they are mere spots of gold or of colour. Simple patterns upon *textureless* draperies; the angels' wings burn with transparent crimson and purple and amber, but they are not set forth with peacocks' plumes; the golden circlets gleam with changeful light, but they are not beaded with pearls, nor set with sapphires.

In the works of Filippino Lippi, Mantegna, and many other painters following, interesting examples may be found of the opposite treatment; and as in Lippi the heads are usually very sweet, and the composition severe, the degrading effect of the realized decorations and imitated dress may be seen in him simply, and without any addition of painfulness from other deficiencies of feeling. . . .

. . . Brightness of colour is altogether inadmissible without purity and harmony; and . . . the sacred painters must not be followed in their frank-ness of unshadowed colour, unless we can also follow them in its clearness.

As far as I am acquainted with the Modern Schools of Germany,[1] they seem to be entirely ignorant of the value of colour as an assistant of feeling, and to think that hardness, dryness and opacity are its virtues as employed in religious art; whereas I hesitate not to affirm that in such art, more than in any other, clearness, luminousness, and intensity of hue are essential to right impression; and from the walls of the Arena Chapel in their rainbow play of brilliant harmonies, to the solemn purple tones of Perugino's fresco in the Albizzi Palace, I know not any great work of sacred art which is not as precious in colour as in all other qualities . . .; only the pure white light and delicate hue of the idealists, whose colours are by preference such as we have seen to be most beautiful . . . are carefully to be distinguished from the golden light and deep-pitched hue of the school of Titian, whose virtue is the grandeur of earthly solemnity, not the glory of heavenly rejoicing.

From *Modern Painters*, Vol. II, Part III, Sec. II, Ch. v, ¶ 14.

Landscape

. . . All landscape grandeur vanishes before that of Titian and Tintoret; and this is true of whatever these two giants touched; but they touched little. A few level flakes of chestnut foliage; a blue abstraction of hill forms from Cadore or the Euganeans; a grand mass or two of glowing ground and mighty herbage, and a few burning fields of quiet cloud, were all they needed; there is evidence of Tintoret's having felt more than this, but it occurs only in secondary fragments of rock, cloud, or pine, hardly noticed among the accumulated interest of his human subject. From the window of Titian's house at Venice, the chain of the Tyrolese Alps is seen lifted in spectral power above the tufted plain of Treviso; every dawn that reddens the towers of Murano lights also a line of pyramidal fires along that colossal ridge; but there is, so far as I know, no evidence in any of the master's works of his ever having beheld, much less felt, the majesty of their burning. The dark firmament and saddened twilight of Tintoret are sufficient for their end; but the sun never plunges behind San Giorgio in Aliga without such retinue of radiant cloud, such crest of zoned light on the green lagoon, as never received image from his hand. . . .

From *Modern Painters*, Vol. I, 3rd edn., Part II, Sec. I, Ch. VII, ¶ 6.

THE ideal landscape of the early religious painters of Italy . . . is absolutely right and beautiful in its peculiar application; but its grasp of nature is

[1] The 'Nazarenes'?

narrow, and its treatment in most respects too severe and conventional to form a profitable example when the landscape is to be alone the subject of thought. The great virtue of it is its entire, exquisite and humble realization of the objects it selects; in this respect differing from such German imitations of it as I have met with, that there is no effort at any fanciful or ornamental modifications, but loving fidelity to the thing studied. The foreground plants are usually neither exaggerated nor stiffened; they do not form arches or frames or borders; their grace is unconfined, their simplicity undestroyed. Cima da Conegliano, in his picture in the church of the Madonna dell'Orto at Venice has given us the oak, the fig, the beautiful 'Erba della Madonna' on the wall, precisely such a bunch of it as may be seen growing at this day on the marble steps of that very church; ivy and other creepers, and a strawberry plant in the foreground, with a blossom, and a berry just set, and one half-ripe and one ripe, all patiently and innocently painted from the real thing, and therefore most divine. Fra Angelico's use of the Oxalis Acetosella is as faithful in representation as touching in feeling. The ferns that grow on the walls of Fiesole may be seen in their simple verity on the architecture of Ghirlandajo. The rose, the myrtle, and the lily, the olive and orange, pomegranate and vine, have received their fairest portraiture where they bear a sacred character; even the common plantains and mallows of the waysides are touched with deep reverence by Raffaelle, and indeed for the perfect treatment of details, of this kind, treatment as delicate and affectionate as it is elevated and manly, it is to the works of these schools alone that we can refer. And on this their peculiar excellence I should the more earnestly insist, because it is of a kind altogether neglected by the English School, and with the most unfortunate result; many of our best painters missing their deserved rank solely from the want of it, as Gainsborough; and all being more or less checked in their progress or vulgarized in their aim.

From *Modern Painters*, Vol. I, 3rd edn., Part II, Sec. I, Ch. VII, ¶ 9.

Finish and Impetuosity

THE fact is, that both finish and impetuosity, specific minuteness and large abstraction, may be the signs of passion, or of its reverse; may result from affection or indifference, intellect or dulness. . . . Now both the finish and incompletion are right where they are the signs of passion or of thought, and both are wrong, and I think the finish the more contemptible of the two, when they cease to be so. The modern Italians will paint every leaf of a laurel or rosebush, without the slightest feeling of their beauty or

character; and without showing one spark of intellect or affection from beginning to end. Anything is better than this; and yet the very highest schools *do* the same thing, or nearly so, but with totally different motives and perceptions, and the result is divine. On the whole, I conceive that the extremes of good and evil lie with the finishers, and that whatever glorious power we may admit in men like Tintoret, whatever attractiveness of method in Rubens, Rembrandt, or, though in far less degree, our own Reynolds, still the thoroughly great men are those who have done everything thoroughly, and who, in a word, have never despised anything, however small, of God's making. And this is the chief fault of our English landscapists, that they have not the intense all-observing penetration of well-balanced mind; they have not, except in one or two instances, anything of that feeling which Wordsworth shows in the following lines:

> 'So fair, so sweet, withal so sensitive;—
> Would that the little flowers were born to live
> Conscious of half the pleasure which they give,
> That to the mountain daisy's self were known
> *The beauty of its star-shaped shadow, thrown*
> *On the smooth surface of this naked stone.*'

That is a little bit of good, downright foreground painting—no mistake about it; daisy, and shadow, and stone texture and all. Our painters must come to this before they have done their duty; and yet, on the other hand, let them beware of finishing, for the sake of finish, all over their picture. The ground is not to be all over daisies, nor is every daisy to have its star-shaped shadow; there is as much finish in the right concealment of things as in the right exhibition of them; and while I demand this amount of specific character where nature shows it, I demand equal fidelity to her where she conceals it. To paint mist rightly, space rightly, and light rightly, it may be often necessary to paint nothing else rightly, but the rule is simple for all that; if the artist is painting something that he knows and loves, as he knows it, because he loves it, whether it be the fair strawberry of Cima, or the clear sky of Francia, or the blazing incomprehensible mist of Turner, he is all right; but the moment he does anything as he thinks it ought to be, because he does not care about it, he is all wrong. He has only to ask himself whether he cares for anything except himself; so far as he does he will make a good picture; so far as he thinks of himself, a vile one.

<div style="text-align:center">From Modern Painters, Vol. I, 3rd edn., Part II, Sec. I, Ch. VII, ¶ 10.</div>

6. ROUGH SKETCHES OF TREE GROWTH. Drawing by Ruskin
Oxford, Ashmolean Museum

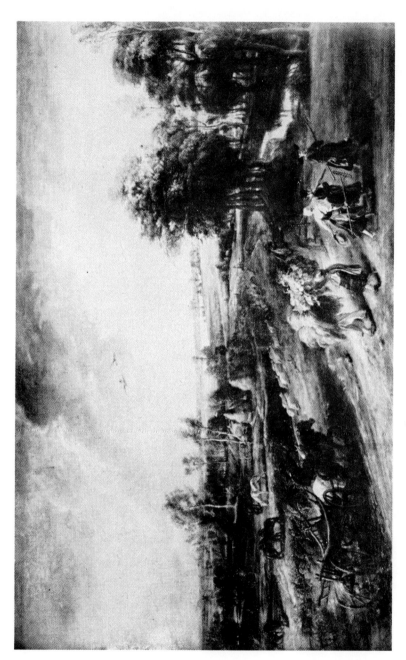

7. THE RETURN FROM FIELD LABOUR. Painting by Rubens. *Florence, Galleria Pitti*

Claude

THOUGH, however, at this period [1] the general grasp of the schools was perpetually contracting, a gift was given to the world by Claude, for which we are perhaps hardly enough grateful, owing to the very frequency of our after enjoyment of it. He set the sun in the heaven, and was, I suppose, the first who attempted anything like the realization of actual sunshine in misty air. He gives the first example of the study of Nature for her own sake, and allowing for the unfortunate circumstances of his education, and for his evident inferiority of intellect, more could hardly have been expected from him. His false taste, forced composition, and ignorant rendering of detail have perhaps been of more detriment to art than the gift he gave was of advantage. The character of his own mind is singular; I know of no other instance of a man's working from nature continually with the desire of being true, and never attaining the power of drawing so much as the bough of a tree rightly.

From *Modern Painters*, Vol. I, 3rd edn., Part II, Sec. I, Ch. VII, ¶ 14.

Landscape

[RUBENS] perhaps furnishes us with the first instances of complete, unconventional, unaffected landscape. His treatment is healthy, manly, and rational, not very affectionate, yet often condescending to minute and multitudinous detail; always, as far as it goes, pure, forcible, and refreshing, consummate in composition, and marvellous in colour. In the Pitti palace, the best of its two Rubens' landscapes [2] has been placed near a characteristic and highly finished Titian, the Marriage of St. Catherine. Were it not for the grandeur of line and solemn feeling in the flock of sheep and the figures of the latter work, I doubt if all its glow and depth of tone could support its overcharged green and blue against the open breezy sunshine of the Fleming. I do not mean to rank the art of Rubens with that of Titian; but it is always to be remembered that Titian hardly ever paints sunshine, but a certain opalescent twilight which has as much of human emotion as of imitative truth in it, and that art of this kind must always be liable to some appearance of failure when compared with a less pathetic statement of facts.

It is to be noted, however, that the licenses taken by Rubens in particular instances are as bold as his general statements are sincere. In the landscape just instanced the horizon is an oblique line; in the Sunset of our own [National] Gallery many of the shadows fall at right angles to the

[1] The period after Tintoretto. [2] 'Return from Field Labour.' Ill. 7 facing this page.

light; in a picture in the Dulwich Gallery a rainbow is seen by the spectator at the side of the sun.

These bold and frank licenses are not to be considered as detracting from the rank of the painter; they are usually characteristic of those minds whose grasp of nature is so certain and extensive as to enable them fearlessly to sacrifice a truth of actuality to a truth of feeling. Yet the young artist must keep in mind that the painter's greatness consists not in his taking, but in his atoning for them. . . .

Passing to the English school, we find a connecting link between them and the Italians formed by Richard Wilson. Had the artist studied under favourable circumstances, there is evidence of his having possessed power enough to produce an original picture; but corrupted by study of the Poussins, and gathering his materials chiefly in their field, the district about Rome—a district especially unfavourable, as exhibiting no pure or healthy nature, but a diseased and overgrown flora among half-developed volcanic rocks, loose calcareous concretions, and mouldering wrecks of buildings, and whose spirit I conceive to be especially opposed to the natural tone of the English mind,—his originality was altogether overpowered; and, though he paints in a manly way and occasionally reaches exquisite tones of colour, as in the small and very precious picture belonging to Mr. Rogers, and sometimes manifests some freshness of feeling, as in the Villa of Maecenas of our National Gallery[1], yet his pictures are in general mere diluted adaptations from Poussin and Salvator, without the dignity of the one, or the fire of the other.

Not so Gainsborough; a great name his, whether of the English or any other school. The greatest colourist since Rubens, and the last, I think, of legitimate colourists; that is to say, of those who were fully acquainted with the power of their material; pure in his English feeling, profound in his seriousness, graceful in his gaiety. There are nevertheless certain deductions to be made from his worthiness which yet I dread to make, because my knowledge of his landscape works is not extensive enough to justify me in speaking of them decisively; but this is to be noted of all that I know, that they are rather motives of feeling and colour than earnest studies; that their execution is in some degree mannered, and always hasty; that they are altogether wanting in the affectionate detail of which I have already spoken; and that their colour is in some measure dependent on a bituminous brown and conventional green, which have more of science than of truth in them. These faults may be sufficiently noted in the magnificent picture presented by him to the Royal Academy,[2] tested by a comparison of it with the Turner (Llanberis) in the same room. Nothing can be more attrac-

[1] Ill. 9 facing page 37.
[2] Diploma Gallery. Landscape with sheep at a fountain. Ill. 8 facing this page.

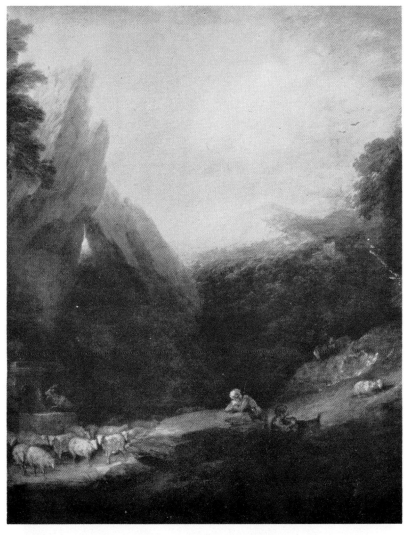

8. LANDSCAPE WITH SHEEP AT A FOUNTAIN. Detail of a painting by Gainsborough
London, Royal Academy of Arts, Diploma Gallery

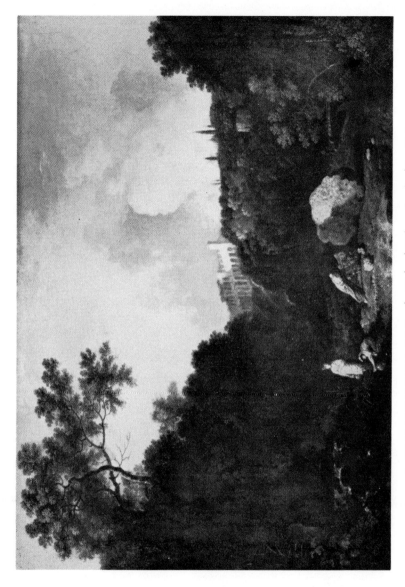

9. VILLA OF MAECENAS. Painting by Richard Wilson. *London, Tate Gallery*

tively luminous or aërial than the distance of the Gainsborough, nothing more bold or inventive than the forms of its crags and the diffusion of the broad distant light upon them, where a vulgar artist would have thrown them into dark contrast. But it will be found that the light of the distance is brought out by a violent exaggeration of the gloom in the valley; that the forms of the green trees which bear the chief light are careless and ineffective; that the markings of the crags are equally hasty, and that no object in the foreground has realization enough to enable the eye to rest upon it. The Turner, a much feebler picture in its first impression, and altogether inferior in the quality and value of its individual hues, will yet be found in the end more forcible, because unexaggerated; its gloom is moderate and aërial, its light deep in tone, its colour entirely unconventional, and the forms of its rocks studied with the most devoted care. . . .

Unteachableness seems to have been a main feature of [Constable's] character, and there is corresponding want of veneration in the way he approaches nature herself. His early education and associations were also against him; they induced in him a morbid preference of subjects of a low order. I have never seen any work of his in which there were any signs of his being able to draw, and hence even the most necessary details are painted by him inefficiently. His works are also eminently wanting both in rest and refinement; and Fuseli's jesting compliment[1] is too true; for the showery weather, in which the artist delights, misses alike the majesty of storm and the loveliness of calm weather; it is great-coat weather, and nothing more. There is strange want of depth in the mind which has no pleasure in sunbeams but when piercing painfully through clouds, nor in foliage but when shaken by the wind, nor in light itself but when flickering, glistening, restless and feeble. Yet, with all these deductions, his works are to be deeply respected, as thoroughly original, thoroughly honest, free from affectation, manly in manner, frequently successful in cool colour, and realizing certain motives of English scenery with perhaps as much affection as such scenery, unless when regarded through media of feeling derived from higher sources, is calculated to inspire.

From *Modern Painters*, Vol. I, 3rd edn., Part II, Sec. I, Ch. VII, ¶ 15.

Prout, Cox and Fielding

. . . The reed pen outline and peculiar touch of Prout, which are frequently considered as mere manner, are in fact the only means of expressing the crumbling character of stone which the artist loves and desires. That character never has been expressed except by him, nor will it ever be expressed

[1] 'I am going to see Constable; bring me mine ombrella.'

except by his means. And it is of the greatest importance to distinguish this kind of necessary and virtuous manner from the conventional manners very frequent in derivative schools, and always utterly to be contemned, wherein an artist, desiring nothing and feeling nothing, executes everything in his own particular mode, and teaches emulous scholars how to do with difficulty what might have been done with ease. It is true that there are sometimes instances in which great masters have employed different means of getting at the same end, but in these cases their choice has been always of those which to them appeared the shortest and most complete; their practice has never been prescribed by affectation or continued from habit, except so far as must be expected from such weakness as is common to all men; from hands that necessarily do most readily what they are most accustomed to do, and minds always liable to prescribe to the hands that which they can do most readily.

The recollection of this will keep us from being offended with the loose and blotted handling of David Cox.[1] There is no other means by which his object could be attained; the looseness, coolness and moisture of his heritage, the rustling crumpled freshness of his broad-leaved weeds, the play of pleasant light across his deep heathered moor or plashing sand, the melting of fragments of white mist into the dropping blue above; all this has not been fully recorded except by him, and what there is of accidental in his mode of reaching it, answers gracefully to the accidental part of nature herself. Yet he is capable of more than this, and if he suffers himself uniformly to paint beneath his capability, that which began in feeling must necessarily end in manner. . . .

. . . I suppose that there are many who, like myself, at some period of their life have derived more intense and healthy pleasure from the works of [Copley Fielding] than of any other whatsoever; healthy, because always based on his faithful and simple rendering of nature, and that of very lovely and impressive nature, altogether freed from coarseness, violence or vulgarity. . . .

He indulges himself too much in the use of crude colour. Pure cobalt, violent rose, and purple, are of frequent occurrence in his distances; pure siennas and other browns in his foregrounds, and that not as expressive of lighted but of local colour. . . . Crude colour is not bright colour, and there was never a noble or brilliant work of colour yet produced, whose real power did not depend on the subduing of its tints rather than the elevation of them.

It is perhaps one of the most difficult lessons to learn in art, that the warm colours of distance, even the most glowing, are subdued by the air so as in no wise to resemble the same colour seen on a foreground object;

[1] Cf. 1st edition, printed above, p. 23.

so that the rose of sunset on clouds or mountains has a grey in it which distinguishes it from the rose colour of the leaf of a flower; and the mingling of this grey of distance without in the slightest degree taking away the intense and perfect purity of the colour in and by itself, is perhaps the last attainment of the great landscape colourist. In the same way the blue of distance, however intense, is not the blue of a bright blue flower; and it is not distinguished from it by different texture merely, but by a certain intermixture and undercurrent of warm colour, which are altogether wanting in many of the blues of Fielding's distances; and so of every bright colour; while in foreground, where colours may be, and ought to be, pure, they yet become expressive of light only where there is the accurate fitting of them to their relative shadows which we find in the works of Giorgione, Titian, Tintoret, Veronese, Turner, and all other great colourists. Of this fitting of light to shadow Fielding is altogether regardless, so that his foregrounds are constantly assuming the aspect of overcharged local colour instead of sunshine, and his figures and cattle look transparent. . . .

It seems strange that to an artist of so quick feeling the details of a mountain foreground should not prove irresistibly attractive, and entice him to greater accuracy of study. There is not a fragment of its living rock, nor a tuft of its heathery herbage, that has not adorable manifestations of God's working thereupon. The harmonies of colour among the native lichens are better than Titian's; the interwoven bells of campanula and heather are better than all the arabesques of the Vatican; they need no improvement, arrangement, nor alteration, nothing but love; and every combination of them is different from every other, so that a painter need never repeat himself if he will only to be true. Yet all these sources of power have been of late entirely neglected by Fielding. There is evidence through all his foregrounds of their being mere home inventions, and like all home inventions, they exhibit perpetual resemblances and repetitions; the painter is evidently embarrassed without his rutted road in the middle, and his boggy pool at the side, which pool he has of late painted in hard lines of violent blue; there is not a stone, even of the nearest and most important, which has its real lichens upon it, or a studied form, or anything more to occupy the mind than certain variations of dark and light browns. . . .

From *Modern Painters*, Vol. I, 3rd edn., Part II, Sec. I, Ch. VII, ¶ 20.

Turner

. . . Turner is the only painter, so far as I know, who has ever drawn the sky, not the clear sky, which we before saw belonged exclusively to the

religious schools, but the various forms and phenomena of the cloudy heavens; all previous artists having only represented it typically or partially, but he absolutely and universally. He is the only painter who has ever drawn a mountain, or a stone; no other man ever having learned their organization, or possessed himself of their spirit, except in part or obscurely. . . . He is the only painter who ever drew the stem of a tree, Titian having come the nearest before him, and excelling him in the muscular development of the larger trunks (though sometimes losing the woody strength in a serpent-like flaccidity), but missing the grace and character of the ramifications. He is the only painter who has ever represented the surface of calm, or the force of agitated water; who has represented the effects of space on distant objects, or who has rendered the abstract beauty of natural colour. These assertions I make deliberately, after careful weighing and consideration, in no spirit of dispute or momentary zeal; but from strong and convinced feeling, and with the consciousness of being able to prove them.

From *Modern Painters*, Vol. I, 3rd edn., Part II, Sec. I, Ch. VII, ¶ 46.

Nineteenth Century Art

THERE IS, perhaps, no phenomenon connected with the history of the first half of the nineteenth century, which will become a subject of more curious investigation in after ages, than the coincident development of the Critical faculty, and extinction of the Arts of Design. Our mechanical energies, vast though they be, are not singular nor characteristic; such, and so great, have before been manifested—and it may perhaps be recorded of us with wonder rather than respect, that we pierced mountains and excavated valleys, only to emulate the activity of the gnat and the swiftness of the swallow. Our discoveries in science, however, accelerated or comprehensive, are but the necessary development of the more wonderful reachings into vacancy of past centuries; and they who struck the piles of the bridge of Chaos will arrest the eyes of Futurity rather than we builders of its towers and gates—theirs the authority of Light, ours but the ordering of courses to the Sun and Moon.

But the Negative character of the age is distinctive. There has not before appeared a race like that of civilized Europe at this day, thoughtfully unproductive of all art—ambitious—industrious—investigative—reflective, and incapable. Disdained by the savage, or scattered by the soldier, dishonoured by the voluptuary, or forbidden by the fanatic, the arts have not, till now, been extinguished by analysis and paralyzed by protection. Our

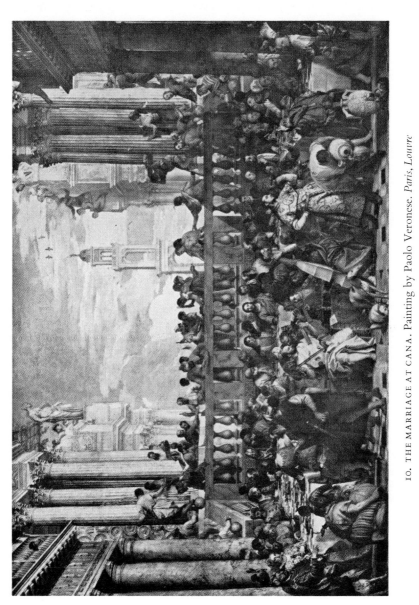

10. THE MARRIAGE AT CANA. Painting by Paolo Veronese. *Paris, Louvre*

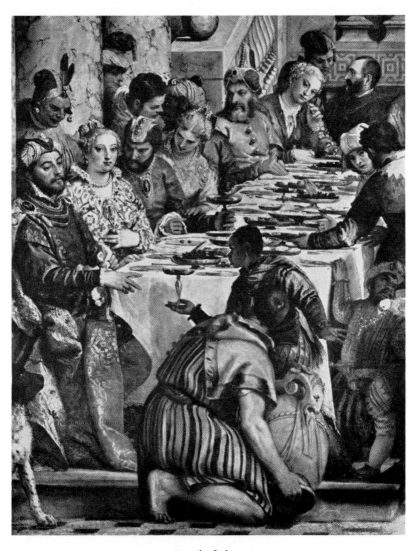

11. Detail of Plate 10

lecturers, learned in history, exhibit the descents of excellence from school to school, and clear from doubt the pedigrees of powers which they cannot re-establish, and of virtues no more to be revived; the scholar is early acquainted with every department of the Impossible, and expresses in proper terms his sense of the deficiencies of Titian and the errors of Michael Angelo: the metaphysician weaves from field to field his analogies of gossamer, which shake and glitter fairly in the sun, but must be torn asunder by the first plough that passes: geometry measures out, by line and rule, the light which is to illustrate heroism, and the shadow which should veil distress; and anatomy counts muscles, and systematizes motion, in the wrestling of genius with its angel. Nor is ingenuity wanting—nor patience; apprehension was never more ready, nor execution more exact—yet nothing is of us, or in us, accomplished;—the treasures of our wealth and will are spent in vain—our cares are as clouds without water—our creations fruitless and perishable; the succeeding Age will trample 'sopra lor vanita che par persona', and point wonderingly back to the strange colourless tessera in the mosaic of human mind.

<div align="right">Review of Lord Lindsay, Sketches of the History of Christian Art.</div>

Notes on the Louvre

P A R I S, *8th September*, 1849.—I entered the Louvre this morning under the peculiar advantage of having been utterly separated from humanity, and from all manifestation of human mind, for full 120 days, and I was suddenly therein brought into contact with perhaps the most varied exhibition of the powers of the human mind in Europe—(for there is a local colour and character about the Florentine and Roman galleries utterly wanting in the *mélange* of Dutch, Spanish, French, and Italian work—all first-rate—presented by the Louvre). I felt as if I had been plunged into a sea of wine of thought, and must drink to drowning. But the first distinct impression which fixed itself on me was that of the entire superiority of Painting to Literature as a test, expression, and record of human intellect, and of the enormously greater quantity of Intellect which might be forced into a picture—and read there—compared with that which might be expressed in words. I felt this strongly as I stood before the Paul Veronese.[1] I felt assured that more of Man, more of awful and inconceivable intellect, went to the making of that picture than of a thousand poems. I saw at once the whole life of the man—his religion, his conception of humanity, his reach of conscience, of moral feeling, his kingly imaginative power, his physical

[1] The 'Wedding Feast at Cana,' No. 1192. Ill. 10 facing page 40.

gifts, his keenness of eye, his sense of colour, his enjoyment of all that was glorious in nature, his chief enjoyment of that which was especially fitted to his sympathies, his patience, his memory, his thoughtfulness—all that he was, that he had, that he could, was there. And as I glanced away to the extravagances, or meannesses, or mightinesses, that shone or shrank beneath my glance along the infinite closing of that sunset-coloured corridor, I felt that painting had never yet been understood as it is—an Interpretation of Humanity.

¶ It is vain to talk of a man's being a great or a little Painter. There is no Greatness of Manhood and of mind too vast to be expressed by it. No meanness nor vileness too little or too foul to be arrested by it. And what the man is, such is his picture: not the achievement of an ill or well practised art, but the magnificent or miserable record of divine or decrepit mind. There is first the choice of subject and the thought of it, in which the whole soul of the man may be traced—his love, his moral principle, his modes of life, the kind of men among which he moved, and whose society he pre-ferred, the degree of understanding he had of these men; and all this to a degree and with an exactitude which no words could ever reach. For the best Poet—use what expressions he may, [is] yet in a sort dependent upon his reader's acceptance and rendering of such expressions. He may talk of nobility of brow or of mien: but the painter alone can show us the exact contour of brow and bearing of limb which he himself felt to be noble; the painter only can show us the very hues and lines he loved, the very cast of thought he most honoured. Let all this be read aright, and then add to it the expression of the less profound gifts, and feelings of the man—of his caprices, his fancies, his prejudices, his wildnesses of imagination, his favourite and familiar branches of knowledge—all stealing in in their due place—and more or less harmonized with his subject according to the degree in which that, or his Art, was predominant. Finally, the colossal power of the Art itself—of mere pictorial invention and execution—how many strange qualities of mind are there not involved in this alone, which in the poet must lie dormant. How feeble are his means of expressing *colour*, at the best, and if the music of words be thought equivalent to it, yet how little and miserable is the Art of arranging syllables and rhyme (often at some sacrifice of meaning), compared with that awful self-command, that lordly foresight and advance, by which the great painter gathers together his glory of deep-dyed light.

¶ Nor as an expression of Vice or Folly is it less distinct, of in exact proportion to the powers which it can express, are the powers it demands. With less than it can receive, it is incomplete. A man who is not a great man from the heart outwards, has no chance—I say not of being a great painter —but of being a painter at all. Cast into a field of contest of giants, he

displays nothing but his own minuteness. And utterly and basely is the nakedness of most men discovered therein. For as in no poem is so much mystery of intellect concentrated as in this work of Veronese, and in many of Titian, Tintoret, M. Angelo, and Raffaelle, so in no book is it possible to display the amount of absolute idiocy which is exhibited in modern French or Italian work. Men may be taught to write grammar, not to draw steadily. For decency's or for learning's sake, they are forced in writing to abstain from *some* words and thoughts, but there is no grossness which pictorial precedent cannot excuse, and in which therefore a gross painter does not indulge himself. There are some ideas of vulgarity or of crime which no words, however laboured, would succeed in suggesting to a gentle heart or a pure mind. But the brutal painter has the eyes at his mercy; and as Kingliness and Holiness, and Manliness and Thoughtfulness were never by words so hymned or so embodied or so enshrined as they have been by Titian, and Angelico, and Veronese, so never were Blasphemy and cruelty and horror and degradation and decrepitude of Intellect—and all that has sunk and will sink Humanity to Hell—so written in words as they are stamped upon the canvasses of Salvator and Jordaens and Caravaggio and modern France.

¶ I was singularly struck with one exemplification of all this that I felt in two pictures of Titian, side by side, which showed the entire grasp the man had of the whole range of the joys and the efforts of the grace and the gloom of human life. The one, a portrait of a man in a dark dress,[1] the darkest possible warm green, passing into coal black, the background dark —the light falling, with Rembrandt simplicity and singleness, on the head and hands (note that Rembrandtism in its truth and in its right application to solemn subject is practised by the greatest men): one arm leaned against the plinth of a grey cold column of stone with an Attic base [a rough sketch of this base], the hand falling over the edge of it in perfect rest— the other, right hand, laid on the sword hilt, the back of the hand upmost; the black hilt, ebony black with one or two intense white flashes on it, like those of Turner on the chains in the 'Slaver',[2] rising between the fore-finger and the second; the front of the thumb seen below, all at rest—the face dark, the hair short, and as black as night; the eye lightless, calm, but sternly set and fixed, the beard dark brown, and full from the lip—almost the only flowing line admitted in the picture (for the sleeve that rounds to the pendent hand is foreshortened—in a series of short waves as below [rough sketch of piece of sleeve], the white of the column being rudely loaded over its flat intense black in a series of apparently inconsiderate sweeps); the mouth curled and scornful, yet not exaggerated, all quiet

[1] Colour-plate facing page 46.
[2] See above p. 30. See *Modern Painters*, Vol. I (Vol. III, p. 571, and Pl. 12).

and self subdued, yet lurid and wrathful in its single wreathed line of burning red—seen through the shade of the hand like a gleam of angry sunset through a thunder cloud.

¶ Beside this picture hangs that of Titian with his mistress:[1] she, all softness and gentleness, her light hair half bound, half bedewed, with pearl, her shoulders heaving under the brown kerchief which is falling from them—and her full breast rising out of the light white loose dress—yet grandly always—not sensually. Pure womanhood—tender and voluptuous, but sublime, not sensual—her round and glowing arm, clasped at the shoulder by an armlet of ruby and gold, bent over the bright, ideal, substanceless ball which seems to mark at once the lustre and the mystery and the hollowness of life and of the world—the Cupid with his arrow sheaf, and azure wings—above,—another bright haired and most lovely nymph, clasping her hands as if in worship of the higher loveliness—her hair wreathed with a sharp laurel-like leaf and white starry flowers—but *both* small and lustrous[2]—and full of grace and purity—her eyes wet, and the light flashing upon them, while those of the Queen of Titian are set on soft and brooding darkness—the brows of both the fair creatures nearly alike—that subdued horizontal arch which has so much at once of grace and power: the dress of one crimson and green, of the other, the Magdalen-like Grace, grey and gold—between them, their Lord, the head in shadow, the white light flashing from his dark cuirass. Note, by-the-bye, this armour is actually more conspicuous than the head of the wearer; reason, first, that the sentiment is chiefly of colour, to which that of the armour is precious; secondly, that the steel gives the greatest possible contrast to the feminine tenderness.

¶ Two pictures of Susannah. Tintoret and Veronese, the first in Standish Gallery;[3] Susannah in attitude of robing Venus of Guido in our gallery;[4] face quite calm and somewhat animal—she does not see that she is watched; a magnificent grey grove, in which the bending and twining symmetry of successive trunks, wreathed with lovely, sharp-edged, exquisitely drawn ivy, is more like architecture than ever architecture was like vegetation (how utterly different in its sculpture-like severity of sentiment from flowing trunks of the same kind with Rubens) leads back in steep perspective to an opening to the sky [sketch of the trunks], whence the two elders, with Tintoret's usual caprice, look in over a kind of altar

[1] This picture is now known as 'An Allegory in honour of Alfonso d'Avalos, Marquis of Guast' (1502-46), the generalissimo of Charles V's armies. [2] In fact myrtle.

[3] The gallery which at that time contained the pictures and other objects of art bequeathed to King Louis-Philippe by Frank Hall Standish (1799-1840), an English author and connoisseur.

[4] This must be a slip of the pen for the Susannah of Guido; in that picture in the National Gallery (No. 196) the attitude—that of screening the breast with the arm—resembles Tintoret's. Ill. 13 facing page 45 shows Tintoret's painting.

12. SUSANNA AND THE ELDERS. Painting by Paolo Veronese. *Paris, Louvre*

13. SUSANNA AND THE ELDERS. Painting by Tintoretto. *Vienna, Kunsthistorisches Museum*

cloth; the foreground is occupied by a water full of reeds and flags, and frogs, and two white nondescript fish tails; but close to the spectator, down among the reeds and water, is a dark grey animal like a rabbit, with long ears, and a malignant human face. There is no doubt, no obscurity about it, it is as plain as the Susannah herself—adding another to my catalogue of the Meaning caprice of the painter. This figure, however, unless it be a white Devil, sent to tempt Susannah, is nearly as inexplicable as the skeleton one of the Crucifixion.

¶ Veronese's treatment is utterly different.[1] The water falls from a dolphin-mouthed fountain—Susannah, sitting on a bench which is under the statue of a faun, is addressed by the elders, grand senatorial figures, the expression of passion thoroughly marked on their otherwise not ignoble features, Susannah gathering her dress about her bosom—looks up to them neither in fear nor shame—but in the most fiery indignation, the face as expressive as one so much side-shortened can possibly be; the background of the most exquisitely painted laurel leaves, natural size.

¶ Titian's drapery seems an exception to the general rule I had hoped to establish, that artists might at once be known, whether of great or mean mind, by the sense of *gravity* and of *generalization* in its treatment. Yet the thought deserves development. I imagine the *seriousness* of the mind, as distinguished from its simple *power*, is to a certain degree shown by its choice of heavily gravitating folds: provided this choice be natural, not affected. Nothing can be more grand—more quiet—more simple—more material than its falls in Veronese. In the French fresco picture of the Magdalen washing Christ's feet in the Madeleine here, the blue drapery of Christ, by way of being grand, hangs like a blanket between two posts, and all the draperies are square at the top, and hang in dead verticals and gigantic masses, off which the spectator cannot take his eye; the blue drapery specified between the knees of the Christ, is the principal object in the semicircle. Consider this peculiar blanketty drapery—Corbould has it in the manner rudely shown . . . [reference to a sketch], and some Germans, and partly the clumsy monks of monument at Dijon.[2] It is affected verticality. Then consider the true and highest sublimity of verticality in M. Angelo, mixed with vast bounding curves. Then the pure and graceful verticality of Angelico passing into affectation in Perugino, etc. All of them different from the manly, simple, everyday natural grandeur of Veronese. Then Titian sometimes majestic, but often, too, mean and broken, marking, I think, a lower sanctity of mind than Veronese—as also his more sensual pictures, his mighty intellect atoning for want of seriousness. Then the various degrees of flutter and of commonplace—the drapery of Jordaens

[1] Ill. 12 facing page 44.
[2] The Puits de Moïse at Champmol.

happened to be next to Veronese's—one fold of it is enough to show the inanity, baseness, and disquietude of the fellow's mind, and to prepare one beforehand for his *Kicking* over the Money tables. Note that exaggerated Verticality in drapery is usually associated with exaggerated Horizontality in sky—and has been run hard by late pursuers of sublime (worth a separate paragraph, this Abuse).

Notes on the Louvre, 1849 ¶ 21–29 (Library Edition, Vol. XII, p. 456).

Finish and Impetuosity

IF human life were endless, or human spirit could fit its compass to its will, it is possible a perfection might be reached which should unite the majesty of invention with the meekness of love. We might conceive that the thoughts arrested by the readiest means, and at first represented by the boldest symbols, might afterwards be set forth with solemn and studied expression, and that the power might know no weariness in clothing which had known no restraint in creating. But dilation and contraction are for molluscs, not for men; we are not ringed into flexibility like worms, nor gifted with opposite sight and mutable colour like chameleons. The mind which moulds and summons cannot at will transmute itself into that which clings and contemplates; nor is it given to us at once to have the potter's power over the lump, the fire's upon the clay, and the gilder's upon the porcelain. Even the temper in which we behold these various displays of mind must be different; and it admits of more than doubt whether, if the bold work of rapid thought were afterwards in all its forms completed with microscopic care, the result would be other than painful. In the shadow at the foot of Tintoret's picture of the Temptation, lies a broken rock-boulder. The dark ground has been first laid in, of colour nearly uniform; and over it a few, not more than fifteen or twenty, strokes of the brush, loaded with a light grey, have quarried the solid block of stone out of the vacancy. Probably ten minutes are the utmost time which those strokes have occupied, though the rock is some four feet square. It may safely be affirmed that no other method, however laborious, could have reached the truth of form which results from the very freedom with which the conception has been expressed; but it is a truth of the simplest kind—the definition of a stone, rather than the painting of one—and the lights are in some degree dead and cold—the natural consequence of striking a mixed opaque pigment over a dark ground. It would now be possible to treat this skeleton of a stone, which could only have been knit together by Tintoret's rough temper, with the care of a Fleming; to leave its fiercely-stricken lights emanating from a golden ground, to gradate with the pen its ponderous shadows, and in its completion, to dwell with endless and intricate precision upon fibres of moss,

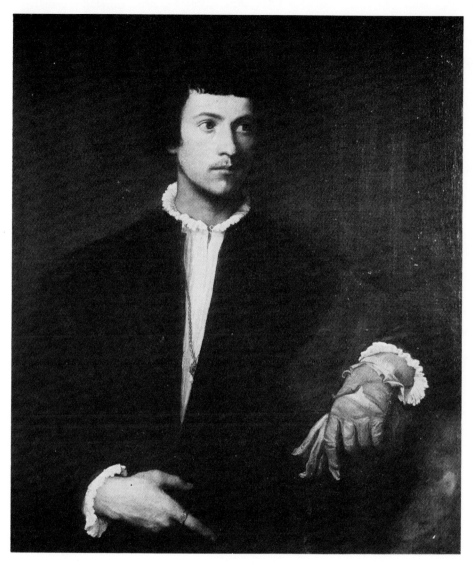

THE MAN WITH THE GLOVE. Painting by Titian. *Paris, Louvre*

[See publisher's note, p. 6.]

bells of heath, blades of grass, and films of lichen. Love like Van Eyck's would separate the fibres as if they were stems of forest, twine the ribbed grass into fanciful articulation, shadow forth capes and islands in the variegated film, and hang the purple bells in counted chiming. A year might pass away and the work yet be incomplete; yet would the purpose of the great picture have been better answered when all had been achieved? or if so, is it to be wished that a year of the life of Tintoret (if such a thing be conceived possible) had been so devoted?

Review of Eastlake's *History of Oil Painting*, ¶ 35.

The Pre-Raphaelites

I WOULD further insist on all that is advanced in these paragraphs,[1] with especial reference to the admirable, though strange, pictures of Mr. Millais and Mr. Holman Hunt; and to the principles exemplified in the efforts of other members of a society which unfortunately, or rather unwisely, has given itself the name of 'Pre-Raphaelite'; unfortunately, because the principles on which its members are working are neither pre- nor post-Raphaelite, but everlasting. They are working to paint, with the highest possible degree of completion, what they see in nature, without reference to conventional or established rules; but by no means to imitate the style of any past epoch. Their works are, in finish of drawing, and in splendour of colour, the best in the Royal Academy; and I have great hope that they may become the foundation of a more earnest and able school of art than we have seen for centuries.

From *Modern Painters*, Vol. I, 5th edn., Part II, Sec. VI, Ch. III, ¶ 16.

SIR,—Your usual liberality will, I trust, give a place in your columns to this expression of my regret that the tone of the critique which appeared in *The Times* of Wednesday last on the works of Mr. Millais and Mr. Hunt, now in the Royal Academy, should have been scornful as well as severe.

I regret it, first, because the mere labour bestowed on those works, and their fidelity to a certain order of truth, (labour and fidelity which are altogether indisputable,) ought at once to have placed them above the level of mere contempt; and, secondly, because I believe these young artists to be at a most critical period of their career—at a turning-point, from which they may either sink into nothingness or rise to very real greatness; and I believe also, that whether they choose the upward or the downward path, may in no small degree depend upon the character of the criticism which their works have to sustain. I do not wish in any way to dispute or invalidate

[1] On the necessity for finish in painting.

the general truth of your critique on the Royal Academy; nor am I surprised at the estimate which the writer formed of the pictures in question when rapidly compared with works of totally different style and aim: nay, when I first saw the chief picture by Millais in the Exhibition of last year,[1] I had nearly come to the same conclusion myself. But I ask your permission, in justice to artists who have at least given much time and toil to their pictures, to institute some more serious inquiry into their merits and faults than your general notice of the Academy could possibly have admitted.

Let me state, in the first place, that I have no acquaintance with any of these artists, and very imperfect sympathy with them. No one who has met with any of my writings will suspect me of desiring to encourage them in their Romanist and Tractarian tendencies. I am glad to see that Mr. Millais' lady in blue [2] is heartily tired of her painted window and idolatrous dressing table; and I have no particular respect for Mr. Collins' lady in white,[3] because her sympathies are limited by a dead wall, or divided between some gold fish and a tadpole—(the latter Mr. Collins may, perhaps, permit me to suggest *en passant*, as he is already half a frog, is rather too small for his age). But I happen to have a special acquaintance with the water plant, *Alisma Plantago*,[4] among which the said gold fish are swimming; and as I never saw it so thoroughly or so well drawn, I must take leave to remonstrate with you, when you say sweepingly that these men 'sacrifice *truth* as well as feeling to eccentricity'. For as a mere botanical study of the water lily and *Alisma*, as well as of the common lily and several other garden flowers, this picture would be invaluable to me, and I heartily wish it were mine.

But, before entering into such particulars, let me correct an impression which your article is likely to induce in most minds, and which is altogether false. These Pre-Raphaelites (I cannot compliment them on common sense in choice of a *nom de guerre*) do *not* desire nor pretend in any way to imitate antique paintings as such. They know very little of ancient paintings who suppose the works of these young artists to resemble them. As far as I can judge of their aim—for, as I said, I do not know the men themselves—the Pre-Raphaelites intend to surrender no advantage which the knowledge or inventions of the present time can afford to their art. They intend to return to early days in this one point only—that, as far as in them lies, they will draw either what they see, or what they suppose might have been the actual facts of the scene they desire to represent, irrespective of any conventional rules of picture-making; and they have chosen their unfortunate though not inaccurate name because all artists did this before Raphael's time, and after Raphael's time did *not* this, but sought to paint

[1] 'Christ in the House of His Parents.' [2] 'Mariana'. Ill. 14 facing this page.
[3] 'Convent Thoughts'; by Charles Allston Collins. Ill. 15 facing page 49. [4] See *Seven Lamps*, p. 168.

14. MARIANA. Painting by Millais. *The Makins Collection*

15. CONVENT THOUGHTS. Painting by C. A. Collins. *Oxford, Ashmolean Museum*

fair pictures, rather than represent stern facts; of which the consequence has been that, from Raphael's time to this day, historical art has been in acknowledged decadence.

Now, Sir, presupposing that the intention of these men was to return to archaic *art* instead of to archaic *honesty*, your critic borrows Fuseli's expression respecting ancient draperies 'snapped instead of folded,' and asserts that in these pictures there is a '*servile* imitation of *false* perspective'. To which I have just this to answer:

That there is not one single error in perspective in four out of the five pictures in question; and that in Millais' 'Mariana' there is but this one— that the top of the green curtain in the distant window has too low a vanishing-point; and that I will undertake, if need be, to point out and prove a dozen worse errors in perspective in any twelve pictures, containing architecture, taken at random from among the works of the popular painters of the day.

Secondly: that, putting aside the small Mulready,[1] and the works of Thorburn and Sir W. Ross, and perhaps some others of those in the mini-ature room which I have not examined, there is not a single study of drapery in the whole Academy, be it in large works or small, which for perfect truth, power, and finish could be compared for an instant with the black sleeve of the Julia, or with the velvet on the breast and the chain mail of the Valentine, of Mr. Hunt's picture;[2] or with the white draperies on the table of Mr. Millais' 'Mariana', and of the right-hand figure in the same painter's 'Dove returning to the Ark'.

And further: that as studies both of drapery and of every minor detail, there has been nothing in art so earnest or so complete as these pictures since the days of Albert Dürer. This I assert generally and fearlessly. On the other hand, I am perfectly ready to admit that Mr. Hunt's 'Sylvia' is not a person whom Proteus or anyone else would have been likely to fall in love with at first sight; and that one cannot feel very sincere delight that Mr. Millais' 'Wives of the Sons of Noah'[3] should have escaped the Deluge; with many other faults besides on which I will not enlarge at present, because I have already occupied too much of your valuable space, and I hope to enter into more special criticism in a future letter.

I have the honour to be, Sir,

Your obedient servant,

THE AUTHOR OF 'MODERN PAINTERS'.

DENMARK HILL, *May 9*.

Letter to *The Times*, May 13, 1851.

[1] 'A Music Lesson,' painted in 1809. [2] 'Valentine defending Sylvia.' Ill. 17 facing page 51.
[3] 'i.e. The Dove returning to the Ark.'

SIR,—Your obliging insertion of my former letter encourages me to trouble you with one or two further notes respecting the pre-Raphaelite pictures. I had intended, in continuation of my first letter, to institute as close an inquiry as I could into the character of the morbid tendencies which prevent these works from favourably arresting the attention of the public; but I believe there are so few pictures in the Academy whose reputation would not be grievously diminished by a deliberate inventory of their errors, that I am disinclined to undertake so ungracious a task with respect to this or that particular work. These points, however, may be noted, partly for the consideration of the painters themselves, partly that forgiveness of them may be asked from the public in consideration of high merits in other respects.

The most painful of these defects is unhappily also the most prominent —the commonness of feature in many of the principal figures. In Mr. Hunt's 'Valentine defending Sylvia', this is, indeed, almost the only fault. Further examination of this picture has even raised the estimate I had previously formed of its marvellous truth in detail and splendour in colour; nor is its general conception less deserving of praise: the action of Valentine, his arm thrown round Sylvia, and his hand clasping hers at the same instant as she falls at his feet, is most faithful and beautiful, nor less so the contending of doubt and distress with awakening hope in the half-shadowed, half-sunlit countenance of Julia. Nay, even the momentary struggle of Proteus with Sylvia just past, is indicated by the trodden grass and broken fungi of the foreground. But all this thoughtful conception, and absolutely inimitable execution, fail in making immediate appeal to the feelings, owing to the unfortunate type chosen for the face of Sylvia. Certainly this cannot be she whose lover was

> 'As rich in having such a jewel,
> As twenty seas, if all their sands were pearl.'

Nor is it, perhaps, less to be regretted that, while in Shakespeare's play there are nominally 'Two Gentlemen', in Mr. Hunt's picture there should only be one—at least, the kneeling figure on the right has by no means the look of a gentleman. But this may be on purpose, for any one who remembers the conduct of Proteus throughout the previous scenes will, I think, be disposed to consider that the error lies more in Shakespeare's nomenclature than in Mr. Hunt's ideal.

No defence can, however, be offered for the choice of features in the left-hand figure of Mr. Millais' 'Dove returning to the Ark'.[1] I cannot understand how a painter so sensible of the utmost refinement of beauty

[1] Ill. 16 facing this page.

16. THE DOVE RETURNING TO THE ARK. Painting by Millais
Oxford, Ashmolean Museum

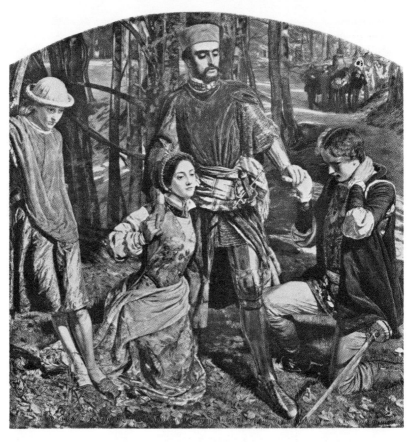

17. VALENTINE DEFENDING SYLVIA. Detail of the painting by Holman Hunt
Birmingham, City Art Gallery

in other objects should deliberately choose for his model a type far inferior to that of average humanity, and unredeemed by any expression save that of dull self-complacency. Yet let the spectator who desires to be just turn away from this head, and contemplate rather the tender and beautiful expression of the stooping figure, and the intense harmony of colour in the exquisitely finished draperies; let him note also the ruffling of the plumage of the wearied dove, one of its feathers falling on the arm of the figure which holds it, and another to the ground, where, by-the-bye, the hay is painted not only elaborately, but with the most perfect ease of touch and mastery of effect, especially to be observed because this freedom of execution is a modern excellence, which it has been inaccurately stated that these painters despise, but which, in reality, is one of the remarkable distinctions between their painting and that of Van Eyck or Memling, which caused me to say in my first letter that 'those knew little of ancient painting who supposed the works of these men to resemble it'.

Next to this false choice of feature, and in connection with it, is to be noted the defect in the colouring of the flesh. The hands, at least in the pictures in Millais, are almost always ill painted, and the flesh tint in general is wrought out of crude purples, and dusky yellows. It appears just possible that much of this evil may arise from the attempt to obtain too much trans-parency—an attempt which has injured also not a few of the best works of Mulready. I believe it will be generally found that close study of minor details is unfavourable to flesh painting; it was noticed of the drawing by John Lewis, in the old water-colour exhibition of 1850 [1] (a work which, as regards its treatment of detail, may be ranged in the same class with the pre-Raphaelite pictures), that the faces were the worst painted portions of the whole.

The apparent want of shade is, however, perhaps the fault which most hurts the general eye. The fact is, nevertheless, that the fault is far more in the other pictures of the Academy than in the pre-Raphaelite ones. It is the former that are false, not the latter, except so far as every picture must be false which endeavours to represent living sunlight with dead pigments. I think Mr. Hunt has a slight tendency to exaggerate reflected lights; and if Mr. Millais has ever been near a piece of good painted glass, he ought to have known that its tone is more dusky and sober than that of his Mariana's window. But for the most part these pictures are rashly condemned because the only light which we are accustomed to see represented is that which falls on the artist's model in his dim painting-room, not that of sunshine in the fields.

I do not think I can go much further in fault-finding. I had, indeed, something to urge respecting what I supposed to be the Romanizing

[1] 'The Harem.'

tendencies of the painters; but I have received a letter assuring me that I was wrong in attributing to them anything of the kind; whereupon, all I can say is that, instead of the 'pilgrimage' of Mr. Collins' maiden over a plank and round a fish-pond, that old pilgrimage of Christiana and her children towards the place where they should 'look the Fountain of Mercy in the face'[1] would have been more to the purpose in these times. And so I wish them all heartily good speed, believing in sincerity that if they temper the courage and energy which they have shown in the adoption of their systems with patience and discretion in framing it, and if they do not suffer themselves to be driven by harsh or careless criticism into rejection of the ordinary means of obtaining influence over the minds of others, they may, as they gain experience, lay in our England the foundations of a school of art nobler than the world has seen for three hundred years.

> I have the honour to be, Sir,
> Your obedient servant,
> THE AUTHOR OF 'MODERN PAINTERS'.

DENMARK HILL, *May 26.*

> Letter to *The Times*, May 30, 1851.

Plan for the New National Gallery

SIR, . . . I say that a picture which is worth buying is also worth seeing; that is, worth so much room of ground and wall as shall enable us to see it to the best advantage. It is not commonly so understood. Nations, like individuals, buy their pictures in mere ostentation, and are content, so that their possessions are acknowledged, that they should be hung in any dark or out-of-the-way corners which their frames will fit. Or, at best, the popular idea of a national gallery is that of a magnificent palace, whose walls must be decorated with coloured panels, every one of which shall cost £1000, and be discernible, through a telescope, for the work of a mighty hand.

¶ I have no doubt that in a few years more there will be a change of feeling in this matter, and that men will begin to perceive, what is indeed the truth—that every noble picture is a manuscript book, of which only one copy exists, or ever can exist; that a national gallery is a great library, of which the books must be read upon their shelves; that every manuscript ought, therefore, to be placed where it can be read most easily; and that the style of the architecture and the effect of the saloons are matters of no

[1] '*The Pilgrim's Progress*, Part ii.'

importance whatsoever, but that our solicitude ought to begin and end in the two imperative requirements—that every picture in the gallery should be perfectly seen and perfectly safe; that none should be thrust up, or down, or aside, to make room for more important ones; that all should be in a good light, all on a level with the eye, and all secure from damp, cold, impurity of atmosphere, and every other avoidable cause of deterioration.

¶ These are the things to be accomplished; and if we set ourselves to do these in our new National Gallery, we shall have made a greater step in art-teaching than if we had built a new Parthenon. I know that it will be a strange idea to most of us that Titians and Tintorets ought, indeed, all to have places upon 'the line', as well as the annual productions of our Royal Academicians[1]; and I know that the *coup d'œil* of the Gallery must be entirely destroyed by such an arrangement. But great pictures ought not to be subjects of '*coups d'œil*'. In the last arrangement of the Louvre, under the Republic, all the noble pictures in the gallery were brought into one room, with a Napoleon-like resolution to produce effect by concentration of force; and, indeed, I would not part willingly with the memory of that saloon, whose obscurest shadows were full of Correggio; in whose out-of-the-way angles one forgot, here and there, a Raphael; and in which the best Tintoret on this side of the Alps was hung sixty feet from the ground![2] But Cleopatra dissolving the pearl was nothing to this; and I trust that in our own Gallery our poverty, if not our will, may consent to a more modest and less lavish manner of displaying such treasures as are intrusted to us, and that the very limitation of our possessions may induce us to make that the object of our care which can hardly be a ground of ostentation. It might, indeed, be a matter of some difficulty to conceive an arrangement of the collections in the Louvre or the Florence Gallery which should admit of every picture being hung upon the line. But the works in our own, including the Vernon and Turner bequests, present no obstacle in their number to our making the building which shall receive them a perfect model of what a National Gallery ought to be. And the conditions of this perfection are so simple that if we only turn our attention to these main points it will need no great architectural ingenuity to attain all that is required.

<div style="text-align:right">Letter to The Times, December 29, 1852.</div>

Pride of Science

HALF OUR artists are ruined for want of education, and by the possession of knowledge; the best that I have known have been educated, and illiterate.

[1] The exhibitions of the Royal Academy were at this time held in the National Gallery.
[2] 'Susannah and the Elders.'

The ideal of an artist, however, is not that he should be illiterate, but well read in the best books, and thoroughly high bred, both in heart and in bearing. In a word, he should be fit for the best society, *and should keep out of it.*★

¶ There are, indeed, some kinds of knowledge with which an artist ought to be thoroughly furnished; those, for instance, which enable him to express himself: for this knowledge relieves instead of encumbering his mind, and permits it to attend to its purposes instead of wearying itself about means. The whole mystery of manipulation and manufacture should be familiar to the painter from a child. He should know the chemistry of all colours and materials whatsoever, and should prepare all his colours himself, in a little laboratory of his own. Limiting his chemistry to this one object, the amount of practical science necessary for it, and such accidental discoveries as might fall in his way in the course of his work, of better colours or better methods of preparing them, would be an infinite refreshment to his mind; a minor subject of interest to which it might turn when jaded with comfortless labour, or exhausted with feverish invention, and yet which would never interfere with its higher functions, when it chose to address itself to them. Even a considerable amount of manual labour, sturdy colour-grinding and canvass-stretching, would be advantageous; though this kind of work ought to be in great part done by pupils. For it is one of the conditions of perfect knowledge in these matters, that every great master should have a certain number of pupils, to whom he is to impart all the knowledge of materials and means which he himself possesses, as soon as possible; so that, at any rate, by the time they are fifteen years old, they may know all that he knows himself in this kind; that is to say, all that the world of artists know, and his own discoveries besides, and so never be troubled about methods any more. Not that the knowledge even of his own particular methods is to be of purpose confined to himself and his pupils, but that necessarily it must be so in some degree; for only those who see him at work daily can understand his small and multitudinous ways of practice. These cannot verbally be explained to every body, nor is it needful that they should, only let them be concealed from nobody who cares to see them; in which case, of course, his attendant scholars will know them best. But all that can be made public in matters of this kind should be so with all speed, every artist throwing his discovery into the common stock, and the whole body of artists taking such pains in this department of science as that there shall be no unsettled questions about any

★ Society always has a destructive influence upon an artist: first, by its sympathy with his meanest powers; secondly, by its chilling want of understanding of his greatest; and, thirdly, by its vain occupation of his time and thoughts. Of course a painter of men must be *among* men; but it ought to be as a watcher, not as a companion.

known material or method: that it shall be an entirely ascertained and indisputable matter which is the best white, and which the best brown; which the strongest canvass, and safest varnish; and which the shortest and most perfect way of doing everything known up to that time: and if any one discovers a better, he is to make it public forthwith. All of them taking care to embarrass themselves with no theories or reasons for anything, but to work empirically only: it not being in any wise their business to know whether the light moves in rays or in waves; or whether the blue rays of the spectrum move slower or faster than the rest; but simply to know how many minutes and seconds such and such a powder must be calcined, to give the brightest blue.

¶ Now it is perhaps the most exquisite absurdity of the whole Renaissance system, that while it has encumbered the artist with every species of knowledge that is of no use to him, this one precious and necessary knowledge it has utterly lost. There is not, I believe, at this moment, a single question which could be put respecting pigments and methods, on which the body of living artists would agree in their answers. The lives of artists are passed in fruitless experiments; fruitless, because undirected by experience and uncommunicated in their results. Every man has methods of his own, which he knows to be insufficient, and yet jealously conceals from his fellow-workmen: every colourman has materials of his own, to which it is rare that the artist can trust: and in the very front of the majestic advance of chemical science, the empirical science of the artist has been annihilated, and the days which should have led us to higher perfection are passed in guessing at, or in mourning over, lost processes; while the so-called Dark ages, possessing no more knowledge of chemistry than a village herbalist does now, discovered, established, and put into daily practice such methods of operation as have made their work, at this day, the despair of all who look upon it. . . .

From *Stones of Venice*, Vol. III, Ch. II, ¶ XIII–XV.

Plan for the National Gallery

IT IS EVIDENT, in the first place, that the building ought to consist of a series of chambers or galleries lighted from above, and built with such reference to the pictures they are to contain, as that opposite a large picture room enough should be allowed for the spectator to retire to the utmost distance at which it can ever be desirable that its effect should be seen; but, as economy of space would become a most important object when every picture was to be hung on a level with the eye, smaller apartments might open from the larger ones for the reception of smaller pictures, one condition being, however, made imperative, whatever space was sacrificed to

it—namely, that the works of every master should be collected together, either in the same apartment, or in contiguous ones. Nothing has so much retarded the advance of art as our miserable habit of mixing the works of every master and of every century. More would be learned by an ordinarily intelligent observer in simply passing from a room in which there were only Titians to another in which there were only Caraccis, than by reading a volume of lectures on colour. Few minds are strong enough first to abstract and then to generalize the characters of paintings hung at random. Few minds are so dull as not at once to perceive the points of difference, were the works of each painter set by themselves. The fatigue of which most persons complain in passing through a picture gallery, as at present arranged, is indeed partly caused by the straining effort to see what is out of sight, but not less by the continual change of temper and of tone of thought, demanded in passing from the work of one master to that of another.

¶ The works of each being, therefore, set by themselves,* and the whole collection arranged in chronological and ethnological order, let apartments be designed for each group large enough to admit of the increase of the existing collection to any probable amount. The whole gallery would thus become of great length, but might be adapted to any form of ground-plan by disposing the whole in a labyrinthine chain, returning upon itself. Its chronological arrangement would necessitate its being continuous, rather than divided into many branches or sections. Being lighted from above, it must be all on the same floor, but ought at least to be raised one story above the ground, and might admit any number of keepers' apartments, or of schools, beneath; though it would be better to make it quite independent of these, in order to diminish the risk of fire. Its walls ought on every side to be surrounded by corridors, so that the interior temperature might be kept equal, and no outer surface of wall on which pictures were hung exposed to the weather. Every picture should be glazed, and the horizon which the painter had given to it placed on a level with the eye.

¶ Lastly, opposite each picture should be a table, containing, under glass, every engraving that had ever been made from it, and any studies for it, by the master's own hand, that remained, or were obtainable. The values of the study and of the picture are reciprocally increased—of the former more than doubled—by their being seen together; and, if this system were once adopted, the keepers of the various galleries of Europe would doubtless consent to such exchanges of the sketches in their possession as would render all their collections more interesting.

* An example of a cognate school might, however, be occasionally introduced for the sake of direct comparison, as in one instance would be necessitated by the condition above mentioned attached to part of the Turner bequest. [i.e. that Turner's Dido building Carthage and Sun rising in a Mist should always hang between Claude's Seaport and his Mill.]

I trust, Sir, that the importance of this subject will excuse the extent of my trespass upon your columns, and that the simplicity and self-evident desirableness of the arrangement I have described may vindicate my proposal of it from the charge of presumption.

<div style="text-align:center">

I have the honour to be, Sir,

Your obedient Servant,

THE AUTHOR OF 'MODERN PAINTERS'.

</div>

HERNE HILL, DULWICH, *Dec. 27.*

<div style="text-align:right">Letter to *The Times*, December 29, 1852.</div>

The Nobility of Colour

OF ALL God's gift to the sight of man, colour is the holiest, the most divine, the most solemn. We speak rashly of gay colour and sad colour, for colour cannot at once be good and gay. All good colour is in some degree pensive, the loveliest is melancholy, and the purest and most thoughtful minds are those which love colour the most.

¶ I know that this will sound strange in many ears, and will be especially startling to those who have considered the subject chiefly with reference to painting; for the great Venetian schools of colour are not usually understood to be either pure or pensive, and the idea of its preeminence is associated in nearly every mind with the coarseness of Rubens, and the sensualities of Correggio and Titian. But a more comprehensive view of art will soon correct this impression. It will be discovered, in the first place, that the more faithful and earnest the religion of the painter, the more pure and prevalent is the system of his colour. It will be found, in the second place, that where colour becomes a primal intention with a painter otherwise mean or sensual, it instantly elevates him, and becomes the one sacred and saving element in his work. The very depth of the stoop to which the Venetian painters and Rubens sometimes condescend, is a consequence of their feeling confidence in the power of their colour to keep them from falling. They hold on by it, as by a chain let down from heaven, with one hand, though they may sometimes seem to gather dust and ashes with the other. And, in the last place, it will be found that so surely as a painter is irreligious, thoughtless, or obscene in disposition, so surely is his colouring cold, gloomy, and valueless. The opposite poles of art in this respect are Frà Angelico and Salvator Rosa; of whom the one was a man who smiled seldom, wept often, prayed constantly, and never

harboured an impure thought. His pictures are simply so many pieces of jewellery, the colours of the draperies being perfectly pure, as various as those of a painted window, chastened only by paleness, and relieved upon a gold ground. Salvator was a dissipated jester and satirist, a man who spent his life in masquing and revelry. But his pictures are full of horror, and their colour is for the most part gloomy grey. Truly it would seem as if art had so much of eternity in it, that it must take its dye from the close rather than the course of life:—'In such laughter the heart of man is sorrowful, and the end of that mirth is heaviness.'

¶ These are no singular instances. I know no law more severely without exception than this of the connexion of pure colour with profound and noble thought. The late Flemish pictures, shallow in conception and obscene in subject, are always sober in colour. But the early religious painting of the Flemings is as brilliant in hue as it is holy in thought. The Bellinis, Francias, Peruginos painted in crimson, and blue, and gold. The Caraccis, Guidos, and Rembrandts in brown and grey. The builders of our great cathedrals veiled their casements and wrapped their pillars with one robe of purple splendour. The builders of the luxurious Renaissance left their palaces filled only with cold white light, and in the paleness of their native stone.

From *Stones of Venice*, Vol. II, Ch. v, ¶ xxx–xxxii.

THE greater number of persons or societies throughout Europe, whom wealth, or chance, or inheritance has put in possession of valuable pictures, do not know a good picture from a bad one,* and have no idea in what the value of a picture really consists. The reputation of certain works is raised, partly by accident, partly by the just testimony of artists, partly by the various and generally bad taste of the public (no picture, that I know of, has ever, in modern times, attained popularity, in the full sense of the term, without having some exceedingly bad qualities mingled with its good ones), and when this reputation has once been completely established, it little matters to what state the picture may be reduced: few minds are so completely devoid of imagination as to be unable to invest it with the beauties which they have heard attributed to it.

¶ This being so, the pictures that are most valued are for the most part those by masters of established renown, which are highly or neatly finished, and of a size small enough to admit of their being placed in

* Many persons, capable of quickly sympathizing with any excellence, when once pointed out to them, easily deceive themselves into the supposition that they are judges of art. There is only one real test of such power of judgment. Can they, at a glance, discover a good picture obscured by the filth, and confused among the rubbish, of the pawnbroker's or dealer's garret?

galleries or saloons, so as to be made subjects of ostentation, and to be easily seen by a crowd. For the support of the fame and value of such pictures, little more is necessary than that they should be kept bright, partly by cleaning, which is incipient destruction, and partly by what is called 'restoring', that is, painting over, which is of course total destruction. Nearly all the gallery pictures in modern Europe have been more or less destroyed by one or other of these operations, generally exactly in proportion to the estimation in which they are held; and as, originally, the smaller and more highly finished works of any great master are usually his worst, the contents of many of our most celebrated galleries are by this time, in reality, of very small value indeed.

¶ On the other hand, the most precious works of any noble painter are usually those which have been done quickly, and in the heat of the first thought, on a large scale, for places where there was little likelihood of their being well seen, or for patrons from whom there was little prospect of rich remuneration. In general, the best things are done in this way, or else in the enthusiasm and pride of accomplishing some great purpose, such as painting a cathedral or a campo-santo from one end to the other, especially when the time has been short, and circumstances disadvantageous.

¶ Works thus executed are of course despised, on account of their quantity, as well as their frequent slightness, in the places where they exist; and they are too large to be portable, and too vast and comprehensive to be read on the spot, in the hasty temper of the present age. They are, therefore, almost universally neglected, whitewashed by custodes, shot at by soldiers, suffered to drop from the walls piecemeal in powder and rags by society in general; but, which is an advantage more than counterbalancing all this evil, they are not often 'restored'. What is left of them, however fragmentary, however ruinous, however obscured and defiled, is almost always *the real thing*; there are no fresh readings: and therefore the greatest treasures of art which Europe at this moment possesses are pieces of old plaster on ruinous brick walls, where the lizards burrow and bask, and which few other living creatures ever approach; and torn sheets of dim canvas, in waste corners of churches; and mildewed stains, in the shape of human figures, on the walls of dark chambers, which now and then an exploring traveller causes to be unlocked by their tottering custode, looks hastily around, and retreats from in a weary satisfaction at his accomplished duty.

From *Stones of Venice*, Vol. II, Ch. VIII, ¶ CXXXV–CXXXVIII.

Colour

. . . No amount of expression or invention can redeem an ill-coloured picture; while, on the other hand, if the colour be right, there is nothing that it will not raise and redeem; and, therefore, wherever colour enters at all anything *may* be sacrificed to it, and rather than it should be false or feeble, everything *must* be sacrificed to it: so that, when an artist touches colour, it is the same thing as when a poet takes up a musical instrument; he implies, in so doing, that he is a master, up to a certain point, of that instrument, and can produce sweet sound from it, and is able to fit the course and measure of his words to its tones, which, if he be not able to do, he had better not have touched it. In like manner, to add colour to a drawing is to undertake for the perfection of a visible music, which, if it be false, will utterly and assuredly mar the whole work; if true, proportionately elevate it, according to its power and sweetness. But, in no case ought the colour to be added in order to increase the realization. The drawing or engraving is all that the imagination needs. To 'paint' the subject merely to make it more real, is only to insult the imaginative power, and to vulgarize the whole. Hence the common, though little understood feeling, among men of ordinary cultivation, that an inferior sketch is always better than a bad painting; although, in the latter, there may verily be more skill than in the former. For the painter who has presumed to touch colour without perfectly under-standing it, not for the colour's sake, nor because he loves it, but for the sake of completion merely, has committed two sins against us; he has dulled the imagination by not trusting it far enough, and then, in this languid state, he oppresses it with base and false colour; for all colour that is not lovely, is discordant; there is no mediate condition. So, therefore, when it is permitted to enter at all, it must be with the pre-determination that, cost what it will, the colour shall be right and lovely: and I only wish that, in general, it were better understood that a *painter's* business is *to paint*, primarily; and that all expression, and grouping, and conceiving, and what else goes to constitute design, *are of less importance than colour, in a coloured work*. And so they were always considered in the noble periods; and some-times all resemblance to nature whatever (as in painted windows, illumin-ated manuscripts, and such other work) is sacrificed to the brilliancy of colour; sometimes distinctness of form to its richness, as by Titian, Turner, and Reynolds; and, which is the point on which we are at present insisting, sometimes, in the pursuit of its utmost refinements on the surfaces of objects, an amount of realization becomes consistent with noble art, which would otherwise be altogether inadmissible, that is to say, which no great mind could otherwise have either produced or enjoyed. The extreme finish given by the Pre-Raphaelites is rendered noble chiefly by their love of colour.

From *Stones of Venice*, Vol. III, Ch. IV, ¶ XXI.

Finish

. . . The quality of finish or detail which may rightly be bestowed upon any work, depends on the number and kind of ideas which the artist wishes to convey, much more than on the amount of realization necessary to enable the imagination to grasp them. It is true that the differences of judgment formed by one or another observer are in great degree dependent on their unequal imaginative powers, as well as their unequal efforts in following the artist's intention; and it constantly happens that the drawing which appears clear to the painter in whose mind the thought is formed, is slightly inadequate to suggest it to the spectator. These causes of false judgment, or imperfect achievement, must always exist, but they are of no importance. For, in nearly every mind, the imaginative power, however unable to act independently, is so easily helped and so brightly animated by the most obscure suggestion, that there is no form of artistical language which will not readily be seized by it, if once it set itself intelligently to the task; and even without such effort there are few hieroglyphics of which, once understanding that it is to take them as hieroglyphics, it cannot make itself a pleasant picture.

¶ Thus, in the case of all sketches, etchings, unfinished engravings, &c., no one ever supposes them to be imitations. Black outlines on white paper cannot produce a deceptive resemblance of anything; and the mind, understanding at once that it is to depend on its own powers for great part of its pleasure, sets itself so actively to the task that it can completely enjoy the rudest outline in which meaning exists. Now, when it is once in this temper, the artist is infinitely to be blamed who insults it by putting anything into his work which is not suggestive: having summoned the imaginative power, he must turn it to account and keep it employed, or it will turn against him in indignation. Whatever he does merely to realize and substantiate an idea is impertinent; he is like a dull storyteller, dwelling on points which the hearer anticipates or disregards. The imagination will say to him: 'I knew all that before; I don't want to be told that. Go on; or be silent, and let me go on in my own way. I can tell the story better than you.'

Observe, then, whenever finish is given for the sake of realization, it is wrong; whenever it is given for the sake of adding ideas, it is right. All true finish consists in the addition of ideas, that is to say, in giving the imagination more food; for once well awaked, it is ravenous for food: but the painter who finishes in order to substantiate takes the food out of its mouth, and it will turn and rend him. . . .

From *Stones of Venice*, Vol. III, Ch. IV, ¶ XXII–XXIII.

Patronage

. . . Enormous sums are spent annually by this country in what is called patronage of art, but in what is for the most part merely buying what strikes our fancies. True and judicious patronage there is indeed; many a work of art is bought by those who do not care for its possession, to assist the struggling artist, or relieve the unsuccessful one. But for the most part, I fear we are too much in the habit of buying simply what we like best, wholly irrespective of any good to be done, either to the artist or to the schools of the country. Now let us remember, that every farthing we spend on objects of art has influence over men's minds and spirits, far more than over their bodies. By the purchase of every print which hangs on your walls, of every cup out of which you drink, and every table off which you eat your bread, you are educating a mass of men in one way or another. You are either employing them healthily or unwholesomely; you are making them lead happy or unhappy lives; you are leading them to look at Nature, and to love her—to think, to feel, to enjoy—or you are blinding them to Nature, and keeping them bound, like beasts of burden, in mechanical and monotonous employments. We shall all be asked one day, why we did not think more of this.

¶ 'Well, but', you will say, 'how can we decide what we ought to buy, but by our likings? You would not have us buy what we don't like?' No, but I would have you thoroughly sure that there *is* an absolute right and wrong in all art, and try to find out the right, and like that; and, secondly, sometimes to sacrifice a careless preference or fancy, to what you know is for the good of your fellow-creatures. For instance, when you spend a guinea upon an engraving, what have you done? You have paid a man for a certain number of hours to sit at a dirty table, in a dirty room, inhaling the fumes of nitric acid, stooping over a steel plate, on which, by the help of a magnifying glass, he is, one by one, laboriously cutting out certain notches and scratches, of which the effect is to be the copy of another man's work. You cannot suppose you have done a very charitable thing in this! On the other hand, whenever you buy a small water-colour drawing, you have employed a man happily and healthily, working in a clean room (if he likes), or more probably still, out in the pure country and fresh air, thinking about something, and learning something every moment; not straining his eyesight, nor breaking his back, but working in ease and happiness. Therefore if you *can* like a modest water-colour better than an elaborate engraving, do. There may indeed be engravings which are worth the suffering it costs to produce them; but at all events, engravings of public dinners and laying of foundation-stones, and such things, might be

dispensed with. The engraving ought to be a first-rate picture of a first-rate subject to be worth buying.

<div align="right">From Edinburgh Lectures, ii, ¶ 46–7.</div>

The Pre-Raphaelites

THE subject on which I would desire to engage your attention this evening, is the nature and probable result of a certain schism which took place a few years ago among our British artists.

This schism, or rather the heresy which led to it, as you are probably aware, was introduced by a small number of very young men; and consists mainly in the assertion that the principles on which art has been taught for these three hundred years back are essentially wrong, and that the principles which ought to guide us are those which prevailed before the time of Raphael; in adopting which, therefore, as their guides, these young men, as a sort of bond of unity among themselves, took the unfortunate and somewhat ludicrous name of 'Pre-Raphaelite Brethren'.

¶ You must also be aware that this heresy has been opposed with all the influence and all the bitterness of art and criticism; but that in spite of these the heresy has gained ground, and the pictures painted on these new principles have obtained a most extensive popularity. These circumstances are sufficiently singular, but their importance is greater even than their singularity. . . .

¶ . . . The time has at last come for all [academic painting] to be put an end to; and nothing can well be more extraordinary than the way in which the men have risen who are to do it. Pupils in the same schools, receiving precisely the same instruction which for so long a time has paralyzed every one of our painters,—these boys agree in disliking to copy the antique statues set before them. They copy them as they are bid, and they copy them better than any one else; they carry off prize after prize, and yet they hate their work. At last they are admitted to study from the life; they find the life very different from the antique, and say so. Their teachers tell them the antique is the best, and they mustn't copy the life. They agree among themselves that they like the life, and that copy it they will. They do copy it faithfully, and their masters forthwith declare them to be lost men. Their fellow-students hiss them whenever they enter the room. They can't help it; they join hands and tacitly resist both the hissing and the instruction. Accidentally, a few prints of the works of Giotto, a few casts from those of Ghiberti, fall into their hands, and they see in these something they never saw before—something intensely and everlastingly true. They

examine farther into the matter; they discover for themselves the greater part of what I have laid before you to-night; they form themselves into a body, and enter upon that crusade which has hitherto been victorious. And which will be absolutely and triumphantly victorious. The great mistake which has hitherto prevented the public mind from fully going with them must soon be corrected. That mistake was the supposition that, instead of wishing to recur to the *principles* of the early ages, these men wished to bring back the *ignorance* of the early ages. This notion, grounded first on some hardness in their earlier works, which resulted—as it must always result—from the downright and earnest effort to paint nature as in a looking-glass, was fostered partly by the jealousy of their beaten competitors, and partly by the pure, perverse, and hopeless ignorance of the whole body of art-critics, so called, connected with the press. No notion was ever more baseless or more ridiculous. It was asserted that the Pre-Raphaelites did not draw well, in the face of the fact, that the principal member of their body,[1] from the time he entered the schools of the Academy, had literally encumbered himself with the medals given as prizes for drawing. It was asserted that they did not draw in perspective, by men who themselves knew no more of perspective than they did of astrology; it was asserted that they sinned against the appearances of nature, by men who had never drawn so much as a leaf or a blossom from nature in their lives. And, lastly, when all these calumnies and absurdities would tell no more, and it began to be forced upon men's unwilling belief that the style of the Pre-Raphaelites *was* true and was according to nature, the last forgery invented respecting them is, that they copy photographs. You observe how com-pletely this last piece of malice defeats all the rest. It admits they are true to nature, though only that it may deprive them of all merit in being so. But it may itself be at once refuted by the bold challenge to their opponents to produce a Pre-Raphaelite picture, or anything like one, by themselves copying a photograph.

¶ Let me at once clear your minds from all these doubts, and at once contradict all these calumnies.

Pre-Raphaelitism has but one principle, that of absolute, uncompromising truth in all that it does, obtained by working everything, down to the most minute detail, from nature, and from nature only.* Every Pre-Raphaelite landscape background is painted to the last touch, in the open

[1] John Everett Millais, admitted to the Academy Schools in 1839, at the age of ten, won a medal for drawing from the antique at thirteen, and the gold medal for painting at eighteen.

* Or, where imagination is necessarily trusted to, by always endeavouring to conceive a fact as it was really likely to have happened, rather than as it most prettily *might* have happened. The various members of the school are not all equally severe in carrying out its principles, some of them trusting their memory or fancy very far; only all agreeing in the effort to make their memories so accurate as to seem like portraiture, and their fancy so probable as to seem like memory.

air, from the thing itself. Every Pre-Raphaelite figure, however studied in expression, is a true portrait of some living person. Every minute accessory is painted in the same manner. And one of the chief reasons for the violent opposition with which the school has been attacked by other artists, is the enormous cost of care and labour which such a system demands from those who adopt it, in contradistinction to the present slovenly and imperfect style.

¶ This is the main Pre-Raphaelite principle. But the battle which its supporters have to fight is a hard one; and for that battle they have been fitted by a very peculiar character.

You perceive that the principal resistance they have to make is to that spurious beauty, whose attractiveness had tempted men to forget, or to despise, the more noble quality of sincerity: and in order at once to put them beyond the power of temptation from this beauty, they are, as a body, characterized by a total absence of sensibility to the ordinary and popular forms of artistic gracefulness; while, to all that still lower kind of prettiness, which regulates the disposition of our scenes upon the stage, and which appears in our lower art, as in our annuals, our commonplace portraits, and statuary, the Pre-Raphaelites are not only dead, but they regard it with a contempt and aversion approaching to disgust. This character is absolutely necessary to them in the present time; but it, of course, occasionally renders their work comparatively unpleasing. As the school becomes less aggressive, and more authoritative—which it will do—they will enlist into their ranks men who will work, mainly, upon their principles, and yet embrace more of those characters which are generally attractive, and this great ground of offence will be removed.

¶ Again: you observe that as landscape painters, their principles must in great part, confine them to mere foreground work; and singularly enough, that they may not be tempted away from this work, they have been born with comparatively little enjoyment of those evanescent effects and distant sublimities which nothing but the memory can arrest, and nothing but a daring conventionalism portray. But for this work they are not needed. Turner . . . had done it before them, he, though his capacity embraced everything, and though he would sometimes, in his foregrounds, paint the spots upon a dead trout, and the dyes upon a butterfly's wing, yet for the most part delighting to begin at that very point where Pre-Raphaelitism become powerless.

¶ Lastly. The habit of constantly carrying everything up to the utmost point of completion deadens the Pre-Raphaelites in general to the merits of men who, with an equal love of truth up to a certain point, yet express themselves habitually with speed and power, rather than with finish, and give abstracts of truth rather than total truth. Probably to the end of time artists will more or less be divided into these classes, and it will be

impossible to make men like Millais understand the merits of men like Tintoret; but this is the more to be regretted because the Pre-Raphaelites have enormous powers of imagination, as well as of realization, and do not yet themselves know of how much they would be capable, if they sometimes worked on a larger scale, and with a less laborious finish.

¶ With all their faults, their pictures are, since Turner's death, the best —incomparably the best—on the walls of the Royal Academy; and such works as Mr. Hunt's 'Claudio and Isabella' have never been rivalled, in some respects never approached, at any other period of art. . . .

¶ . . . The very faithfulness of the Pre-Raphaelites arises from the redundance of their imaginative power. Not only can all the members of the school compose a thousand times better than the men who pretend to look down upon them, but I question whether even the greatest men of old times possessed more exhaustless invention than either Millais or Rossetti; and it is partly the very ease with which they invent which leads them to despise invention. Men who have no imagination, but have learned merely to produce a spurious resemblance of its results by the recipes of composition, are apt to value themselves mightily on their concoctive science; but the man whose mind a thousand living imaginations haunt, every hour, is apt to care too little for them; and too long for the perfect truth which he finds is not to be come at so easily. And though I may perhaps hesitatingly admit that it is possible to love this truth of reality too intensely, yet I have no hesitation in declaring that there is *no hope* for those who despise it, and that the painter, whoever he be, who despises the pictures already produced by the Pre-Raphaelites, has himself no capacity of becoming a great painter of any kind. Paul Veronese and Tintoret themselves, without desiring to imitate the Pre-Raphaelite work, would have looked upon it with deep respect, as John Bellini looked on that of Albert Dürer; none but the ignorant could be unconscious of its truth, and none but the insincere regardless of it.

I thank God that the Pre-Raphaelites *are* young, and that strength is still with them, and life, with all the war of it, still in front of them. Yet Everett Millais is this year of the exact age at which Raphael painted the 'Disputa', his greatest work; Rossetti and Hunt are both of them older still—nor is there one member of the body so young as Giotto, when he was chosen from among the painters of Italy to decorate the Vatican. But Italy, in her great period, knew her great men, and did not 'despise their youth'. It is reserved for England to insult the strength of her noblest children—to wither their warm enthusiasm early into the bitterness of patient battle, and leave to those whom she should have cherished and aided, no hope but in resolution, no refuge but in disdain.

From *Edinburgh Lectures*, IV, ¶ 107–139.

18. THE LIGHT OF THE WORLD. Painting by Holman Hunt. *Oxford, Keble College*

19. Detail of Plate 18

'The Light of the World'

As FAR as regards the technical qualities of Mr. Hunt's painting [The Light of the World [1]], I would only ask the spectator to observe this difference between true Pre-Raphaelite work and its imitations. The true work represents all objects exactly as they would appear in nature in the position and at the distances which the arrangement of the picture supposes. The false work represents them with all their details, as if seen through a microscope. Examine closely the ivy on the door in Mr. Hunt's picture, and there will not be found in it a single clear outline. All is the most exquisite mystery of colour; becoming reality at its due distance. In like manner examine the small gems on the robe of the figure. Not one will be made out in form, and yet there is not one of all those minute points of green colour, but it has two or three distinctly varied shades of green in it, giving it mysterious value and lustre.

The spurious imitations of Pre-Raphaelite work represent the most minute leaves and other objects with sharp outlines, but with no variety of colour, and with none of the concealment, none of the infinity of nature. With this spurious work the walls of the Academy are half covered. . . .

> I have the honour to be, Sir,
> Your obedient servant,
> THE AUTHOR OF 'MODERN PAINTERS'.

DENMARK HILL, *May* 4.

> Letter to *The Times*, May 5, 1854.

'The Awakening Conscience'

SIR,—Your kind insertion of my notes on Mr. Hunt's principal picture encourages me to hope that you may yet allow me room in your columns for a few words respecting his second work in the Royal Academy, the 'Awakening Conscience'.[2] Not that this picture is obscure, or its story feebly told. I am at a loss to know how its meaning could be rendered more distinctly, but assuredly it is not understood. People gaze at it in a blank wonder, and leave it hopelessly; so that, though it is almost an insult to the painter to explain his thoughts in this instance, I cannot persuade myself to leave it thus misunderstood. The poor girl has been sitting singing with her seducer; some chance words of the song, 'Oft in the stilly night', have struck upon the numbed places of her heart; she has started up in

[1] Ill. 18 and 19 facing page 66 and this page. [2] Colour-plate facing page 82.

agony; he, not seeing her face, goes on singing, striking the keys carelessly with his gloved hand.

I suppose that no one possessing the slightest knowledge of expression could remain untouched by the countenance of the lost girl, rent from its beauty into sudden horror; the lips half open, indistinct in their purple quivering; the teeth set hard; the eyes filled with the fearful light of futurity, and with tears of ancient days. But I can easily understand that to many persons the careful rendering of the inferior details in this picture cannot but be at first offensive, as calling their attention away from the principal subject. It is true that detail of this kind has long been so carelessly rendered, that the perfect finishing of it becomes a matter of curiosity, and therefore an interruption to serious thought. But, without entering into the question of the general propriety of such treatment, I would only observe that, at least in this instance, it is based on a truer principle of the pathetic than any of the common artistical expedients of the schools. Nothing is more notable than the way in which even the most trivial objects force themselves upon the attention of a mind which has been fevered by violent and distressful excitement. They thrust themselves forward with a ghastly and unendurable distinctness, as if they would compel the sufferer to count, or measure, or learn them by heart. Even to the mere spectator a strange interest exalts the accessories of a scene in which he bears witness to human sorrow. There is not a single object in all that room—common, modern, vulgar (in the vulgar sense, as it may be), but it becomes tragical, if rightly read. That furniture so carefully painted, even to the last vein of the rosewood—is there nothing to be learnt from that terrible lustre of it, from its fatal newness; nothing there that has the old thoughts of home upon it, or that is ever to become a part of home? Those embossed books, vain and useless—they are also new—marked with no happy wearing of beloved leaves; the torn and dying bird upon the floor; the gilded tapestry, with the fowls of the air feeding on the ripened corn; the picture above the fireplace, with its single drooping figure—the woman taken in adultery; nay, the very hem of the poor girl's dress, at which the painter has laboured so closely, thread by thread, has story in it, if we think how soon its pure whiteness may be soiled with dust and rain, her outcast feet failing in the street; and the fair garden flowers, seen in that reflected sunshine of the mirror,—these also have their language—

> 'Hope not to find delight in us, they say,
> For we are spotless, Jessy—we are pure.'

I surely need not go on. Examine the whole range of the walls of the Academy—nay, examine those of all our public and private galleries—and while pictures will be met with by the thousand which literally tempt

to evil, by the thousand which are directed to the meanest trivialities of incident or emotion, by the thousand to the delicate fancies of inactive religion, there will not be found one powerful as this to meet full in the front the moral evil of the age in which it is painted; to waken into mercy the cruel thoughtlessness of youth, and subdue the severities of judgment into the sanctity of compassion.

<div style="text-align:center">I have the honour to be, Sir,

Your obedient servant,

THE AUTHOR OF 'MODERN PAINTERS'.</div>

DENMARK HILL.

<div style="text-align:right">Letter to The Times, May 25, 1854.</div>

Giotto

BUT WHAT, it may be said by the reader, is the use of the works of Giotto to *us*? They may indeed have been wonderful for their time, and of infinite use in that time; but since, after Giotto, came Leonardo and Correggio, what is the use of going back to the ruder art, and republishing it in the year 1854? Why should we fret ourselves to dig down to the root of the tree, when we may at once enjoy its fruit and foliage? I answer, first, that in all matters relating to human intellect, it is a great thing to have hold of the root: that at least we ought to see it, and taste it, and handle it; for it often happens that the root is wholesome when the leaves, however fair, are useless or poisonous. In nine cases out of ten, the first expression of an idea is the most valuable: the idea may afterwards be polished and softened, and made more attractive to the general eye; but the first expression of it has a freshness and brightness, like the flash of a native crystal compared to the lustre of glass that has been melted and cut. And in the second place, we ought to measure the value of art less by its executive than by its moral power. Giotto was not indeed one of the most accomplished painters, but he was one of the greatest men who ever lived. He was the first master of his time, in architecture as well as in painting; he was the friend of Dante, and the undisputed interpreter of religious truth, by means of painting, over the whole of Italy. The works of such a man may not be the best to set before children in order to teach them drawing; but they assuredly should be studied with the greatest care by all who are interested in the history of the human mind.[1]

¶ One point more remains to be noticed respecting him. As far as I am aware, he never painted profane subjects. All his important existing works are exclusively devoted to the illustration of Christianity. This was

[1] Ill. 20 and 21 after page 70.

not a result of his own peculiar feeling or determination; it was a necessity of the period. Giotto appears to have considered himself simply as a workman, at the command of any employer, for any kind of work, however humble. 'In the sixty-third novel of Franco Sacchetti we read that a stranger, suddenly entering Giotto's study, threw down a shield, and departed, saying, "Paint me my arms on that shield". Giotto looking after him, exclaimed, "Who is he? what is he? He says, 'Paint me my arms', as if he was one of the BARDI. What arms does he bear?"' * But at the time of Giotto's eminence, art was never employed on a great scale except in the service of religion; nor has it ever been otherwise employed, except in declining periods. I do not mean to draw any severe conclusion from this fact; but it is a fact nevertheless, which ought to be very distinctly stated, and very carefully considered. All *progressive* art hitherto has been religious art; and commencements of the periods of decline are accurately marked, in illumination, by its employment on romances instead of psalters; and in painting, by its employment on mythology or profane history instead of sacred history. Yet perhaps I should rather have said, on *heathen mythology* instead of *Christian mythology*; for this latter term—first used, I believe, by Lord Lindsay—is more applicable to the subjects of the early painters than that of 'sacred *history*'. Of all the virtues commonly found in the higher orders of human mind, that of a stern and just respect for truth seems to be the rarest; so that while self-denial, and courage, and charity, and religious zeal, are displayed in their utmost degrees by myriads of saints and heroes, it is only once in a century that a man appears whose word may be implicitly trusted, and who, in the relation of a plain fact, will not allow his prejudices or his pleasure to tempt him to some colouring or distortion of it. Hence the portions of sacred history which have been the constant subjects of fond popular contemplation have, in the lapse of ages, been encumbered with fictitious detail; and their various historians seem to have considered the exercise of their imagination innocent, and even meritorious, if they could increase either the vividness of conception or the sincerity of belief in their readers. A due consideration of that well-known weakness of the popular mind, which renders a statement credible in proportion to the multitude of local and circumstantial details which accompany it, may lead us to look with some indulgence on the errors, however fatal in their issue to the cause they were intended to advance, of those weak teachers, who thought the acceptance of their general statements of Christian doctrine cheaply won by the help of some simple (and generally absurd) inventions of detail respecting the life of the Virgin or the Apostles. . . .

More especially in the domain of painting, it is surprising to see how strictly the early workmen confined themselves to representations of the

* Notes to Roger's *Italy*.

20. THE MARRIAGE OF THE VIRGIN. Detail from a fresco by Giotto
Padua, Arena Chapel

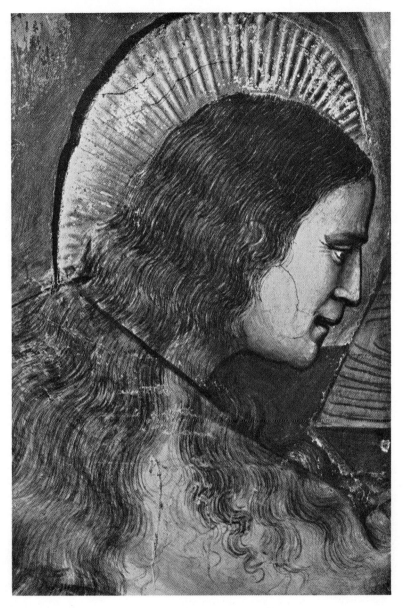

21. HEAD OF MARY MAGDALEN

Detail from the fresco 'The Crucifixion' by Giotto. *Padua, Arena Chapel*

same series of scenes; how little of pictorial embellishment they usually added; and how, even in the positions and gestures of figures, they strove to give the idea rather of their having seen the *fact*, than imagined a picturesque treatment of it. Often, in examining early art, we mistake conscientiousness for servility, and attribute to the absence of invention what was indeed the result of the earnestness of faith.

Nor, in a merely artificial point of view, is it less important to note, that the greatest advance in power was made when painters had few subjects to treat. The day has perhaps come when genius should be shown in the discovery of perpetually various interest amidst the incidents of actual life; and the absence of inventive capacity is very assuredly proved by the narrow selection of subjects which commonly appear on the walls of our exhibitions. But yet it is to be always remembered, that more originality may be shown in giving interest to a well-known subject than in discovering a new one; that the greatest poets whom the world has seen have been contented to retouch and exalt the creations of their predecessors; and that the painters of the Middle Ages reached their upmost power by unweariedly treading a narrow circle of sacred subjects.

In our modern art we have indeed lost sight of one great principle which regulated that of the Middle Ages, namely, that chiaroscuro and colour are incompatible in their highest degrees. Wherever chiaroscuro enters, colour must lose some of its brilliancy. There is no *shade* in a rainbow, nor in an opal, nor in a piece of mother-of-pearl, nor in a well-designed painted window; only various hues of perfect colour. The best pictures, by subduing their colour and conventionalizing their chiaroscuro, reconcile both in their diminished degrees; but a perfect light and shade cannot be given without considerable loss of liveliness in colour. Hence the supposed inferiority of Tintoret to Titian. Tintoret is, in reality, the greater colourist of the two; but he could not bear to falsify his light and shadow enough to set off his colour. Titian nearly strikes the exact mean between the painted glass of the thirteenth century and Rembrandt; while Giotto closely approaches the system of painted glass, and hence his compositions lose grievously by being translated into black and white. . . .

¶ Lastly. It is especially to be noticed that these works of Giotto, in common with all others of the period, are independent of all the inferior sources of pictorial interest. They never show the slightest attempt at imitative realization: they are simple suggestions of ideas, claiming no regard except for the inherent value of the thoughts. There is no filling of the landscape with variety of scenery, architecture, or incident, as in the works of Benozzo Gozzoli or Perugino; no wealth of jewellery and gold spent on the dresses of the figures, as in the delicate labours of Angelico or Gentile da Fabriano. The background is never more than a few gloomy masses

of rock, with a tree or two, and perhaps a fountain; the architecture is merely what is necessary to explain the scene; the dresses are painted sternly on the 'heroic' principle of Sir Joshua Reynolds—that drapery is to be 'drapery, and nothing more',—there is no silk, nor velvet, nor distinguishable material of any kind: the whole power of the picture is rested on the three simple essentials of painting—pure Colour, noble Form, noble Thought.

We moderns, educated in reality far more under the influence of the Dutch masters than the Italian, and taught to look for realization in all things, have been in the habit of casting scorn on these early Italian works, as if their simplicity were the result of ignorance merely. When we know a little more of art in general, we shall begin to suspect that a man of Giotto's power of mind did not altogether suppose his clusters of formal trees, or diminutive masses of architecture, to be perfect representations of the woods of Judea, or of the streets of Jerusalem: we shall begin to understand that there is a symbolical art which addresses the imagination, as well as a realist art which supersedes it; and that the powers of contemplation and conception, which could be satisfied or excited by these simple types of natural things, were infinitely more majestic than those which are so dependent on the completeness of what is presented to them as to be paralyzed by an error in perspective, or stifled by the absence of atmosphere. . . .

The worst characters of modern work result from its constant appeal to our desire of change, and pathetic excitement; while the best features of the elder art appealed to love of contemplation. It would appear to be the object of the truest artists to give permanence to images such as we should always desire to behold, and might behold without agitation; while the inferior branches of design are concerned with the acuter passions which depend on the turn of a narrative, or the course of an emotion. Where it is possible to unite these two sources of pleasure, and, as in the Assumption of Titian, an action of absorbing interest is united with perfect and perpetual elements of beauty, the highest point of conception would appear to have been touched: but in the degree in which the interest of action *supersedes* beauty of form and colour, the art is lowered; and where real deformity enters, in any other degree than as a momentary shadow or opposing force, the art is illegitimate. Such art can exist only by accident, when a nation has forgotten or betrayed the eternal purposes of its genius, and gives birth to painters whom it cannot teach, and to teachers whom it will not hear. The best talents of all our English painters have been spent either in endeavours to find room for the expression of feelings which no master guided to a worthy end, or to obtain the attention of a public whose mind was dead to natural beauty, by sharpness of satire, or variety of dramatic circumstance.

The work to which England is now devoting herself withdraws her eyes from beauty, as her heart from rest; nor do I conceive any revival of great art to be possible among us while the nation continues in its present temper. As long as it can bear to see misery and squalor in its streets, it can neither invent nor accept human beauty in its pictures; and so long as in passion of rivalry, or thrift of gain, it crushes the roots of happiness, and forsakes the ways of peace, the great souls whom it may chance to produce will all pass away from it helpless, in error, in wrath, or in silence. Amiable visionaries may retire into the delight of devotional abstraction, strong men of the world may yet hope to do service by their rebuke or their satire; but for the clear sight of Love there will be no horizon, for its quiet words no answer; nor any place for the art which alone is faithfully Religious, because it is Lovely and True.

Giotto and his Works in Padua, ¶ 13–23.

' *Cimabue's Madonna carried in Procession through the Streets of Florence,*' *by F. Leighton*

THIS is a very important and very beautiful picture.[1] It has both sincerity and grace, and is painted on the purest principles of Venetian art—that is to say, on the calm acceptance of the whole of nature, small and great, as, in its place, deserving of faithful rendering. The great secret of the Venetians was their simplicity. They were great colourists, not because they had peculiar secrets about oil and colour, but because, when they saw a thing red, they painted it red; and when they saw it blue, they painted it blue; and when they saw it distinctly, they painted it distinctly. In all Paul Veronese's pictures, the lace borders of the table-cloths or fringes of the dresses are painted with just as much care as the faces of the principal figures; and the reader may rest assured that in all great art it is so. Everything in it is done as well as it *can* be done. Thus, in the picture before us, in the background is the Church of San Miniato, strictly accurate in every detail; on the top of the wall are oleanders and pinks, as carefully painted as the church; the architecture of the shrine on the wall is well studied from thirteenth-century Gothic, and painted with as much care as the pinks; the dresses of the figures, very beautifully designed, are painted with as much care as the architecture; and the faces with as much care as the dresses—that is to say, all things, throughout, with as much care as the painter could bestow. It necessarily follows, that what is most difficult (i.e. the faces) should be comparatively the worst done. But if they are done as well as the painter could do them, it is all we have to ask; and modern

[1] Ill. 22–24 after page 74.

artists are under a wonderful mistake in thinking that when they have painted faces ill, they make their picture more valuable by painting the dresses worse.

The painting before us has been objected to, because it seems broken up into bits. Precisely the same objection would hold, and in very nearly the same degree, against the best works of the Venetians. All faithful colourists' work, in figure-painting, has a look of sharp separation between part and part. I will not detain the reader by explaining *why* this is so, but he may convince himself of the fact by one walk through the Louvre, comparing the Venetian pictures in this respect with those of all other schools. Although, however, in common with all other works of its class, it is marked by these sharp divisions, there is no confusion in its arrangement. The principal figure is nobly principal, not by extraordinary light, but by its own pure whiteness; and both the master and the young Giotto attract full regard by distinction of form and face. The features of the boy are carefully studied, and are indeed what, from the existing portraits of him, we know those of Giotto must have been in his youth. The head of the young girl who wears the garland of blue flowers is also very sweetly conceived.

Such are the chief merits of the picture. Its defect is, that the equal care given to the whole of it, is not yet *care enough*. I am aware of no instance of a young painter, who was to be really great, who did not in his youth paint with intense effort and delicacy of finish. The handling here is much too broad; and the faces are, in many instances, out of drawing, and very opaque and feeble in colour. Nor have they, in general, the dignity of the countenance of the thirteenth century. The Dante especially is ill-conceived —far too haughty, and in no wise noble or thoughtful. It seems to me probable that Mr. Leighton has greatness in him, but there is no absolute proof of it in this picture; and if he does not, in succeeding years, paint far better, he will soon lose his power of painting so well.

From *Academy Notes*, 1855, Vol. XIV, p. 25.

The Academy

EXHIBITION OF THE ROYAL ACADEMY

IF THE reader, before fixing his attention on any particular work, will glance generally round any of the rooms, he will be struck by a singular change in the character of the entire exhibition. He will find that he can no longer distinguish the Pre-Raphaelite works as a separate class, but that between them and the comparatively few pictures remaining quite of the old school, there is a perfectly unbroken gradation, formed by the works

22. CIMABUE'S MADONNA CARRIED IN PROCESSION THROUGH THE STREETS OF FLORENCE
Painting by Sir Frederick Leighton. *London, St. James's Palace.* (Reproduced by the gracious permission of H.M. the Queen)

23. Detail of Plate 22

24. Detail of Plate 22

25. THE SCAPEGOAT. Painting by Holman Hunt. *Port Sunlight, Lady Lever Art Gallery*

of painters in various stages of progress, struggling forward out of their conventionalism to the Pre-Raphaelite standard. The meaning of this is simply that the battle is completely and confessedly won by the latter party; that animosity has changed into emulation, astonishment into sympathy, and that a true and consistent school of art is at last established in the Royal Academy of England.

Such an exhibition I have never yet seen, and the excellence of it is al the more to be rejoiced in because it is every whit progressive. It does not consist merely in the splendour of the work of one noble artist, urged to unusual exertion (though this it can boast), nor in an accidental assemblage of the happiest efforts of several (though by this also it is adorned); but in the achievement which has rewarded the steady effort of all, now at last turned in the right direction, and ensuring for each, in process of time, such utmost success as his genius is capable of. There is hardly an exhibitor this year who has not surpassed himself, and who will not surpass himself again in every subsequent effort; and I know that they must feel this, and must be as happy in their sense of sudden power, and in the perception of the new world opened to their sincerity, as we spectators have cause to be in the gifts of art they offer us. . . .

Hunt's 'Scapegoat'

The Scapegoat (Lev. xvi) by W. H. Hunt.[1]

THIS singular picture, although in many respects faultful, and in some wholly a failure, is yet the one of all in the gallery which should furnish us with most food for thought. First, consider it simply as an indicator of the temper and aim of the rising artists of England. Until of late years, young painters have been mostly divided into two groups: one poor, hard-working, and suffering, compelled more or less, for immediate bread, to obey whatever call might be made upon them by patron or publisher; the other, of perhaps more manifest cleverness or power, able in some degree to command the market, and apt to make the pursuit of art somewhat complementary to that of pleasure, so that a successful artist's studio has not been in general a place where idle and gay people would have found themselves ill at ease, or at a loss for amusement. But here is a young painter, the slave neither of poverty nor pleasure—emancipated from the garret, despising the green room, and selecting for his studio a place where he is liable certainly to no agreeable forms of interruption. He travels, not merely to fill his portfolio with pretty sketches, but in as determined a temper as ever mediaeval pilgrim, to do a certain work in the Holy Land.

[1] Ill. 25 facing this page.

Arrived there, with the cloud of Eastern War gathered to the north of him, and involving, for most men, according to their adventurous or timid temper, either an interest which would at once have attracted them to its immediate field, or a terror which would have driven them from work in its threatening neighbourhood, he pursues calmly his original purpose; and while the hills of the Crimea were white with tents of war, and the fiercest passions of the nations of Europe burned in high funeral flames over their innumerable dead, one peaceful English tent was pitched beside a shipless sea, and the whole strength of an English heart spent in painting a weary goat, dying upon its salt sand.

And utmost strength of heart is needed. Though the tradition that a bird cannot fly over this sea is an exaggeration, the air in its neighbourhood is stagnant and pestiferous, polluted by the decaying vegetation brought down by the Jordan in its floods; the bones of the beasts of burden that have died by the 'way of the sea',[1] lie like wrecks upon its edge, bared by the vultures and bleached by the salt ooze, which though tideless, rises and falls irregularly, swollen or wasted. Swarms of flies, fed on the carcases, darken an atmosphere heavy at once with the poison of the marsh and the fever of the desert; and the Arabs themselves will not encamp for a night amidst the exhalations of the volcanic chasm.

This place of study the young English painter chooses. He encamps a little way above it; sets his easel upon its actual shore; pursues his work with patience through months of solitude; and paints, crag by crag, the purple mountains of Moab, and, grain by grain, the pale ashes of Gomorrah.

And I think his subject is one worthy of such an effort. Of all the scenes in the Holy Land, there are none whose present aspect tends so definitely to confirm the statements of Scripture as this condemned shore. It is therefore exactly the scene of which it might seem most desirable to give a perfect idea to those who cannot see it for themselves; it is that also which fewest travellers are able to see; and which I suppose, no one but Mr. Hunt himself would ever have dreamed of making the subject of a close pictorial study. The work was therefore worth his effort; and he has connected it in a simple, but most touching way with other subjects of reflection, by the figure of the animal upon its shore. This is, indeed, one of the instances in which the subject of a picture is wholly incapable of explaining itself; but, as we are too apt—somewhat too hastily—to accept at once a subject as intelligible and rightly painted, if we happen to know enough of the story to interest us in it, some are apt, somewhat unkindly, to refuse a painter the little patience of inquiry or remembrance, which, once granted, would enable him to interest us all the more deeply, because the thoughts suggested were not entirely familiar. It is necessary, in this

[1] Isaiah ix. 1; Matthew iv. 15.

present instance, only to remember that the view taken by the Jews of the appointed sending forth of the scapegoat into the Wilderness was that it represented the carrying away of their sin into a place uninhabited and forgotten; and that the animal on whose head the sin was laid became accursed, so that, 'though not commanded by the law, they used to maltreat the goat Azazel;—to spit upon him, and to pluck off his hair'.* The goat, thus tormented, and with a scarlet fillet bound about its brow, was driven by the multitude wildly out of camp, and pursued into the Wilderness. The painter supposes it to have fled towards the Dead Sea, and to be just about to fall exhausted at sunset—its hoofs entangled in the crust of salt upon the shore. The opposite mountains, seen in the fading light, are that chain of Abarim on which Moses died.

Now, we cannot, I think, esteem too highly, or receive too gratefully, the temper and the toil which have produced this picture for us. Consider for a little while the feelings involved in its conception, and the self-denial and resolve needed for its execution; and compare them with the modes of thought in which our former painters used to furnish us annually with their 'Cattle pieces' or 'Lake scenes', and I think we shall see cause to hold this picture as one more truly honourable to us, and more deep and sure in its promise of future greatness in our schools of painting, than all the works of 'high art' that since the foundation of the Academy have ever taxed the wonder, or weariness, of the English public. But, at the same time, this picture indicates a danger to our students of a kind hitherto unknown in any school—the danger of a too great intensity of feeling, making them forget the requirements of painting as an *art*. This picture regarded merely as a landscape, or as a composition, is a total failure. The mind of the painter has been so excited by the circumstances of the scene, that, like a youth expressing his earnest feeling by feeble verse (which seems to him good, because he *means* so much by it), Mr. Hunt has been blinded by his intense sentiment to the real weakness of the pictorial ex-pression; and in his earnest desire to paint the Scapegoat, has forgotten to ask himself first, whether he could paint a goat at all.

I am not surprised that he should fail in painting the distant mountains; for the forms of large distant landscape are a quite new study to the Pre-Raphaelites, and they cannot be expected to conquer them at first: but it is a great disappointment to me to observe, even in the painting of the goat itself, and of the fillet on its brow, a nearly total want of all that effective manipulation which Mr. Hunt displayed in his earlier pictures. I do not say that there is absolute want of skill—there may be difficulties encountered which I do not perceive—but the difficulties, whatever they may have been, are not conquered: this may be very faithful and very wonderful painting

* Sermon preached at Lothbury, by the Rev. H. Melvill. (*Pulpit*, Thursday, March 27, 1856.)

—but it is not *good* painting; and much as I esteem feeling and thought in all works of art, still I repeat, again and again, a painter's business is first to *paint*. No one could sympathize more than I with the general feeling displayed in the 'Light of the World'; but unless it had been accompanied with perfectly good nettle painting, and ivy painting, and jewel painting, I should never have praised it; and though I acknowledge the good purpose of this picture, yet, inasmuch as there is no good hair painting, nor hoof painting in it, I hold it to be good only as an omen, not as an achievement; and I have hardly ever seen a composition left apparently almost to chance, come so unluckily: the insertion of the animal in the exact centre of the canvas making it look as if it were painted for a sign. I can only, therefore, in thanking Mr. Hunt heartily for his work, pray him, for practice' sake, now to paint a few pictures with less feeling in them, and more handling.

From *Academy Notes*, 1856, Vol. xiv, p. 47.

Patronage

. . . In nearly all the great periods of art the choice of subject has not been left to the painter. His employer—abbot, baron, or monarch—determined for him whether he should earn his bread by making cloisters bright with choirs of saints, painting coats of arms on leaves of romances, or decorating presence chambers with complimentary mythology; and his own personal feelings are ascertainable only by watching, in the themes assigned to him, what are the points in which he seems to take most pleasure. Thus, in the prolonged ranges of varied subjects, with which Benozzo Gozzoli decorated the cloisters of Pisa,[1] it is easy to see that love of simple domestic incident, sweet landscape, and glittering ornament, prevails slightly over the solemn elements of religious feeling, which, nevertheless, the Spirit of the age instilled into him in such measure as to form a very lovely and noble mind, though it is still one of the second order. In the work of Orcagna, an intense solemnity and energy in the sublimest groups of his figures, fading away as he touches inferior subjects, indicates that his home was among the archangels, and his rank among the first of the sons of men; while Correggio, in the sidelong grace, artificial smiles, and purple languors of his saints, indicates the inferior instinct which would have guided his choice in quite other directions, had it not been for the fashion of the age, and the need of the day.

From *Modern Painters*, Vol. iii, Part iv, Ch. iii, ¶ 8.

[1] Ill. 26 facing this page.

26. THE CITY OF BABYLON. Detail of a fresco by Benozzo Gozzoli. *Pisa, Camposanto*

27. ST. LAWRENCE. Detail from the painting 'The Virgin Enthroned'
by Fra Angelico. *Florence, Museo di S. Marco*

Old and New Pre-Raphaelites

THE perfect unison of expression as the painter's main purpose, with the full and natural exertion of his pictorial power in the details of the work, is found only in the old Pre-Raphaelite periods, and in the modern Pre-Raphaelite school. In the works of Giotto, Angelico,[1] Orcagna, John Bellini, and one or two more, these two conditions of high art are entirely fulfilled, so far as the knowledge of those days enabled them to be fulfilled; and in the modern Pre-Raphaelite school they are fulfilled nearly to the uttermost. Hunt's 'Light of the World' is, I believe, the most perfect instance of expressional purpose with technical power, which the world has yet produced.

From *Modern Painters*, Vol. III, Part IV, Ch. III, ¶ 10.

The Foil of Beauty

. . . Beauty deprived of its proper foils and adjuncts ceases to be enjoyed as beauty, just as light deprived of all shadow ceases to be enjoyed as light. A white canvas cannot produce an effect of sunshine; the painter must darken it in some places before he can make it look luminous in others; nor can an uninterrupted succession of beauty produce the true effect of beauty; it must be foiled by inferiority before its own power can be developed. Nature has for the most part mingled her inferior and noble elements as she mingles sunshine with shade, giving due use and influence to both, and the painter who chooses to remove the shadow, perishes in the burning desert he has created. The truly high and beautiful art of Angelico is continually refreshed and strengthened by his frank portraiture of the most ordinary features of his brother monks and of the recorded peculiarities of ungainly sanctity; but the modern German and Raphaelesque schools lose all honour and nobleness in barber-like admiration of handsome faces, and have, in fact, no real faith except in straight noses, and curled hair. Paul Veronese opposes the dwarf to the soldier,[2] and the negress to the queen; Shakespeare places Caliban beside Miranda, and Autolycus beside Perdita; but the vulgar idealist withdraws his beauty to the safety of the saloon, and his innocence to the seclusion of the cloister; he pretends that he does this in delicacy of choice and purity of sentiment, while in truth he has neither courage to front the monster, nor wit enough to furnish the knave.

[1] Ill. 27 facing this page. [2] In the 'Family of Darius', National Gallery.

It is only by the habit of representing faithfully all things, that we can truly learn what is beautiful, and what is not. The ugliest objects contain some elements of beauty; and in all it is an element peculiar to themselves, which cannot be separated from their ugliness, but must either be enjoyed together with it or not at all. The more a painter accepts nature as he finds it, the more unexpected beauty he discovers in what he at first despised; but once let him arrogate the right of rejection, and he will gradually contract his circle of enjoyment, until what he supposed to be nobleness of selection ends in narrowness of perception. Dwelling perpetually upon one class of ideas, his art becomes at once monstrous and morbid; until at last he cannot faithfully represent even what he chooses to retain; his discrimination contracts into darkness, and his fastidiousness fades into fatuity.

From *Modern Painters*, Vol. III, Part IV, Ch. III, ¶ 14.

Rembrandt and Veronese

. . . Rembrandt always chooses to represent the exact force with which the light on the most illumined part of an object is opposed to its obscurer portions. In order to obtain this, in most cases, not very important truth, he sacrifices the light and colour of five-sixths of his picture, and the expression of every character of objects which depends on tenderness of shape or tint. But he obtains his single truth, and what picturesque and forcible expression is dependent upon it, with magnificent skill and subtlety. Veronese, on the contrary, chooses to represent the great relations of visible things to each other, to the heaven above, and to the earth beneath them. He holds it more important to show how a figure stands relieved from delicate air, or marble wall; now as a red, or purple, or white figure, it separates itself, in clear discernibility, from things not red, nor purple, nor white; now infinite daylight shines round it; now innumerable veils of faint shadow invest it; now its blackness and darkness are, in the excess of their nature, just as limited and local as its intensity of light; all this, I say, he feels to be more important than showing merely the exact *measure* of the spark of sunshine that gleams on a dagger-hilt, or glows on a jewel. All this, moreover, he feels to be harmonious—capable of being joined in one great system of spacious truth, and with inevitable watchfulness, inestimable subtlety, he unites all this in tenderest balance, noting in each hair's breadth of colour, not merely what its rightness or wrongness is in itself, but what its relation is to every other on his canvas; restraining, for truth's sake, his exhaustless energy, reining back, for truth's sake, his fiery strength; veiling, before truth, the vanity of brightness; penetrating, for

truth, the discouragement of gloom; ruling his restless invention with a rod of iron; pardoning no error, no thoughtlessness, no forgetfulness; and subduing all his powers, impulses, and imaginations, to the arbitrament of a merciless justice, and the obedience of an incorruptible verity.

From *Modern Painters*, Vol. III, Part IV, Ch. III, ¶ 16.

Grotesque

. . . It seems not only permissible, but even desirable, that the art by which the grotesque is expressed should be more or less imperfect, and this seems a most beneficial ordinance, as respects the human race in general. For the grotesque being not only a most forceful instrument of teaching, but a most natural manner of expression, springing as it does at once from any tendency to playfulness in minds highly comprehensive of truth; and being also one of the readiest ways in which such satire and wit as may be possessed by men of any inferior rank of mind can be for perpetuity expressed, it becomes on all grounds desirable that what is suggested in times of play should be rightly sayable without toil; and what occurs to men of inferior power or knowledge, sayable without any high degree of skill. Hence it is an infinite good to mankind when there is a full acceptance of the grotesque, slightly sketched or expressed; and, if field for such expression be freely granted, an enormous mass of intellectual power is turned to everlasting use, which, in this present century of ours, evaporates in street gibing or vain revelling; all the good wit and satire expiring in daily talk (like foam or wine), which in the thirteenth and fourteenth centuries had a permitted and useful expression in the arts of sculpture and illumination, like foam fixed into chalcedony. It is with a view (not the least important among many others bearing upon art) to the reopening of this great field of human intelligence, long entirely closed, that I am striving to introduce Gothic architecture into daily domestic use; and to revive the art of illumination, properly so-called; not the art of miniature painting in books, or on vellum, which has ridiculously been confused with it; but of making *writing*, simple writing, beautiful to the eye, by investing it with the great chord of perfect colour, blue, purple, scarlet, white, and gold, and in that chord of colour, permitting the continual play of the fancy of the writer in every species of grotesque imagination, carefully excluding shadow; the distinctive difference between illumination and painting proper, being that illumination admits *no* shadows, but only gradations of pure colour. . . .

From *Modern Painters*, Vol. III, Part IV, Ch. VIII, ¶ 9.

English Finish

PERHAPS one of the most remarkable points of difference between the English and Continental nations is in the degree of finish given to their ordinary work. It is enough to cross from Dover to Calais to feel this difference; and to travel further only increases the sense of it. English windows for the most part fit their sashes, and their wood-work is neatly planed and smoothed; French windows are larger, heavier, and framed with wood that looks as if it had been cut to its shape with a hatchet; they have curious and cumbrous fastenings, and can only be forced asunder or together by some ingenuity and effort, and even then not properly. So with everything else—French, Italian, German, and, as far as I know, Continental. . . .

There is in this conclusion no ground for national vanity; for though the desire to do things as well as they can be done at first appears like a virtue, it is certainly not so in all its forms. On the contrary, it proceeds in nine cases out of ten more from vanity than conscientiousness; and that, moreover, often a weak vanity. I suppose that as much finish is displayed in the fittings of the private carriages of our young rich men as in any other department of English manufacture; and that our St. James's Street cabs, dogcarts and liveries are singularly perfect in their way. . . .

Now, so far from the labour's being turned to good account which is given to our English 'finishing', I believe it to be usually destructive of the best powers of our workmen's minds. For it is evident, in the first place, that there is almost always a useful and a useless finish; the hammering and welding which are necessary to produce a sword blade of the best quality, are useful finishing; the polish of its surface useless. In nearly all work this distinction will, more or less, take place between substantial finish and apparent finish, or what may be briefly characterized as 'Make' and 'Polish'. And so far as finish is bestowed for purposes of 'make' I have nothing to say against it. Even the vanity which displays itself in giving strength to our work is rather a virtue than a vice. But so far as finish is bestowed for purposes of 'polish' there is much to be said against it. . . . God alone can finish; and the more intelligent the human mind becomes, the more the infiniteness of interval is felt between human and divine work in this respect. So then it is not a little absurd to weary ourselves in struggling towards a point which we never can reach, and to exhaust our strength in vain endeavours to produce qualities which exist inimitably and inexhaustibly in the commonest things around us.

From *Modern Painters*, Vol. III, Part IV, Ch. IX, ¶ 4.

THE AWAKENING CONSCIENCE. Detail of the painting by Holman Hunt. *Coll. Sir Colin Anderson*

[See publisher's note, p. 6.]

Turner and the Pre-Raphaelites

THERE is not the slightest inconsistency in the mode in which, throughout this work, I have desired the relative merits of painters to be judged. I have always said, he who is closest to Nature is best. All rules are useless, all genius is useless, all labour is useless, if you do not give facts; the more facts you give, the greater you are; and there is no fact so unimportant as to be prudently despised, if it be possible to represent it. Nor, but that I have long known the truth of Herbert's lines,

> 'Some men are
> Full of themselves, and answer their own notion',[1]

would it have been without intense surprise that I heard querulous readers asking, 'how it was possible' that I could praise Pre-Raphaelitism and Turner also. For, from the beginning of this book to this page of it, I have never praised Turner highly for any other cause than that he *gave facts* more delicately, more Pre-Raphaelitically, than other men. Careless readers, who dashed at the descriptions and missed the arguments, took up their own conceptions of the cause of my liking Turner, and said to themselves: 'Turner cannot draw, Turner is generalizing, vague, visionary; and the Pre-Raphaelites are hard and distinct. How can anyone like both?' But *I* never said that Turner could not draw.—*I* never said that he was vague or visionary.—What *I* said was that nobody had ever drawn so well: that nobody was so certain, so *un*visionary; that nobody had ever given so many hard and downright facts. . . .

Turner is praised for his truth and finish; that truth of which I am beginning to give examples. Pre-Raphaelitism is praised for its truth and finish; and the whole duty inculcated upon the artist is that of being in all respects as like Nature as possible.

From *Modern Painters*, Vol. III, Part IV, Ch. X, ¶ 5.

The Seventeenth Century

THE Venetian school of landscape expired with Tintoretto, in the year 1594; and the sixteenth century closed, like a grave, over the great art of the world. There is *no* entirely sincere or great art in the seventeenth century. Rubens and Rembrandt are its two greatest men, both deeply stained by the errors and affectations of their age. The influence of the Venetians hardly extended to them; the tower of the Titianesque art fell southwards, and on

[1] *The Church Porch*, LIV.

the dust of its ruins grew various art-weeds, such as Domenichino and the Caraccis. Their landscape, which may in few words be accurately defined as 'Scum of Titian', possesses no single merit, nor any ground for the forgiveness of demerit; they are to be named only as a link through which the Venetian influence came dimly down to Claude and Salvator.

From *Modern Painters*, Vol. III, Part IV, Ch. XVIII, ¶ 26.

Turner and the Old Masters

. . . When Turner arose with an earnest desire to paint the whole of nature, he found that the existence of the sun was an important fact, and by no means an easily manageable one. *He* loved sunshine for its own sake; but he could not at first paint it. Most things else, he would more or less manage without much technical difficulty; but the burning orb and the golden haze could not, somehow, be got out of the oil paint. Naturally, he went to Claude, who really had got them out of oil paint; approached him with great reverence, as having done that which seemed to Turner most difficult of all technical matters, and he became his faithful disciple. How much he learned from him of manipulation, I cannot tell; but one thing is certain, that he never quite equalled him in that particular forte of his. I imagine that Claude's way of laying on oil colour was so methodical that it could not possibly be imitated by a man whose mechanism was interfered with by hundreds of thoughts and aims totally different from Claude's; and, besides, I suppose that certain useful principles in the management of paint, of which our schools are now wholly ignorant, had come down as far as Claude, from the Venetians. Turner at last gave up the attempt, and adopted a manipulation of his own, which indeed effected certain objects attainable in no other way, but which still was in many respects unsatisfactory, dangerous, and deeply to be regretted. . . .

¶ Of the influence of Gaspar and Nicolo Poussin on Turner, there is hardly anything to be said, nor much respecting that which they had on landscape generally. Nicolo Poussin had noble powers of design, and might have been a thoroughly great painter had he been trained in Venice; but his Roman education kept him tame; his trenchant severity was contrary to the tendencies of the age, and had few imitators compared to the dashing of Salvator, and the mist of Claude. Those few imitators adopted his manner without possessing either his science or invention; and the Italian school of landscape soon expired. Reminiscences of him occur sometimes in Turner's compositions of sculptured stones for foreground; and the beautiful Triumph of Flora, in the Louvre, probably first showed Turner the use of definite

flower, or blossom-painting, in landscape. I doubt if he took anything from Gaspar; whatever he might have learned from him respecting masses of foliage, and golden distances, could have been learned, and, I believe, *was* learned, from Titian.

¶ Meantime, a lower, but more living school had developed itself in the North; Cuyp had painted sunshine as truly as Claude, gilding with it a more homely, but far more honestly conceived landscape; and the effects of light of De Hooghe and Rembrandt presented examples of treatment to which southern art could show no parallel. Turner evidently studied these with the greatest care, and with great benefit in every way; especially this, that they neutralized the idealisms of Claude, and showed the young painter what power might be in plain truth, even of the most familiar kind. He painted several pictures in imitation of these masters; and those in which he tried to rival Cuyp are healthy and noble works, being, in fact, just what most of Cuyp's own pictures are—faithful studies of Dutch boats in calm weather on smooth water. De Hooghe was too precise, and Rembrandt too dark, to be successfully or affectionately followed by him; but he evidently learned much from both.

¶ Finally, he painted many pictures in the manner of Vandeveld (who was the accepted authority of his time in sea painting), and received much injury from him. To the close of his life, Turner always painted the sea too grey, and too opaque, in consequence of his early study of Vandevelde. He never seemed to perceive colour so truly in the sea as he saw it elsewhere. But he soon discovered the poorness of Vandevelde's forms of waves, and raised their meanly divided surfaces into massive surge. . . .

Such was the art to which Turner, in early years, devoted his most earnest thoughts. More or less respectful contemplation of Reynolds, Loutherbourg, Wilson, Gainsborough, Morland, and Wilkie, was incidentally mingled with his graver study; and he maintained a questioning watchfulness of even the smallest successes of his brother artists of the modern landscape school. . . .

From *Modern Painters*, Vol. III, Part IV, Ch. XVIII, ¶ 25.

Colour and Light

. . . We find the greatest artists mainly divided into two groups—those who paint principally with respect to local colour, headed by Paul Veronese, Titian and Turner; and those who paint principally with reference to light and shade irrespective of colour, headed by Leonardo da Vinci, Rembrandt, and Raphael. The noblest members of each of these classes introduce the

element proper to the other class, in a subordinate way. Paul Veronese introduces a subordinate light and shade, and Leonardo introduces a subordinate local colour. The main difference is, that with Leonardo, Rembrandt and Raphael, vast masses of the picture are lost in comparatively colourless (dark grey or brown) shadow; these painters *beginning* with the *lights* and going *down* to blackness; but with Veronese, Titian, and Turner, the whole picture is like the rose,—glowing with colour in the shadows, and rising into paler and more delicate hues, or masses of whiteness in the lights; they having *begun* with the *shadows*, and gone *up* to whiteness.

¶ The colourists have in this respect one disadvantage, and three advantages. The disadvantage is, that between their less violent hues, it is not possible to draw all the forms which can be represented by the exaggerated shadows of the chiaroscurists, and therefore a slight tendency to flatness is always characteristic of the greater colourists, as opposed to Leonardo or Rembrandt. Where the form of some single object is to be given, and its subtleties are to be rendered to the utmost, the Leonardesque manner of drawing is often very noble. It is generally adopted by Albert Dürer, in his engravings, and is very useful, when employed by a thorough master, in many kinds of engravings; but it is an utterly false method of *study*. . . .

¶ Of the three advantages possessed by the colourists over the chiaroscurists, the first is, that they have in the greater portions of their pictures *absolute* truth, . . . while the chiaroscurists have no absolute truth anywhere. With the colourists the shadows are right; the lights untrue: but with the chiaroscurists lights and shadows are both untrue. The second advantage is, that also the *relations* of colour are broader and vaster with the colourists than the chiaroscurists. Take, for example, that piece of drapery studied by Leonardo, in the Louvre, with white lights and black shadows. Ask yourself, first, whether the real drapery was black or white. If white, then its high lights are rightly white; but its folds being black, it could not *as a mass* be distinguished from the black or dark objects in its neighbourhood. But the fact is, that a white cloth or handkerchief always *is* distinguished in daylight, as a *whole white thing*, from all that is coloured about it: we see at once that there is a white piece of stuff, and a red, or green, or grey one near it, as the case may be: and this relation of the white object to other objects not white, Leonardo has wholly deprived himself of the power of expressing; while if the cloth were black or dark, much more has he erred in making its lights white. In either case, he has missed the large relation of mass to mass for the sake of the small one of fold to fold. And this is more or less the case with all chiaroscurists; with all painters, that is to say, who endeavour in their studies of objects to get rid of the idea of colour, and give the abstract shade. They invariably exaggerate the

shadows, not with respect to the thing itself, but with respect to all around it; and they exaggerate the lights also, by leaving pure white for the high light of what in reality is grey, rose-coloured, or, in some way, not white.

From *Modern Painters*, Vol. IV, Part V, Ch. III, ¶ 18–20.

Pride

. . . The longer I live, the more ground I see to hold in high honour a certain sort of childishness or innocent susceptibility. Generally speaking, I find that when we first look at a subject, we get a glimpse of some of the greatest truths about it; as we look longer, our vanity, and false reasoning, and half-knowledge, lead us into various wrong opinions; but as we look longer still, we gradually return to our first impressions, only with a full understanding of their mystical and innermost reasons; and of much beyond and beside them, not then known to us, now added (partly as a foundation, partly as a corollary) to what at first we felt or saw. . . .

¶ I have also been more and more convinced the more I think of it, that in general *pride is at the bottom of all great mistakes*. All the other passions do occasional good, but whenever pride puts in *its* word, everything goes wrong, and what it might really be desirable to do, quietly and innocently, it is mortally dangerous to do proudly. Thus, while it is very often good for the artist to make *studies* of things, for the sake of knowing their forms, with their high lights all white, the moment he does this in a haughty way, and thinks himself drawing in the great style, because he leaves his high lights white, it is all over with him. . . .

From *Modern Painters*, Vol. IV, Part V, Ch. III, ¶ 21–22.

Clarity and Mystery

JOHN BELLINI, Leonardo, Angelico, Dürer, Perugino, Raphael—all of them hated fog, and repudiated indignantly all manner of concealment. Clear, calm, placid, perpetual vision, far and near; endless perspicuity of space; unfatigued veracity of eternal light; perfectly accurate delineation of every leaf on the trees, every flower in the fields, every golden thread in the dresses of the figures, up to the highest point of calm brilliance which was penetrable to the eye, or possible to the pencil,—these were their glory. On the other—the entirely mysterious—side, we have only sullen and sombre Rembrandt, desperate Salvator; filmy, futile Claude; occasionally

some countenance from Correggio and Titian, and a careless condescension or two from Tintoret,* not by any means a balanced weight of authority. Then, even in modern times, putting Turner (who is at present the prisoner at the bar) out of the question, we have, in landscape, Stanfield and Harding as definers, against Copley Fielding and Robson on the side of the clouds;† Mulready and Wilkie against Etty,—even Etty being not so much misty in conception as vague in execution, and not, therefore, quite legitimately to be claimed on the foggy side; while, finally, the whole body of the Pre-Raphaelites—certainly the greatest men, taken as a class, whom modern Europe has produced in concernment with the arts—entirely agree with the elder religious painters, and do, to their utmost, dwell in an element of light and declaration, in antagonism to all mist and deception. . . .

From *Modern Painters*, Vol. IV, Part V, Ch. IV, ¶ 2.

Distance

. . . Every distance and size of picture has its own proper method of work; the artist will necessarily vary that method somewhat according to circumstances and expectations: he may sometimes finish in a way fitted for close observation, to please his patron, or catch the public eye; and sometimes be tempted into such finish by his zeal, or betrayed into it by forgetfulness, as I think Tintoret has been, slightly, in his Paradise. . . . But there never yet was a picture thoroughly effective at a distance, which did not look more or less unintelligible near. Things which in distant effect are folds of dress, seen near are only two or three grains of golden colour set there apparently by chance; what far off is a solid limb, near is a grey shade with a misty outline, so broken that it is not easy to find its boundary; and what far off may perhaps be a man's face, near, is only a piece of thin brown colour, enclosed by a single flowing wave of a brush loaded with white, while three brown touches across one edge of it, ten feet away, become a mouth and eyes. The more subtle the power of the artist, the more curious the difference will be between the apparent means and the effect produced; and one of the most sublime feelings connected with art consists in the perception of this very strangeness, and in a sympathy with the foreseeing and foreordaining power of the artist. In Turner, Tintoret, and Paul Veronese,

* In the clouds around Mount Sinai, in the picture of the Golden Calf; the smoke turning into angels, in the Cenacolo at San Giorgio Maggiore; and several other instances.

† Stanfield I call a definer as opposed to Copley Fielding, because, though like all other moderns, he paints cloud and storm, he will generally paint all the masts and yards of a ship, rather than merely her black bows gleaming through the foam; and all the rocks on a hill-side, rather than the blue outline of the hill through a mist.

the intenseness of perception, first, as to what is to be done, and then, of the means of doing it, is so colossal, that I always feel in the presence of their pictures just as other people would in that of a supernatural being. Common talkers use the word 'magic' of a great painter's power without knowing what they mean by it. They mean a great truth. That power *is* magical; so magical, that, well understood, no enchanter's work could be more miraculous or more *appalling*; and though I am not often kept from saying things by timidity, I should be afraid of offending the reader, if I were to define to him accurately the kind and the degree of awe, with which I have stood before Tintoret's Adoration of the Magi, at Venice, and Veronese's Marriage in Cana, in the Louvre.

From *Modern Painters*, Vol. IV, Part V, Ch. IV, ¶ 15.

Turner

. . . It is first to be remembered that in every one of his English or French drawings, Turner's mind was in two great instincts, at variance with itself. The *affections* of it clung . . . to humble scenery; gentle wildness of pastoral life. But the *admiration* of it was, more than any other artist's whatsoever, fastened on largeness of scale. With all his heart, he was attached to the narrow meadows and rounded knolls of England; by all his imagination he was urged to the reverence of endless vales and measureless hills: nor could any scene be too contracted for his love, or too vast for his ambition. Hence when he returned to English scenery after his first studies in Savoy and Dauphiné, he was continually endeavouring to reconcile old fondnesses with new sublimities; and, as in Switzerland he chose rounded Alps for the love of Yorkshire, so in Yorkshire he exaggerated scale, in the memory of Switzerland, and gave to Ingleborough, seen from Hornby Castle, in great part, the expression of cloudy majesty and height which he had seen in the Alps from Grenoble. . . .

From *Modern Painters*, Vol. IV, Part V, Ch. XVI, ¶ 29.

Vagueness and Solidity

IT IS somewhat singular that the indistinctness of treatment which has been so often noticed as characteristic of our present art shows itself always most when there is least apparent reason for it. Modern artists, having some true sympathy with what is vague in nature, draw all that is uncertain

and evasive without evasion, and render faithfully whatever can be discerned in faithless mist or mocking vapours; but having no sympathy with what is solid and serene, they seem to become uncertain themselves in proportion to the certainty of what they see; and while they render flakes of far-away cloud, or fringes of inextricable forest, with something like patience and fidelity, give nothing but the hastiest indication of the ground they tread upon or touch. It is only in modern art that we find any complete representation of clouds, and only in ancient art that, generally speaking, we find any careful realization of stones.

From *Modern Painters*, Vol. IV, Part V, Ch. XVIII, ¶ I.

Mulready's 'Young Brother'

The Young Brother by W. Mulready, R.A.[1]

WITHOUT exception, the least interesting piece of good painting I have ever seen in my life. I call it a 'piece of painting', not a 'picture', because the artist's mind has been evidently fixed throughout on his modes of work, not on his subject—if subject it can be called. Is it not sorrowful to see all this labour and artistical knowledge appointed, by a command issued from the grave, to paint—and employed for a couple of years in painting—for the perpetual possession and contemplation of the English people, the ill-laced bodice of an untidy girl? Yet the picture will be a valuable one; perhaps the most forcible illustration ever given of the frivolous application of great powers. For this is not, observe, the commonplace littleness of an inferior mind, nor commonplace wantonness of a great one. We have had examples enough of mean subjects chosen by the trifling, and slight subjects chosen by the feeble: nor is it a new thing to see great intellects overthrown by impetuosity, or wasted in indolence; stumbling and lost among the dark mountains, or lying helpless by the wayside, listless or desolate. All this we have seen often; but never, I think, till now, patience disappointed of her hope, and conscientiousness mistaken in her aim; labour beguiled of her reward, and discretion warped in her choice. We have not known until now that the greatest gifts might be wasted by prudence, and the greatest errors committed by precision.

For it is quite curious how, throughout this composition, the artist seems to have aimed at showing the uselessness of all kinds of good. There is an exquisite richness of decoration in the pattern of the yellow dress, yet the picture is none the richer for it; an exquisite play of colour in the

[1] Ill. 28 facing this page.

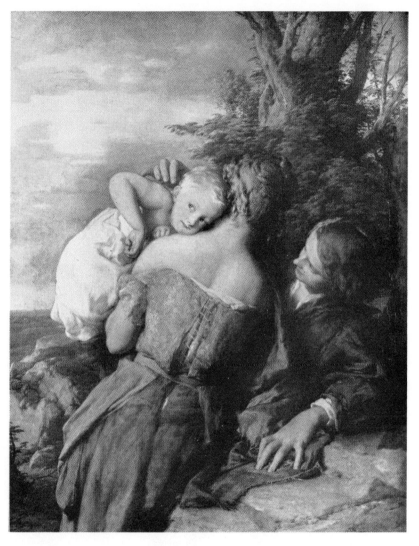

28. THE YOUNGER BROTHER. Painting by W. Mulready. *London, Tate Gallery*

29. SIR ISUMBRAS AT THE FORD. Painting by Millais

Port Sunlight, Lady Lever Art Gallery

30. THE BAY OF BAIAE. Detail of a painting by Turner. *London, Tate Gallery*

flesh, yet the girl is none the fairer for it: her dress is loose, without grace; and her beauty hidden, without decency. The colour of the whole is pure, but it does not refresh; its arrangement subtle, but it does not entertain: the child laughs without gaiety; and the youth reclines without repose.

We may be sure, however—which is some comfort—that failure of this total kind *cannot* take place unless there is somewhere a wilful departure from truth; for truth, however ill-chosen, is never *wholly* uninteresting. For instance, here, the sense of country life is destroyed by the false forms of the trees, which are only green horizontal flakes of colour, not foliage; and the dead blue dress of the youth, though it seems at first well painted, is shaded either with pure dark blue, dirty green, or violet, wholly at random, and of course, therefore, with destruction of brilliancy as well as of relief; while the folds of the girl's gown, though they at first look well drawn, are mere angular masses, without either flow or fall.

Millais' 'Sir Isumbras at the Ford'

A Dream of the Past by J. E. Millais, R.A.[1]

THE HIGH praise which I felt it my duty to give to this painter's work last year was warranted by my observing in it, for the first time, the entirely inventive arrangement of colour and masses, which can be achieved only by the highest intellect. I must repeat briefly here what I have had occasion hundreds of times to explain elsewhere, but never yet often enough to get it generally understood—that painters are broadly divisible into three classes: first, the large class who are more or less affected or false in all their work, and whose productions, however dexterous, are of no value whatever; secondly, the literally true painters, who copy with various feeling but unanimously honest purpose, the actualities of Nature, but can only paint them as they see them, without selection or arrangement; whose works are therefore of a moderate but sterling value, varying according to the interest of the subject; lastly, the inventive painters, who are not only true in all they do, but compose and relieve the truths they paint, so as to give to each the utmost possible value; which last class is in all ages a very small one; and it is a matter to congratulate a nation upon, when an artist rises in the midst of it who gives any promise of belonging to this great Imaginative group of Masters.

And this promise was very visible in the works of Millais last year; a new power of conception being proved in them—to instance two things among many—by the arrangement of the myrtle branches in the 'Peace',

[1] Catalogued and known as 'Sir Isumbras at the Ford'. Ill. 29 between page 90 and this page.

and the play of the colours in the heap of 'Autumn Leaves'. There was a
slovenliness and imperfection in many portions, however, which I did not
speak of, because I thought them accidental—consequent, probably, on too
exulting a trial of his new powers, and likely to disappear as he became
accustomed to them. But, as it is possible to stoop to victory, it is also
possible to climb to defeat; and I see with consternation that it was not
the Parnassian rock which Mr. Millais was ascending, but the Tarpeian.
The change in his manner, from the years of 'Ophelia' and 'Mariana' to
1857, is not merely Fall—it is Catastrophe; not merely a loss of power,
but a reversal of principle: his excellence has been effaced, 'as a man wipeth
a dish—wiping it, and turning it upside down'.[1] There may still be in him
power of repentance, but I cannot tell: for those who have never known
the right way, its narrow wicket-gate stands always on the latch; but for
him who, having known it, has wandered thus insolently, the by-ways to
the prison-house are short, and the voices of recall are few.

I have not patience much to examine into the meaning of the picture
under consideration. If it has one, it should not have been disguised by the
legend associated with it, which, by the way, does not exist in the Romance
from which it professes to be quoted, and is now pretty generally under-
stood to be only a clever mystification by one of the artist's friends, written
chiefly with the view of guarding the awkward horse against criticism. I
am not sure whether the bitterest enemies of Pre-Raphaelitism have yet
accused it of expecting to cover its errors by describing them in bad English.[2]

Putting the legend, however, out of question, the fancy of the picture
is pretty, and might have been sublime, but that it is too ill painted to be
dwelt upon. The primal error in pictorial grammar, of painting figures in
twilight as bright as yellow and vermillion can make them, while the towers
and hills, far above and far more exposed to light, are yet dark and blue,
could hardly have been redeemed by any subsequent harmonies of tone,
much less by random brilliancy; and the mistake of painting the water

[1] 2 Kings xxi. 13.
[2] The lines written for the picture by Tom Taylor began thus:

> 'The goode hors that the knyghte bestrode,
> I trow his backe it was full brode,
> And wighte and warie still he rode,
> Noght reckinge of rivere;
> He was so mickle and so stronge,
> And thereto so wonderlich longe,
> In lande was none his peer.
> N'as hors but by him seemed smalle.
> The knyghte him ycleped Launcival,
> But lords at borde and grooms in stalle
> Ycleped him Graund Destrere.'

They were described as being 'from the Metrical Romance of Sir Ysumbras'.

brighter than the sky which it reflects, though constant among inferior painters in subordinate parts of their work, is a singularly disgraceful one for a painter of standing.

These, and the other errors or shortcomings in the work, too visible to need proving, and too many to bear numbering, are all the less excusable because the thought of the picture was a noble one, and might seem both justly to claim, and tenderly to encourage, the utmost skill and patience in its rendering. It does not matter whether we take it as a fact or as a type: whether we look verily upon an old knight riding home in the summer twilight, with the dust of his weary day's journey on his golden armour, taking the woodman's children across the river with him, holding the girl so tenderly that she does not so much as feel the grasp of the gauntlets, but holds the horse's mane as well, lest she should fall; or whether we receive it as a type of noble human life, tried in all war, and aged in all counsel and wisdom, finding its crowning work at last to be bearing the children of poverty in its arms, and that the best use of its panoply of battle is to be clasped by the feeble fingers, wearied with gathering the sheddings of the autumnal woods. It might bear a deeper meaning even than this: it might be an image less of life than of the great Christian Angel of Death, who gives the eternal nobleness to small and great, and clasps the mean and the mighty with his golden armour—Death, bearing the two children with him across the calm river, whither they know not; one questioning the strange blue eyes which she sees fixed on heaven, the other only resting from his labour, and feeling no more his burden. All this, and much more than this—for the picture might be otherwise suggestive to us in a thousand ways—it would have brought home at once to the heart of every spectator, had the idea but been realized with any steadiness of purpose or veracity of detail. As it stands, it can only be considered as a rough sketch of a great subject, injudiciously exposed to general criticism, and needing both modification in its arrangement and devoted labour in its future realization.

I am sorrowfully doubtful, however, how far Mr. Millais may yet be capable of such labour. There are two signs conspicuous in his this year's work, of augury strangely sinister: the first, an irregularity in the conception of facts, quite unprecedented in any work that I know in the Realistic schools of any age; the second, a warped feeling in the selection of facts, peculiar, as far as I know, to Millais from his earliest youth.

I say, first, an irregularity of conception. Thus, it seems only to have struck the painter suddenly, as he was finishing the knight's armour, that it ought to be more or less reflective; and he gives only one reflection in it —of the crimson cloth of the saddle, that one reflection being violently exaggerated: for though, from a golden surface, it would have been, as he has rendered it, warmer than the crimson, no reflection is ever *brighter*

than the thing reflected. But all the rest of the armour is wholly untouched by the colour of the children's dresses, or of their glowing faces, or of the river or sky. And if Mr. Millais meant it to be old armour, rough with wear, it ought to have been deadened and darkened in colour, hacked with edges of weapons, stained with stains of death; if he meant it merely to be dusty, the dust should have lain white on some of the ridges, been clearly absent from others, and should have been dark where it was wet by the splashing of the horse. The ripple of the water against the horse itself, however, being unnoticed, it is little wonder if the dash of the chance spray is missed. A more manifest sign still of this irregular appliance of mind is in the fact that the peacock's plume, the bundle of wood, and the stripes of the saddle-cloth are painted with care; while the children's faces, though right in expression, are rudely sketched, with unrounded edges, half in rose colour and half in dirty brown. Vestiges of his old power of colouring, still unattainable by any other man, exist, however, in that saddle-cloth and in the peacock's feather. But the second sign, the warping of feeling, is a still more threatening one.

Millais' 'Escape of the Heretic'

THE CONCEPTION of his second picture (408)[1] is an example of the darkest error in judgment—the fatalest failure in the instinct of the painter's mind. At once coarse and ghastly in fancy, exaggerated and obscure in action, the work seems to have been wrought with the resolute purpose of confirming all that the bitterest adversaries of the school have delighted to allege against it; and whatever friendship has murmured, or enmity proclaimed, of its wilful preference of ugliness to beauty, is now sealed into everlasting acceptance. It is not merely in manifest things, like the selection of such a model as this for the type of the foot of a Spanish lady, or the monstrous protrusion of the lover's lip in his intense appeal for silence; but the dwelling perpetually upon the harshest lines of form, and most painful conditions of expression, both in human feature and in natural objects, which long ago, when they appeared in Millais's picture of the 'Carpenter's Shop', restrained the advance of Pre-Raphaelitism; and would arrest its advance now, unless there were other painters to support its cause, who will disengage it from unnaturalness of error, and vindicate it from confusion of contempt.

[1] 'The Escape of the Heretic, 1559.' A scene, as described in an illustrative note in the catalogue, from the Spanish Inquisition. A Spanish lover, disguised as a monk, rescuing his mistress, who has already been robed in her fiery gaberdine for the *auto-da-fé;* in the background a monk, bound and gagged. The subject was suggested to Millais by some engravings and documents shown to him by Stirling-Maxwell (see *Life and Letters of Millais,* Vol. I, p. 319).

For Mr. Millais there is no hope but in a return to quiet perfectness of work. I cannot bring myself to believe that powers were given to him only to be wasted, which are so great, even in their aberration, that no pictures in the Academy are so interesting as these, or can be for a moment compared with them for occasional excellence and marvellousness of execution. Yet it seems to be within the purpose of Providence sometimes to bestow great powers only that we may be humiliated by their failure, or appalled by their annihilation; and sometimes to strengthen the hills with iron, only that they may attract the thunderbolt. A time is probably fixed in every man's career, when his own choice determines the relation of his endowments with his destiny; and the time has come when this painter must choose, and choose finally, whether the eminence he cannot abdicate is to make him conspicuous in honour, or in ruin.

From *Academy Notes*, 1857, XIV, p. 91.

Turner's Four Periods

THE WORKS of Turner are broadly referable to four periods, during each of which the painter wrought with a different aim, or with different powers. . . .

The pictures belonging to [the first period, that of studentship from 1800 to 1820], are notable for their grey or brown colour, and firm, sometimes heavy, laying on of paint. And this for two reasons. Every great artist, without exception, needs, and feels that he needs, to learn to express the forms of things before he can express the colours of things; and it much facilitates this expression of form if the learner will use at first few and simple colours, and the paint is laid on firmly, partly in mere unskilfulness (it being much easier to lay a heavy touch than a light one), but partly also in the struggle of the learner against indecision, just as the notes are struck heavily in early practice (if useful and progressive) on a pianoforte. But besides these reasons, the kind of landscapes which were set before Turner as his models, and which, during nearly the whole of this epoch, he was striving to imitate, were commonly sober in colour, and heavy in touch. Brown was thought the proper colour for trees, grey for shadows, and fog-yellow for high lights. 'Child Roland to the dark tower came', and had to clear his way through all the fog; twenty years of his [working] life passed before he could fairly get leave to see. It follows that the evidences of invention, or of new perception, must be rarer in the pictures of this period than in subsequent ones. It was not so much to think brilliantly as to draw accurately, that Turner was trying; not so much

to invent new things, as to rival the old. His own perceptions are traceable only by fits and fragments through the more or less successful imitation. . . .

[The second period, or that of Mastership, runs from 1820 to 1835.] The reader may perhaps suppose that I limit Turner's course of conception too arbitrarily in assigning a single year as the period of its change. But the fact is that though the human mind is prepared for its great transitions by many previous circumstances, and much gradual accumulation of knowledge, those transitions may, and frequently do, take place in a moment. One glance of the eye, one springing aside of a fancy, may cast a spark on the prepared pile; and the whole theory and practice of past life may be burnt up like stubble; and new foundations be laid in the next hour, for the perpetual future toil of existence. This cannot, however, take place, with the utmost sharpness of catastrophe, in so difficult an art as that of painting; old habits will remain in the hand, and the knowledge necessary to carry out the new principles needs to be gradually gathered; still, the new conviction, whatever it be, will probably be expressed, within no very distant period from its acquirement, in some single picture, which will at once enable us to mark the old theories as rejected, at all events, then, if not before. This condemning and confirming picture is, in the present instance, I believe, the Bay of Baiae.[1]

For, in the year 1819, Turner exhibited the 'Orange Merchant' and 'Richmond Hill',[2] both in his first manner. In 1820, 'Rome from the Vatican'; which is little more than a study of materials in the view of Rome from the Loggie, expressed in terms of general challenge to every known law of perspective to hold its own, if it could, against the new views of the professor, on that subject. In 1821, *nothing*: a notable pause. In 1822, 'What you Will', a small picture. In 1823 came the 'Bay of Baiae'.

Why I put the real time of change so far back as 1820 will appear, after I have briefly stated the characters in which the change consists.

Pictures belonging to the second period are technically distinguished from those of the first in three particulars:

1. Colour takes the place of grey.
2. Refinement takes the place of force.
3. Quantity takes the place of mass.

First, Colour appears everywhere instead of grey. That is to say, Turner had discovered that the shaded sides of objects, as well as their illumined ones, are in reality, of different, and often brilliant colours. His shadow is, therefore, no longer of one hue, but perpetually varied; whilst the lights, instead of being subdued or any conventional level, are always painted as near the brightness of natural colour as he can.

[1] Ill. 30 facing page 91. [2] Colour-plate facing page 98.

Secondly, Refinement takes the place of force. He had discovered that it is much more difficult to draw tenderly than ponderously, and that all the most beautiful things in nature depended on definitely delicate lines. His effort is, therefore, always, now, to trace lines as finely, and shades as softly, as the point of the brush and feeling of hand are capable of doing; and the effects sought are themselves the most subtle and delicate which nature presents, rarely those which are violent. The change is the same as from the heavy touch and noisy preferences of a beginner in music, to the subdued and tender fingering or breathing of a great musician—rising, however, always into far more masterful stress when the occasion comes.

Thirdly, Quantity takes the place of mass. Turner had also ascertained in the course of his studies, that Nature was infinitely full, and that old painters had not only missed her pitch of hue, but her power of accumulation. He saw there were more clouds in any sky than ever had been painted; more trees in every forest, more crags on every hill side; and he set himself with all his strength to proclaim this great fact of Quantity in the universe.

Now, so long as he introduced all these three changes in an instinctive and unpretending way, his work was noble; but the moment he tried to idealize, and introduced his principles for the sake of display, they led him into depths of error proportioned exactly to the extent of effort. His painting, at this period, of an English town, or a Welsh hill, was magnificent and faultless, but all his idealism, mythology, romance, and composition in general, were more or less wrong. He erred through all, and by reason of all—his great discoveries. He erred in *colour*; because not content with discerning the brilliancy of nature he tried to enhance that brilliancy by every species of coloured accessory, until colour was killed by colour, and the blue skies and snowy mountains, which would have been lovely by themselves, were confused and vulgarized by the blue dresses and white complexions of the foreground figures. He erred in *refinement*, because, not content with the natural tenderness of tender things, he strove to idealize even strong things into gentleness, until his architecture became transparent, and his ground ghostly; and he erred finally, and chiefly, in *quantity*, because, in his enthusiastic perception of the fulness of nature, he did not allow for the narrowness of the human heart; he saw, indeed, that there were no limits to creation, but forgot that there were many to reception; he thus spoiled his most careful works by the very richness of invention they contained, and concentrated the materials of twenty noble pictures into a single failure.

The oil pictures exhibited at the Academy, as being always more or less done for show, and to produce imposing effect, display these weaknesses in the greatest degree; the drawings in which he tried to do his best are next in failure, but the drawings in which he simply liked his

subject, and painted it for its own simple sake, are wholly faultless and magnificent. . . .

One more point needs notice in them. They generally are painted with far more enjoyment [than those of the first period]. Master now of himself and his subjects, at rest as to the choice of the thing to be done, and triumphing in perpetually new perceptions of the beauty of the nature he had learned to interpret, his work seems poured out in perpetual rejoicing; his sympathy with the pomp, splendour, and gladness of the world increases, while he forgets its humiliation and its pain; they cannot now stay the career of his power, nor check the brightness of his exultation. From the dens of the serpent and the dragon he ascends into the soft gardens and balmy glades; and from the roll of the wagon on the dusty road, or labour of the boat along the stormy shore, he turns aside to watch the dance of the nymph, and listen to the ringing of the cymbal. . . .

[The third period of Turner's work extends from 1835 to 1845.] As Turner became more and more accustomed to, and satisfied in, the principles of art he had introduced, his mind naturally dwelt upon them with less of the pride of discovery, and turned more and more to the noble subjects of natural colour and effect, which he found himself now able to represent. He began to think less of showing or trying what he *could* do, and more of actually doing this or that beautiful thing. It was no more a question with him how many alternations of blue with gold he could crowd into a canvas, but how nearly he could reach the actual blue of the Bay of Uri, when the dawn was on its golden cliffs. I believe, also, that in powerful minds there is generally, towards age, a return to the superstitious love of Nature which they felt in their youth; and assuredly, as Turner drew towards old age, the aspect of mechanical effort and ambitious accumulation fade from his work, and a deep imaginative delight, and tender rest in the loveliness of what he had learned to see in Nature, take their place. It is true that when goaded by the reproaches cast upon him, he would often, meet contempt with contempt, and paint not, as in his middle period, to prove his powers, but merely to astonish, or to defy, his critics, often also, he would play with his Academy work, and engage in colour tournaments with his painter-friends; the spirit which prompted such jests or challenges being natural enough to a mind no longer in a state of doubt, but conscious of confirmed power. But here, again, the evil attendant on such play, or scorn, becomes concentrated in the Academy pictures; while the real strength and majesty of his mind are seen undiminished only in the sketches which he made during his summer holidays for his own pleasure, and in the drawings he completed from them. . . .

Lastly, though in most respects this is the crowning period of Turner's genius, in a few, there are evidences in it of approaching decline. As we

RICHMOND HILL. Detail of the painting by Turner. *London, Tate Gallery*

[See publisher's note, p. 6.]

have seen, in each former phase of his efforts, that the full character was not developed till about its central year, so in this last the full character was not developed till the year 1840, and that character involved, in the very fulness of its imaginative beauty, some loss of distinctness, some absence of deliberation in arrangement; and, as we approach nearer and nearer the period of decline, considerable feebleness of hand. These several deficiencies, when they happen to be united in one of the fantasies struck out during retouching days at the Academy, produce results which, at the time they appeared, might have justified a regretful criticism, provided only that criticism had been offered under such sense of the painter's real greatness as might have rendered it acceptable or serviceable to him; whereas, being expressed in terms as insulting to his then existing power as forgetful of his past, they merely checked his efforts, challenged his caprices, and accelerated his decline. . . .

[The last period of Turner's work extends from 1840 to 1850.] Virtually,[1] the works belonging to this period are limited to the first five years of it. His health, and with it in great degree, his mind, failed suddenly in the year 1845. He died in 1851. The paintings of these five closing years are, to the rest of his work, what *Count Robert of Paris* and *Castle Dangerous* are to the Waverley Novels. But Scott's mind failed slowly, by almost imperceptible degrees; Turner's suddenly with snap of some vital chord in 1845. The work of the first five years of the decade is in many respects supremely, and with *reviving* power, beautiful. The 'Campo Santo, Venice', 1842, and the 'Approach to Venice', 1844, were, when first painted, the two most beautiful pieces of colour that I ever saw from his hand, and the noblest drawings in the present series are of the years 1842 and 1843.

From *Notes on the Turner Gallery* (Oil Paintings), Vol. xii, pp. 92 ff.

The Academy

EXHIBITION OF THE ROYAL ACADEMY

THE Academy walls present us this year with much matter for curious speculation, or rather for careful and earnest forecasting of the probable course of our schools of art in this their transitional stage of effort. Accidentally, there are no leading pictures, and the rooms are filled with more or less successful works by the disciples of the Pre-Raphaelite school, which, as I stated five years ago, it would, has entirely prevailed against all opposition; sweeping away in its strong current many of the opposers themselves,

[1] Ruskin did not include the last period in his *Notes on the Turner Exhibition* but characterizes it in the catalogue of his own drawings by Turner, Vol. xii, p. 409.

whirling them hither and thither, for the moment, in its eddies, without giving them time to strike out; and tearing down in its victory a few useful old landmarks, which we shall have to build up again by-and-by. But the main question forced upon our thoughts this year is the result of the new modes of study on minds of average or inferior power. For what was done in the first instance by men of singular genius, under intense conditions of mental excitement, is now done, partly as a quiet duty, partly in compliance with the prevalent fashion, by men of ordinary powers in ordinary tempers—resulting, of course, not in brilliant, but only in worthy and satisfactory work; respecting which commonplace completeness there are several points of interest for our consideration. For a year or two considerable disappointment may be felt by the disciples of the new school. Conscious in themselves of an entire change in their modes of thought, and a vigorous advance in powers both of sight and execution, they will be necessarily mortified to find that the advance is unrewarded by distinction; that their pictures, which before were unnoticed in the midst of others as wrong, are now unnoticed in the midst of others as right; and that they have become no more conspicuous in reformation than they were in heresy. There is, however, this comfort for them (without counting the comfort in the mere consciousness of being right, whether noticed or not), that the kind of painting which they now practise is capable of far more extended appeal to the popular mind. The old art of trick and tradition had no language but for the connoisseur; this natural art speaks to all men: around it daily the circles of sympathy will enlarge; pictures will become gradually as necessary to domestic life as books; they will be largely bought —though little wondered at; the painter will have to content himself with being as undistinguished as an author, and must be satisfied in this unpraised usefulness.

Secondly, the pictures of the rising school will in a few years be much more interesting than they are now. In learning to work carefully from Nature, everybody has been obliged to paint what will stay to be painted; and the best of Nature will not wait. Moreover, a subject which must be returned to every day for a couple of months must necessarily be near the house door; and artists cannot always have their lodgings where they choose: many of them, unable to quit their usual residences, must paint the best thing they can find in their neighbourhood; and this best accessible bit, however good as a study—(anything will do for that)—will usually be uninteresting to the public. The evil is increased by affectations of Wordsworthian simplicity; also by a good deal of genuine simplicity; and of more or less foolish sentiment. . . . We must not be surprised to find that naïveté may sometimes be tiresome as well as formalism, and the exaggeration of sensibility as offensive as the pedantry of science. The

compensation is in this case greater than the evil: we are sure that whatever thoughts or passions truly possess the painter, will be truly expressed by him; while in old times they would have been silenced or constrained. The extent of these two adverse influences, however, is curiously shown in the present Academy. Because it is necessary to paint on successive days from the same object, in order to realize it to perfection, we have hardly a single interesting sky in the whole gallery—Mr. Dillon's sunset on the Nile (273) and Mr. E. W. Cooke's at Venice (557)[1] are almost the only pictures of merit which acknowledge the existence of clouds as a matter of serious interest—and because the humblest subjects are pathetic when Pre-Raphael-itically rendered, the two pieces most representative of the school in the rooms are both of stone-breakers: one (Mr. Brett's) of a boy hard at work on his heap in the morning, and the other (Mr. Wallis's) of an old man dead on his heap at night.[2] Taking which facts in their full significance, it is pleasant to think what this new school of ours will do when it once gets fairly to work on materials worth its while. Here we have literally only experiments and early lessons: trials of strength on fragments of landscape in serene weather; quiet little mill-streams and corners of meadows, slopes of sand-hills, farmyard gates, blackberry hedges, and clumps of furze. But what shall we say when the power of painting, which makes even these so interesting, begins to exert itself, with the aid of imagination and memory, on the splendid transcience of Nature, and her noblest continu-ance; when we have the courses of heaven's golden clouds instead of squares of blue through cottage casements; and the fair river mists and mountain shrouds of vapour instead of cottage smoke—pine forests as well as banks of grass, and fallen precipices instead of heaps of flints. All this is yet to come; nay, even the best of the quiet, accessible, simple gifts of Nature are yet to come. How strange that among all this painting of delicate detail there is not a true one of English spring!—that no Pre-Raphaelite has painted a cherry-tree in blossom, dark-white against the twilight of April; nor an almond-tree rosy on the blue sky; nor the flush of the apple-blossom, nor a blackthorn hedge, nor a wild-rose hedge; nor a bank with crown-circlets of the white nettle; nor a wood-ground of hyacinths; * no, nor even heather, and such things of which we talk continually. Nobody has ever painted heather yet, nor a rock spotted richly with mosses; nor gentians, nor Alpine roses, nor white oxalis in the woods, nor anemone nemorosa, nor even so

[1] 273. 'Emigrants on the Nile.' 557. 'Sunset on the Lagune: San Giorgio in Aliga and the Euganean Hills in the distance.'
[2] 1089. 'The Stonebreaker.' 562. 'Thou wert our Conscript.'
* That is to say, so as to bring out their beauty for a principal subject. Mr. Inchbold painted some wood hyacinths and gentians, but too few, and half hidden in a litter of other flowers. Mr. Oakes painted a beautiful lichened rock, but obscured with furze and rubbish—not brought out in its power.

much as the first springing leaves of any tree in their pale, dispersed, delicate sharpness of shape. Everything has to be done yet; and we must not think quite so much of ourselves till we have done it, even though we have got to be so profoundly moral that we make everybody who looks at our work the wiser for it. We must take care not always to make them sadder also. Indeed, I look with deep respect and delight on the steady purpose of doing good, which has thus in a few years changed the spirit of our pictures, and turned most of them into a sort of sermons;—only let it always be remembered that it is much easier to be didactic than to be lovely, and that it is sometimes desirable to excite the joy of the spectator as well as his indignation.

What, however, I have to say this year of particular pictures will cast itself, to my regret, a little into the form of carping; for now that nearly all are careful and well-intended, there is no possibility of praising the universal care, or describing the universal intention; while, on the other hand, there are no leading pictures of the class that silence fault-finding, but several which just miss of being leading pictures, owing to faults which it therefore becomes a duty to find. I hope it will be understood that in my statement of these blemishes, I do not in general fix upon them because the picture in question has more faults than others, but because its merits make them more to be regretted.

Frith's 'Derby Day'

The Derby Day by W. P. Frith, R.A.[1]

I AM not sure how much power is involved in the production of such a picture as this; great ability there is assuredly—long and careful study— considerable humour—untiring industry,—all of them qualities entitled to high praise, which I doubt not they will receive from the delighted public. It is also quite proper and desirable that this English carnival should be painted; and of the entirely popular manner of painting, which, however, we must remember, is necessarily, because popular, stooping and restricted, I have never seen an abler example. The drawing of the distant figures seems to me especially dexterous and admirable; but it is very difficult to characterize the picture in accurate general terms. It is a kind of cross between John Leech and Wilkie, with a dash of daguerreotype here and there, and some pretty seasoning with Dickens's sentiment.

[1] Ill. 31 facing this page and colour-plate facing page 114.

31. DERBY DAY. Detail from the painting by W. P. Frith. *London,* *Tate Gallery*

32. THE NATIVITY. Painting by A. Hughes. *Birmingham, City Art Gallery*

Hughes' 'Nativity'

The Nativity by A. Hughes.[1]

QUITE beautiful in thought, and indicative of greater colourist's power than anything in the rooms; there is no other picture so right in manner of work, the utmost possible value being given to every atom of tint laid on the canvas. I happen to know that it was hastily finished, in an after-thought; and I am sorry to see that the painter has been fatigued to the point of not seeing how far he had failed in some parts of his purpose. He had another picture perfectly finished—and, though a little grotesque in fancy, exquisitely beautiful—'The King's Garden': why has he not sent that? *

It is quite possible that, in this nativity, thoughtless people may be offended by an angel's being set to hold a stable lantern. Everybody is ready to repeat pretty verses from Spenser about angels who 'watch and truly ward', without ever asking themselves what they look out for, or what they ward off; everybody is also ready to talk about ministering spirits, so long as it is not asked what ministry means. Perhaps they might even reach to a distinct idea of such practical ministries on the part of angels as warding off a bullet from their son in India, or leading him to a spring when he was thirsty. But they cannot conceive that highest of all dignity in the entirely angelic ministration which would simply do rightly whatever needed to be done—great or small—and steady a stable lantern if it swung uneasily, just as willingly as drive back a thunder-cloud, or helm a ship with a thousand souls in it from a lee shore.

Brett's 'Stonebreaker'

Stonebreaker by J. Brett.[2]

THIS, after John Lewis's, is simply the most perfect piece of painting

[1] Ill. 32 facing this page.
[2] Ill. 34 between page 106 and 107.
* The absence of the other Pre-Raphaelite leaders from their posts is highly to be reprobated. They have no business to set themselves to work which they can't finish in proper time. Every year, at this season, the moment they have seen the effect of their picture on the public, every one of them should go into the country, and before the long days are half over each of them should have painted one picture of moderate size for next year: let them lock that up, and resolve not to look at it again till they see it on the Academy walls. Then set themselves to whatever perennial labour they choose to undertake, resting from it always about Easter, so as to be quite fresh to begin their regular Academy work again in May.

with respect to touch in the Academy this year; in some points of precision it goes beyond anything the Pre-Raphaelites have done yet. I know no such thistledown, no such chalk hills, and elm-trees, no such natural pieces of far-away cloud, in any of their works.

The composition is palpably crude and wrong in many ways, especially in the awkward white cloud at the top; and the tone of the whole a little too much as if some of the chalk of the flints had been mixed with all the colours. For all that, it is a marvellous picture, and may be examined inch by inch with delight; though nearly the last stone I should ever have thought of any one's sitting down to paint would have been a chalk flint. If he can make so much of that, what will Mr. Brett not make of mica slate and gneiss! If he can paint so lovely a distance from the Surrey downs and railway-traversed vales, what would he not make of the chestnut groves of the Val d'Aosta! I heartily wish him good-speed and long exile.

From *Academy Notes*, 1858, Vol. xiv, p. 417.

Millais' 'Vale of Rest'

The Vale of Rest by J. E. Millais, R.A.[1]

I HAVE no doubt the beholder is considerably offended at first sight of this picture—justifiably so, considering what might once have been hoped for from its painter; but unjustifiably, if the offence taken prevents his staying by it, for it deserves his study. 'We are offended by it.' Granted. Perhaps the painter did not mean us to be pleased. It may be that he supposed we should have been offended if we had seen the real nun digging her real grave;* that she and it might have appeared to us not altogether pathetic, romantic, or sublime, but only strange or horrible; and that he chooses to fasten this sensation upon us rather than any other.

It is a temper into which many a good painter has fallen before now. You would not find it a pleasant thing to be left at twilight in the church of the Madonna of the Garden at Venice, with the last light falling on the skeletons—half alive, dreamy, stammering skeletons—shaking the dust off their ribs, in Tintoret's 'Last Judgment'. Perhaps even you might not be at your ease before one or two pale crucifixes which I remember of Giotto's and other not mean men, where the dark red runlets twine and trickle

[1] Ill. 35 between page 106 and 107.
* I believe, in point of fact, nuns neither dig their own graves nor erect tombstones; but we will take the picture on its own terms.

from the feet down to the skull at the root of the cross. Many an ugly spectre and ghastly face has been painted by the gloomier German workmen before now, and been in some sort approved by us; nay, there is more horror by far, of a certain kind, in modern French works—Vernet's Eylau and Plague, and such like—which we do not hear any one declaim against; nay, which seem to meet a large division of public taste—than in this picture which so many people call 'frightful'.

Why *so* frightful? Is it not because it is so nearly beautiful?—Because the dark green field, and windless trees, and purple sky might be so lovely to persons unconcerned about their graves?

Or is it that the faces are so ugly? You would have liked them better to be fair faces, such as would grace a drawing-room; and the grave to be dug in prettier ground—under a rose-bush or willow, and in turf set with violets—nothing like a bone visible as one threw the mould out. So, it would have been a sweet piece of convent sentiment.

I am afraid that it is a good deal more like real convent sentiment as it is. Death—confessed for king before his time—asserts, so far as I have seen, some authority over such places; either unperceived, and then the worst, in drowsy unquickening of the soul; or felt and terrible, pouring out his white ashes upon the heart—ashes that burn with cold. If you think what the kind of persons who have strength of conviction enough to give up the world might have done for the world had they *not* given it up; and how the King of Terror must rejoice when he wins for himself another soul that might have gone forth to calm the earth, and folds his wide white wings over it for ever (He also gathering his children together); and how those white sarcophagi, towered and belfried, each with his companies of living dead, gleam still so multitudinous among the mountain pyramids of the fairest countries of the earth—places of silence for their sweet voices; places of binding for their faithfullest hands; places of fading for their mightiest intelligences;—you may, perhaps, feel also that so great wrong cannot be lovely in the near aspect of it; and that if this very day, at evening, we were allowed to see what the last clouds of twilight glow upon in some convent garden of the Appenines, we might leave the place with some such horror as this picture will leave upon us; not all of it noble horror, but in some sort repulsive and ignoble.

It is, for these reasons, to me, a great work. Nevertheless, part of its power is not to the painter's praise. The crude painting is here in a kind of harmony with the expression of discord which was needed. But it is crude —not in momentary compliance with the mood which prompted this wild design, but in apparent consistency of decline from the artist's earlier ways of labour.

Millais' 'Apple Blossoms'

PASS TO his other picture—the 'Spring'[1] and we find the colour not less abrupt, though more vivid. And when we look at this fierce and rigid orchard—this angry blooming (petals, as it were, of japanned brass); and remember the lovely wild roses and flowers scattered on the stream in the 'Ophelia'; there is, I regret to say, no ground for any diminution of the doubt which I expressed two years since respecting the future career of a painter who can fall thus strangely beneath himself.

The power has not yet left him. With all its faults, and they are grievous, this is still mighty painting: nothing else is as strong, or approximately as strong, within these walls. But it is a phenomenon, so far as I know, unparalleled hitherto in art history, that any workman capable of so much should rest content with so little. All former art, by men of any intellect, has been wrought, under whatever limitations of time, as well as the painter could do it; evidently with an effort to reach something beyond what was actually done: if a sketch, the sketch showed a straining towards completion; if a picture, it showed a straining to a higher perfection. But here, we have a careless and insolent indication of things that might be; not the splendid promise of a grand impatience, but the scrabbled remnant of a scornfully abandoned aim.

And this wildness of execution is strangely associated with the distortion of feature which more or less has been sought for by this painter from his earliest youth; just as it was by Martin Schongauer and Mantegna. In the first picture (from Keats' 'Isabella') which attracted public attention, the figure in the foreground writhed in violence of constrained rage; in the picture of the 'Holy Family at Nazareth' the Virgin's features were contorted in sorrow over a wounded hand; violent ugliness of feature spoiled a beautiful arrangement of colour in the 'Return of the Dove', and disturbed a powerful piece of dramatic effect in the 'Escape from the Inquisition'. And in this present picture, the unsightliness of some of the faces, and the preternatural grimness of others, with the fierce colour and angular masses of the flowers above, force upon me a strange impression, which I cannot shake off—that this is an illustration of the song of some modern Dante, who, at the first entrance of an Inferno for English Society, had found carpeted with ghostly grass, a field of penance for young ladies, where girl-blossoms, who had been vainly gay, or treacherously amiable, were condemned to recline in reprobation under red-hot apple blossom, and sip scalding milk out of a poisoned porringer.

[1] Better known as 'Apple Blossoms'

33. MOSS AND WILD STRAWBERRY. Drawing by Ruskin. *Oxford, Ashmolean Museum*

34. THE STONEBREAKER. Painting by J. Brett. *Liverpool, Walker Art Gallery*

35. THE VALE OF REST. Painting by Millais. *London, Tate Gallery*

36. VAL D'AOSTA. Painting by J. Brett. *Berkhamsted, Sir William Cooper*

Brett's 'Val d'Aosta'

'Val d'Aosta' by J. Brett.[1]

YES, HERE we have it at last—some close-coming to it at least—historical landscape, properly so-called—landscape painting with a meaning and a use. We have had hitherto plenty of industry, precision quite unlimited; but all useless, or nearly so, being wasted on scenes of no majesty or enduring interest. Here is, at last, a scene worth painting—painted with all our might (not quite with all our heart, perhaps, but with might of hand and eye). And here, accordingly, for the first time in history, we have, by help of art, the power of visiting a place, reasoning about it, and knowing it, just as if we were there, except only that we cannot stir from our place, nor look behind us. For the rest, standing before this picture is just as good as standing on that spot in Val d'Aosta, so far as gaining of knowledge is concerned; and perhaps in some degree pleasanter, for it would be very hot on that rock to-day, and there would probably be a disagreeable smell of juniper plants growing on the slopes above.

So if any simple-minded, quietly-living person, indisposed towards railroad stations or crowded inns, cares to know in an untroublous and uncostly way what a Piedmontese valley is like in July, there it is for him. Rocks overlaid with velvet and fur to stand on in the first place: if you look close into the velvet you will find it is jewelled and set with stars in a stately way. White poplars by the roadside, shaking silvery in the wind: I regret to say the wind is apt to come up the Val d'Aosta in an ill-tempered and rude manner, turning leaves thus the wrong side out; but it will be over in a moment. Beyond the poplars you may see the slopes of arable and vineyard ground, such as give the wealth and life to Italy which she idly trusts in—ground laid ages ago in wreaths, like new cut hay by the mountain streams, now terraced and trimmed into all gentle service. If you want to know what vines look like under Italian training (far from the best), *that* is the look of them—the dark spots and irregular cavities, seen through the broken green of their square-set ranks, distinguishing them at any distance from the continuous pale fields of low-set staff and leaf, divided by no gaps of gloom, which clothe a true vine country. There, down in the mid-valley, you see what pasture and meadow land we have, we Piedmontese, with our hamlet and cottage life, and groups of glorious wood. Just beyond the rock are two splendid sweet chestnut trees, with forming fruit, good for making bread of, no less than maize; lower down, far to the left, a furlong or two of the main stream with its white shore and alders: not beautiful, for it has come down into all this fair country from the Courmayeur glaciers, and is yet untamed, cold, and furious,

[1] Ill. 36 facing this page.

incapable of rest. But above, there is rest, where the sunshine streams into iridescence through branches of pine, and turns the pastures into strange golden clouds, half grass, half dew; for the shadows of the great hills have kept the dew there since morning. Rest also, calm enough, among the ridges of rock and forest that heap themselves into that purple pyramid high on the right. Look well into the making of it—it is indeed so that a great mountain is built and bears itself, and its forest fringes, and village jewels —for those white spots far up the ravine are villages—and peasant dynasties are hidden among the film of blue. And above all are other more desolate dynasties—the crowns that cannot shake—of jagged rock; they also true and right, even to their finest serration. So it is that the snow lies on those dark diadems for ever. A notable picture truly; a possession of much within a few square feet.

Yet not, in the strong, essential meaning of the word, a noble picture. It has a strange fault, considering the school to which it belongs—it seems to me wholly emotionless. I cannot find from it that the painter loved, or feared, anything in all that wonderful piece of the world. There seems to me no awe of the mountains there—no real love of the chestnuts or the vines. Keenness of eye and fineness of hand as much as you choose; but of emotion, or of intention, nothing traceable. Not but that I believe the painter to be capable of the highest emotion: anyone who can paint thus must have passion within him; but the passion here is assuredly not out of him. He has cared for nothing, except as it was more or less pretty in colour and form. I never saw the mirror so held up to Nature; but it is Mirror's work, not Man's. This absence of sentiment is peculiarly indicated by the feeble anger of the sky. Had it been wholly cloudless—burning down in one calm field of light behind the purple hills, all the rest of the landscape would have been gathered into unity by its repose; and for the sleeping girl we should have feared no other disturbance than the bleating of the favourite of her flock, who has returned to seek her—his companions wandering forgetful. But now she will be comfortlessly waked by hailstorm in another quarter of an hour: and yet there is no majesty in the clouds, nor any grand incumbency of them on the hills; they are but a dash of mist, gusty and disagreeable enough—in no otherwise to be dreaded; highly un-divine clouds—incognizant of Olympus—what have they to do here upon the hill thrones—κορυφαῖς ἱεραῖς χιονοβλήτοισι.

Historical landscape it is, unquestionably; meteorological also; poetical —by no means: yet precious, in its patient way; and, as a wonder of toil and delicate handling, unimpeachable. There is no such subtle and precise work on any other canvas here. The chestnut trees are like a finished design of Dürer's—every leaf a study; the poplar trunks and boughs drawn with an unexampled exquisiteness of texture and curve. And if it does not touch

you at first, stay by it a little; look well at the cottage among the meadows; think of all that this Italian life might be among these sacred hills, and of what Italian life has been, and yet is, in spite of silver crosses on the breast, and how far it is your fault and mine that this is so,—and the picture may be serviceable to you in quite other ways than by pleasing your eyes with purple and gold.

<div align="right">From Academy Notes, 1859, Vol. XIV, p. 209.</div>

The Technique of Painting

. . . The absolutely best, or centrally, and entirely *right* way of painting is as follows:—

A light ground, white, red, yellow or grey, not brown or black. On that an entirely accurate, and firm black outline of the whole picture, in its principal masses. The outline to be exquisitely correct as far it is reaches, but not to include small details; the use of it being to limit the masses of first colour. The ground colours then to be laid firmly, each on its own proper part of the picture, an inlaid work in a mosaic table, meeting each other truly at the edges; as much of each being laid as will get itself into the state which the artist requires it to be in for his second painting, by the time he comes to it. On this first colour, the second colours and subordinate masses laid in due order, now, of course, necessarily without previous outline, and all small detail reserved to the last, the bracelet being not touched, nor indicated in the least, till the arm is finished.*

This is, as far as can be expressed in a few words, the right, or Venetian way of painting; but it is incapable of absolute definition, for it depends on the scale, the material, and the nature of the object represented, *how much* a great painter will do with his first colour; or how many after processes he will use. Very often the first colour, richly blended and worked into, is also the last; sometimes it wants a glaze only to modify it; sometimes an entirely different colour above it. Turner's storm-blues, for instance, were produced by a black ground with opaque blue, mixed with white, struck over it.† The amount of detail given in the first colour will also depend on convenience. For instance, if a jewel *fastens* a fold of dress, a Venetian

* Thus, in the Holy Family of Titian, lately purchased for the National Gallery, the piece of St. Catherine's dress over her shoulders is painted on the underdress, after that was dry. All its value would have been lost, had the slightest tint or trace of it been given previously. This picture I think, and certainly many of Tintoret's, are painted on dark grounds; but this is to save time, and with some loss to the future brightness of the colour.

† In cleaning the 'Hero and Leander', now in the National Collection, these upper glazes were taken off, and only the black ground left. I remember the picture when its distance was of the most exquisite blue. I have no doubt the 'Fire at Sea' has had its distance destroyed in the same manner.

will lay probably a piece of the jewel colour in its place at the time he draws the fold; but if the jewel *falls upon* the dress, he will paint the folds only in the ground colour, and the jewel afterwards. For in the first case his hand must pause, at any rate, where the fold is fastened; so that he may as well mark the colours of the gem; but he would have to check his hand in the sweep with which he drew the drapery, if he painted a jewel that fell upon it with the first colour. So far, however, as he can possibly use the under colour, he will, in whatever he has to superimpose. There is a pretty little instance of such economical work in the painting of the pearls on the breast of the elder princess, in our best Paul Veronese (Family of Darius). The lowest is about the size of a small hazel-nut, and falls on her rose-red dress. Any other but a Venetian would have put a complete piece of white paint over the dress for the whole pearl, and painted into that the colours of the stone. But Veronese knows beforehand that all the dark side of the pearl will reflect the red of the dress. He will not put white over the red, only to put red over the white again. He leaves the actual dress for the dark side of the pearl, and with two small separate touches, one white, another brown, places its high light and shadow. This he does with perfect care and calm; but in two decisive seconds. There is no dash, nor display, nor hurry, nor error. The exactly right thing is done in the exactly right place, and not one atom of colour, nor moment of time spent vainly. Look close at the two touches,—you wonder what they mean. Retire six feet from the picture—the pearl is there!

From *Modern Painters*, Vol. v, Part viii, Ch. iv, ¶ 16, 17, 18.

Dutch Landscape

I SHOULD attach greater importance to this rural feeling [in Dutch landscape] if there were any true humanity in it, or any feeling for beauty. But there is neither. No incidents of this lower life are painted for the sake of the incidents, but only for the effects of light. You will find that the Dutch painters do not care about the people, but about the lustres on them. Paul Potter, their best herd and cattle painter, does not care even for sheep, but only for wool; regards not cows, but cowhide. He attains great dexterity in drawing tufts and locks, lingers in the little parallel ravines and furrows of fleece that open across sheep's backs as they turn; is unsurpassed in twisting a horn or pointing a nose; but he cannot paint eyes, nor perceive any condition of an animal's mind, except its desire of grazing. Cuyp can, indeed, paint sunlight,[1] the best that Holland's sun can show; he is a man of

[1] Ill. 37 facing this page.

37. UBBERGER CASTLE AND LAKE. Painting by Cuyp. *London, National Gallery*

38. THE STRAWBERRY GIRL. Painting by Reynolds. *London, Wallace Collection*

large natural gift, and sees broadly, nay, even seriously; finds out—a wonderful thing for men to find out in those days—that there are reflections in water, and that boats require often to be painted upside down. A brewer by trade, he feels the quiet of a summer afternoon, and his work will make you marvellously drowsy. It is good for nothing else that I know of; strong; but unhelpful and unthoughtful. Nothing happens in his pictures, except some indifferent person asking the way of somebody else, who, by his cast of countenance, seems not likely to know it. For further entertainment perhaps, a red cow and a white one; or puppies at play, not playfully; the man's heart not going even with the puppies. Essentially he sees nothing but the shine on the flaps of their ears.

From *Modern Painters*, Vol. IV, Part IX, Ch. VI, ¶ 12.

Reynolds and Gainsborough

. . . Why did not Sir Joshua—or could not—or would not Sir Joshua—paint Madonnas? neither he, nor his great rival-friend Gainsborough? Both of them painters of women, such as since Giorgione and Correggio had not been; both painters of men, such as had not been since Titian. How is it that these English friends can so brightly paint that particular order of humanity which we call 'gentlemen and ladies', but neither heroes, nor saints, nor angels? Can it be because they were both country-bred boys, and for ever after strangely sensitive to courtliness? Why, Giotto also was a country-bred boy. Allegri's native Correggio, Titian's Cadore, were but hill villages; yet these men painted not the court, nor the drawing-room, but the Earth: and not a little of Heaven besides: while our good Sir Joshua never trusts himself outside the park palings. He could not even have drawn the strawberry girl,[1] unless she had got through a gap in them—or rather, I think, she must have been let in at the porter's lodge, for her strawberries are in a pottle, ready for the ladies at the Hall. Giorgione would have set them, wild and fragrant, among their leaves, in her hand. Between his fairness, and Sir Joshua's May-fairness, there is a strange, impassable limit—as of the white reef that in Pacific isles encircles their inner lakelets, and shuts them from the surf and sound of sea. Clear and calm they rest, reflecting fringed shadows of the palm-trees, and the passing of fretted clouds across their own sweet circle of blue sky. But beyond and round and round their coral bar, lies the blue of sea and heaven together—blue of eternal deep.

¶ You will find it a pregnant question, if you follow it forth, and leading to many others, not trivial, Why it is, that in Sir Joshua's girl, or

[1] Ill. 38 facing this page.

Gainsborough's, we always think first of the Ladyhood; but in Giotto's, of the Womanhood? Why, in Sir Joshua's hero, or Vandyck's, it is always the Prince or the Sir whom we see first; but in Titian's, the man.

Not that Titian's gentlemen are less finished than Sir Joshua's; but their gentlemanliness * is not the principal thing about them; their manhood absorbs, conquers, wears it as a despised thing. Nor—and this is another stern ground of separation—will Titian make a gentleman of every one he paints. He will make him so if he is so, not otherwise; and this not merely in general servitude to truth, but because, in his sympathy with deeper humanity, the courtier is not more interesting to him than anyone else. 'You have learned to dance and fence; you can speak with clearness, and think with precision; your hands are small, your senses acute, and your features well-shaped. Yes: I see all this in you, and will do it justice. You shall stand as none but a well-bred man could stand; and your fingers shall fall on the sword-hilt as no fingers could but those that knew the grasp of it. But for the rest, this grisly fisherman, with rusty cheek and rope-frayed hand, is a man as well as you, and might possibly make several of you, if souls were divisible. His bronze colour is quite as interesting to me, Titian, as your paleness, and his hoary spray of stormy hair takes the light as well as your waving curls. Him also I will paint, with such picturesqueness as he may have; yet not putting the picturesqueness first in him, as in you I have not put the gentlemanliness first. In him I see a strong human creature, contending with all hardship: in you also a human creature, un-contending, and possibly not strong. Contention or strength, weakness or picturesqueness, and all other such accidents in either, shall have due place. But the immortality and miracle of you—this clay that burns, this colour that changes—are in truth the awful things in both: these shall be first painted—and last.'

¶ With which question respecting treatment of character we have to connect also this further one: How is it that the attempts of so great painters as Reynolds and Gainsborough are, beyond portraiture, limited almost like children's? No domestic drama—no history—no noble natural scenes, far less any religious subject:—only market carts; girls with pigs; woodmen going home to supper; watering-places; grey cart-horses in fields, and such like. Reynolds, indeed, once or twice touched higher themes,—'among the chords his fingers laid', and recoiled: wisely; for, strange to say, his very sensibility deserts him when he leaves his courtly quiet. The horror of the

* The reader must observe that I use the word here in a limited sense, as meaning only the effect of careful education, good society, and refined habits of life, on average temper and character. Of deep and true gentlemanliness—based as it is on intense sensibility and sincerity, perfected by courage, and other qualities of race; as well as of that union of insensibility with cunning, which is the essence of vulgarity, I shall have to speak at length in another place. (*Modern Painters*, Vol. v.)

subjects he chose (Cardinal Beaufort and Ugolino) showed inherent apathy: had he felt deeply, he would not have sought for this strongest possible excitement of feeling,—would not willingly have dwelt on the worst conditions of despair—the despair of the ignoble. His religious subjects are conceived even with less care than these. Beautiful as it is, this Holy Family by which we stand has neither dignity nor sacredness, other than those which attach to every group of gentle mother and ruddy babe; while his Faiths, Charities, or other well-ordered and emblem-fitted virtues, are even less lovely than his ordinary portraits of women.

It was a faultful temper, which, having so mighty a power of realization at command, never became so much interested in any fact of human history as to spend one touch of heartfelt skill upon it;—which, yielding momentarily to indolent imagination, ended, at best, in a Puck, or a Thais; a Mercury as Thief, or a Cupid as Linkboy. How wide the interval between this gently trivial humour, guided by the wave of a feather, or arrested by the enchantment of a smile,—and the habitual dwelling of the thoughts of the great Greeks and Florentines among the beings and the interests of the eternal world!

¶ In some degree it may indeed be true that the modesty and sense of the English painters are the causes of their simple practice. All that they did, they did well, and attempted nothing over which conquest was doubtful. They knew they could paint men and women: it did not follow that they could paint angels. Their own gifts never appeared to them so great as to call for serious question as to the use to be made of them. 'They could mix colours and catch likeness—yes; but were they therefore able to teach religion, or reform the world? To support themselves honourably, pass the hours of life happily, please their friends, and leave no enemies, was not this all that duty could require, or prudence recommend? Their own art was, it seemed, difficult enough to employ all their genius: was it reasonable to hope also to be poets or theologians? Such men had, indeed, existed; but the age of miracles and prophets was long past; nor, because they could seize the trick of an expression, or the turn of a head, had they any right to think themselves able to conceive heroes with Homer, or gods with Michael Angelo.'

¶ Such was, in the main, their feeling: wise, modest, unenvious, and unambitious. Meaner men, their contemporaries or successors, raved of high art with incoherent passion; arrogated to themselves an equality with the masters of elder time, and declaimed against the degenerate tastes of a public which acknowledged not the return of the Heraclidæ. But the two great—the two only painters of their age—happy in a reputation founded as deeply in the heart as in the judgment of mankind, demanded no higher function than that of soothing the domestic affections; and achieved for

themselves at last an immortality not the less noble, because in their life-time they had concerned themselves less to claim it than to bestow.

¶ Yet, while we acknowledge the discretion and simple-heartedness of these men, honouring them for both: and the more when we compare their tranquil powers with the hot egotism and hollow ambition of their inferiors: we have to remember, on the other hand, that the measure they thus set to their aims was, if a just, yet a narrow one; that amiable discretion is not the highest virtue, nor to please the frivolous, the best success. There is probably some strange weakness in the painter, and some fatal error in the age, when in thinking over the examples of their greatest work, for some type of culminating loveliness or veracity, we remember no expression either of religion or heroism, and instead of reverently naming a Madonna di San Sisto, can only whisper, modestly, 'Mrs Pelham feeding chickens'.

From *Sir Joshua and Holbein*, Vol. XIX, p. 3.

Domestic Art

ADDRESSING ourselves . . . to discern the inner impulse and temper of our modern art, I would say that its first characteristic is its Compassion-ateness—its various human sympathy even warping it away from its own proper sources of power, and turning the muse of painting into a sister of Charity. And this is especially shown in the importance which subjects exhibiting the life of the humbler classes have assumed, and by the delicate treatment of these. For in older art poverty was only studied for its pic-turesqueness—now it is tenderly watched for its mental character; of old we painted only the rags of the poor—but now, their distress. For indeed, though there never was a period in which that distress was more wantonly and widely inflicted by carelessness, there also never was a period in which it was so faithfully and brotherly pitied and helped, when it is truly dis-cerned. The sentence which Eugène Sue takes for his text in the *Mysteries of Paris*—'Si les Riches savaient'—is indeed the key to all our error and cruelty—'If the Rich only knew'. . . .

¶ Then the second characteristic is Domesticity. All previous art contemplated men in their public aspect, and expressed only their public Thought. But our art paints their home aspect, and reveals their home thoughts. Old art waited reverently in the Forum. Ours plays happily in the Nursery; we may call it briefly—conclusively—Art of the Nest. It does not in the least appeal for appreciation to the proud civic multitude, re-joicing in procession and assembly. It appeals only to Papa and Mama and Nurse. And these not being in general severe judges, painters must be

DERBY DAY. Detail of the painting by W. P. Frith. *London, Tate Gallery*

[See publisher's note, p. 6.]

content if a great deal of the work produced for their approbation should be ratified by their's only.

¶ Connected with this Domestic character is the third, I am sorry to say now no more quite laudable, attribute of modern work—its shallowness. A great part of the virtue of Home is actually dependent on Narrowness of thought. To be quite comfortable in your nest, you must not care too much about what is going on outside. You must be deeply interested in little things, and greatly enjoy moderate things; that is all very bright and right on one side of it, but the morals of home, like its prettiest tapestry, have a wrong side as well as a right, and when we simply transfer that phrase of home morality to art morality, and say that this art of the nest 'is deeply interested in little things and greatly enjoys moderate things', we seem to have turned our wrong side outwards. And thus while the pictures of the Middle Ages are full of intellectual matter and meaning—schools of philosophy and theology, and solemn exponents of the faiths and fears of earnest religion—we may pass furlongs of exhibition wall without receiving any idea or sentiment, other than that home-made ginger is hot in the mouth, and that it is pleasant to be out on the lawn in fine weather.

¶ But farther—and worse. As there is in the spirit of domesticity always a sanctified littleness, there may be also a sanctified selfishness, and a very fearful one. A man will openly do an injustice for his family's sake which he would never have done for his own; and the womanly tenderness, meant by Heaven to comfort the stranger and cherish the desolate, may, in totally unconscious selfishness, passionately exhaust itself in the sweet servilities and delicious anxieties of home. To every great error there is as great an opposite error, and the fault of modesty and simplicity which is blind to every duty but that of the family, and to every need but that of the native land, has been fatally reversed by the ascetic or missionary enthusiasm which fills the convent quiet with useless virtue, and slakes the desert sands with noble blood.

But between these there is a state of disciplined citizenship, in which the household, beloved in solemn secrecy of faithfulness, is nevertheless subjected always in thought and act to the deeper duty rendered to the larger home of the State. This ideal of citizenship has been always approached in states capable either of great art or wise legislation. From this ideal we have grievously fallen; we have retracted our consciences and affections wholly under the shadow of the roof, and losing the tenure and edified strength of national fellowship, have rounded our interests into petty spheres that clash together like the dissolute pebbles of the beach. To such a nation no policy is possible but one determined by chance, and no art possible but that of petty purposes and broken designs.

¶ Then the next characteristic of modern art, sequent partly upon this privacy and partly on the extent of recent discovery, is its eccentricity. As we live much by ourselves, so we form strong personal characters and prejudices, and these are farther modified by the variety of circumstance induced by modern adventure and invention, while the difficulty of consistent teaching multiplies with our multitudes, and the sense of every word we utter is lost in the hubbub of voices. Hence we have of late learned the little we could, each of us by our own weary gleaning or collision with contingent teachers, none of whom we recognize as wise, or listen to with any honest reverence. If we like what they say, we adopt it and overact it; if we dislike, we refuse and contradict it. And therefore our art is a chaos of small personal powers and preferences, of originality corrupted by isolation or of borrowed merit appropriated by autograph of private folly. It is full of impertinent insistence upon contrary aims and competitive display of diverse dexterities, most of them ignorant, all of them partial, pitifully excellent, and deplorably admirable.

¶ And the last of which I would speak, and most fatal, in some of its consequences, of all habits of modern art, is its desire of dramatic excitement. . . .

¶ Observe, first, one of the chief ways in which the great masters keep their Dramatic subordinate to their Constant art was by suggesting the action in a quaint and unliteral manner; not as it ever could have actually happened, but as the sign of its having happened, or rather of something greater having happened. Take this sketch of Holbein's, for instance.[1] I cannot show you a grander piece of ideal art. It is not meant here that the angel is striking, or the demon struggling, or the little soul pulling at the scales in any physical manner. All three actions are in some degree purposefully impossible and false to show that they are ideal and symbolical actions, meaning a very different thing from common striking and common weighing. Now there is nothing more beautiful than this kind of reserve as practised by the great men; but an evil consequence followed from it —that people got out of the habit of thinking at all how things did take place or could really have taken place, and, by accepting symbols of drama for true drama, gradually came to regard the truths of human history and religion as if they were all symbolisms. And besides that, a quantity of utterly vile and vapid art followed in imitation of the great school in which the drama was false from real want of understanding or invention and not from reserve. And against this false and decayed school rose up the modern English school of true and literal drama. Turner's picture of Apollo killing the Python, as opposed to the treatment of the same subject on Greek vases, is the first great example of it that I know; but the founder and leader

[1] Holbein's drawing of St. Michael in the Bâle Museum.

of the school, in its more important relations to Christian art, was Dante Gabriel Rossetti. He was the first who set the example of a living dramatic truth in conceptions of events in sacred history. We will not any more, said he and his followers, think of Christ and the Madonna as they never could have been seen by human eyes. We will not make the figures of them mere illuminated letters for the better glorifying of our own sentiments. We will think of them to the utmost of our power as they were truly seen on the earth—as they lived and moved and suffered. We may think erroneously, but at least we will think honestly and earnestly, and paint what seems to us likeliest to have been the fact.

¶ Together with Rossetti, and at first working wholly under his guidance, but differing from him entirely in certain conditions of temperament, and especially in having purer sympathy for the repose of the Constant schools, rose up another, I do not fear to say, great dramatic master— Edward Burne-Jones. He did not begin art early enough in boyhood; and therefore, in spite of all his power and genius, his pictures were at first full of very visible faults, which he is gradually conquering. In spite of what still remain of these, his designs bid fair to be quite dominant in the English dramatic school; and already, in those qualities which are most desirable and inimitable, may challenge comparison with the best dramatic design of the great periods, and in its purity and seeking for good and virtue as the life of all things and creatures, his designs stand, I think unrivalled and alone. . . .

From *On the Present State of Modern Art*, 1867, Vol. XIX, p. 197.

Serenity in Art

. . . Tintoret entirely conceives his figures as solid statues: sees them in his mind on every side; detaches each from the other by imagined air and light; and foreshortens, interposes, or involves them as if they were pieces of clay in his hand. On the contrary, Michael Angelo conceives his sculpture partly as if it were painted; and using his pen like a chisel, uses also his chisel like a pencil; is sometimes as picturesque as Rembrandt, and sometimes as soft as Correggio. . . .

¶ Let me at once point out to you that [the calmness of the art of Giovanni Bellini] is the attribute of the entirely highest class of art; the introduction of strong or violently emotional incident is at once a confession of inferiority.

Those are the two first attributes of the best art. Faultless workmanship, and perfect serenity; a continuous, not momentary, action,—or entire inaction. You are to be interested in the living creatures; not in what is happening to them.

Then the third attribute of the best art is that it compels you to think of the spirit of the creature, and therefore of its face, more than of its body.

And the fourth is that in the face you shall be led to see only beauty or joy;—never vileness, vice, or pain.

Those are the four essentials of the greatest art. I repeat them, they are easily learned.

1. Faultless and permanent workmanship.
2. Serenity in state or action.
3. The Face principal, not the body.
4. And the Face free from either vice or pain.

¶ It is not possible, of course, always literally to observe the second condition, that there shall be quiet action or none; but Bellini's treatment of violence in action you may see exemplified in a notable way in his St. Peter Martyr.[1] The soldier is indeed striking the sword down into his breast; but in the face of the Saint is only resignation, and faintness of death, not pain—that of the executioner is impassive; and, while a painter of the later schools would have covered breast and sword with blood, Bellini allows no stain of it; but pleases himself by the most elaborate and exquisite painting of a soft crimson feather in the executioner's helmet.

¶ Now the changes brought about by Michael Angelo—and permitted, or persisted in calamitously, by Tintoret—are in the four points these:

1st. Bad workmanship.

The greater part of all that these two men did is hastily and incompletely done; and all that they did on a large scale in colour is in the best qualities of it perished.

2nd. Violence of transitional action.

The figures flying—falling—striking—or biting. Scenes of Judgment,—battle,—martyrdom,—massacre; anything that is in the acme of instantaneous interest and violent gesture. They cannot any more trust their public to care for anything but that.

3rd. Physical instead of mental interest. The body, and its anatomy, made the entire subject of interest: the face, shadowed, as in the Duke Lorenzo,* unfinished, as in the Twilight, or entirely foreshortened, back-shortened, and despised, among labyrinths of limbs, and mountains of sides and shoulders.

4th. Evil chosen rather than good. On the face itself, instead of joy or virtue, at the best, sadness, probably pride, often sensuality, and always, by

[1] Ill. 39 facing this page.

* Julian, rather. See Mr. Tyrwhitt's notice of the lately discovered error, in his *Lectures on Christian Art.*

39. THE DEATH OF PETER MARTYR. Detail from the painting by Giovanni Bellini
London, National Gallery

40. Detail from THE LAST JUDGEMENT. Fresco by Michelangelo
Vatican, Sistine Chapel

preference, vice or agony as the subject of thought. In the Last Judgment of Michael Angelo,[1] and the Last Judgment of Tintoret, it is the wrath of the Dies Iræ, not its justice, in which they delight; and their only passionate thought of the coming of Christ in the clouds, is that all kindreds of the earth shall wail because of Him.

Those are the four great changes wrought by Michael Angelo. I repeat them:

Ill work for good.
Tumult for Peace.
The Flesh of Man for his Spirit.
And the Curse of God for His Blessing.

¶ Hitherto, I have massed, necessarily, but most unjustly, Michael Angelo and Tintoret together, because of their common relation to the art of others. I shall now proceed to distinguish the qualities of their own. And first as to the general temper of the two men.

Nearly every existing work by Michael Angelo is an attempt to execute something beyond his power, coupled with a fevered desire that his power may be acknowledged. He is always matching himself either against the Greeks whom he cannot rival, or against rivals whom he cannot forget. He is proud, yet not proud enough to be at peace; melancholy, yet not deeply enough to be raised above petty pain; and strong beyond all his companion workmen, yet never strong enough to command his temper, or limit his aims.

Tintoret, on the contrary, works in the consciousness of supreme strength, which cannot be wounded by neglect, and is only to be thwarted by time and space. He knows precisely all that art can accomplish under given conditions; determines absolutely how much of what can be done he will himself for the moment choose to do; and fulfils his purpose with as much ease as if, through his human body, were working the great forces of nature. Not that he is ever satisfied with what he has done, as vulgar and feeble artists are satisfied. He falls short of his ideal, more than any other man; but not more than is necessary; and is content to fall short of it to that degree, as he is content that his figures, however well painted, do not move nor speak. He is also entirely unconcerned respecting the satisfaction of the public. He neither cares to display his strength to them, nor convey his ideas to them; when he finishes his work, it is because he is in the humour to do so; and the sketch which a meaner painter would have left incomplete to show how cleverly it was begun, Tintoret simply leaves because he has done as much of it as he likes.

¶ Both Raphael and Michael Angelo are thus, in the most vital of all points, separate from the great Venetian. They are always in dramatic

[1] Ill. 40 facing this page.

attitudes, and always appealing to the public for praise. They are the leading athletes in the gymnasium of the arts, and the crowd of the circus cannot take its eyes away from them; while the Venetian walks or rests with the simplicity of a wild animal; is scarcely noticed in his occasionally swifter motion; when he springs, it is to please himself; and so calmly, that no one thinks of estimating the distance covered.

I do not praise him wholly in this. I praise him only for the well-founded pride, infinitely nobler than Michael Angelo's. You do not hear of Tintoret's putting any one into hell because they had found fault with his work. Tintoret would as soon have thought of putting a dog into hell for laying his paws on it. But he is to be blamed in this—that he thinks as little of the pleasure of the public, as of their opinion. A great painter's business is to do what the public ask of him, in the way that shall be helpful and instructive to them. His relation to them is exactly that of a tutor to a child; he is not to defer to their judgment, but he is carefully to form it;—not to consult their pleasure for his own sake, but to consult it much for theirs. It was scarcely, however, possible that this should be the case between Tintoret and his Venetians; he could not paint for the people, and in some respects he was happily protected by his subordination to the Senate. Raphael and Michael Angelo lived in a world of court intrigue, in which it was impossible to escape petty irritation, or refuse themselves the pleasure of mean victory. But Tintoret and Titian, even at the height of their reputation, practically lived as craftsmen in their workshops, and sent in samples of their wares, not to be praised or cavilled at, but to be either taken or refused. . . .

¶ And now I shall take the four conditions of change in succession, and examine the distinctions between the two masters, in their acceptance of, or resistance to, them.

1. The change of good and permanent workmanship for bad and insecure workmanship.

You have often heard quoted the saying of Michael Angelo, that oil-painting was only fit for women and children.

He said so, simply because he had neither the skill to lay a single touch of good oil-painting, nor the patience to overcome even its elementary difficulties.

And it is one of my reasons for the choice of subject in this concluding lecture on Sculpture, that I may, with direct reference to this much quoted saying of Michael Angelo, make the positive statement to you, that oil-painting is the Art of arts;* that it is sculpture, drawing, and music all in one, involving the technical dexterities of those three several arts; that is to say—the decision and strength of the stroke of the chisel;—the balanced

* I beg that this statement may be observed with attention. It is of great importance, as in opposition to the views usually held respecting the grave schools of painting.

distribution of appliance of that force necessary for graduation in light and shade;—and the passionate felicity of rightly multiplied actions, all unerring, which on an instrument produce right sound, and on canvas, living colour. There is no other human skill so great or so wonderful as the skill of fine oil-painting; and there is no other art whose results are so absolutely permanent. Music is gone as soon as produced—marble discolours,—fresco fades,—glass darkens or decomposes—painting alone, well guarded, is practically everlasting.

Of this splendid art Michael Angelo understood nothing; he understood even fresco, imperfectly. Tintoret understood both perfectly; but he —when no one would pay for his colours (and sometimes nobody would even give him space of wall to paint on)—used cheap blue for ultramarine; and he worked so rapidly, and on such huge spaces of canvas, that between damp and dry, his colours must go, for the most part; but any complete oil-painting of his stands as well as one of Bellini's own: while Michael Angelo's fresco is defaced already in every part of it, and Leonardo's oil-painting is all either gone black, or gone to nothing.

2. Introduction of dramatic interest for the sake of excitement. I have already, in the *Stones of Venice*, illustrated Tintoret's dramatic power at so great length, that I will not, to-day, make any farther statement to justify my assertion that it is as much beyond Michael Angelo's as Shakespeare's is beyond Milton's—and somewhat with the same kind of difference in manner. Neither can I speak to-day, time not permitting me, of the abuse of their dramatic power by Venetian or Florentine; one thing only I beg you to note, that with full half of his strength, Tintoret remains faithful to the serenity of the past; and the examples I have given you from his work in S. 50,[1] are, one, of the most splendid drama, and the other, of the quietest portraiture ever attained by the arts of the Middle Ages.

Note also this respecting his picture of the Judgment, that, in spite of all the violence and wildness of the imagined scene, Tintoret has not given, so far as I remember, the spectacle of any one soul under infliction of actual pain. In all previous representations of the Last Judgment there had at least been one division of the picture set apart for the representation of torment; and even the gentle Angelico shrinks from no orthodox detail in this respect; but Tintoret, too vivid and true in imagination to be able to endure the common thoughts of hell, represents indeed the wicked in ruin, but not in agony. They are swept down by flood and whirlwind—the place of

[1] The 'Paradise', version in the Prado no. 398 [compare Ill. 42 facing page 127] and the 'Two Senators' in the Accademia at Venice [Ill. 41 facing page 126]. The reference is made to the photographs that Ruskin made available to his students. About the original sketch of 'Paradise' by Tintoretto (Louvre) and the large workshop painting in the Ducal Palace, Venice see H. Tietze *Tintoretto*, p. 365-6.

them shall know them no more, but not one is seen in more than the natural pain of swift and irrevocable death.

3. I pass to the third condition; the priority of flesh to spirit, and of the body to the face.

In this alone, of the four innovations, Michael Angelo and Tintoret have the Greeks with them;—in this, alone, have they any right to be called classical. The Greeks gave them no excuse for bad workmanship; none for temporary passion; none for the preference of pain. Only in the honour done to the body may be alleged for them the authority of the ancients.

You remember, I hope, how often in my preceding lectures I had to insist on the fact that Greek sculpture was essentially ἀπρόσωπος; independent, not only of the expression, but even of the beauty of the face. Nay, independent of its being so much as seen. The greater number of the finest pieces of it which remain for us to judge by, have had the heads broken away;—we do not seriously miss them either from the Three Fates, the Ilissus, or the Torso of the Vatican. The face of the Theseus is so far destroyed by time that you can form little conception of its former aspect. But it is otherwise in Christian sculpture. Strike the head off even the rudest statue in the porch of Chartres and you will greatly miss it—the harm would be still worse to Donatello's St. George:—and if you take the heads from a statue of Mino, or a painting of Angelico—very little but drapery will be left;—drapery made redundant in quantity and rigid in fold, that it may conceal the forms, and give a proud or ascetic reserve to the actions, of the bodily frame. Bellini and his school, indeed, rejected at once the false theory, and the easy mannerism, of such religious design; and painted the body without fear or reserve, as, in its subordination, honourable and lovely. But the inner heart and fire of it are by them always first thought of, and no action is given to it merely to show its beauty. Whereas the great culminating masters, and chiefly of these, Tintoret, Correggio, and Michael Angelo, delight in the body for its own sake, and cast it into every conceivable attitude, often in violation of all natural probability, that they may exhibit the action of its skeleton, and the contours of its flesh. The movement of a hand with Cima or Bellini expresses mental emotion only; but the clustering and twining of the fingers of Correggio's St. Catherine is enjoyed by the painter just in the same way as he would enjoy the twining of the branches of a graceful plant, and he compels them into intricacies which have little or no relation to St. Catherine's mind. In the two drawings of Correggio it is the rounding of limbs and softness of foot resting on cloud which are principally thought of in the form of the Madonna; and the countenance of St. John is foreshortened into a section, that full prominence may be given to the muscles of his arms and breast.

So in Tintoret's drawing of the Graces, he has entirely neglected the individual character of the Goddesses, and been content to indicate it merely by attributes of dice or flower, so only that he may sufficiently display varieties of contour in thigh and shoulder.

¶ Thus far, then, the Greeks, Correggio, Michael Angelo, Raphael in his latter design, and Tintoret in his scenic design (as opposed to portraiture), are at one. But the Greeks, Correggio, and Tintoret, are also together in this farther point; that they all draw the body for true delight in it, and with knowledge of it living; while Michael Angelo and Raphael draw the body for vanity, and from knowledge of it dead.

The Venus of Melos,—Correggio's Venus (with Mercury teaching Cupid to read)—and Tintoret's Graces, have the forms which their designers truly *liked* to see in women. They may have been wrong or right in liking those forms, but they carved and painted them for their pleasure, not for vanity.

But the form of Michael Angelo's Night is not one which he delighted to see in women. He gave it her, because he thought it was fine, and that he would be admired for reaching so lofty an ideal.*

¶ Again. The Greeks, Correggio, and Tintoret, learn the body from the living body, and delight in its breath, colour, and motion.†

Raphael and Michael Angelo learned it essentially from the corpse, and had no delight in it whatever, but great pride in showing that they knew all its mechanisms; they therefore sacrifice its colours, and insist on its muscles, and surrender the breath and fire of it, for what is—not merely carnal,—but osseous, knowing that for one person who can recognize the loveliness of a look, or the purity of a colour, there are a hundred who can calculate the length of a bone.

The boy with the doves, in Raphael's cartoon of the Beautiful Gate of the Temple, is not a child running, but a surgical diagram of a child in a running posture.

Farther, when the Greeks, Correggio, and Tintoret, draw the body active, it is because they rejoice in its force, and when they draw it inactive, it is because they rejoice in its repose. But Michael Angelo and Raphael invent for it ingenious mechanical motion, because they think it uninteresting when it is quiet, and cannot, in their pictures, endure any person's being simple-minded enough to stand upon both his legs at once, nor venture to imagine any one's being clear enough in his language to make himself intelligible without pointing.

* He had, indeed, other and more solemn thoughts of the Night than Correggio; and these he tried to express by distorting form, and making her partly Medusa-like. In this lecture I am only dwelling on points hitherto unnoticed of dangerous evil in the too much admired master.

† Tintoret dissected, and used clay models, in the true academical manner, and produced academical results thereby; but all his fine work is done from life, like that of the Greeks.

In all these conditions, the Greek and Venetian treatment of the body is faithful, modest, and natural; but Michael Angelo's dishonest, insolent, and artificial.

¶ But between him and Tintoret there is a separation deeper than all these, when we examine their treatment of the face. Michael Angelo's vanity of surgical science rendered it impossible for him ever to treat the body as well as the Greeks treated it; but it left him wholly at liberty to treat the face as ill; and he did: and in some respects very curiously worse.

The Greeks had, in all their work, one type of face for beautiful and honourable persons; and another, much contrary to it, for dishonourable ones; and they were continually setting these in opposition. Their type of beauty lay chiefly in the undisturbed peace and simplicity of all contours; in full roundness of chin; in perfect formation of the lips, showing neither pride nor care; and, most of all, in a straight and firm line from the brow to the end of the nose.

The Greek type of dishonourable persons, especially satyrs, fauns, and sensual powers, consisted in irregular excrescence and decrement of features, especially in flatness of the upper part of the nose, and projection of the end of it into a blunt knob.

By the most grotesque fatality, as if the personal bodily injury he had himself received had passed with a sickly echo into his mind also, Michael Angelo is always dwelling on this satyric form of countenance;—sometimes violently caricatures it, but never can help drawing it; and all the best profiles in this collection at Oxford have what Mr. Robinson calls a 'nez retroussé'; but what is, in reality, the nose of the Greek Bacchic mask, treated as a dignified feature.

But it is one of the chief misfortunes affecting Michael Angelo's reputation, that his ostentatious display of strength and science has a natural attraction for comparatively weak and pedantic persons. And this sheet of Vasari's 'teste divine' contains, in fact, not a single drawing of high quality—only one of moderate agreeableness, and two caricatured heads, one of a satyr with hair like the fur of animals, and one of a monstrous and sensual face, such as could only have occurred to the sculptor in a fatigued dream. . . .

¶ Returning, however, to the divine heads above it, I wish you to note 'the most conspicuous and important of all', a study for one of the Genii behind the Sibylla Libyca. This Genius, like the young woman of a majestic character, and the man with his mouth open, wears a cap, or turban; opposite to him in the sheet, is a female in profile, 'wearing a hood of massive drapery'. And, when once your attention is directed to this point, you will perhaps be surprised to find how many of Michael Angelo's figures, intended to be sublime, have their heads bandaged. If you have

been a student of Michael Angelo chiefly, you may easily have vitiated your taste to the extent of thinking that this is a dignified costume; but if you study Greek work, instead, you will find that nothing is more important in the system of it than a finished disposition of the hair, and as soon as you acquaint yourself with the execution of carved marbles generally, you will perceive these massy fillets to be merely a cheap means of getting over a difficulty too great for Michael Angelo's patience, and too exigent for his invention. They are not sublime arrangements, but economies of labour, and reliefs from the necessity of design; and if you had proposed to the sculptor of the Venus of Melos, or of the Jupiter of Olympia, to bind the ambrosial locks up in towels, you would most likely have been instantly bound, yourself; and sent to the nearest temple of Æsculapius.

I need not, surely, tell you,—I need only remind,—how in all these points, the Venetians and Correggio reverse Michael Angelo's evil, and vanquish him in good; how they refuse caricature, rejoice in beauty, and thirst for opportunity of toil. The waves of hair in a single figure of Tintoret's (the Mary Magdalen of the Paradise) contain more intellectual design in themselves alone than all the folds of unseemly linen in the Sistine chapel put together.

¶ In the fourth and last place, as Tintoret does not sacrifice, except as he is forced by the exigences of display, the face for the body, so also he does not sacrifice happiness for pain. The chief reason why we all know the 'Last Judgment' of Michael Angelo, and not the 'Paradise' of Tintoret,[1] is the same love of sensation which makes us read the *Inferno* of Dante, and not his *Paradise*; and the choice, believe me, is our fault, not his; some farther evil influence is due to the fact that Michael Angelo has invested all his figures with picturesque and palpable elements of effect, while Tintoret has only made them lovely in themselves and has been content that they should deserve, not demand, your attention.

¶ You are accustomed to think the figures of Michael Angelo sublime—because they are dark, and colossal, and involved, and mysterious—because, in a word, they look sometimes like shadows, and sometimes like mountains, and sometimes like spectres, but never like human beings. Believe me, yet once more, in what I told you long since—man can invent nothing nobler than humanity. He cannot raise his form into anything better than God made it, by giving it either the flight of birds or strength of beasts, by enveloping it in mist, or heaping it into multitude. Your pilgrim must look like a pilgrim in a straw hat, or you will not make him into one with cockle and nimbus; an angel must look like an angel on the ground, as well as in the air; and the much-denounced pre-Raphaelite faith that a saint cannot look saintly unless he has thin legs, is not more

[1] Ill. 42 facing page 127.

absurd than Michael Angelo's that a Sibyl cannot look Sibylline unless she has thick ones.

¶ All that shadowing, storming, and coiling of his, when you look into it, is mere stage decoration, and that of a vulgar kind. Light is, in reality, more awful than darkness—modesty more majestic than strength; and there is truer sublimity in the sweet joy of a child, or the sweet virtue of a maiden, than in the strength of Antæus, or thunder-clouds of Ætna.

Now, though in nearly all his greater pictures, Tintoret is entirely carried away by his sympathy with Michael Angelo, and conquers him in his own field;—outflies him in motion, outnumbers him in multitude, outwits him in fancy, and outflames him in rage,—he can be just as gentle as he is strong: and that Paradise, though it is the largest picture in the world, without any question, is also the thoughtfullest, and most precious.

The Thoughtfullest!—it would be saying but little, as far as Michael Angelo is concerned.

¶ For consider of it yourselves. You have heard, from your youth up (and all educated persons have heard for three centuries), of this Last Judgment of his, as the most sublime picture in existence. . . .

¶ . . . Tell me, whether you yourselves, or any one you have known, did ever at any time receive from this picture any, the smallest vital thought, warning, quickening, or help? It may have appalled, or impressed you for a time, as a thunder-cloud might: but has it ever taught you anything—chastised in you anything—confirmed a purpose—fortified a resistance—purified a passion? I know that, for you, it has done none of these things; and I know also that, for others, it has done very different things. In every vain and proud designer who has since lived, that dark carnality of Michael Angelo's has fostered insolent science, and fleshly imagination. Daubers and blockheads think themselves painters, and are received by the public as such, if they know how to foreshorten bones and decipher entrails; and men with capacity of art either shrink away (the best of them always do) into petty felicities and innocencies of genre painting—landscapes, cattle, family breakfasts, village schoolings, and the like; or else, if they have the full sensuous art-faculty that would have made true painters of them, being taught, from their youth up, to look for and learn the body insteady of the spirit, have learned it, and taught it to such purpose, that at this hour, when I speak to you, the rooms of the Royal Academy of England, receiving also what of best can be sent there by the masters of France, contain *not one* picture honourable to the arts of their age; and contain many which are shameful in their record of its manners.

¶ . . . I will close to-day giving you some brief account of the scheme of Tintoret's Paradise, in justification of my assertion that it is the thoughtfullest as well as mightiest picture in the world.

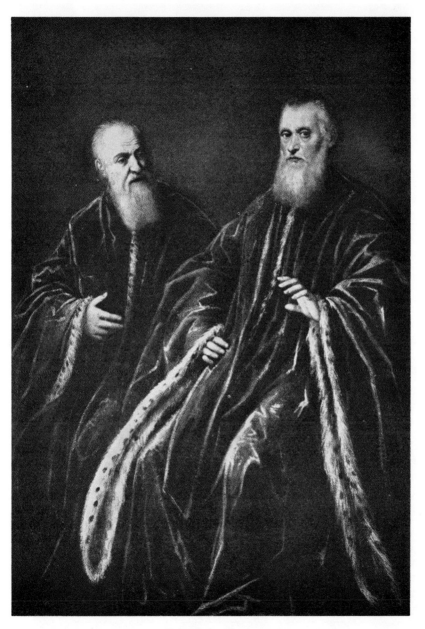

41. TWO SENATORS. Painting by Tintoretto. *Venice, Accademia*

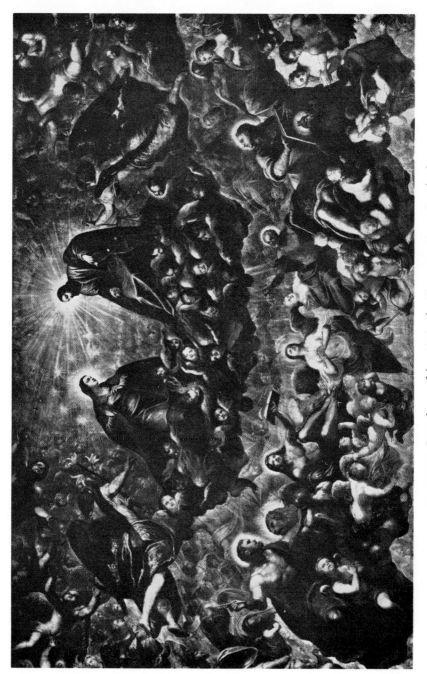

42. PARADISE. Central part of the painting by Tintoretto. *Venice, Ducal Palace*

In the highest centre is Christ, leaning on the globe of the earth, which is of dark crystal. Christ is crowned with a glory as of the sun, and all the picture is lighted by that glory, descending through circle beneath circle of cloud, and of flying or throned spirits.

The Madonna, beneath Christ, and at some interval from Him, kneels to Him. She is crowned with the Seven stars, and kneels on a cloud of angels, whose wings change into ruby fire, where they are near her.

The three great Archangels, meeting from three sides, fly towards Christ. Michael delivers up his scales and sword. He is followed by the Thrones and Principalities of the Earth; so inscribed—Throni—Principatus. The Spirits of the Thrones bear scales in their hands; and of the Princedoms, shining globes: beneath the wings of the last of these are the four great teachers and lawgivers, St. Ambrose, St. Jerome, St. Gregory, St. Augustine, and behind St. Augustine stands his mother, watching him, her chief joy in Paradise.

Under the Thrones, are set the Apostles, St. Paul separated a little from the rest, and put lowest, yet principal; under St. Paul, is St. Christopher, bearing a massive globe, with a cross upon it; but to mark him as the Christ-bearer, since here in Paradise he cannot have the Child on his shoulders, Tintoret has thrown on the globe a flashing stellar reflection of the sun round the head of Christ.

All this side of the picture is kept in glowing colour,—the four Doctors of the Church have golden mitres and mantles; except the Cardinal, St. Jerome, who is in burning scarlet, his naked breast glowing, warm with noble life,—the darker red of his robe relieved against a white glory.

¶ Opposite to Michael, Gabriel flies towards the Madonna, having in his hand the Annunciation lily, large, and triple-blossomed. Above him, and above Michael, equally, extends a cloud of white angels, inscribed 'Serafini'; but the group following Gabriel, and corresponding to the Throni follow-ing Michael, is inscribed 'Cherubini'. Under these are the great prophets, and singers and foretellers of the happiness or of the sorrow of time. David, and Solomon, and Isaiah, and Amos of the herdsmen. David has a colossal golden psaltery laid horizontally across his knees;—two angels behind him dictate to him as he sings, looking up towards Christ; but one strong angel sweeps down to Solomon from among the cherubs, and opens a book, resting it on the head of Solomon, who looks down earnestly unconscious of it;—to the left of David, separate from the group of prophets, as Paul from the apostles, is Moses, dark-robed; in the full light, withdrawn far behind him, Abraham, embracing Isaac with his left arm, and near him, pale St. Agnes. In front, nearer, dark and colossal, stands the glorious figure of Santa Giustina of Padua; then a little subordinate to her, St. Catherine, and, far on the left, and high, St. Barbara leaning on her tower.

In front, nearer, flies Raphael; and under him is the four-square group of the Evangelists. Beneath them, on the left, Noah; on the right, Adam and Eve, both floating unsupported by cloud or angel; Noah buoyed by the Ark, which he holds above him, and it is *this* into which Solomon gazes down, so earnestly. Eve's face is, perhaps, the most beautiful ever painted by Tintoret—full in light, but dark-eyed. Adam floats beside her, his figure fading into a winged gloom, edged in the outline of fig-leaves. Far down, under these, central in the lowest part of the picture, rises the Angel of the Sea, praying for Venice; for Tintoret conceives his Paradise as existing now, not as in the future. I at first mistook this soft Angel of the Sea for the Magdalen, for he is sustained by other three angels on either side, as the Magdalen is, in designs of earlier time, because of the verse, 'There is joy in the presence of the angels over one sinner that repenteth'. But the Magdalen is on the right, behind St. Monica; and on the same side, but lowest of all, Rachel, among the angels of her children, gathered now again to her for ever.

¶ I have no hesitation in asserting this picture to be by far the most precious work of art of any kind whatsoever, now existing in the world; and it is, I believe, on the eve of final destruction; for it is said that the angle of the great council-chamber is soon to be rebuilt;[1] and that process will involve the destruction of the picture by removal, and, far more, by repainting. I had thought of making some effort to save it by an appeal in London to persons generally interested in the arts; but the recent desolation of Paris has familiarized us with destruction, and I have no doubt the answer to me would be, that Venice must take care of her own. But remember, at least, that I have borne witness to you to-day of the treasures that we forget, while we amuse ourselves with the poor toys, and the petty or vile arts, of our time.

The years of that time have perhaps come, when we are to be taught to look no more to the dreams of painters, either for knowledge of Judgment, or of Paradise. The anger of Heaven will not longer, I think, be mocked for our amusement; and perhaps its love may not always be despised by our pride. Believe me, all the arts, and all the treasures of men, are fulfilled and preserved to them only, so far as they have chosen first, with their hearts, not the curse of God, but His blessing. Our Earth is now encumbered with ruin, our Heaven is clouded by Death. May we not wisely judge ourselves in some things now, instead of amusing ourselves with the painting of judgments to come?

From *The Relation between Michael Angelo and Tintoret*, Vol. XXII, p. 77.

[1] The picture on canvas was removed from the wall with little damage.

Christian Faithful and Classic

THE 1300 SCHOOL [of Italian art] is specially sensitive, the 1400 specially demonstrative; but they had other characters than these, and I wish you always in future to think of them in their wholeness as Christian Faithful and Christian Classic. The first—awaking, as Adam in that sculpture of Giotto, the first on the base of his tower—awaking to the sight of heaven and God; the second, accepting and writing down the certain laws of both —certain, enduring, inevitable—in all arts and acts of men. To the school of Perception—that which depends on its instinctive sight and sense— belongs necessarily the foundational discovery of the existence and true nature of things; while to the demonstrative, instructive, or mathematic school belongs the comparison, discipline, arrangement, and correction of impressions received by the senses. I call the former school 'Christian Faithful', because faith—the evidence of things not seen—is the highest æsthetic. 'We walk by Faith, not by sight' means 'we walk by spiritual sight, not bodily.' I call the second school 'Christian Classic' as that which ascertains what is right, and determines it, by law. . . .

From *The Schools of Art in Florence*, Vol, XXIII, p. 232.

Christian Romantic

THE THIRD school, on the examination of which we enter to-day, formed by the galaxy of perfect painters, who wrought centrally in the Sistine Chapel, and belonging to this epoch of 1500, you . . . may best remember as the Christian Romantic group. Thus:

> 1300. Christian Faithful.
> 1400. Christian Classic.
> 1500. Christian Romantic.

But in calling this third school so, I don't mean that Faith and Knowledge together necessarily issue in Romance, but that the progress of mind in other directions had rendered it necessary that the junction of faith with knowledge should take a Romantic form; and by Romantic I mean the pure state of imagination dependent on Chivalry.

¶ The perfect Christian schools of art are the junction of faith with knowledge under the political state of Chivalry. (Perfect Christianity is the Christianity of Sir Philip Sidney and George Herbert, not of John Knox or Calvin.) The intense worship of womanhood expresses itself in the central power of the Madonna; its soldierly courage in the central

power of St. Michael and St. George; and its grace and courtesy and happiness in making the brightness of all intellect gentle, and the pride of all decoration holy. It unites all the delights of the enlightened eyes, all the severities of the determining intellect, and all the passions of the pure and burning heart. . . .

¶ Pure Christianity in this chivalric period divided itself practically into two great collateral powers—domestic and monastic;—the virtue of the Home and of the Desert.

The Virtue, I say—not ignorant, I, to my sorrow, of the histories which delight in recording the vices of Christians, or the hypocrisy of those who were not Christian. But we have nothing to do with the vices of the Home or the Desert, with treachery in the household or sensuality in the cloister. The Home which was violated by hatred, the monastery which was seclusion of sin, do not come under our judgment, for they bring nothing to be judged. It is the chief privilege of the study of Christian art that we know in an instant where the deed is, there the truth was; no false lover ever painted beauty, no false monk, divinity. I mean, therefore, by domestic and monastic only the power of true love, and true sacrifice of love, when that was needful. And these two glories of Christianity were, as I told you, understood to the full together only by one man—Giotto; while, taught always by him—his children in the school of chivalry—the two unmatched masters in painting of the romantic Christianity, Angelico and Botticelli, taught to Florence, one the happiness of Heaven, and the other the Holiness of Earth. . . .

¶ . . . Faithfullest of the faithful, [Angelico] is the painter of the felicities of heaven, down to the least things. Before him Simon Memmi had given the gate of Paradise with the children entering it hand in hand; [1] it was for Angelico to make them enter *celestemente ballando, per la porta del Paradiso*.[2] But the notablest literal fulfilment of joy in him is that all nature becomes transfigured into the colours of blossoming for him. You know for these twenty years back I have been teaching the sacredness of colour—that a rose or a violet is not less divine than its leaves, but more divine. Well, to Angelico all nature becomes literally *couleur de rose*; so that architecture itself, trees, ground, all become rainbow-coloured to him. The joy of his heart makes it like a crystal cut in the faith of the Trinity, and making all heaven's light seven-zoned.

¶ All the true monastic painters delight in like manner in the most splendid dress, and the most worldly flesh painters of the body habitually sneer at them for trying to make fine, say they, what they cannot make lovely. But the instinct is an entirely noble and right one; only you must distinguish always between the men who only want to show they can

[1] In the Spanish Chapel. [2] Vasari.

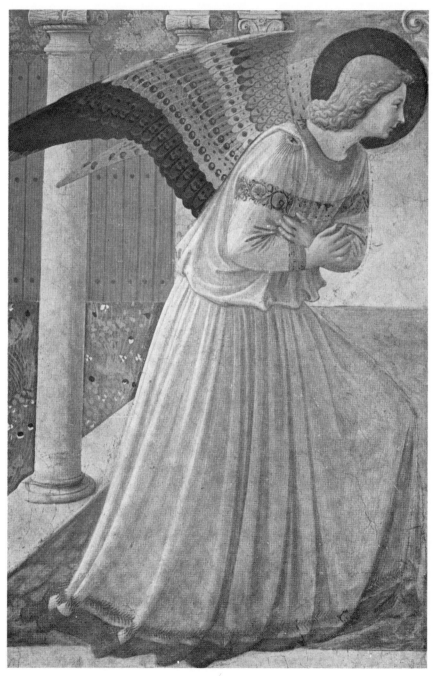

ANGEL. Detail from 'The Annunciation' by Fra Angelico. *Florence, San Marco*

[See publisher's note, p. 6.]

paint jewels, and those who rejoice in the real beauty of the jewel. The Dutchmen, even in their sacred schools, always lose themselves in showing their skill, even the stupendously perfect work of Van Eyck is definitely more jewel and metal than humanity; the lower men paint gems on their saints, and dewdrops on their flowers, merely to show you how well they can cheat. . . .

¶ But if you want really to see what jewel painting for love is, nay for divine love, you must do as I bid you at Florence. You will all, when there, give an hour or two at least to the Academy of Fine Arts. You may learn much more there than you can in the Uffizii. On your right hand, just after you enter the first room, you will see the large Taking down from the Cross, by Angelico, No. 34, of which you are told in this catalogue, 'l'auteur a exécuté avec tant de soin ce tableau, qu'on peut le considérer comme son chef d'œuvre'.

Now that picture has been entirely repainted, and so horribly that I should think no more ridiculous, more glaring, or detestable piece of work could be found in the most impudent dealer's hands of London or Florence. But the two little figures at the border of it are still genuine, and by looking alternately from them to the repainted centre you may learn, once for all, what repainting means, and something of what Angelico's hand is.

¶ Having examined and compared these portions, leave that room, and ask for the Gallery of the Old Pictures, and nearly at the farther end of that you will see, on your right, No. 20, a picture very sad and dingy at first glance, and in great part rubbed quite out. It is nevertheless the most precious Angelico in Florence, and, as far as I know, in the world. It represents Our Lady enthroned, with the infant Christ.[1] St. Cosmo and Damian kneel before the throne. On the Madonna's left hand, St. Dominic, St. Francis, and St. Peter Martyr; on her right, St. Mark, St. John the Evangelist, and St. Lawrence—in the guide-book called St. Stephen, though his name is written on the nimbus.

The picture has been wrought by Angelico with the most extreme care I have ever seen him give. He has intended it to be his masterpiece. And Angelico differs from nearly all other great painters in this, that he can't be too careful. The more he endeavours, the more he achieves. All his work prospers in his hands.

St. Lawrence is dressed in the following manner. He has a rose-coloured tunic studded with golden stars, each star centred by a turquoise. On his breast is a large square scroll of gold, with an arabesque of pearls upon it, and his sleeves are embroidered with silver.[2]

Now I said in the second volume of *Modern Painters* [3] that Angelico

[1] Ill. 43 facing page 132. [2] Ill. 27 facing page 79.
[3] Ruskin equated the Etruscan tradition in Italian mediaeval art with the school of Fesole.

did not paint real jewels but only abstract ornaments. I was utterly wrong. It is true that in his ordinary work he does a great deal with mere engraving in the gold in lines and dots, and with spots of colour. But here we have him doing his best; and every turquoise and pearl is painted to a point beyond everything else in art. Chinese, Indian, American, old Spanish, Venetian, German, what you will,—no gold and pearls were ever designed or done in the world like these. Van Eyck, Memling, Mantegna, even Botticelli, are nowhere in comparison.

¶ Now what is the meaning of this? It is the old Etruscan faculty— Fésole faculty—of jewellery, with Christian passion in it. Every pearl is painted as if he had sold all that he had to buy it; but what do you think the result will be on St. Lawrence? A very fine St. Lawrence you think perhaps he will be, and nothing else. Yes; in the hands of any other painter that would have been so. In his pearly affluence St. Lawrence would only have reminded you of the principal dish at the Princess Parizade's dinner —cucumbers stuffed with pearls. With Angelico it is the exact reverse. By the entirely passionate and perfect painting of them the jewels become divine; they become worthy of the saint in their own supreme perfectness; their beauty is so great that it becomes beauty of holiness; and instead of feeling as if they disguised St. Lawrence, you feel as if he could have been dressed no otherwise, nay, had I not told you to look at his breastplate of pearl, you never would have looked at it. Quercia withdraws all ornament from the statue of Ilaria that you may see her face; but Angelico pours out every earthly treasure around his St. Lawrence, and forces you to look only at the face still—the highest visible expression of religious life yet, as far as I know, achieved by man.

From *The Schools of Art in Florence*, Vol. XXIII p. 249.

Colourists, Delineators and Chiaroscurists

ALL GREAT artists may be classified under three heads—Colourists, Delineators, Chiaroscurists; that is to say, they all possess one of these three qualities pre-eminently, though they possess all three in a greater or lesser degree, the greatest artists having almost as much of the other two qualities as of their pre-eminent one. Of Chiaroscurists, the chief is Tintoret. He learned of painters only, Titian and Giorgione. He had the pencil or the brush in his hand from his youth; his favourite colours were black and white; he painted with a broad brush. There is no chiaroscuro like Tintoret's; but under it is colour as subtle as Angelico's, though subordinate. Of Colourists, the chief is Angelico. He learned to paint by writing; he was taught by a Dominican illuminator, and is himself the chief illuminator of

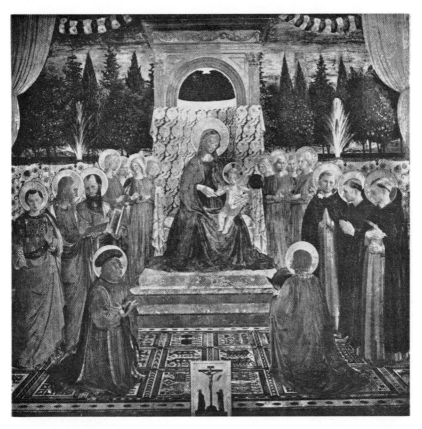

43. THE VIRGIN ENTHRONED. Painting by Fra Angelico. *Florence, Museo di S. Marco*

44. ST. MICHAEL. Detail from the painting 'The Virgin Enthroned' by Botticelli
Florence, Uffizi

the world. There is no colour like Angelico's; but under it is chiaroscuro as subtle as Tintoret's, though subordinate. His jewel painting was not enough leaned on; a single amethyst in the robe of the Madonna would have taken me half a day to copy, in the gradations of its transparently flushed purple. Of Delineators, the chief is Botticelli. Taught by a goldsmith, he learnt by gold-beating and engraving, and is himself a master goldsmith and engraver. Ghirlandajo is a goldsmith selling plated goods; Botticelli's is pure gold tried in the fire, and engraved as Bezaleel and Aholiab engraved. There is no drawing like Botticelli's; but under it is colour and chiaroscuro as subtle as Angelico's and Tintoret's, but subordinate. He draws first with the point of the brush; but, like all masters who begin with the point, he soon gets a wonderful power with the side of it, and we find leaves drawn by Botticelli with a single stroke,—the point of the brush beginning, and the brush opening out as it goes. Angelico entered a convent at twenty, painting and living only for the poor, and called 'Beatus'. Botticelli lived amidst the concourse of Florence, admiring all earthly beauty, himself untainted by it. He is in one the most learned theologian, the most perfect artist, and the most kind gentleman whom Florence produced. He knows all that Dante knew of theology, and much more; and he is the only unerring, unfearing, and to this day trustworthy and true preacher of the reformed doctrine of the Church of Christ. As an artist he is incomparable. He has the power of Tintoret, with the virtue of Angelico; and he is such a gentleman that he interprets all things with charity in days of grievous guilt, spends himself and all he has in the passionate service of men and of God, and dies in Florence, having given not half but all his goods to the poor—engraving the triumph of the faith of Savonarola.

Botticelli

Now you know I told you . . . that Angelico and Botticelli represented the monastic and domestic life. Angelico is a perfect monk. At twenty, in the prime of youth, he takes the monk's habit, the Dominican vows, in this monastery of Fésole. His own name Guido he changes to John; all who know him call him 'blessed'; all that he received for his painting he gives to the poor.

Botticelli is perfect in the life of the nobly natural world. . . . He is the only painter of all the religious schools who unites every bodily with every spiritual power and knowledge. He only can delight in every earthly and material beauty and enforce every material law without the least taint passing over him. He only is the interpreter in all things of the mission of the Baptist, to whom the temple of his Etruscan home was built—as

Angelico in the repose of Fésole, so he among the concourse of men in the square of Florence, when the Precursor had guided their feet into the way of peace, and for the first time in the history of nations, in the midst of a world of war, Florence then raised her lily standard in the name of the peace of God; not the narrow Irene of Athens, peace only within her own walls, and prosperity in her own palaces, but peace published with eager foot upon the distant hills, and with shout of the good tidings in the street of strangers. . . .

I NEVER attempt to describe things now, but only to make you look at them and feel them. The St. Michael of Botticelli is . . . a simple knight of Florence, standing before the Madonna, and there is no dragon beneath him, and no look of victory in his face. St. Catherine stands opposite him, and in the sweet coronal of holy creatures, you cannot think of her pain any more than of St. Michael's war; you know her by her look, not by her jagged wheel. Her veil falls over it, and St. Michael seems entirely without trophy. Only at last you see that he holds a globe in his hand, the globe of the world, and on its surface the dark seas take the cloudy shape of the dragon. He is the St. Michael of Peace, who stilleth the noise of the crowd and the tumult of the people, who maketh wars to cease in all the world.

¶ The picture in which you will find this St. Michael is one of two in the Academy of Florence, by the greatest of all her masters at his greatest time, and alike in pure manual skill and pure mental passion, they are beyond all other work in Italy. Of manual skill especially nothing unites so much as a crowning of the Madonna, the favourite Florentine subject. She is surrounded by a choir of twelve angels, not dancing, nor flying, but carried literally in a whorl, or vortex, whirlwind of the breath of heaven; their wings lie level, interwoven among the clouds, pale sky of intense light, yet darker than the white clouds they pass through, their arms stretched to each other, their hands clasped—it is as if the morning sky had all been changed into marble, and they into living creatures; they are led in their swift wheel by Gabriel, who is opposite to you, between the Christ and the Madonna; a close rain of golden rays falls from the hand of Christ, He placing the crown on the Virgin's head; and Gabriel is seen through it as a white bird through rain, looking up, seeing the fulfilment of his message. And as I told you that all the delight of Angelico in material things became sacred in its intensity, so the material workmanship of this greater master becomes sacred in its completion. Of this falling golden rain he has burnished every separate ray into enduring perfectness; it is not gilding, but beaten gold, wrought with the inherited Etruscan skill of a thousand years, and able to stand for a thousand years to come.

¹ Ill. 44 facing page 133.

¶ Now observe what he had to do in this way. The main figures are the size of life. The surrounding choir of angels—about one-third the size of life—and the Gabriel is diminished by perspective on the farther side, so that his face is only about two inches wide. Well, across his face, between you and him, fall eight or ten straight bars of this golden rain like the base of a helmet visor. Right down across the face, every edge of them as fine and true as a line of gossamer, but you think the face will be spoiled. It is as perfect as if no line crossed it; you see it as through a veil, tender, infinite in rejoicing, lifted in a light of the spirit brighter than gold.

I never saw such a thing. Fancy what command of his materials, what unstinted care and time, what knowledge of all possibilities of change are involved in doing such a piece of work to stand for four hundred years without one sparkle failing.

From *The Schools of Art in Florence*, Vol. XXIII, p. 185.

The Academy

BEFORE looking at any single picture, let us understand the scope and character of the Exhibition as a whole. The Royal Academy of England, in its annual publication, is now nothing more than a large coloured *Illustrated Times* folded in saloons,—the splendidest May number of the *Graphic*, shall we call it? That is to say, it is a certain quantity of pleasant, but imperfect, 'illustration' of passing events, mixed with as much gossip of the past, and tattle of the future, as may be probably agreeable to a populace supremely ignorant of the one, and reckless of the other.

Supremely ignorant, I say;—ignorant, that is, on the lofty ground of their supremacy in useless knowledge.

For instance: the actual facts which Shakespeare knew about Rome were, in number and accuracy, compared to those which M. Alma-Tadema knows, as the pictures of a child's first story-book compared to Smith's *Dictionary of Antiquities*.

But when Shakespeare wrote—

'The noble sister of Publicola,
The Moon of Rome; chaste as the icicle
That's curdled by the frost from purest snow,
And hangs on Dian's temple'—

he knew Rome herself, to the heart; and M. Tadema, after reading his Smith's *Dictionary* through from A to Z, knows nothing of her but her shadow; and that, cast at sunset.

Yet observe, in saying that Academy work is now nothing more, virtually, than cheap coloured woodcut, I do not mean to depreciate the talent employed in it. Our public press is supported by an ingenuity and skill in rapid art unrivalled at any period of history; nor have I ever been so humbled, or astonished, by the mightiest work of Tintoret, Turner, or Velasquez, as I was, one afternoon last year, in watching, in the Dudley Gallery, two ordinary workmen for a daily newspaper finishing their drawings on the blocks by gaslight, against time.

Nay, not in skill only, but in pretty sentiment, our press illustration, in its higher ranks, far surpasses—or indeed, in that department finds no rivalship in—the schools of classical art; and it happens curiously that the only drawing of which the memory remains with me as a possession, out of the Old Water-Colour Exhibition of this year—Mrs. Allingham's 'Young Customers'—should be, not only by an accomplished designer of woodcut, but itself the illustration of a popular story. The drawing, with whatever temporary purpose executed, is for ever lovely; a thing which I believe Gainsborough would have given one of his own pictures for,— old-fashioned as red-tipped daises are—and more precious than rubies.

And I am conscious of, and deeply regret, the inevitable warp which my own lately exclusive training under the elder schools gives to my estimate of this current art of the day; and submissively bear the blame due to my sullen refusal of what good is offered me in the railroad station, because I cannot find in it what I found in the Ducal Palace. And I may be permitted to say this much, in the outset, in apology for myself, that I determined on writing this number of *Academy Notes* simply because I was so much delighted with Mr. Leslie's School, Mr. Leighton's Little Fatima, Mr. Hook's Hearts of Oak, and Mr. Couldery's Kittens, that I thought I should be able to write an entirely good-humoured, and therefore, in all likelihood, practically useful, sketch of the socially pleasant qualities of modern English painting, which were not enough acknowledged in my former essays.

As I set myself to the work, and examined more important pictures, my humour changed, though much against my will. Not more reluctantly the son of Beor found his utterances become benedictory, than I mine— the reverse. But the need of speaking, if not the service (for too often we can help least where need is most), is assuredly greater than if I could have spoken smooth things without ruffling anywhere the calm of praise.

Popular or classic, temporary or eternal, all good art is more or less didactic. My artist adversaries rage at me for saying so; but the gayest of them cannot help being momentarily grave, nor the emptiest-headed occasionally instructive: and whatever work any of them do that is indeed honourable to themselves, is also intellectually helpful, no less than enter-

taining, to others. And it will be the surest way of estimating the intrinsic value of the art of this year, if we proceed to examine it in the several provinces which its didactic functions occupy; and collect the sum of its teaching on the subjects—which will, I think, sufficiently embrace its efforts in every kind—of Theology, History, Biography, Natural History, Landscape, and as the end of all, Policy.[1]

<div align="right">From Academy Notes, 1875, Vol. XIV, p. 261.</div>

English Art

. . . Within certain limits I believe [the efforts to improve the designs of our manufactures] may indeed take effect: so that we may no more humour momentary fashions by ugly results of chance instead of design; and may produce both good tissues, of harmonious colours, and good forms and substance of pottery and glass. But we shall never excel in decorative design. Such design is usually produced by people of great natural powers of mind, who have no variety of subjects to employ themselves on, no oppressive anxieties, and are in circumstances either of natural scenery or of daily life, which cause pleasurable excitement. *We* cannot design, because we have too much to think of, and we think of it too anxiously. It has long been observed how little real anxiety exists in the minds of the partly savage races which excel in decorative art; and we must not suppose that the temper of the Middle Ages was a troubled one, because every day brought its danger or its change. The very eventfulness of the life rendered it careless, as generally is still the case with soldiers and sailors. Now, when there are great powers of thought, and little to think of, all the waste energy and fancy are thrown into the manual work, and you have so much intellect as would direct the affairs of a large mercantile concern for a day, spent all at once, quite unconsciously, in drawing an ingenious spiral.

Also, powers of doing fine ornamental work are only to be reached by a perpetual discipline of the hand as well as of the fancy; discipline as attentive and painful as that which a juggler has to put himself through, to overcome the more palpable difficulties of his profession. The execution of the best artists is always a splendid tour-de-force; and much that in painting is supposed to be dependent on material is indeed only a lovely and quite inimitable legerdemain. Now, when powers of fancy, stimulated by this triumphant precision of manual dexterity, descend uninterruptedly from generation to generation, you have at last, what is not so much a

[1]Ruskin continues criticising individual pictures classified under these headings.

trained artist, as a new species of animal, with whose instinctive gifts you have no chance of contending. And thus all our imitations of other people's work are futile. We must learn first to make honest English wares, and afterwards to decorate them as may please the then approving Graces.

¶ Secondly—and this is an incapacity of a graver kind, yet having its own good in it also—we shall never be successful in the highest fields of ideal or theological art.

For there is one strange, but quite essential, character in us—ever since the Conquest, if not earlier—a delight in the forms of burlesque which are connected in some degree with the foulness of evil. I think the most perfect type of a true English mind in its best possible temper, is that of Chaucer; and you will find that, while it is for the most part full of thoughts of beauty, pure and wild like that of an April morning, there are, even in the midst of this, sometimes momentarily jesting passages which stoop to play with evil—while the power of listening to and enjoying the jesting of entirely gross persons, whatever the feeling may be which permits it, afterwards degenerates into forms of humour which render some of quite the greatest, wisest, and most moral of English writers now almost useless for our youth. And yet you will find that whenever Englishmen are wholly without this instinct, their genius is comparatively weak and restricted.

¶ Now, the first necessity for the doing of any great work in ideal art, is the looking upon all foulness with horror, as a contemptible though dreadful enemy. You may easily understand what I mean, by comparing the feelings with which Dante regards any form of obscenity or of base jest, with the temper in which the same things are regarded by Shakespeare. And this strange earthly instinct of ours, coupled as it is, in our good men, with great simplicity and common sense, renders them shrewd and perfect observers and delineators of actual nature, low or high; but precludes them from that speciality of art which is properly called sublime. If ever we try anything in the manner of Michael Angelo or of Dante, we catch a fall, even in literature, as Milton in the battle of the angels, spoiled from Hesiod; while in art, every attempt in this style has hitherto been the sign either of the presumptuous egotism of persons who had never really learned to be workmen, or it has been connected with very tragic forms of the contemplation of death,—it has always been partly insane, and never once wholly successful.

But we need not feel any discomfort in these limitations of our capacity. We can do much that others cannot, and more than we have ever yet ourselves completely done. Our first great gift is in the portraiture of living people—a power already so accomplished in both Reynolds and Gainsborough that nothing is left for future masters but to add the calm of perfect workmanship to their vigour and felicity of perception. And of

what value a true school of portraiture may become in the future, when worthy men will desire only to be known, and others will not fear to know them, for what they truly were, we cannot from any past records of art influence yet conceive. But in my next address it will be partly my endeavour to show you how much more useful, because more humble, the labour of great masters might have been, had they been content to bear record of the souls that were dwelling with them on earth, instead of striving to give a deceptive glory to those they dreamed of in heaven.

¶ Secondly, we have an intense power of invention and expression in domestic drama (King Lear and Hamlet being essentially domestic in their strongest motives of interest). There is a tendency at this moment towards a noble development of our art in this direction, checked by many adverse conditions, which may be summed in one,—the insufficiency of generous civic or patriotic passion in the heart of the English people; a fault which makes its domestic affection selfish, contracted, and, therefore, frivolous.

¶ Thirdly, in connection with our simplicity and good-humour, and partly with that very love of the grotesque which debases our ideal, we have a sympathy with the lower animals which is peculiarly our own; and which, though it has already found some exquisite expression in the works of Bewick and Landseer, is yet quite undeveloped. This sympathy, with the aid of our now authoritative science of physiology, and in association with our British love of adventure, will, I hope, enable us to give to the future inhabitants of the globe an almost perfect record of the present forms of animal life upon it, of which many are on the point of being extinguished.

Lastly, and not the least important of our special powers, I have to note our skill in landscape. . . .

From *Inaugural Lecture as Slade Professor of Fine Art at Oxford*, 1870, Vol. XX, p. 17.

Art and Religion

. . . Suppose it be admitted that by enclosing ground with walls, and performing certain ceremonies there habitually, some kind of sanctity is indeed secured within that space,—still the question remains open whether it be advisable for religious purposes to decorate the enclosure. For separation the mere walls would be enough. What is the purpose of your decoration?

Let us take an instance—the most noble with which I am acquainted, the Cathedral of Chartres. You have there the most splendid coloured glass, and the richest sculpture, and the grandest proportions of building, united

to produce a sensation of pleasure and awe. We profess that this is to honour the Deity; or, in other words, that it is pleasing to Him that we should delight our eyes with blue and golden colours, and solemnize our spirits by the sight of large stones laid one on another, and ingeniously carved.

¶ I do not think it can be doubted that it *is* pleasing to Him when we do this; for He has Himself prepared for us, nearly every morning and evening, windows painted with Divine art, in blue and gold and vermilion: windows lighted from within by the lustre of that heaven which we may assume, at least with more certainty than any consecrated ground, to be one of His dwelling-places. Again, in every mountain side, and cliff of rude sea shore, He has heaped stones one upon another of greater magnitude than those of Chartres Cathedral, and sculptured them with floral ornament,— surely not less sacred because living?

¶ Must it not then be only because we love our own work better than His, that we respect the lucent glass, but not the lucent clouds; that we weave embroidered robes with ingenious fingers, and make bright the gilded vaults we have beautifully ordained—while yet we have not considered the heavens, the work of His fingers, nor the stars of the strange vault which He has ordained? And do we dream that by carving fonts and lifting pillars in His honour, who cuts the way of the rivers among the rocks, and at whose reproof the pillars of the earth are astonished, we shall obtain pardon for the dishonour done to the hills and streams by which He has appointed our dwelling-place;—for the infection of their sweet air with poison;—for the burning up of their tender grass and flowers with fire, and for spreading such a shame of mixed luxury and misery over our native land, as if we laboured only that, at least here in England, we might be able to give the lie to the song, whether of the Cherubim above, or Church beneath—'Holy, holy, Lord God of all creatures; Heaven—*and Earth*—are full of Thy glory'?

From *Second Oxford Lecture. The Relation of Art to Religion*, 1870, Vol. xx, p. 45.

Colour

NOW, THE course of our main colour schools is briefly this: First we have . . . *line*; then *spaces* filled with pure colour; and then *masses* expressed or rounded with pure colour. And during these two stages the masters of colour delight in the purest tints, and endeavour as far as possible to rival those of opals and flowers. In saying 'the purest tints', I do not mean the simplest types of red, blue, and yellow, but the most pure tints obtainable by their combinations.

¶ You remember I told you,[1] when the colourists painted masses or projecting spaces, they, aiming always at colour, perceived from the first and held to the last the fact that shadows, though of course darker than the lights with reference to which they *are* shadows, are not therefore necessarily less vigorous colours, but perhaps more vigorous. Some of the most beautiful blues and purples in nature, for instance, are those of mountains in shadow against amber sky; and the darkness of the hollow in the centre of a wild rose is one glow of orange fire, owing to the quantity of its yellow stamens. Well, the Venetians always saw this, and all great colourists see it, and are thus separated from the non-colourists or schools of mere chiaroscuro, not by difference in style merely, but by being right while the others are wrong. It is an absolute fact that shadows are as much colours as lights are; and whoever represents them by merely the subdued or darkened tint of the light, represents them falsely. I particularly want you to observe that this is no matter of taste, but fact. If you are especially sober-minded, you may indeed choose sober colours where Venetians would have chosen gay ones; that is a matter of taste; you may think it proper for a hero to wear a dress without patterns on it, rather than an embroidered one; that is similarly a matter of taste: but, though you may also think it would be dignified for a hero's limbs to be all black, or brown, on the shaded side of them, yet, if you are using colour at all, you cannot so have him to your mind, except by falsehood; he never, under any circumstances, could be entirely black or brown on one side of him.

¶ In this, then, the Venetians are separate from other schools by rightness, and they are so to their last days. Venetian painting is in this matter always right. But also, in their early days, the colourists are separated from other schools by their contentment with tranquil cheerfulness of light; their never wanting to be dazzled. None of their lights are flashing or blinding; they are soft, winning, precious; lights of pearl, not of lime: only, you know, on this condition they cannot have sunshine: their day is the day of Paradise; they need no candle, neither light of the sun, in their cities; and everything is seen clear, as through crystal, far or near.

This holds to the end of the fifteenth century. Then they begin to see that this, beautiful as it may be, is still a make-believe light; that we do not live in the inside of a pearl; but in an atmosphere through which a burning sun shines thwartedly, and over which a sorrowful night must far prevail. And then the chiaroscurists succeed in persuading them of the fact that there is a mystery in the day as in the night, and show them how constantly to see truly, is to see dimly. And also they teach them the brilliancy of light, and the degree in which it is raised from the darkness; and instead of their sweet and pearly peace, tempt them to look for the strength of flame

[1] ¶ 139, Lecture VI, Vol. xx, p. 127.

and coruscation of lightning, and flash of sunshine on armour and on points of spears.

¶ The noble painters take the lesson nobly, alike for gloom or flame. Titian with deliberate strength, Tintoret with stormy passion, read it, side by side. Titian deepens the hues of his Assumption, as of his Entombment, into a solemn twilight; Tintoret involves his earth in coils of volcanic cloud, and withdraws, through circle flaming above circle, the distant light of Paradise. Both of them, becoming naturalist and human, add the veracity of Holbein's intense portraiture to the glow and dignity they had themselves inherited from the Masters of Peace: at the same moment another, as strong as they, and in pure felicity of art-faculty, even greater than they, but trained in a lower school,—Velasquez,—produced the miracles of colour and shadow-painting, which made Reynolds say of him, 'What we all do with labour, he does with ease'; and one more, Correggio, uniting the sensual element of the Greek schools with their gloom, and their light with their beauty, and all these with the Lombardic colour, became, as since I think it has been admitted without question, the captain of the painter's art as such. Other men have nobler or more numerous gifts, but as a painter, master of the art of laying colour so as to be lovely, Correggio is alone.

¶ I said the noble men learned their lesson nobly. The base men also, and necessarily, learn it basely. The great men rise from colour to sunlight. The base ones fall from colour to candlelight. To-day, 'non ragioniam di lor', but let us see what this great change which perfects the art of painting mainly consists in, and means. For though we are only at present speaking of technical matters, every one of them, I can scarcely too often repeat, is the outcome and sign of a mental character, and you can only understand the folds of the veil, by those of the form it veils.

¶ The complete painters, we find, have brought dimness and mystery into their method of colouring. That means that the world all round them has resolved to dream, or to believe, no more; but to know, and to see. And instantly all knowledge and sight are given, no more as in the Gothic times, through a window of glass, brightly, but as through a telescope-glass, darkly. Your cathedral window shut you from the true sky, and illumined you with a vision; your telescope leads you to the sky, but darkens its light, and reveals nebula beyond nebula, far and farther, and to no conceivable farthest—unresolvable. That is what the mystery means.

¶ Next, what does that Greek opposition of black and white mean?

In the sweet crystalline time of colour, the painters, whether on glass or canvas, employed intricate patterns, in order to mingle hues beautifully with each other, and make one perfect melody of them all. But in the great naturalist school, they like their patterns to come in the Greek way, dashed dark on light,—gleaming light out of dark. That means also that the world

round them has again returned to the Greek conviction, that all nature, especially human nature, is not entirely melodious nor luminous; but a barred and broken thing: that saints have their foibles, sinners their forces; that the most luminous virtue is often only a flash, and the blackest-looking fault is sometimes only a stain: and, without confusing in the least black with white, they can forgive, or even take delight in things that are like the νεβρίς, dappled.

¶ You have then—first, mystery. Secondly, opposition of dark and light. Then, lastly, whatever truth of form the dark and light can show.

That is to say, truth altogether, and resignation to it, and quiet resolve to make the best of it. And therefore portraiture of living men, women, and children,—no more of saints, cherubs, or demons. So here I have brought for your standards of perfect art, a little maiden of the Strozzi family, with her dog, by Titian; and a little princess of the house of Savoy, by Vandyke; and Charles the Fifth by Titian; and a queen, by Velasquez; and an English girl in a brocaded gown, by Reynolds; and an English physician in his plain coat, and wig, by Reynolds: and if you do not like them, I cannot help myself, for I can find nothing better for you.

¶ Better?—I must pause at the word. Nothing stronger, certainly nor so strong. Nothing so wonderful, so inimitable, so keen in unprejudiced and unbiassed sight.

Yet better, perhaps, the sight that was guided by a sacred will; the power that could be taught to weaker hands; the work that was faultless, though not inimitable, bright with felicity of heart, and consummate in a disciplined and companionable skill. . . . I have ventured to call the æra of painting represented by John Bellini, the time 'of the Masters'. Truly they deserved the name, who did nothing but what was lovely, and taught only what was right. These mightier, who succeeded them, crowned, but closed, the dynasties of art, and since their day, painting has never flourished more.

¶ There were many reasons for this, without fault of theirs. They were exponents, in the first place, of the change in all men's minds from civil and religious to merely domestic passion; the love of their gods and their country had contracted itself now into that of their domestic circle, which was little more than the halo of themselves. You will see the reflection of this change in painting at once by comparing the two Madonnas (John Bellini's, and Raphael's, called 'della Seggiola'). Bellini's Madonna cares for all creatures through her child; Raphael's, for her child only.

Again, the world round these painters had become sad and proud, instead of happy and humble;—its domestic peace was darkened by irreligion, its national action fevered by pride. And for sign of its Love, the Hymen, whose statue this fair English girl, according to Reynolds's thought, has to decorate, is blind, and holds a coronet.

Again, in the splendid power of realization, which these greatest of artists had reached, there was the latent possibility of amusement by deception, and of excitement by sensualism. And Dutch trickeries of base resemblance, and French fancies of insidious beauty, soon occupied the eyes of the populace of Europe, too restless and wretched now to care for the sweet earth-berries and Madonna's ivy of Cima, and too ignoble to perceive Titian's colour, or Correggio's shade.

¶ Enough sources of evil were here, in the temper and power of the consummate art. In its practical methods there was another, the fatallest of all. These great artists brought with them mystery, despondency, domesticity, sensuality: of all these, good came, as well as evil. One thing more they brought, of which nothing but evil ever comes, or can come—LIBERTY.

By the discipline of five hundred years they had learned and inherited such power, that whereas all former painters could be right only by effort, they could be right with ease; and whereas all former painters could be right only under restraint, they could be right, free. Tintoret's touch, Luini's, Correggio's, Reynolds's, and Velasquez's, are all as free as the air, and yet right. 'How very fine!' said everybody. Unquestionably, very fine. Next, said everybody, 'What a grand discovery! Here is the finest work ever done, and it is quite free. Let us all be free then, and what fine things shall we not do also!' With what results we too well know.

Nevertheless, remember you are to delight in the freedom won by these mighty men through obedience, though you are not to covet it. Obey, and you also shall be free in time; but in these minor things, as well as in great, it is only right service which is perfect freedom.

¶ This, broadly, is the history of the early and late colour-schools. The first of these I shall call generally, henceforward, the school of crystal; the other that of clay: potter's clay, or human, are too sorrowfully the same, as far as art is concerned. But remember, in practice, you cannot follow both these schools; you must distinctly adopt the principles of one or the other. I will put the means of following either within your reach; and according to your dispositions you will choose one or the other: all I have to guard you against is the mistake of thinking you can unite the two. If you want to paint (even in the most distant and feeble way) in the Greek School, the school of Leonardo, Correggio, and Turner, you cannot design coloured windows, nor Angelican paradises. If, on the other hand, you choose to live in the peace of paradise, you cannot share in the gloomy triumphs of the earth. . . .

¶ But for my own part, with what poor gift and skill is in me, I belong wholly to the chiaroscurist school; and shall teach you therefore chiefly that which I am best able to teach: and the rather, that it is only in this school that you can follow out the study either of natural history or

45. THE PRESENTATION IN THE TEMPLE
Painting by Vittore Carpaccio. *Venice, Accademia*

46. Detail of Plate 45

landscape. The form of a wild animal, or the wrath of a mountain torrent, would both be revolting (or in a certain sense invisible) to the calm fantasy of a painter in the schools of crystal. He must lay his lion asleep in St. Jerome's study beside his tame partridge and easy slippers; lead the appeased river by alternate azure promontories, and restrain its courtly little stream-lets with margins of marble. But, on the other hand, your studies of myth-ology and literature may best be connected with these schools of purest and calmest imagination; and their discipline will be useful to you in yet another direction, and that a very important one. It will teach you to take delight in little things, and develop in you the joy which all men should feel in purity and order, not only in pictures but in reality. For, indeed, the best art of this school of fantasy may at last be in reality, and the chiaro-scurists, true in ideal, may be less helpful in act. We cannot arrest sunsets nor carve mountains, but we may turn every English homestead, if we choose, into a picture by Cima or John Bellini, which shall be 'no counter-feit, but the true and perfect image of life indeed'.

From *Seventh Oxford Lecture. Colour*, 1870, Vol. xx, p. 166.

Carpaccio

. . . The best picture in the Academy of Venice [is] Carpaccio's 'Presenta-tion in the Temple'. Signed 'Victor Carpaccio, 1510'. From the Church of St. Job.[1]

You have no . . . leave, however, good general spectator, to find fault with anything *here!* You may measure yourself, outside and in,—your religion, your taste, your knowledge of art, your knowledge of men and things,—by the quantity of admiration which honestly, after due time given, you can feel for this picture.

You are not required to think the Madonna pretty, or to receive the same religious delight from the conception of the scene, which you would rightly receive from Angelico, Filippo Lippi, or Perugino. This is essentially Venetian,—prosaic, matter of fact,—retaining its supreme common-sense through all enthusiasm.

Nor are you required to think this a first-rate work in Venetian colour. This is the best picture in the Academy precisely because it is *not* the best piece of colour there;—because the great master has subdued his own main passion, and restrained his colour-faculty, though the best in Venice, that you might *not* say the moment you came before the picture, as you do on the Paris Bordone,[2] '*What* a piece of colour!'

[1] Ill. 45 facing page 144. [2] 'The Fisherman presenting the King to the Doge.'

To Paris, the Duke, the Senate, and the Miracle are all merely vehicles for flashes of scarlet and gold on marble and silk; but Carpaccio, in this picture of the Presentation, does not want you to think of *his* colour, but of *your* Christ.

To whom the Madonna also is subjected—to whom all is subjected: you will not find such another Infant Christ in Venice (but always look carefully at Paul Veronese's, for it is one of the most singular points in the character of this usually decorative and inexpressive painter, that his Infant Christs are always beautiful).

For the rest, I am not going to praise Carpaccio's work. Give time to it; and if you don't delight in it, the essential faculty of enjoying good art is wanting in you, and I can't give it you by ten minutes' talk; but if you begin really to feel the picture, observe that its supreme merit is in the exactly just balance of all virtue;—detail perfect, yet inconspicuous; composition intricate and severe, but concealed under apparent simplicity; and painter's faculty of the supremest, used nevertheless with entire subjection of it to intellectual purpose. Titian, compared to Carpaccio, paints as a circus-rider rides,—there is nothing to be thought of in him but his riding. But Carpaccio paints as a good knight rides; his riding is the least of him; and to himself—unconscious in its ease.

When you have seen all you can of the picture as a whole, go near, and make out the little pictures on the edge of St. Simeon's robe; four quite lovely ones; the lowest admitting, to make the whole perfect, delightful grotesque of fairy angels within a heavenly castle wall, thrusting down a troop of supine devils to the deep. The other three, more beautiful in their mystery of shade; but I have not made them out yet. There is one solemn piece of charge to a spirit folding its arms in obedience; and I think the others must be myths of creation, but can't tell yet

Let us examine [Carpaccio's pictures of the legend of St. Ursula] without hurry.

In the first place, then, we find this curious fact, intensely characteristic of the fifteenth as opposed to the nineteenth century—that the figures are true and natural, but the landscape false and unnatural, being by such fallacy made entirely subordinate to the figures. I have never approved of, and only a little understand, this state of things. The painter is never interested in the ground, but only in the creatures that tread on it. A castle tower is left a mere brown bit of canvas, and all his colouring kept for the trumpeters on the top of it. The fields are obscurely green; the sky imperfectly blue; and the mountains could not possibly stand on the very small foundations they are furnished with.

Here is a Religion of Humanity, and nothing else,—to purpose! Nothing in the universe thought worth a look, unless it is in service or foil to some

two-legged creature showing itself off to the best advantage. If a flower is in a girl's hair, it shall be painted properly; but in the fields, shall be only a spot: if a striped pattern is on a boy's jacket, we paint all the ins and outs of it, and drop not a stitch; but the striped patterns of vineyards or furrow in field, the enamelled mossy mantles of the rocks, the barred heraldry of the shield of the sky,—perhaps insects and birds may take pleasure in them, not we. To his own native lagunes and sea, the painter is yet less sensitive. His absurd rocks, and dotty black hedges round bitumen-coloured fields, are yet painted with some grotesque humour, some modest and unworldly beauty; and sustain or engird their castellated quaintnesses in a manner pleasing to the pre-Raphaelite mind. But the sea—waveless as a deal board —and in that tranquility, for the most part reflecting nothing at its edge, —literally, such a sea justifies that uncourteous saying of earlier Venice of her Doge's bride,—'Mare sub pede pono.' *

In the next place, I want you to notice Carpaccio's fancy in what he does represent very beautifully,—the architecture, real and ideal, of his day.

His fancy, I say; or phantasy; the notion he has of what architecture should be; of which, without doubt, you see his clearest expression in the Paradise, and in the palace of the most Christian King, St. Ursula's father.

And here I must ask you to remember, or learn if you do not know, the general course of transition in the architecture of Venice;—namely, that there are three epochs of good building in Venice; the first lasting to 1300, Byzantine in the style of St. Mark's; the second, 1300 to 1480, Gothic, in the style of the Ducal Palace; and the third, 1480 to 1520, in a manner which architects have yet given no entirely accepted name to, but which, from the name of its greatest designer, Brother Giocondo, of Verona,† I mean, myself, henceforward to call 'Giocondine'.

Now the dates on these pictures of Carpaccio's run from 1480 to 1485, so that you see he was painting in the youthful gush, as it were, and fullest impetus of giocondine architecture, which all Venice, and chiefly Carpaccio, in the joy of art, thought was really at last the architecture divinely de-signed, and arrived at by steady progress of taste, from the Creation to 1480, and then the ne plus ultra, and real Babel-style without bewilderment —its top truly reaching to heaven,—style which was never thenceforth to be bettered by human thought or skill. . . .

[Carpaccio's fourth picture shows] the great King of ideal England,

* On the scroll in the hand of the throned Venice on the Piazzetta side of the Ducal Palace, the entire inscription is,

'Fortis, justa, trono furias, mare sub pede, pono.'
'Strong, and just, I put the furies beneath my throne, and the sea beneath my foot.'

† Called 'the second Founder of Venice', for his engineering work on the Brenta. His archi-tecture is chiefly at Verona; the style being adopted and enriched at Venice by the Lombardi.

under an octagonal temple of audience; all the scene being meant to show the conditions of a state in perfect power and prosperity.

A state, therefore, that is at once old and young; that has had a history for centuries past, and will have one for centuries to come.

Ideal, founded mainly on the Venice of his own day; mingled a little with thoughts of great Rome, and of great antagonist Genoa: but, in all spirit and hope, the Venice of 1480-1500 is here living before you. And now, therefore, you can see at once what she meant by a 'Campo', allowing for the conventional manner of representing grass, which of course at first you will laugh at; but which is by no means deserving of your contempt. Any hack draughtsman of Dalziel's [1] can sketch for you, or any member of the Water-colour or Dudley Societies dab for you, in ten minutes, a field of hay that you would fancy you could mow, and make cocks of. But this green ground of Carpaccio's with implanted flowers and tufts of grass, is traditional from the first Greek-Christian mosaics, and is an entirely systematic ornamental ground, and to be understood as such, primarily, and as grass only symbolically. Careless indeed, more than is usual with him—much spoiled and repainted also; but quite clear enough in expression for us of the orderliness and freshness of a Venetian campo in the great times; garden and city you see mingled inseparably, the wild strawberry growing at the steps of the king's court of justice, and their marble sharp and bright out of the turf. Clean everything, and pure;—no cigars in anybody's poisoned mouth,—no voiding of perpetual excrement of saliva on the precious marble or living flowers. Perfect peace and befittingness of behaviour in all men and creatures. Your very monkey in repose, perfect in his mediaeval dress; the Darwinian theory in all its sacredness, breadth divinity, and sagacity,—but reposeful, not venturing to thrust itself into political council. Crowds on the bridges and quays, but untumultuous, close set as beds of flowers, richly decorative in their mass, and a beautiful mosaic of men, and of black, red, blue, and golden bonnets. Ruins, indeed, among the prosperity; but glorious ones;—not shells of abandoned speculation, but remnants of mighty state long ago, now restored to nature's peace; the arches of the first bridge the city had built, broken down by storm, yet what was left of them spared for memory's sake. (So stood for a little while, a few years ago, the broken Ponte-a-Mare at Pisa; so at Rome, for ages, stood the Ponte Rotto, till the engineers and modern mob got at it, making what was in my youth the most lovely and holy scene in Rome, *now* a place where a swineherd could not stand without holding his nose, and which no woman can stop at.)

But here, the old arches are covered with sweet weeds, like native rock, and (for once!) reflected a little in the pure water under the meadowy

[1] The Dalziels were successful and fashionable London engravers.

hills. Much besides of noteworthy, if you are yourself worthy of noting it, you may find in this lovely distance. But the picture, it may be complained, seems for the most part—distance, architecture, and scattered crowd; while of foreground objects, we have principally cloaks, and very curiously thin legs.* Well, yes,—the distance is indeed the prettiest part of this picture; and since, in modern art and drama, we have been accustomed, for anatomical and other reasons, to depend on nothing else but legs, I admit the supply of legs to be here scanty, and even of brachial, pectoral, and other admirable muscles. If you choose to look at the *faces* instead, you will find something in them; nevertheless, Carpaccio has been, on the whole, playing with himself, and with us, in his treatment of this subject. For Carpaccio is, in the most vital and conclusive sense, a man of genius, who will not at all supply you, nor can in the least supply himself, with sublimity and pathos to order; but is sublime, or delightful, or sometimes dull, or frequently grotesque, as Heaven wills it; or—profane persons will say,— as the humour takes him. And his humour here has been dominant. For since much depends on the answer brought back from St. Ursula, besides the young Prince's happiness, one should have thought, the return of the embassy might have been represented in a loftier manner. But only two of the ambassadors are here; the king is occupied in hearing a cause which will take long,—(see how gravely his minister is reading over the documents in question);—meantime the young prince, impatient, going down the steps of the throne, makes his own private inquiries, proudly: 'Your embassy has, I trust, been received, gentlemen, with a just understanding of our diplomatic relations?' 'Your Royal Highness', the lowly and gravely bowing principal ambassador replies, 'must yourself be the only fitting judge of that matter, on fully hearing our report.' Meantime, the chargé d'affaires holds St. Ursula's answer—behind his back.

A piece of play, very nearly, the whole picture; a painter living in the midst of a prosperous city, happy in his own power, entirely believing in God, and in the saints, and in eternal life; and, at intervals, bending his whole soul to the expression of most deep and holy tragedy,—such a man needs must have his times of play; which Carpaccio takes, in his work. Another man, instead of painting this piece with its monkey, and its little fiddler, and its jesting courtiers, would have played some ape-tricks of his own,—spent an hour or two among literal fiddlers, and living courtiers. Carpaccio is not heard of among such—amuses himself still with pencil in hand, and us also, pleasantly, for a little while. You shall be serious enough, soon, with him, if you will. . . .

From *Guide to the Principal Pictures in the Academy of Fine Arts at Venice*, 1877.

* Not in the least unnaturally thin, however, in the forms of persons of sedentary life.

Pre-Raphaelites

I WAS lately staying in a country house,[1] in which, opposite each other at the sides of the drawing-room window, were two pictures, belonging to what in the nineteenth century, must be called old times, namely, Rossetti's 'Annunciation',[2] and Millais' 'Blind Girl',[3] while, at the corner of the chimney-piece in the same room, there was a little drawing of a Marriage-dance, by Edward Burne-Jones. . . .

¶ The first picture I named, Rossetti's 'Annunciation', was, I believe, among the earliest that drew some public attention to the so-called 'Pre-Raphaelite' school. The one opposite to it,—Millais' 'Blind Girl', is among those chiefly characteristic of that school in its determined manner. And the third, though small and unimportant, is no less characteristic, in its essential qualities, of the mind of the greatest master whom that school has yet produced. . . .

¶ . . . Rossetti's 'Annunciation' differs from every previous conception of the scene known to me, in representing the angel as waking the Virgin from sleep to give her his message. The messenger himself also differs from angels as they are commonly represented, in not depending, for recognition of his supernatural character, on the insertion of bird's wings at his shoulders. If we are to know him for an angel at all, it must be by his face which is that simply of youthful, but grave manhood. He is neither transparent in body, luminous in presence, nor auriferous in apparel;—wears a plain, long, white robe,—casts a natural and undiminished shadow,—and, although there are flames beneath his feet, which upbear him, so that he does not touch the earth, these are unseen by the Virgin.

She herself is an English, not a Jewish girl, of about sixteen or seventeen, of such pale and thoughtful beauty as Rossetti could best imagine for her. . . .

She has risen half up, not *started* up, in being awakened; and is not looking at the angel, but only thinking, it seems, with eyes cast down, as if supposing herself in a strange dream. The morning light fills the room, and shows at the foot of her little pallet-bed, her embroidery work, left off the evening before,—an upright lily.

Upright, and very accurately upright, as also the edges of the piece of cloth in its frame,—as also the gliding form of the angel,—as also, in severe foreshortening, that of the Virgin herself. It has been studied, so far as it has been studied at all, from a very thin model; and the disturbed coverlid is thrown into confused angular folds, which admit no suggestion whatever of ordinary girlish grace. So that, to any spectator little inclined towards

[1] That of William Graham at Dunira, Perthshire.
[2] Ill. 47 facing this page. [3] Ill. 49 facing page 158.

47. THE ANNUNCIATION. Painting by Rossetti. *London, Tate Gallery*

48. THE KING'S WEDDING. Water-colour by Burne-Jones
Newmarket, The Hon. Mrs. George Lambton

the praise of barren 'uprightnesse', and accustomed on the contrary to expect radiance in archangels, and grace in Madonnas, the first effect of the design must be extremely displeasing, and the first is perhaps, with most art-amateurs of modern days, likely to be the last.

¶ The background of the second picture (Millais' 'Blind Girl') is an open English common, skirted by the tidy houses of a well-to-do village in the cockney rural districts. I have no doubt that the scene is a real one within some twenty miles from London,[1] and painted mostly on the spot. The houses are entirely uninteresting, but decent, trim, as human dwellings should be. . . .

The common is a fairly spacious bit of ragged pasture, with a couple of donkeys feeding on it, and a cow or two, and at the side of the public road passing over it, the blind girl has sat down to rest awhile. She is a simple beggar, not a poetical or vicious one;—being peripatetic with musical instrument, she will, I suppose, come under the general term of tramp; a girl of eighteen or twenty, extremely plain-featured, but healthy, and just now resting, as any of us would rest, not because she is much tired, but because the sun has but this moment come out after a shower, and the smell of the grass is pleasant.

The shower has been heavy, and is so still in the distance, where an intensely bright double rainbow is relieved against the departing thunder-cloud. The freshly wet grass is all radiant through and through with the new sunshine; full noon at its purest, the very donkeys bathed in the rain-dew, and prismatic with it under their rough breasts as they graze; the weeds at the girl's side as bright as a Byzantine enamel, and inlaid with blue veronica; her upturned face all aglow with the light that seeks its way through her wet eyelashes (wet only with the rain). Very quiet, she is,—so quiet that a radiant butterfly has settled on her shoulder, and basks there in the warm sun. Against her knee, on which her poor instrument of musical beggary rests (harmonium) leans another child, half her age—her guide;—indifferent, this one, either to sun or rain, only a little tired of waiting. No more than a half profile of her face is seen; and that is quite expression-less, and not the least pretty.

¶ Both of these pictures are oil-paintings. The third, Mr. Burne-Jones' 'Bridal',[2] is a small water colour drawing, scarcely more than a sketch; but full and deep in such colour as it admits. . . . This drawing . . . is far less representative of his scale of power than either of the two pieces already described, which have both cost their artists much care and time; while this little water-colour has been perhaps done in the course of a summer afternoon. It is only about seven inches by nine: the figures of the average

[1] It was in fact painted at Winchelsea.
[2] Usually called 'The King's Wedding'; painted in 1870. Ill. 48 facing this page.

size of Angelico's or any altar predella; and the heads, of those on an average Corinthian or Syracusan coin. The bride and bridegroom sit on a slightly raised throne at the side of the picture, the bride nearest us; her head seen in profile, a little bowed. Before them, the three bridesmaids and their groomsmen dance in circle, holding each other's hands, barefooted,[1] and dressed in long dark blue robes. Their figures are scarcely detached from the dark background, which is a wilful mingling of shadow and light, as the artist chose to put them, representing, as far as I remember, nothing in particular. The deep tone of the picture leaves several of the faces in obscurity, and none are drawn with much care, not even the bride's; but with enough to show that her features are at least as beautiful as those of an ordinary Greek goddess, while the depth of the distant background throws out her pale head, in an almost lunar, yet unexaggerated, light; and the white and blue flowers of her narrow coronal, though *merely* white and blue, shine, one knows not how, like gems. Her bridegroom stoops forward a little to look at her, so that we see his front face, and can see also that he loves her.

¶ Such being the respective effort and design of the three pictures, although I put by, for the moment, any question of their mechanical skill or manner, it must yet, I believe, be felt by the reader that, as works of young men, they contained, and even nailed to the Academy gates, a kind of Lutheran challenge to the then accepted teachers in all European schools of Art: perhaps a little too shrill and petulant in the tone of it, but yet curiously resolute and steady in its triple Fraternity. . . .

We have, indeed, since these pictures were first exhibited, become accustomed to many forms both of pleasing and revolting innovation: but consider, in those early times, how the pious persons who had always been accustomed to see their Madonnas dressed in scrupulously folded and exquisitely falling robes of blue, with edges embroidered in gold,—to find them also, sitting under arcades of exquisitest architecture by Bernini,— and reverently to observe them receive the angel's message with their hands folded on their breasts in the most graceful positions, and the missals they had been previously studying laid open on their knees . . .;—consider, I repeat, the shock to the feelings of all these delicately minded persons, on being asked to conceive a Virgin waking from her sleep on a pallet bed, in a plain room, startled by sudden words and ghostly presence which she does not comprehend, and casting in her mind what manner of salutation this should be.

¶ Again, consider, with respect to the second picture, how the learned possessors of works of established reputation by the ancient masters, classically catalogued as 'landscapes with figures'; and who held it for eternal

[1] Ruskin wrote from memory; the dancers are shod.

artistic law that such pictures should either consist of a rock, with a Spanish chestnut growing out of the side of it, and three banditti in helmets and big feathers on the top, or else of a Corinthian temple, built beside an arm of the sea, with the Queen of Sheba beneath, preparing for embarkation to visit Solomon—the whole properly toned down with amber varnish;—imagine the first consternation and final wrath, of these *cognoscenti*; at being asked to contemplate, deliberately, and to the last rent of her ragged gown, and for principal object in a finished picture, a vagrant who ought at once to have been sent to the workhouse; and some really green grass and blue flowers, as they actually may any day be seen on an English common-side.

And finally, let us imagine, if imagination fail us not, the far more wide and weighty indignation of the public, accustomed always to see its paintings of marriages elaborated in Christian propriety and splendour; with a bishop officiating, assisted by a dean and an arch-deacon; the modesty of the bride expressed by a veil of the most expensive Valenciennes, and the robes of the bridesmaids designed by the perfectest of Parisian artists, and looped up with stuffed robins or other such tender rarities;—think with what sense of hitherto unheard-of impropriety, the British public must have received a picture of a marriage, in which the bride was only crowned with flowers,—at which the bridesmaids danced barefoot,—and in which nothing was known, or even conjecturable, respecting the bridegroom, but his love!

¶ Such being the manifestly opponent and agonistic temper of these three pictures (and admitting, which I will crave the reader to do for the nonce, their real worth and power to be considerable), it surely becomes a matter of no little interest to see what spirit it is that they have in common, which, recognized as revolutionary in the minds of the young artists themselves, caused them, with more or less of firmness, to constitute themselves into a society, partly monastic, partly predicatory, called 'Pre-Raphaelite': and also recognized as such with indignation, by the public caused the youthfully didactic society to be regarded with various degrees of contempt, passing into anger (as of offended personal dignity), and embittered farther, among certain classes of persons, even into a kind of instinctive abhorrence.

¶ I believe the reader will discover, on reflection, that there is really only one quite common and sympathetic impulse shown in these three works, otherwise so distinct in aim and execution. And this fraternal link he will, if careful in reflection, discover to be an effort to represent, so far as in these youths lay either the choice or the power, things as they are or were, or may be, instead of according to the practice of their instructors and the wishes of their public, things as they are *not*, never were, and never can be: this effort being founded deeply on a conviction that it is at

first better, and finally, more pleasing, for human minds to contemplate things as they are, than as they are not.

Thus, Mr. Rossetti, in this and subsequent works of the kind, thought it better for himself and his public to make some effort, towards a real notion of what actually did happen in the carpenter's cottage at Nazareth, giving rise to the subsequent traditions delivered in the gospels, than merely to produce a variety in the pattern of Virgin, pattern of Virgin's gown, and pattern of Virgin's house, which had been set by the jewellers of the fifteenth century.

Similarly, Mr. Millais, in this and other works of the kind, thought it desirable rather to paint such grass and foliage as he saw in Kent, Surrey, and other solidly accessible English counties, than to imitate even the most Elysian fields enamelled by Claude, or the gloomiest branches of Hades forest rent by Salvator: and yet more, to manifest his own strong personal feeling that the humanity, no less than the herbage, near us and around, was that which it was the painter's duty first to portray; and that, if Words-worth were indeed right in feeling that the meanest flower that blows can give,—much more, for any kindly heart it should be true that the meanest tramp that walks can give—'thoughts that do often lie too deep for tears'.

¶ And if at first—or even always to careless sight—the third of these pictures seem opposite to the two others in the very point of choice, be-tween what is and what is not; insomuch that while *they* with all their strength avouch realities, *this* with simplest confession dwells upon a dream,— yet in this very separation from them it sums their power and seals their brotherhood; reaching beyond them to the more perfect truth of things, not only that once were,—not only that now are,—but which are the same yesterday, to-day, and for ever;—the love by whose ordaining the world itself, and all that dwell therein, live, and move, and have their being; by which the morning stars rejoice in their courses—in which the virgins of deathless Israel rejoice in the dance—and in whose constancy the giver of light to stars, and love to men, Himself is glad in the creatures of His hand,—day by new day proclaiming to His Church of all the ages, 'As the bridegroom rejoiceth over the bride, so shall thy Lord rejoice over thee'.

Such, the reader will find, if he cares to learn it, is indeed the purport and effort of these three designs—so far as by youthful hands and in time of trouble and rebuke, such effort could be brought to good end. Of their visible weaknesses, with the best justice I may,—of their veritable merits with the best insight I may, and of the farther history of the school which these masters founded, I hope to be permitted to speak more under the branches that do not 'remember their green felicity. . . .'

¶ The central branch of the school represented by the central picture above described:—'The Blind Girl'—was essentially and vitally an un-

educated one. It was headed, in literary power, by Wordsworth; but the first pure example of its mind and manner of Art, as opposed to the erudite and *artificial* schools, will be found, so far as I know, in Molière's song: *j'aime mieux ma mie.*

Its mental power consisted in discerning what was lovely in present nature, and in pure moral emotion concerning it.

Its physical power, in an intense veracity of direct realization to the eye.

So far as Mr. Millais saw what was beautiful in vagrants, or commons, or crows, or donkeys, or the straw under children's feet in the Ark (Noah's or anybody else's does not matter),—in the Huguenot and his mistress, or the ivy behind them,—in the face of Ophelia, or in the flowers floating over it as it sank;—much more, so far as he saw what instantly comprehensible nobleness of passion might be in the finding of a handkerchief,—in the utterance of two words, 'Trust me' or the like: he prevailed, and rightly prevailed, over all prejudice, and opposition; to that extent he will in what he has done, or may yet do, take, as a standard-bearer, an honourable place among the reformers of our day.

So far as he could not see what was beautiful, but what was essentially and for ever common (in that God had not cleansed it), and so far as he did not see truly what he thought he saw; (as for instance, in this picture, under immediate consideration, when he paints the spark of light in a crow's eye a hundred yards off, as if he were only painting a miniature of a crow close by,)—he failed of his purpose and hope; but how far, I have neither the power nor the disposition to consider.

The school represented by Mr. Rossetti's picture and adopted for his own by Mr. Holman Hunt, professed, necessarily, to be a learned one; and to represent things which had happened long ago, in a manner credible to any moderns who were interested in them. The value to us of such a school necessarily depends on the things it chooses to represent, out of the infinite history of mankind. . . . What our own painters have done for us in this kind has been too unworthy of their real powers, for Mr. Rossetti threw more than half his strength into literature, and, in that precise measure, left himself unequal to his appointed task in painting; while Mr. Hunt, not knowing the necessity of masters any more than the rest of our painters, and attaching too great importance to the externals of the life of Christ, separated himself for long years from all discipline by the recognized laws of his art; and fell into errors which wofully shortened his hand and discredited his cause—into which again I hold it no part of my duty to enter. But such works as either of these painters have done, without antagonism or ostentation, and in their own true instincts; as all Rossetti's drawing from the life of Christ, more especially that of the Madonna gathering the bitter herbs for the Passover when He was twelve years old; and that of the

Magdalen leaving her companions to come to Him; these, together with all the mythic scenes which he painted from the *Vita Nuova* and *Paradiso* of Dante, are of quite imperishable power and value: as also many of the poems to which he gave up part of his painter's strength. Of Holman Hunt's 'Light of the World' and 'Awakening Conscience', I have publicly spoken and written, now for many years, as standard in their kind. . . .

But the school represented by the third painting, 'The Bridal' is that into which the greatest masters of *all* ages are gathered and in which they are walled round as in Elysian fields, unapproachable but by the reverent and loving souls, in some sort already among the Dead. . . .

From *The Three Colours of Pre-Raphaelitism*, 1877.

Middle-Class Patronage

IT IS especially to be remembered that drawings of this simple character were made [sixty years since] for [the] middle classes, exclusively; and even for the second order of the middle classes, more accurately expressed by the term *bourgeoisie*. The great people always bought Canaletto, not Prout, and Van Huysum, not Hunt. There was indeed no quality in the bright little water-colours which could look other than pert in ghostly corridors, and petty in halls of state; but they gave an unquestionable tone of liberal-mindedness to a suburban villa, and were the cheerfullest possible decorations for a moderate-sized breakfast-parlour opening on a nicely mown lawn. Their loveliness even rose, on occasion, to the charity of beautifying the narrow chambers of those whom business or fixed habit still retained in the obscurity of London itself; and I remember with peculiar respect the pride of a benevolent physician,[1] who never would exchange his neighbourhood to the poor of St. Giles's for the lucrative lustre of a West End square, in wreathing his tiny little front drawing-room with Hunt's loveliest apple-blossom, and taking the patients for whom he had prescribed fresh air the next instant on a little visit to the country.

¶ Nor was this adaptation to the tastes and circumstances of the London citizen a constrained or obsequious compliance on the part of the kindly artists. They were themselves, in mind, as in habits of life, completely a part of the characteristic metropolitan population whom an occasional visit to the Continent always thrilled with surprise on finding themselves again among persons who familiarly spoke French; and whose summer holidays, though more customary, amused them nevertheless with the adventure, and beguiled them with the pastoral charm, of an uninterrupted

[1] Probably Mr. R. Wade, of Dean Street, Soho; his collection was dispersed in 1872.

picnic. Mr. Prout lived at Brixton, just at the rural extremity of Cold Harbour Lane, where the spire of Brixton Church, the principal architectural ornament of the neighbourhood, could not but greatly exalt, by comparison, the impressions received from that of Strasburg Cathedral, or the Hôtel de Ville of Bruxelles; and Mr. Hunt, though often in the spring and summer luxuriating in country lodgings, was only properly at home in the Hampstead Road, and never painted a cluster of nuts without some expression, visible enough by the manner of their presentation, of the pleasure it was to him to see them in the shell, instead of in a bag at the greengrocer's.

¶ The lightly rippled level of this civic life lay, as will be easily imagined, far beneath the distractions, while it maintained itself meekly, yet severely, independent of the advantages, held out by the social system of what is most reverently called 'Town'. Neither the disposition, the health, nor the means of either artist admitted of their spending their evenings, in general, elsewhere than by their own firesides; nor could a spring levée of English peeresses and foreign ambassadors be invited by the modest painter whose only studio was his little back-parlour, commanding a partial view of the scullery steps and the water-butt. The fluctuations of moral and æsthetic sentiment in the public mind were of small moment to the humble colourists, who depended only on the consistency of its views on the subject of early strawberries; and the thrilling subjects presented by the events or politics of the day were equally indifferent to the designer who invited interest to nothing later than the architecture of the fifteenth century. Even the treasures of scientific instruction, and marvels of physical discovery, were without material influence on the tranquility of the two native painters' uneducated skill. Prout drew every lovely street in Europe, without troubling himself to learn a single rule of perspective; while Hunt painted mossy banks for five-and-twenty years, without ever caring to know a sphagnum from a polybody, and embossed or embowered his birds' eggs to a perfection, which Greek connoisseurs would have assured us the mother had unsuspectingly sat on, without enlarging his range of ornithological experience beyond the rarities of tomtit and hedge-sparrow.

¶ This uncomplaining resignation of patronage, and unblushing blindness to instruction, were allied, in both painters, with a steady consistency in technical practice, which, from the first, and to the last, precluded both from all hope of promotion to the honours, as it withheld them from the peril of entanglement in the rivalries, connected with the system of exhibition in the Royal Academy. Mr. Prout's method of work was entirely founded on the quite elementary qualities of white paper and black Cumberland lead; and expressly terminated within the narrow range of prismatic effects producible by a brown or blue outline, with a wash of ochre or

cobalt. Mr. Hunt's early drawings depended for their peculiar charm on the most open and simple management of transparent colour; and his later ones, for their highest attainments, on the flexibility of a pigment which yielded to the slightest touch and softest motion of a hand always more sensitive than firm. The skill which unceasing practice, within limits thus modestly unrelaxed, and with facilities of instrument thus openly confessed, enabled each draughtsman in his special path to attain, was exerted with a vividness of instinct somewhat resembling that of animals, only in the slightest degree conscious of praiseworthiness, but animated by a healthy complacency, as little anxious for external sympathy as the self-content of a bee in the translucent symmetry of its cell, or of a chaffinch in the silver tracery of her nest—and uniting, through the course of their uneventful and active lives, the frankness of the bird with the industry of the insect.

From *Notes on Prout and Hunt*, 1879, Vol. XI, p. 63.

The Pre-Raphaelites

I WISH to render such account as is possible to me of the vivid phase into which I find our English art in general to have developed since first I knew it: and, though perhaps not without passing deprecation of some of its tendencies, to rejoice with you unqualifiedly in the honour which may most justly be rendered to the leaders, whether passed away or yet present with us, of England's Modern Painters.

I may be permitted, in the reverence of sorrow, to speak first of my much loved friend, Gabriel Rossetti. But, in justice, no less than in the kindness due to death,[1] I believe his name should be placed first on the list of men, within my own range of knowledge, who have raised and changed the spirit of modern Art: raised, in absolute attainment; changed, in direction of temper. Rossetti added to the before accepted systems of colour in painting, one based on the principles of manuscript illumination, which permits his design to rival the most beautiful qualities of painted glass, without losing either the mystery or the dignity of light and shade. And he was, as I believe it is now generally admitted, the chief intellectual force in the establishment of the modern romantic school in England.

¶ Those who are acquainted with my former writings must be aware that I use the word 'romantic' always in a noble sense; meaning the habit of regarding the external and real word as a singer of Romaunts would have regarded it in the Middle Ages, and as Scott, Burns, Byron, and Tennyson have regarded it in our own times. But, as Rossetti's colour was based on the former art of illumination, so his romance was based on traditions

[1] Rossetti had died in 1882.

49. THE BLIND GIRL. Painting by Millais. *Birmingham, City Art Gallery*

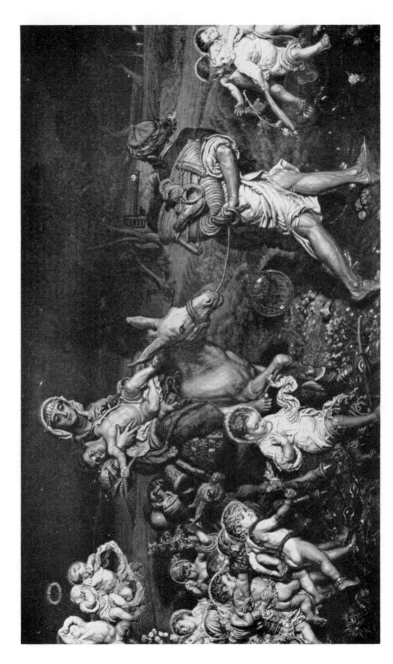

50. TRIUMPH OF THE INNOCENTS. Painting by Holman Hunt. *Liverpool, Walker Art Gallery*

of earlier and more sacred origin than those which have inspired our highest modern romantic literature. That literature has in all cases remained strongest in dealing with contemporary fact. The genius of Tennyson is at its highest in the poems of 'Maud', 'In Memoriam', and the 'Northern Farmer'; but that of Rossetti, as of his greatest disciple, is seen only when on pilgrimage in Palestine.

¶ I trust that Mr. Holman Hunt will not think that in speaking of him as Rossetti's disciple I derogate from the respect due to his own noble and determined genius. In all living schools it chances often that the disciple is greater than his master; and it is always the first sign of a dominant and splendid intellect, that it knows of whom to learn. Rossetti's great poetical genius justified my claiming for him total, and, I believe, earliest, originality in the sternly materialistic, though deeply reverent, veracity, with which alone, of all schools of painters, this brotherhood of Englishmen has conceived the circumstances of the life of Christ. And if I had to choose one picture which represented in purity and completeness this manner of their thought, it would be Rossetti's 'Virgin in the House of St. John'.[1]

¶ But when Holman Hunt, under such impressive influence, quitting virtually for ever the range of worldly subjects, to which belonged the pictures of Valentine and Sylvia, of Claudio and Isabel, and of the 'Awakening Conscience', rose into the spiritual passion which first expressed itself in 'The Light of the World', an instant and quite final difference was manifested between his method of conception, and that of his forerunner. To Rossetti, the Old and New Testaments were only the greatest poems he knew; and he painted scenes from them with no more actual belief in their relation to the present life and business of men than he gave also to the 'Morte d'Arthur' and the 'Vita Nuova'. But to Holman Hunt, the story of the New Testament, when once his mind entirely fastened on it, became what it was to an old Puritan, or an old Catholic of true blood,—not merely a Reality, not merely the greatest of Realities, but the only Reality. So that there is nothing in the earth for him any more that does not speak of that;—there is no course of thought nor force of skill for him, but it springs from and ends in that.

So absolutely, and so involuntarily—I use the word in its noblest meaning—is this so with him, that in all subjects which fall short in the religious element, his power also is shortened, and he does those things worst which are easiest to other men.

Beyond calculation, greater, beyond comparison, happier, than Rossetti, in this sincerity, he is distinguished also from him by a respect for physical and material truth which renders his work far more generally, far more serenely, exemplary.

[1] Ill. 51 facing page 162.

¶ The specialty of colour-method which I have signalized in Rossetti, as founded on missal painting, is in exactly that degree conventional and unreal. Its light is not the light of sunshine itself, but of sunshine diffused through coloured glass. And in object-painting he not only refused, partly through idleness, partly in the absolute want of opportunity for the study of nature involved in his choice of abode in a garret at Blackfriars,—refused, I say, the natural aid of pure landscape and sky, but wilfully perverted and lacerated his powers of conception with Chinese puzzles and Japanese monsters, until his foliage looked generally fit for nothing but a fire-screen, and his landscape distances like the furniture of a Noah's Ark from the nearest toy-shop. Whereas Holman Hunt, in the very beginning of his career, fixed his mind, as a colourist, on the true representation of actual sunshine, of growing leafage, of living rock, of heavenly cloud; and his long and resolute exile, deeply on many grounds to be regretted both for himself and us, bound only closer to his heart the mighty forms and hues of God's earth and sky, and the mysteries of its appointed lights of the day and of the night—opening on the foam—'Of desolate seas, in—Sacred—lands forlorn.'

¶ You have, for the last ten or fifteen years, been accustomed to see among the pictures principally characteristic of the English school, a certain average number of attentive studies, both of sunshine, and the forms of lower nature, whose beauty is meant to be seen by its light. Those of Mr. Brett may be named with especial praise; and you probably will many of you remember with pleasure the study of cattle on a Highland moor in the evening by Mr. Davis,[1] which in last year's Academy carried us out, at the end of the first room, into sudden solitude among the hills. But we forget, in the enjoyment of these new and healthy pleasures connected with painting, to whom we first owe them all. The apparently unimportant picture by Holman Hunt, 'The Strayed Sheep', which—painted thirty years ago—you may perhaps have seen last autumn in the rooms of the [Fine] Art Society in Bond Street, at once achieved all that can ever be done in that kind: it will not be surpassed—it is little likely to be rivalled—by the best efforts of the times to come. It showed to us, for the first time in the history of art, the absolutely faithful balances of colour and shade by which actual sunshine might be transposed into a key in which the harmonies possible with material pigments should yet produce the same impressions upon the mind which were caused by the light itself.

¶ And remember, all previous work whatever has been either subdued into narrow truth, or only by convention suggestive of the greater. Claude's sunshine is colourless,—only the golden haze of a quiet afternoon;—so also that of Cuyp: Turner's, so bold in conventionalism that it is credible to few of you, and offensive to many. But the pure natural green and tufted

[1] H. W. B. Davis, b. 1833.

gold of the herbage in the hollow of that little sea-cliff must be recognized for true merely by a minute's pause of attention. Standing long before the picture, you were soothed by it, and raised into such peace as you are intended to find in the glory and the stillness of summer, possessing all things.

¶ I cannot say of this power of true sunshine the least thing that I would. Often it is said to me by kindly readers, that I have taught them to see what they had not seen: and yet never—in all the many volumes of effort—have I been able to tell them my own feelings about what I myself see. You may suppose that I have been all this time trying to express my personal feelings about Nature. No; not a whit. I soon found I could not, and did not try to. All my writing is only the effort to distinguish what is constantly, and to all men, lovable, and if they will look, lovely, from what is vile or empty,—or, to well-trained eyes and hearts, loathsome;—but you will never find me talking about what *I* feel, or what *I* think. I know that fresh air is more wholesome than fog, and that blue sky is more beautiful than black, to people happily born and bred. But you will never find, except of late, and for special reasons, effort of mine to say how I am myself oppressed or comforted by such things.

¶ This is partly my steady principle, and partly it is incapacity. Forms of personal feeling in this kind can only be expressed in poetry; and I am not a poet, nor in any articulate manner could I the least explain to you what a deep element of life, for me, is in the sight merely of pure sunshine on a bank of living grass.

More than any pathetic music,—yet I love music,—more than any artful colour—and yet I love colour,—more than other merely material thing visible to these old eyes, in earth or sky. It is so, I believe, with many of you also,—with many more than know it of themselves; and this picture, were it only the first that cast true sunshine on the grass, would have been in that virtue sacred: but in its deeper meaning, it is, actually, the first of Hunt's sacred paintings—the first in which, for those who can read, the substance of the conviction and the teaching of his after life is written, though not distinctly told till afterwards in the symbolic picture of 'The Scapegoat'. 'All we like sheep have gone astray, we have turned every one to his own way, and the Lord hath laid on Him the iniquity of us all.'

¶ The picture of which I came to-day chiefly to speak,[1] as a symbol

[1] 'The Triumph of the Innocents' [Ill. 50 facing page 159]. What Ruskin saw was the first picture, which the painter afterwards abandoned owing to defects in the canvas. The design was afterwards repeated on a larger canvas, and the completed picture was exhibited at the Fine Art Society's rooms in 1885; it was in 1900 in the possession of Mr. J. T. Middlemore, M.P., of Birmingham. The relinquished painting was at a later date finished, and is in the Walker Art Gallery at Liverpool. See *Catalogue of an Exhibition of the Collected Works of W. Holman Hunt, with a Prefatory Note by Sir W. B. Richmond*, 1906; and the artist's *Pre-Raphaelitism and the Pre-Raphaelite Brotherhood*, Vol. II, Ch. XII, where (on pp. 341-342) he quotes ¶¶ 16, 17 of Ruskin's lecture.

of that doctrine, was incomplete when I saw it, and is so still; but enough was done to constitute it the most important work of Hunt's life, as yet; and if health is granted to him for its completion, it will, both in reality and in esteem, be the greatest religious painting of our time.

You know that in the most beautiful former conceptions of the Flight into Egypt, the Holy Family were always represented as watched over, and ministered to, by attendant angels. But only the safety and peace of the Divine Child and its mother are thought of. No sadness or wonder of meditation returns to the desolate homes of Bethlehem.

But in this English picture all the story of the escape, as of the flight, is told, in fulness of peace, and yet of compassion. The travel is in the dead of the night, the way unseen and unknown;—but, partly stooping from the starlight, and partly floating on the desert mirage, move, with the Holy Family, the glorified souls of the Innocents. Clear in celestial light, and gathered into child-garlands of gladness, they look to the Child in whom they live, and yet for them to die. Waters of the River of Life flow before on the sands: the Christ stretches out His arms to the nearest of them;—leaning from His mother's breast.

¶ It may have been observed, and perhaps with question of my meaning, by some readers, that in my last lecture I used the word 'materialistic' of the method of conception common to Rossetti and Hunt, with the greater number of their scholars. I used that expression to denote their peculiar tendency to feel and illustrate the relation of spiritual creatures to the substance and conditions of the visible world; more especially, the familiar, or in a sort humiliating, accidents or employments of their earthly life;—as, for instance, in the picture I referred to, Rossetti's Virgin in the house of St. John, the Madonna's being drawn at the moment when she rises to trim their lamp. In many such cases, the incidents may of course have symbolical meaning, as, in the unfinished drawing by Rossetti of the Passover, the boy Christ is watching the blood struck on the doorpost;—but the peculiar value and character of the treatment is in what I called its *material* veracity, compelling the spectator's belief, if he have the instinct of belief in him at all, in the thing's having verily happened; and not being a mere poetical fancy. If the spectator, on the contrary, have no capacity of belief in him, the use of such representation is in making him detect his own incredulity; and recognize, that in his former dreamy acceptance of the story, he had never really asked himself whether these things were so. . . .

¶ And you will observe farther, that this way of thinking about a thing compels, with a painter, also a certain way of painting it. I do not mean a necessarily close or minute way, but a necessarily complete, substantial, and emphatic one. The thing may be expressed with a few fierce dashes of the pencil; but it will be wholly and bodily there; it may be in

51. THE VIRGIN IN THE HOUSE OF ST. JOHN. Painting by Rossetti. *London, Tate Gallery*

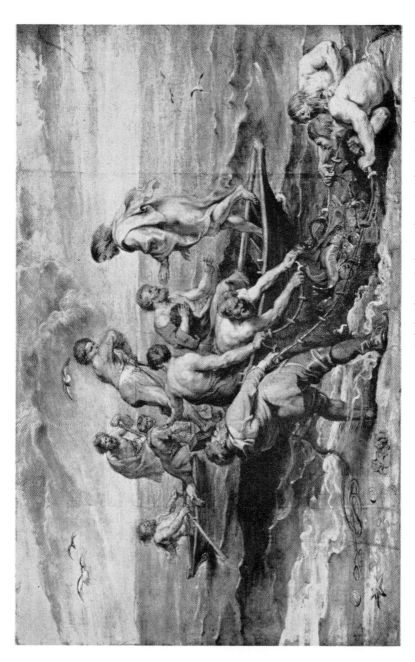

52. THE MIRACULOUS DRAUGHT OF FISHES. Oil-sketch ascribed to Rubens. *London, National Gallery*

the broadest and simplest terms, but nothing will be hazy or hidden, nothing clouded round, or melted away: and all that is told will be as explanatory and lucid as may be—as of a thing examined in daylight, not dreamt of in moonlight.

¶ I must delay you a little, though perhaps tiresomely, to make myself well understood on this point; for the first celebrated pictures of the pre-Raphaelite school having been extremely minute in finish, you might easily take minuteness for a speciality of the style,—but it is not so in the least. Minuteness I *do* somewhat claim, for a quality insisted upon by myself, and required in the work of my own pupils; it is—at least in landscape —Turnerian and Ruskinian—not pre-Raphaelite at all:—the pre-Raphaelism common to us all is in the frankness and honesty of the touch, not in its dimensions.

¶ I think I may, once for all, explain this to you, and convince you of it, by asking you, when you next go up to London, to look at a sketch by Vandyke in the National Gallery, No. 680, purporting to represent . . . the miraculous draught of fishes.[1] It is one of the too numerous brown sketches in the manner of the Flemish School, which seem to me always rather done for the sake of wiping the brush clean than of painting anything. There is no colour in it, and no light and shade;—but a certain quantity of bitumen is rubbed about so as to slip more or less greasily into the shape of figures; and one of St. John's (or St. James's) legs is suddenly terminated by a wriggle of white across it, to signify that he is standing in the sea. Now that was the kind of work of the Dutch School, which I spent so many pages in vituperating throughout the first volume of *Modern Painters*—pages, seemingly, vain to this day; for still, the brown daubs are hung in the best rooms of the National Gallery, and the loveliest Turner drawings are nailed to the wall of its cellar,—and might as well be buried at Pompeii for any use they are to the British public;—but, vain or effectless as the said chapters may be, they are altogether true in that firm statement, that these brown flourishes of the Dutch brush are by men who lived, virtually, the gentle, at court,—the simple, in the pothouse: and could indeed paint, according to their habitation, a nobleman or a boor; but were not only incapable of conceiving, but wholly unwishful to conceive, anything, natural or supernatural, beyond the precincts of the Presence and the tavern. So that they especially failed in giving the life and beauty of little things in lower nature; and if, by good hap, they may sometimes more or less succeed in painting St. Peter the Fisher's face, never by any chance realize for you the green wave dashing over his feet.

¶ Now, therefore, understand of the opposite so called 'Pre-Raphaelite', and, much more, pre-Rubensite, society, that its primary virtue is the

[1] Ill. 52 facing this page, bought in 1861 as Van Dyck, now ascribed to Rubens.

trying to conceive things as they are, and thinking and feeling them quite out:—believing joyfully if we may, doubting bravely, if we must,—but never mystifying, or shrinking from, or choosing for argument's sake, this or that fact; but giving every fact its own full power, and every incident and accessory its own true place,—so that, still keeping to our illustrations from Brighton or Yarmouth beach, in that most noble picture by Millais which probably most of you saw last autumn in London, the 'Caller Herrin',—picture which, as a piece of art, I should myself put highest of all yet produced by the Pre-Raphaelite school;—in that most noble picture, I say, the herrings were painted just as well as the girl, and the master was not the least afraid that, for all he could do to them, you would look at the herrings first.

¶ Now then, I think I have got the manner of Pre-Raphaelite 'Realization'—'Verification'—'Materialization'—or whatever else you choose to call it, positively enough asserted and defined: and hence you will see that it follows, as a necessary consequence, that Pre-Raphaelite subjects must usually be of real persons in a solid world—not of personifications in a vaporescent one.

The persons may be spiritual, but they are individual,—St. George, himself, not the vague idea of Fortitude; St. Cecily herself, not the mere power of music. And, although spiritual, there is no attempt whatever made by this school to indicate their immortal nature by any evanescence or obscurity of aspect. All transparent ghosts and unoutlined spectra are the work of failing imagination,—rest you sure of that. Botticelli indeed paints the Favonian breeze transparent, but never the Angel Gabriel; and in [Hunt's 'Triumph of the Innocents']—if there *be* a fault which may jar for a moment on your feelings when you first see it, I am afraid it will be that the souls of the Innocents are a little too chubby, and one or two of them, I should say, just a dimple too fat. . . .

Nevertheless, we find one of the artists whose close friendship with Rossetti, and fellowship with other members of the Pre-Raphaelite brotherhood, have more or less identified his work with theirs, yet differing from them all diametrically in this, that his essential gift and habit of thought is *in* personification, and that,—for sharp and brief instance,—had both Rossetti and he been set to illustrate the first chapter of Genesis, Rossetti would have painted either Adam or Eve; but Edward Burne-Jones, a Day of Creation.

And in this gift, he becomes a painter, neither of Divine History, nor of Divine Natural History, but of Mythology, accepted as such, and understood by its symbolic figures to represent only general truths, or abstract ideas. . . .

¶ [Both in line and colour], Mr. Burne-Jones has developed their

applicable powers to their highest extent. His outline is the purest and quietest that is possible to the pencil; nearly all other masters accentuate falsely, or in some places, as Richter, add shadows which are more or less conventional. But an outline by Burne-Jones is as pure as the lines of engraving on an Etruscan mirror; and the series of drawings from the story of Psyche [are] faultlessly exemplary in this kind. Whether pleasing or displeasing to your taste, they are entirely masterful; and it is only by trying to copy these or other such outlines, that you will fully feel the grandeur of action in the moving hand, tranquil and swift as a hawk's flight, and never allowing a vulgar tremor, or a momentary impulse, to impair its precision, or to disturb its serenity.

¶ Again, though Mr. Jones has a sense of colour, in its kind, perfect, he is essentially a chiaroscurist. Diametrically opposed to Rossetti, who could conceive in colour only, he prefers subjects which can be divested of superficial attractiveness; appeal first to the intellect and the heart; and convey their lesson either through intricacies of delicate line, or in the dimness or coruscation of ominous light . . .

¶ For there is this perpetually increasing difficulty towards the completion of any work, that the added forces of colour destroy the value of the pale and subtle tints or shades which give the nobleness to expression; so that the most powerful masters in oil painting rarely aim at expression, but only at general character: and I believe the great artist whose name I have associated with that of Burne-Jones as representing the mythic schools, Mr. G. F. Watts, has been partly restrained, and partly oppressed, by the very earnestness and extent of the study through which he has sought to make his work on all sides perfect. His constant reference to the highest examples of Greek art in form, and his sensitiveness to the qualities at once of tenderness and breadth in pencil and chalk drawing, have virtually ranked him among the painters of the great Athenian days, of whom, in the sixth book of the *Laws*, Plato wrote: 'You know how the intently accurate toil of a painter seems never to reach a term that satisfies him; but he must either farther touch, or soften the touches laid already, and never seems to reach a point where he has not yet some power to do more, so as to make the things he has drawn more beautiful, and more apparent: καλλίω τε καὶ φανερώτερα.' [1]

From *The Art of England*, 1883.

Classic and Gothic

IN THIS FOLLOWING lecture, you must please understand at once that I use the word 'classic', first in its own sense of senatorial, academic, and authoritative; but, as a necessary consequence of that first meaning,

[1] *Laws*, Vol. VI, p. 769B.

also in the sense, more proper to our immediate subject, of Anti-Gothic; antagonist, that is to say, to the temper in which Gothic architecture was built: and not only antagonist to that form of art, but contemptuous of it; unforgiving to its faults, cold to its enthusiasms, and impatient of its absurdities. In which contempt the classic mind is certainly illiberal; and narrower than the mind of an equitable art student should be in these enlightened days:—for instance, in the British Museum, it is quite right that the British public should see the Elgin marbles to the best advantage; but not that they should be unable to see any example of the sculpture of Chartres or Wells, unless they go to the miscellaneous collection at Kensington, where Gothic saints and sinners are confounded alike among steam thrashing-machines and dynamite-proof ships of war; or to the Crystal Palace, where they are mixed up with Rimmel's perfumery.

¶ For this hostility, in our present English schools, between the votaries of classic and Gothic art, there is no ground in past history, and no excuse in the nature of those arts themselves. Briefly, to-day, I would sum for you the statement of their historical continuity . . .

Only observe, for the present, you must please put Oriental Art entirely out of your heads. I shall allow myself no allusion to China, Japan, India, Assyria, or Arabia: though this restraint on myself will be all the more difficult, because, only a few weeks since, I had a delightful audience of Sir Frederic Leighton beside his Arabian fountain, and beneath his Aladdin's palace glass.[1] Yet I shall not allude, in what I say of his designs, to any points in which they may perchance have been influenced by those enchantments. Similarly there were some charming Zobeides and Cleopatras among the variegated colour fancies of Mr. Alma Tadema in the last Grosvenor;[2] but I have nothing yet to say of *them*: it is only as a careful and learned interpreter of certain phases of Greek and Roman life, and as himself a most accomplished painter, on long-established principles, that I name him as representatively 'classic'.

¶ The summary, therefore, which I have to give you of the course of Pagan and Gothic Art must be understood as kept wholly on this side of the Bosphorus, and recognizing no farther shore beyond the Mediterranean. Thus fixing our termini, you find from the earliest times, in Greece and Italy, a multitude of artists gradually perfecting the knowledge and representation of the human body, glorified by the exercises of war. And you have, north of Greece and Italy, innumerably and incorrigibly savage nations, representing, with rude and irregular efforts, on huge stones and

[1] In 'Leighton House', Holland Park Road, presented by Leighton's sisters to a committee for public purposes.

[2] The Winter Exhibition at the Grosvenor Gallery, 1882-1883, consisted for the most part of a 'Collection of the Works of L. Alma Tadema, R.A.'

ice-borne boulders, on cave-bones and forest-stocks and logs, with any manner of innocent tinting or scratching possible to them, sometimes beasts, sometimes hobgoblins—sometimes, heaven only knows what; but never attaining any skill in figure-drawing, until, whether invading or invaded, Greece and Italy teach them what a human being is like; and with that help they dream and blunder on through the centuries, achieving many fantastic and amusing things, more especially the art of rhyming, whereby they usually express their notions of things far better than by painting. Nevertheless, in due course we get a Holbein out of them; and, in the end, for best product hitherto, Sir Joshua, and the supremely Gothic Gainsborough, whose last words we may take for a beautiful reconciliation of all schools and souls who have done their work to the best of their knowledge and con-science,—'We are all going to Heaven, and Vandyke is of the company.' . . .

¶ In turning now from these subjects of Gothic art to consider the classic ideal, though I do so in painful sense of transgressing the limits of my accurate knowledge, I do not feel entirely out of my element, because in some degree I claim even Sir Frederic Leighton as a kindred Goth. For, if you will overpass quickly in your minds, what you remember of the treasures of Greek antiquity, you will find that, among them all, you can get no notion of what a Greek little girl was like. Matronly Junos, and tremendous Demeters, and Gorgonian Minervas, as many as you please; but for my own part, always speaking as a Goth, I had much rather have had some idea of the Spartan Helen dabbling with Castor and Pollux in the Eurotas—none of them over ten years old. And it is with extreme gratitude, therefore, and unqualified admiration, that I find Sir Frederic condescending from the majesties of Olympus to the worship of these unappalling powers, which, heaven be thanked, are as brightly Anglo-Saxon as Hellenic; and painting for us, with a soft charm peculiarly his own, the witchcraft and the wonderfulness of childhood.

¶ I have no right whatever to speak of the works of higher effort and claim, which have been the result of his acutely observant and en-thusiastic study of the organism of the human body. I am indeed able to recognize his skill; but have no sympathy with the subjects that admit of its display. I am enabled, however, to show you with what integrity of application it has been gained, by his kindness in lending me for the Ruskin school two perfect early drawings, one of a lemon tree,—and another, of the same date, of a Byzantine well, which determine for you without appeal, the question respecting necessity of delineation as the first skill of a painter.[1] Of all our present masters, Sir Frederic Leighton delights most

[1] The 'Lemon Tree' was drawn at Capri in the spring of 1859; the 'Byzantine well-head' is dated 1852. These pencil studies were returned to the artist, and in 1900 were in the possession of Mr. S. Pepys Cockerell.

in softly-blended colours, and his ideal of beauty is more nearly that of Correggio than any seen since Correggio's time. But you see by what precision of terminal outline he at first restrained, and exalted, his gift of beautiful vaghezza.

¶ Nor is the lesson one whit less sternly conveyed to you by the work of M. Alma Tadema, who differs from all the artists I have ever known, except John Lewis, in the gradual increase of technical accuracy, which attends and enhances together the expanding range of his dramatic invention; while every year he displays more varied and complex powers of minute draughtsmanship, more especially in architectural detail, wherein, somewhat priding myself as a specialty, I nevertheless receive continual lessons from him; except only in this one point,—that, with me, the translucency and glow of marble is the principal character of its substance, while with M. Tadema it is chiefly the superficial lustre and veining which seem to attract him; and these, also, seen, not in the strength of southern sun, but in the cool twilight of luxurious chambers. With which insufficient, not to say degrading, choice of architectural colour and shade, there is a fallacy in his classic idealism, against which, while I respectfully acknowledge his scholarship and his earnestness, it is necessary that you should be gravely and conclusively warned. . . .

¶ Now observe, that whether of Greek or Roman life, M. Alma Tadema's pictures are always in twilight—interiors, ὑπὸ συμμιγεῖ σκιᾷ [1], I don't know if you saw the collection of them last year at the Grosvenor, but with that universal twilight there was also universal crouching or lolling posture,—either in fear or laziness. And the most gloomy, the most crouching, the most dastardly of all these representations of classic life, was the little picture called the Pyrrhic Dance, of which the general effect was exactly like a microscopic view of a small detachment of black-beetles, in search of a dead rat.

¶ I have named to you the Achillean splendour as primary type of Greek war; but you need only glance, in your memory, for a few instants, over the habitual expressions of all the great poets, to recognize the magnificence of light, terrible or hopeful; the radiance of armour, over all the field of battle, or flaming at every gate of the city; as in the blazoned heraldry of the Seven against Thebes,—or beautiful, as in the golden armour of Glaucus, down to the baser brightness for which Camilla died: remember also that the ancient Doric dance was strictly the dance of Apollo; seized again by your own mightiest poet for the chief remnant of the past in the Greece of to-day—

> 'You have the Pyrrhic dance as yet;
> Where is the Pyrrhic phalanx gone?'

[1] Plato, *Phædrus*, 239, C.

And *this* is just the piece of classic life which your nineteenth century fancy sets forth under its fuliginous and cantharoid disfigurement and disgrace.

I say, *your* nineteenth century fancy, for M. Alma Tadema does but represent—or rather, has haplessly got himself entangled in,—the vast vortex of recent Italian and French revolutionary rage against all that resists, or ever did resist, its licence; in a word, against all priesthood and knighthood.

The Roman state, observe, in the strength of it expresses both these; the orders of chivalry do not rise out of the disciplining of the hordes of Tartar horsemen, but by the Christianizing of the Roman eques; and the noble priesthood of Western Christendom is not, in the heart of it, hieratic, but pontifical. And it is the last corruption of this Roman state, and its Bacchanalian phrenzy, which M. Alma Tadema seems to hold it his heavenly mission to pourtray.

¶ I have no mind, as I told you, to darken the healthy work I hope to lead you into by any frequent reference to antagonist influences. But it is absolutely necessary for me to-day to distinguish, once for all, what it is above everything your duty, as scholars in Oxford, to know and love— the perpetual laws of classic literature and art, the laws of the Muses, from what has of late again infected the schools of Europe under the pretence of classic study, being indeed only the continuing poison of the Renaissance, and ruled, not by the choir of the Muses, but by the spawn of the Python. And this I have been long minded to do; but am only now enabled to do completely and clearly, and beyond your doubt, by having obtained for you the evidence, unmistakable, of what remains classic from the ancient life of Italy—the ancient Etruscan life, down to this day; which is the perfection of humility, modesty, and serviceableness, as opposed to the character which remains in my mind as the total impression of the Academy and Grosvenor,—that the young people of this day desire to be painted first as proud, saying, How grand I am; next as immodest, saying, How beautiful I am; lastly as idle, saying, I am able to pay for flunkeys, and never did a stroke of work in my life.

¶ Since the day of the opening of the great Manchester exhibition in 1857, every Englishman, desiring to express interest in the arts, considers it his duty to assert with Keats that a thing of beauty is a *joy* for ever.[1] I do not know in what sense the saying was understood by the Manchester school. But this I know, that what joy may remain still for you and for your children—in the fields, the homes, and the churches of England—you must win by otherwise reading the fallacious line. A beautiful thing may exist but for a moment, as a reality;—it exists for ever as a testimony. To the

[1] See Vol. XVI, p. 11.

law and to the witness of it the nations must appeal, 'in secula seculorum';
and in very deed and very truth, a thing of beauty is a *law* for ever.

That is the true meaning of classic art and of classic literature;—not the
licence of pleasure, but the law of goodness; and if, of the two words,
καλὸς κ'ἀγαθός, one can be left unspoken, as implied by the other, it is the
first, not the last. It is written that the Creator of all things beheld them
—not in that they were beautiful, but in that they were good.

¶ This law of beauty may be one, for aught we know, fulfilling itself
more perfectly as the years roll on; but at least it is one from which no jot
shall pass. The beauty of Greece depended on the laws of Lycurgus; the
beauty of Rome, on those of Numa; our own, on the laws of Christ.
On all the beautiful features of men and women, throughout the ages,
are written the solemnities and majesty of the law they knew, with the
charity and meekness of their obedience; on all unbeautiful features are
written either ignorance of the law, or the malice and insolence of their dis-
obedience. . . .

<div style="text-align:right">From The Art of England, 1883.</div>

English Landscape

. . . I wish in the present lecture to define to you the nature and
meaning of landscape art, as it arose in England eighty years ago, without
reference to the great master whose works have been the principal subject
of my own enthusiasm. I have always stated distinctly that the genius of
Turner was exceptional, both in its kind and in its height: and although his
elementary modes of work are beyond dispute authoritative, and the best
that can be given for example and exercise, the general tenor of his design
is entirely beyond the acceptance of common knowledge, and even of safe
sympathy. For in his extreme sadness, and in the morbid tones of mind out
of which it arose, he is one with Byron and Goethe; and is no more to be
held representative of general English landscape art than *Childe Harold* or
Faust are exponents of the total love of Nature expressed in English or
German literature. To take a single illustrative instance, there is no fore-
ground of Turner's in which you can find a flower.

¶ In some respects, indeed, the vast strength of this unfollowable
Eremite of a master was crushing, instead of edifying, to the English schools.
All the true and strong men who were his contemporaries shrank from the
slightest attempt at rivalry with him on his own lines;—and his own lines
were cast far. But for him, Stanfield might have sometimes painted an
Alpine valley, or a Biscay storm; but the moment there was any question of

rendering magnitude, or terror, every effort became puny beside Turner, and Stanfield meekly resigned himself to potter all his life round the Isle of Wight, and paint the Needles on one side, and squalls off Cowes on the other. In like manner, Copley Fielding in his young days painted vigorously in oil, and showed promise of attaining considerable dignity in classic composition; but the moment Turner's Garden of Hesperides and Building of Carthage appeared in the Academy, there was an end to ambition in that direction; and thenceforth Fielding settled down to his quiet presidency of the old Water-Colour Society, and painted, in unassuming replicas, his passing showers in the Highlands, and sheep on the South Downs.

¶ Which are, indeed, for most of us, much more appropriate objects of contemplation; and the old water-colour room at that time, adorned yearly with the complete year's labour of Fielding, Robson, De Wint, Barret, Prout, and William Hunt, presented an aggregate of unaffected pleasantness and truth, the like of which, if you could now see, after a morning spent among the enormities of luscious and exotic art which frown or glare along your miles of exhibition wall, would really be felt by you to possess the charm of a bouquet of bluebells and cowslips, amidst a prize show of cactus and orchid from the hothouses of Kew.

The root of this delightfulness was an extremely rare sincerity in the personal pleasure which all these men took, not in their own pictures, but in the *subjects* of them—a form of enthusiasm which, while it was as simple, was also as romantic, in the best sense, as the sentiment of a young girl: and whose nature I can the better both define and certify to you, because it was the impulse to which I owed the best force of my own life, and in sympathy with which I have done or said whatever of saying or doing in it has been useful to others.

¶ I believe that with the name of Richard Wilson, the history of sincere landscape art, founded on a meditative love of Nature, begins for England: and, I may add, for Europe, without any wide extension of claim; for the only continental landscape work of any sterling merit with which I am acquainted, consists in the old-fashioned drawings, made fifty years ago to meet the demand of the first influx of British travellers into Switzerland after the fall of Napoleon.

With Richard Wilson, at all events, our own true and modest schools began, an especial direction being presently given to them in the rendering effects of aerial perspective by the skill in water-colour of Girtin and Cozens. The drawings of these two masters, recently bequeathed to the British Museum, and I hope soon to be placed in a well-lighted gallery, contain quite insuperable examples of skill in the management of clear tints, and of the meditative charm consisting in the quiet and unaffected treatment of literally true scenes.

But the impulse to which the new school owed the discovery of its power in *colour* was owing, I believe, to the poetry of Scott and Byron. Both by their vivid passion and accurate description, the painters of their day were taught the true value of natural colour, while the love of mountains, common to both poets, forced their illustrators into reverent pilgrimage to scenes which till then had been thought too desolate for the spectator's interest, or too difficult for the painter's skill.

¶ I have endeavoured, in the 92nd number of *Fors Clavigera*, to give some analysis of the main character of the scenery by which Scott was inspired; but, in endeavouring to mark with distinctness enough the dependence of all its sentiment on the beauty of its rivers, I have not enough referred to the collateral charm, in a borderer's mind, of the very mists and rain that feed them. In the climates of Greece and Italy, the monotonous sunshine, burning away the deep colours of everything into white and grey, and wasting the strongest mountain-streams into threads among their shingle, alternates with the blue-fiery thunder-cloud, with sheets of flooding rain, and volleying musquetry of hail. But throughout all the wild uplands of the former Saxon kingdom of Northumbria, from Edwin's crag to Hilda's cliff, the wreaths of softly resting mist, and wandering to and fro of capricious shadows of clouds, and drooping swathes, or flying fringes, of the benignant western rain, cherish, on every moorland summit, the deep-fibred moss,—embalm the myrtle,—gild the asphodel,—enchant along the valleys the wild grace of their woods, and the green elf land of their meadows; and passing away, or melting into the translucent calm of mountain air, leave to the open sunshine a world with every creature ready to rejoice in its comfort, and every rock and flower reflecting new loveliness to its light. . . .

¶ Neither must you think that this painting of fresh air is an entirely easy or soon managed business. You may paint a modern French emotional landscape, with a pail of whitewash and a pot of gas-tar in ten minutes, at the outside. I don't know how long the operator himself takes to it— of course some little more time must be occupied in plastering on the oil-paint so that it will stick, and not run; but the skill of a good plasterer is really all that is required,—the rather that in the modern idea of solemn symmetry you always make the bottom of your picture, as much as you can, like the top. You put seven or eight streaks of the plaster for your sky, to begin with; then you put in a row of bushes with the gas-tar, then you rub the ends of them into the same shapes upside down—you put three or four more streaks of white, to intimate the presence of a pool of water— and if you finish off with a log that looks something like a dead body, your picture will have the credit of being a digest of a whole novel of Gaboriau, and lead the talk of the season.

¶ Far other was the kind of labour required of even the least disciple of the old English water-colour school. In the first place, the skill of laying a perfectly even and smooth tint with absolute precision of complex out-line was attained to a degree which no amateur draughtsman can have the least conception of. Water-colour, under the ordinary sketcher's mismanage-ment, drops and dries pretty nearly to its own fancy,—slops over every outline, clots in every shade, seams itself with undesirable edges, speckles itself with inexplicable grit, and is never supposed capable of representing anything it is meant for, till most of it has been washed out. But the great primary masters of the trade could lay, with unerring precision of tone and equality of depth, the absolute tint they wanted without a flaw or a re-touch; and there is perhaps no greater marvel of artistic practice and finely accurate intention existing, in a simple kind, greater than the study of a Yorkshire waterfall, by Girtin, now in the British Museum, in which every sparkle, ripple, and current is left in frank light by the steady pencil which is at the same instant, and with the same touch, drawing the forms of the dark congeries of channelled rocks, while around them it disperses the glitter of their spray.

¶ Then further, on such basis of well-laid primary tint, the old water-colour men were wont to obtain their effects of atmosphere by the most delicate washes of transparent colour, reaching subtleties of gradation in misty light, which were wholly unthought of before their time. In this kind the depth of far-distant brightness, freshness, and mystery of morning air with which Copley Fielding used to invest the ridges of the South Downs, as they rose out of the blue Sussex champaign, remains, and I believe must remain, insuperable, while his sense of beauty in the cloud-forms associ-ated with higher mountains, enabled him to invest the comparatively modest scenery of our own island,—out of which he never travelled,— with a charm seldom attained by the most ambitious painters of Alp or Apennine . . .

From *The Art of England*, 1883.

PART TWO

ARCHITECTURE AND SCULPTURE

ARCHITECTURE
AND SCULPTURE

English and French Cottages

. . . The principal thing worthy of observation in the lowland cottage of England is its finished neatness. The thatch is firmly pegged down, and mathematically levelled at the edges; and, though the martin is permitted to attach his humble domicile, in undisturbed security, to the eaves 'he may be considered as enhancing the effect of the cottage, by increasing its usefulness, and making it contribute to the comfort of more beings than one. The whitewash is stainless, and its rough surface catches a side light as brightly as a front one: the luxuriant rose is trained gracefully over the window; and the gleaming lattice, divided not into heavy squares, but into small pointed diamonds, is thrown half open, as is just discovered by its glance among the green leaves of the sweet briar, to admit the breeze, that, as it passes over the flowers, becomes full of their fragrance. The light wooden porch breaks the flat of the cottage face by its projection; and a branch or two of wandering honeysuckle spread over the low hatch. A few square feet of garden, and a latched wicket, persuading the weary and dusty pedestrian, with expressive eloquence, to lean upon it for an instant, and request a drink of water or milk, complete a picture, which, if it be far enough from London to be unspoiled by town sophistications, is a very perfect thing in its way. The ideas it awakens are agreeable, and the architecture is all that we want in such a situation. It is pretty and appropriate; and if it boasted of any other perfection, it would be at the expense of its propriety.

¶ Let us now cross the Channel, and endeavour to find a country cottage on the other side, if we can; for it is a difficult matter. There are many villages; but such a thing as an isolated cottage is extremely rare. Let us try one or two of the green valleys among the chalk eminences which sweep from Abbeville to Rouen. Here is a cottage at last, and a picturesque one, which is more than we could say for the English domicile. What then is the difference? There is a general air of *nonchalance* about the French peasant's habitation, which is aided by a perfect want of everything like neatness; and rendered more conspicuous by some points about the

building which have a look of neglected beauty, and obliterated ornament. Half of the whitewash is worn off, and the other half coloured by various mosses and wandering lichens, which have been permitted to vegetate upon it, and which, though beautiful, constitute a kind of beauty from which the ideas of age and decay are inseparable. The tall roof of the garret window stands fantastically out; and underneath it, where in England, we had a plain double lattice, is a deep recess, flatly arched at the top, built of solid masses of grey stone, fluted on the edge; while the brightness of the glass within (if there be any) is lost in shade, causing the recess to appear to the observer like a dark eye. The door has the same character: it is also of stone, which is so much broken and disguised as to prevent it from giving any idea of strength or stability. The entrance is always open; no roses, or anything else, are wreathed about it; several out-houses, built in the same style, give the buildings extent; and the group (in all probability, the dependency of some large old château in the distance) does not peep out of copse or thicket, or a group of tall and beautiful trees, but stands comfortlessly between two individuals of the column of long-trunked facsimile elms which keep guard along the length of the public road.

¶ Now, let it be observed how perfectly, how singularly, the distinctive characters of these two cottages agree with those of the countries in which they are built; and of the people for whose use they are constructed. England is a country whose every scene is in miniature. Its green valleys are not wide; its dewy hills are not high; its forests are of no extent, or, rather, it has nothing that can pretend to a more sounding title than that of 'wood'. Its champaigns are minutely chequered into fields; we can never see far at a time; and there is a sense of something inexpressible, except by the truly English word 'snug', in every quiet nook and sheltered lane. The English cottage, therefore, is equally small, equally sheltered, equally invisible at a distance.

¶ But France is a country on a large scale. Low, but long hills, sweep away for miles into vast uninterrupted champaigns; immense forests shadow the country for hundreds of square miles, without once letting through the light of day; its pastures and arable land are divided on the same scale; there are no fences; we can hardly place ourselves in any spot where we shall not see for leagues around; and there is a kind of comfortless sublimity in the size of every scene. The French cottage, therefore, is on the same scale, equally large and desolate-looking; but . . . it can arouse feelings which, though they cannot be said to give it sublimity, yet are of a higher order than any which can be awakened at the sight of an English cottage. . . .

The Poetry of Architecture; or the Architecture of the Nations of Europe considered in its Association with Natural Scenery and National Character, Vol. I, p. 5.[1]

[1] The articles, over the signature Kataphusin, appeared in the *Architectural Magazine* of 1837-8.

53. STUDIES OF TREE GROWTH. Drawing by Ruskin. *Oxford, Ashmolean Museum*

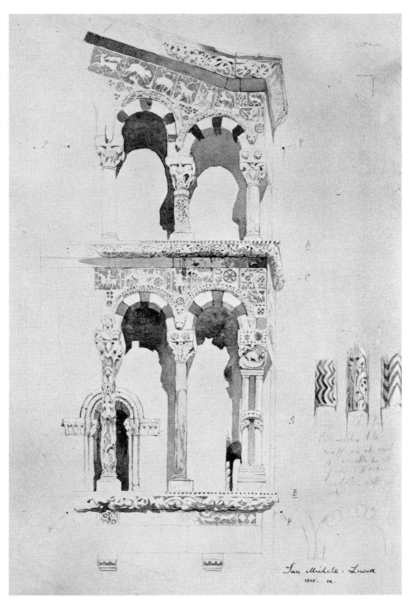

54. FAÇADE OF S. MICHELE AT LUCCA. Drawing by Ruskin. *Oxford, Ashmolean Museum*

Antiquity

IT IS evident, first, that if the design of the building be originally bad, the only virtue it can ever possess will be in signs of antiquity. All that in this world enlarges the sphere of affection or imagination is to be reverenced, and all those circumstances enlarge it which strengthen our memory or quicken our conception of the dead. Hence it is no light sin to destroy anything that is old; more especially because, even with the aid of all obtainable records of the past, we, the living, occupy a space of too large importance and interest in our own eyes; we look upon the world too much as our own, too much as if we had possessed it and should possess it for ever, and forget that it is a mere hostelry, which we occupy the apartments for a time, which others better than we have sojourned in before, who are now where we should desire to be with them. Fortunately for mankind, as some counterbalance to that wretched love of novelty which originates in selfishness, shallowness, and conceit, and which especially characterizes all vulgar minds, there is set in the deeper places of the heart, such affection for the signs of age that the eye is delighted even by injuries which are the work of time; not but that there is also real and absolute beauty in the forms and colours so obtained for which the original lines of the architecture, unless they have been very grand indeed, are well exchanged; so that there is hardly any building so ugly but that it may be made an agreeable object by such appearances. It would not be easy, for instance, to find a less pleasing piece of architecture than the portion of the front of Queen's College, Oxford, which has just been restored; yet I believe that few persons could have looked with total indifference on the mouldering and shattered surface of the oolite limestone, previous to its restoration. . . .

Again, upon all forms of sculptural ornament the effect of time is such, that if the design be poor, it will enrich it; if overcharged, simplify it; if harsh and violent, soften it; if smooth and obscure, exhibit it; whatever faults it may have are rapidly disguised; whatever virtue it has still shines and steals out in the mellow light; and this to such an extent, that the artist is always liable to be tempted to the drawing of details in old buildings as of extreme beauty, which look cold and hard in their architectural lines; and I have never yet seen any restoration or cleaned portion of a building whose effect was not inferior to the weathered parts, even to those of which the design had in some parts almost disappeared. On the front of the Church of San Michele at Lucca[1] the mosaics have fallen out of half the columns, and lie in weedy ruin beneath; in many, the frost has torn large masses of the entire coating away, leaving a scarred unsightly surface.

[1] Ill. 54 facing this page.

Two of the shafts of the upper star window are eaten entirely away by the sea-wind; the rest have lost their proportions; the edges of the arches are hacked into deep hollows, and cast indented shadows on the weed-grown wall. The process has gone too far, and yet I doubt not but that this building is seen to greater advantage now than when first built. . . .

From *Modern Painters*, Vol. I, Part II, Sec. I, Ch. VII, ¶ 26.

Shadow and Ornament

IT IS, I believe, hardly enough observed among architects, that the same decorations are of totally different effect according to their position and the time of day. A moulding which is of value on a building facing south, where it takes dark shadows from steep sun, may be utterly ineffective if placed west or east; and a mould which is chaste and intelligible in shade on a north side may be grotesque, vulgar or confused when it takes black shadows on the south. Farther, there is a time of day in which every architectural decoration is seen to best advantage, and certain times in which its peculiar force and character are best explained. Of these niceties the architect takes little cognizance, as he must in some sort calculate on the effect of ornament at all times: but to the artist they are of infinite importance. . . .

From *Modern Painters*, Vol. I, Part II, Sec. I, Ch. VII, ¶ 27.

Ilaria di Caretto

IN THE Cathedral of Lucca, near the entrance door of the north transept, there is a monument by Jacopo della Quercia to Ilaria di Caretto,[1] the wife of Paolo Guinigi. I name it not as more beautiful or perfect than other examples of the same period; but as furnishing an instance of the exact and right mean between the rigidity and rudeness of the earlier monumental effigies, and the morbid imitation of life, sleep, or death, of which the fashion has taken place in modern times. She is lying on a simple couch with a hound at her feet; not on the side, but with the head laid straight and simply on the hard pillow, in which, let it be observed, there is no effort at deceptive imitation of pressure. It is understood as a pillow, but not mistaken for one. The hair is bound in a flat braid over the fair brow, the sweet and arched eyes are closed, the tenderness of the loving lips is set and quiet; there is that about them which forbids breath; something which is not death nor sleep, but the pure image of both. The hands are not

[1] Ill. 71 and 72 facing page 283.

lifted in prayer, neither folded, but the arms are laid at length upon the body, and the hands cross as they fall. The feet are hidden by the drapery, and the forms of the limbs concealed, but not their tenderness.

If any of us, after staying for a time beside this tomb, could see, through his tears, one of the vain and unkind encumbrances of the grave, which, in these hollow and heartless days, feigned sorrow builds to foolish pride, he would, I believe, receive such a lesson of love as no coldness could refuse, no fatuity forget, and no insolence disobey.

From *Modern Painters*, Vol. II, Part III, Sec. I, Ch. VII, ¶ 7.

THE SEVEN LAMPS OF ARCHITECTURE

I THE LAMP OF SACRIFICE

II THE LAMP OF TRUTH . III THE LAMP OF POWER

IV THE LAMP OF BEAUTY . V THE LAMP OF LIFE

VI THE LAMP OF MEMORY

VII THE LAMP OF OBEDIENCE

The Lamp of Sacrifice

. . . I would place first that spirit which . . . has . . . especial reference to devotional and memorial architecture—the spirit which offers for such work precious things, simply because they are precious; not as being necessary to the building, but as an offering, surrendering, and sacrifice of what is to ourselves desirable. It seems to me, not only that this feeling is in most cases wholly wanting in those who forward the devotional buildings of the present day; but that it would even be regarded as a dangerous, or perhaps criminal, principle by many among us. I have not space to enter into dispute of all the various objections which may be urged against it —they are many and specious; but I may, perhaps, ask the reader's patience while I set down those simple reasons which cause me to believe it a good and just feeling, and as well-pleasing to God and honourable in men, as it is beyond all dispute necessary to the production of any great work in the kind with which we are at present concerned.

¶ Now, first, to define this Lamp, or Spirit, of Sacrifice, clearly. I have said that it prompts us to the offering of precious things, merely because

they are precious, not because they are useful or necessary. It is a spirit, for instance, which of two marbles, equally beautiful, applicable, and durable, would choose the more costly, because it was so, and of two kinds of decoration, equally effective, would choose the more elaborate because it was so, in order that it might in the same compass present more cost and more thought. It is therefore most unreasoning and enthusiastic, and perhaps less negatively defined, as the opposite of the prevalent feelings of modern times, which desires to produce the largest results at the least cost. . . .

¶ The question is not between God's house and His poor: it is not between God's house and His Gospel. It is between God's house and ours. Have we no tesselated colours on our floors? no frescoed fancies on our roofs? no niched statuary in our corridors? no gilded furniture in our chambers? no costly stones in our cabinets? Has even the tithe of these been offered? They are, or they ought to be, the signs that enough has been devoted to the great purposes of human stewardship, and that there remains to us what we can spend in luxury; but there is a greater and prouder luxury than this selfish one—that of bringing a portion of such things as these into sacred service, and presenting them for a memorial * that our pleasure as well as our toil has been hallowed by the remembrance of Him who gave both the strength and the reward. And until this has been done, I do not see how such possessions can be retained in happiness. I do not understand the feeling which would arch our own gates and pave our own thresholds, and leave the church with its narrow door and foot-worn sill; the feeling which enriches our own chambers with all manner of costliness, and endures the bare wall and mean compass of the temple. There is seldom even so severe a choice to be made, seldom so much self-denial to be exercised. There are isolated cases, in which men's happiness and mental activity depend upon a certain degree of luxury in their houses; but then this is true luxury, felt and tasted, and profited by. In the plurality of instances nothing of the kind is attempted, nor can be enjoyed; men's average resources cannot reach it; and that which they *can* reach, gives them no pleasure, and might be spared. It will be seen, in the course of the following chapters, that I am no advocate for meanness of private habitation. I would fain introduce into it all magnificence, care, and beauty, where they are possible; but I would not have that useless expense in unnoticed fineries or formalities; cornicing of ceilings and graining of doors, and fringing of curtains, and thousands such; things which have become falsely and apathetically habitual—things on whose common appliance hang whole trades, to which there never yet belonged the blessing of giving one ray of real pleasure, or becoming of the remotest or most contemptible use—

* Num. xxxi. 54. Psa. lxxvi. 11.

things which cause half the expense of life, and destroy more than half
its comfort, manliness, respectability, freshness, and facility. I speak from
experience: I know what it is to live in a cottage with a deal floor and roof,
and a hearth of mica slate; and I know it to be in many respects healthier
and happier than living between a Turkey carpet and gilded ceiling, beside
a steel grate and polished fender. I do not say that such things have not
their place and propriety; but I say this, emphatically, that the tenth part
of the expense which is sacrificed in domestic vanities, if not absolutely
and meaninglessly lost in domestic discomforts and incumbrances, would, if
collectively offered and wisely employed, build a marble church for every
town in England; such a church as it should be a joy and a blessing even to
pass near in our daily ways and walks, and as it would bring the light into
the eyes to see from afar, lifting its fair height above the purple crowd of
humble roofs.

¶ . . . All old work nearly has been hard work. It may be the hard
work of children, of barbarians, of rustics; but it is always their utmost.
Ours has as constantly the look of money's worth, of a stopping short
wherever and whenever we can, of a lazy compliance with low conditions;
never of a fair putting forth of our strength. Let us have done with this
kind of work at once: cast off every temptation to it: do not let us degrade
ourselves voluntarily, and then mutter and mourn over our shortcomings;
let us confess our poverty or our parsimony, but not belie our human
intellect. It is not even a question of how *much* we are to do, but of how it
is to be done; it is not a question of doing more, but of doing better. Do
not let us boss our roofs with wretched half-worked, blunt-edged rosettes;
do not let us flank our gates with rigid imitations of mediæval statuary.
Such things are mere insults to common sense, and only unfit us for feeling
the nobility of their prototypes. We have so much, suppose, to be spent in
decoration; let us go to the Flaxman of his time, whoever he may be; and
bid him carve for us a single statue, frieze, or capital, or as many as we can
afford, compelling upon him the one condition, that they shall be the best
he can do; place them where they will be of the most value, and be content.
Our other capitals may be mere blocks, and our other niches empty. No
matter: better our work unfinished than all bad. It may be that we do not
desire ornament of so high an order: choose, then, a less developed style,
as also, if you will, rougher material; the law which we are enforcing
requires only that what we pretend to do and to give, shall both be the
best of their kind; choose, therefore, the Norman hatchet work, instead of
the Flaxman frieze and statue, but let it be the best hatchet work; and if
you cannot afford marble use Caen stone, but from the best bed; and if
not stone, brick, but the best brick; preferring always what is good of a
lower order of work or material, to what is bad of a higher; for this is not

only the way to improve every form of work, and to put every kind of material to better use; but it is more honest and unpretending, and is in harmony with other just, upright, and manly principles. . . .

¶ The other condition which we had to notice, was the value of the appearance of labour upon architecture. . . . It is, indeed, one of the most frequent sources of pleasure which belong to the art, always, however, within certain somewhat remarkable limits. For it does not at first appear easily to be explained why labour, as represented by materials of value, should, without sense of wrong or error, bear being wasted; while the waste of actual workmanship is always painful, so soon as it is apparent. But so it is, that, while precious materials may, with a certain profusion and negligence, be employed for the magnificence of what is seldom seen, the work of man cannot be carelessly and idly bestowed, without an immediate sense of wrong; as if the strength of the living creature were never intended by its Maker to be sacrified in vain, though it is well for us sometimes to part with what we esteem precious of substance, as showing that in such service it becomes but dross and dust. And in the nice balance between the straitening of effort or enthusiasm on the one hand, and vainly casting it away upon the other, there are more questions than can be met by any but very just and watchful feeling. In general it is less the mere loss of labour that offends us, than the lack of judgment implied by such loss; so that if men confessedly work for work's sake, and it does not appear that they are ignorant where or how to make their labour tell, we shall not be grossly offended. On the contrary, we shall be pleased if the work be lost in carrying out a principle, or in avoiding a deception. It, indeed, is a law properly belonging to another part of our subject, but it may be allowably stated here, that, whenever, by the construction of a building, some parts of it are hidden from the eye which are the continuation of others bearing some consistent ornament, it is not well that the ornament should cease in the parts concealed; credit is given for it, and it should not be deceptively withdrawn: as, for instance, in the sculpture of the backs of the statues of a temple pediment; never, perhaps, to be seen, but yet not lawfully to be left unfinished. And so in the working out of ornaments in dark or concealed places, in which it is best to err on the side of completion; and in the carrying round of string courses, and other such continuous work; not but that they may stop sometimes, on the point of going into some palpably impenetrable recess, but then let them stop boldly and markedly, on some distinct terminal ornament, and never be supposed to exist where they do not. The arches of the towers which flank the transepts of Rouen Cathedral have rosette ornaments on their spandrels, on the three visible sides; none on the side towards the roof. The right of this is rather a nice point for question.

¶ Finally, work may be wasted by being too good for its material, or too fine to bear exposure; and this, generally a characteristic of late, especially of renaissance, work, is perhaps the worst fault of all. I do not know anything more painful or pitiful than the kind of ivory carving with which the Certosa of Pavia, and part of the Colleone sepulchral chapel at Bergamo, and other such buildings are incrusted, of which it is not possible so much as to think without exhaustion; and a heavy sense of the misery it would be, to be forced to look at it all. And this is not from the quantity of it, nor because it is bad work—much of it is inventive and able; but because it looks as if it were only fit to be put in inlaid cabinets and velveted caskets, and as if it could not bear one drifted shower or gnawing frost. We are afraid for it, anxious about it, and tormented by it; and we feel that a massy shaft and a bold shadow would be worth it all. . . .

From *The Seven Lamps of Architecture*, Ch. I, 'The Lamp of Sacrifice'.

The Lamp of Truth

FOR, AS I advocated the expression of the Spirit of Sacrifice in the acts and pleasures of men, not as if thereby those acts could further the cause of religion, but because most assuredly they might therein be infinitely ennobled themselves, so I would have the Spirit or Lamp of Truth clear in the hearts of our artists and handicraftsmen, not as if the truthful practice of handicrafts could far advance the cause of truth, but because I would fain see the handicrafts themselves urged by the spurs of chivalry: and it is, indeed, marvellous to see what power and universality there are in this single principle, and how in the consulting or forgetting of it lies half the dignity or decline of every art and act of man. . . .

¶ The violations of truth, which dishonour poetry and painting, are thus for the most part confined to the treatment of their subjects. But in architecture another and a less subtle, more contemptible, violation of truth is possible; a direct falsity of assertion respecting the nature of material, or the quantity of labour. And this is, in the full sense of the word, wrong; it is as truly deserving of reprobation as any other moral delinquency; it is unworthy alike of architects and of nations; and it has been a sign, wherever it has widely and with toleration existed, of a singular debasement of the arts: that it is not a sign of worse than this, of a general want of severe probity, can be accounted for only by our knowledge of the strange separation which has for some centuries existed between the arts and all other subjects of human interest, as matters of conscience . . .; otherwise it might appear more than strange that a nation so distinguished for its general

uprightness and faith as the English, should admit in their architecture more of pretence, concealment, and deceit, than any other of this or of past time. . . .

¶ Architectural Deceits are broadly to be considered under three heads:

1st. The suggestion of a mode of structure or support, other than the true one; as in pendants of late Gothic roofs.

2nd. The painting of surfaces to represent some other material than that of which they actually consist (as in the marbling of wood), or the deceptive representation of sculptured ornament upon them.

The use of cast or machine-made ornaments of any kind.

Now, it may be broadly stated, that architecture will be noble exactly in the degree in which all these false expedients are avoided. Nevertheless, there are certain degrees of them, which, owing to their frequent usage, or to other causes, have so far lost the nature of deceit as to be admissible; as, for instance, gilding, which is in architecture no deceit, because it is therein not understood for gold; while in jewellery it is a deceit, because it is so understood, and therefore altogether to be reprehended. . . .

¶ The architect is not *bound* to exhibit structure; nor are we to complain of him for concealing it, any more than we should regret that the outer surfaces of the human frame conceal much of its anatomy; nevertheless, that building will generally be the noblest, which to an intelligent eye discovers the great secrets of its structure, as an animal form does, although from a careless observer they may be concealed. In the vaulting of a Gothic roof it is no deceit to throw the strength into the ribs of it, and to make the intermediate vault a mere shell. Such a structure would be presumed by an intelligent observer, the first time he saw such a roof; and the beauty of its traceries would be enhanced to him if they confessed and followed the lines of its main strength. If, however, the intermediate shell were made of wood instead of stone, and whitewashed to look like the rest,—this would, of course, be direct deceit, and altogether unpardonable.

There is, however, a certain deception necessarily occurring in Gothic architecture, which relates not to the points, but to the manner of support. The resemblance in its shafts and ribs to the external relations of stems and branches, which has been the ground of so much foolish speculation, necessarily induces in the mind of the spectator a sense or belief of a correspondent internal structure; that is to say, of a fibrous and continuous strength from the root into the limbs, and an elasticity communicated *upwards*, sufficient for the support of the ramified portions. The idea of the real conditions, of a great weight of ceiling thrown upon certain narrow, jointed lines, which have a tendency partly to be crushed, and partly to separate and be pushed outwards, is with difficulty received; and the more so when the pillars would be, if unassisted, too slight for the

weight, and are supported by external flying buttresses, as in the apse of Beauvais, and other such achievements of the bolder Gothic. Now, there is a nice question of conscience in this, which we shall hardly settle but by considering that, when the mind is informed beyond the possibility of mistake as to the true nature of things, the affecting it with a contrary impression, however distinct, is no dishonesty, but on the contrary, a legitimate appeal to the imagination. For instance, the greater part of the happiness which we have in contemplating clouds, results from the impression of their having massive, luminous, warm, and mountain-like surfaces; and our delight in the sky frequently depends upon our considering it as a blue vault. But, if we choose, we may know the contrary, in both instances; and easily ascertain the cloud to be a damp fog, or a drift of snow-flakes; and the sky to be a lightless abyss. There is, therefore, no dishonesty, while there is much delight, in the irresistibly contrary impression. In the same way, so long as we see the stones and joints, and are not deceived as to the points of support in any piece of architecture, we may rather praise than regret the dexterous artifices which compel us to feel as if there were fibre in its shafts and life in its branches. Nor is even the concealment of the support of the external buttress reprehensible, so long as the pillars are not sensibly inadequate to their duty. For the weight of a roof is a circumstance of which the spectator generally has no idea, and the provisions for it, consequently, circumstances whose necessity or adaptation he could not understand. It is no deceit, therefore, when the weight to be borne is necessarily unknown, to conceal also the means of bearing it, leaving only to be perceived so much of the support as is indeed adequate to the weight supposed. For the shafts do, indeed, bear as much as they are ever imagined to bear, and the system of added support is no more, as a matter of conscience, to be exhibited, than, in the human or any other form, mechanical provisions for those functions which are themselves unperceived.

But the moment that the conditions of weight are apprehended, both truth and feeling require that the conditions of support should be also apprehended. Nothing can be worse, either as judged by the taste or the conscience, than affectedly inadequate supports—suspensions in air, and other such tricks and vanities. Mr. Hope [1] wisely reprehends, for this reason, the arrangement of the main piers of St. Sophia at Constantinople. King's College Chapel, Cambridge, is a piece of architectural juggling, if possible still more to be condemned, because less sublime.

With deceptive concealments of structure are to be classed, though still more blameable, deceptive assumptions of it,—the introduction of members which should have, or profess to have, a duty, and have none. One of the most general instances of this will be found in the form of the flying

[1] Thomas Hope, *An Historical Essay on Architecture*, 2 vols., London 1835, p. 125.

buttress in late Gothic. The use of that member is, of course, to convey support from one pier to another when the plan of the building renders it necessary or desirable that the supporting masses should be divided into groups; the most frequent necessity of this kind arising from the intermediate range of chapels or aisles between the nave or choir walls and their supporting piers. The natural, healthy, and beautiful arrangement is that of a steeply sloping bar of stone, sustained by an arch with its spandrel carried farthest down on the lowest side, and dying into the vertical of the outer pier; that pier being, of course, not square, but rather a piece of wall set at right angles to the supported walls, and, if need be, crowned by a pinnacle to give it greater weight. The whole arrangement is exquisitely carried out in the choir of Beauvais. In later Gothic the pinnacle became gradually a decorative member, and was used in all places merely for the sake of its beauty. There is no objection to this; it is just as lawful to build a pinnacle for its beauty as a tower; but also the *buttress* became a decorative member; and was used, first, where it was not wanted, and, secondly, in forms in which it could be of no use, becoming a mere tie, not between the pier and wall, but between the wall and the top of the decorative pinnacle, thus attaching itself to the very point where its thrust, if it made any, could not be resisted. The most flagrant instance of this barbarism that I remember, (though it prevails partially in all the spires of the Netherlands,) is the lantern of St. Ouen at Rouen, where the pierced buttress, having an ogee curve, looks about as much calculated to bear a thrust as a switch of willow; and the pinnacles, huge and richly decorated, have evidently no work to do whatsoever, but stand round the central tower, like four idle servants, as they are—heraldic supporters, that central tower being merely a hollow crown, which needs no more buttressing than a basket does. In fact, I do not know anything more strange or unwise than the praise lavished upon this lantern; it is one of the basest pieces of Gothic in Europe; its flamboyant traceries being of the last and most degraded form, and its entire plan and decoration resembling, and deserving little more credit than, the burnt sugar ornaments of elaborate confectionery.

¶ Perhaps the most fruitful sources of these kinds of corruption which we have to guard against in recent times, is one which, nevertheless, comes in a 'questionable shape', and of which it is not easy to determine the proper laws and limits; I mean the use of iron. The definition of the art of architecture, given in the first Chapter, is independent of its materials. Nevertheless, that art having been, up to the beginning of the present century, practised for the most part in clay, stone, or wood, it has resulted that the sense of proportion and the laws of structure have been based, the one altogether, the other in great part, on the necessities consequent on the employment of those materials; and that the entire or principal employment

of metallic framework would, therefore, be generally felt as a departure from the first principles of the art. Abstractedly there appears no reason why iron should not be used as well as wood; and the time is probably near when a new system of architectural laws will be developed, adapted entirely to metallic construction. But I believe that the tendency of all present sympathy and association is to limit the idea of architecture to non-metallic work; and that not without reason. For architecture being in its perfection the earliest, as in its elements it is necessarily the first, of arts, will always precede, in any barbarous nation, the possession of the science necessary either for the obtaining or the management of iron. Its first existence and its earliest laws must, therefore, depend upon the use of materials accessible in quantity, and on the surface of the earth; that is to say, clay, wood, or stone; and as I think it cannot but be generally felt that one of the chief dignities of architecture is its historical use, and since the latter is partly dependent on consistency of style, it will be felt right to retain as far as may be, even in periods of more advanced science, the materials and principles of earlier ages. . . .

[The] rule is, I think, that metals may be used as a *cement*, but not as a *support*. For as cements of other kinds are often so strong that the stones may easier be broken than separated, and the wall becomes a solid mass, without for that reason losing the character of architecture, there is no reason why, when a nation has obtained the knowledge and practice of iron work, metal rods or rivets should not be used in the place of cement, and establish the same or a greater strength and adherence, without in any wise inducing departure from the types and system of architecture before established; nor does it make any difference, except as to sightliness, whether the metal bands or rods so employed be in the body of the wall or on its exterior, or set as stays and cross-bands; so only that the use of them be always and distinctly one which might be superseded by mere strength of cement; as for instance if a pinnacle or mullion be propped or tied by an iron band, it is evident that the iron only prevents the separation of the stones by lateral force, which the cement would have done, had it been strong enough. But the moment that the iron in the least degree takes the place of the stone, and acts by its resistance to crushing, and bears super-incumbent weight, or if it acts by its own weight as a counterpoise, and so supersedes the use of pinnacles or buttresses in resisting a lateral thrust, or if, in the form of a rod or girder, it is used to do what wooden beams would have done as well, that instant the building ceases, so far as such applications of metal extend, to be true architecture.

¶ The last form of fallacy which . . . we had to deprecate, was the substitution of cast or machine work for that of the hand, generally expressible as Operative Deceit.

There are two reasons, both weighty, against this practice: one, that all cast and machine work is bad, as work; the other, that it is dishonest. . . .

Ornament, as I have often before observed, has two entirely distinct sources of agreeableness, one, that of the abstract beauty of its forms, which, for the present, we will suppose to be the same whether they come from the hand or the machine; the other, the sense of human labour and care spent upon it. How great this latter influence we may perhaps judge, by considering that there is not a cluster of weeds growing in any cranny of ruin which has not a beauty in all respects *nearly* equal, and, in some, immeasurably superior, to that of the most elaborate sculpture of its stones: and that all our interest in the carved work, our sense of its richness, though it is tenfold less rich than the knots of grass beside it; of its delicacy, though it is a thousandfold less delicate; of its admirableness, though a millionfold less admirable; results from our consciousness of its being the work of poor, clumsy, toilsome man. Its true delightfulness depends on our discovering in it the record of thoughts, and intents, and trials, and heart-breakings— of recoveries and joyfulnesses of success: all this *can* be traced by a practised eye; but, granting it even obscure, it is presumed or understood; and in that is the worth of the thing, just as much as the worth of any thing else we call precious. The worth of a diamond is simply the understanding of the time it must take to look for it before it is found; and the worth of an ornament is the time it must take before it can be cut. It has an intrinsic value besides, which the diamond has not; (for a diamond has no more real beauty than a piece of glass;) but I do not speak of that at present; I place the two on the same ground; and I suppose that hand-wrought ornament can no more be generally known from machine work, than a diamond can be known from paste; nay, that the latter may deceive, for a moment, the mason's, as the other the jeweller's eye; and that it can be detected only by the closest examination. Yet exactly as a woman of feeling would not wear false jewels, so would a builder of honour disdain false ornaments. The using of them is just as downright and inexcusable a lie. . . .

¶ Thus in the use of brick: since that is known to be originally moulded, there is no reason why it should not be moulded into diverse forms. It will never be supposed to have been cut, and, therefore, will cause no deception; it will have only the credit it deserves. In flat countries, far from any quarry of stone, cast brick may be legitimately, and most successfully, used in decoration, and that elaborate, and even refined. The brick mouldings of the Palazzo Pepoli at Bologna, and those which run round the market-place of Vercelli, are among the richest in Italy. So also, tile and porcelain work, of which the former is grotesquely, but successfully, employed in the domestic architecture of France, coloured tiles being inserted in the diamond spaces between the crossing timbers; and the latter

admirably in Tuscany, in external bas-reliefs, by the Robbia family, in which works, while we cannot but sometimes regret the useless and ill-arranged colours, we would by no means blame the employment of a material which, whatever its defects, excels every other in permanence, and, perhaps, requires even greater skill in its management than marble. For it is not the material, but the absence of the human labour, which makes the thing worthless; and a piece of terra cotta, or of plaster of Paris, which has been wrought by the human hand, is worth all the stone in Carrara, cut by machinery. It is, indeed, possible, and even usual, for men to sink into machines themselves, so that even hand-work has all the characters of mechanism; of the difference between living and dead hand-work I shall speak presently; all that I ask at present is, what it is always in our power to secure—the confession of what we have done, and what we have given; so that when we use stone at all (since all stone is naturally supposed to be carved by hand,) we must not carve it by machinery; neither must we use any artificial stone cast into shape, nor any stucco ornaments of the colour of stone, or which might in any wise be mistaken for it, as the stucco-mouldings in the cortile of the Palazzo Vecchio at Florence, which cast a shame and suspicion over every part of the building.

From *The Seven Lamps of Architecture*, Ch. II, 'The Lamp of Truth'.

The Lamp of Power

WHILE, THEREFORE, it is not to be supposed that mere size will ennoble a mean design, yet every increase of magnitude will bestow upon it a certain degree of nobleness: so that it is well to determine at first, whether the building is to be markedly beautiful, or markedly sublime; and if the latter, not to be withheld by respect to smaller parts from reaching large-ness of scale; provided only, that it be evidently in the architect's power to reach at least that degree of magnitude which is the lowest at which sublimity begins, rudely definable as that which will make a living figure look less than life beside it. It is the misfortune of most of our modern buildings that we would fain have an universal excellence in them; and so part of the funds must go in painting, part in gilding, part in fitting up, part in painted windows, part in small steeples, part in ornaments here and there; and neither the windows, nor the steeple, nor the ornaments, are worth their materials. For there is a crust about the impressible part of men's minds, which must be pierced through before they can be touched to the quick; and though we may prick at it and scratch it in a thousand separate places, we might as well have let it alone if we do not come through

somewhere with a deep thrust: and if we can give such a thrust anywhere, there is no need of another; it need not be even so 'wide as a church door', so that it be *enough*. And mere weight will do this; it is a clumsy way of doing it, but an effectual one, too; and the apathy which cannot be pierced through by a small steeple, nor shone through by a small window, can be broken through in a moment by the mere weight of a great wall. Let, therefore, the architect who has not large resources, choose his point of attack first, and, if he chooses size, let him abandon decoration; for, unless they are concentrated, and numerous enough to make their concentration conspicuous, all his ornaments together will not be worth one huge stone. And the choice must be a decided one, without compromise. It must be no question whether his capitals would not look better with a little carving —let him leave them huge as blocks; or whether his arches should not have richer architraves—let him throw them a foot higher, if he can; a yard more across the nave will be worth more to him than a tesselated pavement; and another fathom of outer wall, than an army of pinnacles. The limitation of size must be only in the uses of the building, or in the ground at his disposal. . . .

¶ Of the many broad divisions under which architecture may be considered, none appear to me more significant than that into buildings, whose interest is in their walls and those whose interest is in the lines dividing their walls. In the Greek temple the wall is as nothing; the entire interest is in the detached columns and the frieze they bear; in French Flamboyant, and in our detestable Perpendicular, the object is to get rid of the wall surface, and keep the eye altogether on tracery of line: in Romanesque work and Egyptian, the wall is a confessed and honoured member, and the light is often allowed to fall on large areas of it, variously decorated. Now, both these principles are admitted by Nature, the one in her woods and thickets, the other in her plains, and cliffs, and waters; but the latter is pre-eminently the principle of power, and, in some sense, of beauty also. For, whatever infinity of fair form there may be in the maze of the forest, there is a fairer, as I think, in the surface of the quiet lake; and I hardly know that association of shaft or tracery, for which I would exchange the warm sleep of sunshine on some smooth, broad, human-like front of marble. Nevertheless, if breadth is to be beautiful, its substance must in some sort be beautiful; and we must not hastily condemn the exclusive resting of the northern architects in divided lines, until at least we have remembered the difference between a blank surface of Caen stone, and one mixed from Genoa and Carrara, of serpentine with snow: but as regards abstract power and awfulness, there is no question; without breadth of surface it is in vain to seek them, and it matters little, so that the surface be wide. bold, and unbroken, whether it be of brick or of jasper; the light

of heaven upon it, and the weight of earth in it, are all we need: for it is singular how forgetful the mind may become both of material and workmanship, if only it have space enough over which to range, and to remind it, however, feebly, of the joy that it has in contemplating the flatness and sweep of great plains and broad seas. And it is a noble thing for men to do this with their cut stone or moulded clay, and to make the face of a wall look infinite, and its edge against the sky like an horizon: or even if less than this be reached, it is still delightful to mark the play of passing light on its broad surface, and to see by how many artifices and gradations of tinting and shadow, time and storm will set their wild signatures upon it; and how in the rising or declining of the day the unbroken twilight rests long and luridly on its high lineless forehead, and fades away untraceably down its tiers of confused and countless stone.

¶ Now, it does not seem to me sufficiently recollected, that a wall surface is to an architect simply what a white canvas is to a painter, with this only difference, that the wall has already a sublimity in its height, substance, and other characters . . ., on which it is more dangerous to break than to touch with shade the canvas surface, and, for my part, I think a smooth broad, freshly laid surface of gesso a fairer thing than most pictures I see painted on it; much more, a noble surface of stone than most architectural features which it is caused to assume. . . .

¶ Positive shade is a more necessary and more sublime thing in an architect's hands than in a painter's. For the latter being able to temper his light with an undertone throughout, and to make it delightful with sweet colour, or awful with lurid colour, and to represent distance, and air, and sun, by the depth of it, and fill its whole space with expression, can deal with an enormous, nay, almost with an universal, extent of it, and the best painters most delight in such extent; but as light, with the architect, is nearly always liable to become full and untempered sunshine seen upon solid surface, his only rests, and his chief means of sublimity, are definite shades. So that, after size and weight, the Power of architecture may be said to depend on the quantity (whether measured in space or intenseness) of its shadow; and it seems to me, that the reality of its works, and the use and influence they have in the daily life of men, (as opposed to those works or art with which we have nothing to do but in times of rest or of pleasure,) require of it that it should express a kind of human sympathy, by a measure of darkness as great as there is in human life: and that as the great poem and great fiction generally affect us most by the majesty of their masses of shade, and cannot take hold upon us if they affect a continuance of lyric sprightliness, but must be often serious, and sometimes melancholy, else they do not express the truth of this wild world of ours; so there must be, in this magnificently human art of architecture, some equivalent expression for the trouble

and wrath of life, for its sorrow and its mystery: and this it can only give by depth or diffusion of gloom, by the frown upon its front, and the shadow of its recess. So that Rembrandtism is a noble manner in architecture, though a false one in painting; and I do not believe that ever any building was truly great, unless it had mighty masses, vigorous and deep, of shadow mingled with its surface. And among the first habits that a young architect should learn, is that of thinking in shadow, not looking at a design in its miserably liny skeleton; but conceiving it as it will be when the dawn lights it, and the dusk leaves it; when its stones will be hot, and its crannies cool; when the lizards will bask on the one, and the birds build in the other. Let him design with the sense of cold and heat upon him; let him cut out the shadows, as men dig wells in unwatered plains; and lead along the lights, as a founder does his hot metal; let him keep the full command of both, and see that he knows how they fall, and where they fade. His paper lines and proportions are of no value: all that he has to do must be done by spaces of light and darkness; and his business is to see that the one is broad and bold enough not to be swallowed up by twilight, and the other deep enough not to be dried like a shallow pool by a noon-day sun.

¶ . . . I know not how it is, unless that our English hearts have more oak than stone in them, and have more filial sympathy with acorns than Alps; but all that we do is small and mean, if not worse—thin, and wasted, and unsubstantial. It is not modern work only; we have built like frogs and mice since the thirteenth century (except only in our castles). What a contrast between the pitiful little pigeon-holes which stand for doors in the east front of Salisbury, looking like the entrances to a beehive or a wasp's nest, and the soaring arches and kingly crowning of the gates of Abbeville, Rouen, and Rheims, or the rock-hewn piers of Chartres, or the dark and vaulted porches and writhed pillars of Verona! Of domestic architecture what need is there to speak? How small, how cramped, how poor, how miserable in its petty neatness is our best! how beneath the mark of attack, and the level of contempt, that which is common with us! What a strange sense of formalised deformity, of shrivelled precision, of starved accuracy, of minute misanthropy have we, as we leave even the rude streets of Picardy for the market towns of Kent! Until that street architecture of ours is bettered, until we give it some size and boldness, until we give our windows recess, and our walls thickness, I know not how we can blame our architects for their feebleness in more important work; their eyes are inured to narrowness and slightness: can we expect them at a word to conceive and deal with breadth and solidity? They ought not to live in our cities; there is that in their miserable walls which bricks up to death men's imaginations, as surely as ever perished forsworn nun. An architect should live as little in cities as a painter. Send him to our hills,

and let him study there what nature understands by a buttress, and what by a dome. There was something in the old power of architecture, which it had from the recluse more than from the citizen. The buildings of which I have spoken with chief praise, rose, indeed, out of the war of the piazza, and above the fury of the populace: and Heaven forbid that for such cause we should ever have to lay a larger stone, or rivet a firmer bar, in our England! But we have other sources of power, in the imagery of our iron coasts and azure hills; of power more pure, nor less serene, than that of the hermit spirit which once lighted with white lines of cloisters the glades of the Alpine pine, and raised into ordered spires the wild rocks of the Norman sea; which gave to the temple gate the depth and darkness of Elijah's Horeb cave; and lifted, out of the populous city, grey cliffs of lonely stone, into the midst of sailing birds and silent air.

From *The Seven Lamps of Architecture*, Ch. III, 'The Lamp of Power'.

The Lamp of Beauty

NOW, I WOULD insist especially on the fact, of which I doubt not farther illustrations will occur to the mind of every reader, that all most lovely forms and thoughts are directly taken from natural objects; because I would fain be allowed to assume also the converse of this, namely, that forms which are *not* taken from natural objects *must* be ugly. I know this is a bold assumption; but as I have not space to reason out the points wherein essential beauty of form consists, that being far too serious a work to be undertaken in a bye way, I have no other resource than to use this accidental mark or test of beauty, of whose truth the considerations which I hope hereafter to lay before the reader may assure him. I say an accidental mark, since forms are not beautiful *because* they are copied from Nature; only it is out of the power of man to conceive beauty without her aid. I believe the reader will grant me this, even from the examples above advanced; the degree of confidence with which it is granted must attach also to his acceptance of the conclusions which will follow from it; but if it be granted frankly, it will enable me to determine a matter of very essential importance, namely, what *is* or is *not* ornament. For there are many forms of so called decoration in architecture, habitual, and received, therefore, with approval, or at all events without any venture at expression of dislike, which I have no hesitation in asserting to be not ornament at all, but to be ugly things, the expense of which ought in truth to be set down in the architect's contract, as 'For monstrification . . .'. I think I am justified in considering those forms to be *most* natural which are most frequent; or rather, that on the

shapes which in the every-day world are familiar to the eyes of men, God has stamped those characters of beauty which He has made it man's nature to love; while in certain exceptional forms He has shown that the adoption of the others was not a matter of necessity, but part of the adjusted harmony of creation! I believe that thus we may reason from Frequency to Beauty, and *vice versa*; that, knowing a thing to be frequent, we may assume it to be beautiful; and assume that which is most frequent to be most beautiful: I mean, of course, *visibly* frequent; for the forms of things which are hidden in caverns of the earth, or in the anatomy of animal frames, are evidently not intended by their Maker to bear the habitual gaze of man. And, again, by frequency I mean that limited and isolated frequency which is characteristic of all perfection; not mere multitude: as a rose is a common flower, but yet there are not so many roses on the tree as there are leaves. In this respect Nature is sparing of her highest, and lavish of her less, beauty; but I call the flower as frequent as the leaf, because, each in its allotted quantity, where the one is, there will ordinarily be the other.[1] . . .

From *The Seven Lamps*, Ch. IV, ¶ 3.

Railway Stations

ANOTHER of the strange and evil tendencies of the present day is to the decoration of the railroad station. Now, if there be any place in the world in which people are deprived of that portion of temper and discretion which is necessary to the contemplation of beauty, it is there. It is the very temple of discomfort, and the only charity that the builder can extend to us is to show us, plainly as may be, how soonest to escape from it. The whole system of railroad travelling is addressed to people who, being in a hurry, are therefore, for the time being, miserable. No one would travel in that manner who could help it—who had time to go leisurely over hills and between hedges, instead of through tunnels and between banks: at least, those who would, have no sense of beauty so acute as that we need consult it at the station. The railroad is in all its relations a matter of earnest business, to be got through as soon as possible. It transmutes a man from a traveller into a living parcel. For the time he has parted with the nobler characteristics of his humanity for the sake of a planetary power of locomotion. Do not ask him to admire anything. You might as well

[1] Ruskin continues to attack, at length, such 'artificial' forms as the Greek fret or guilloche, the Tudor portcullis, and with it all heraldic decoration, except for single badges or symbols, inscriptions of any kind, scroll work, garlands, drapery, and conventional architectural ornaments such as dripstones.

ask the wind. Carry him safely, dismiss him soon: he will thank you for nothing else. All attempts to please him in any other way are mere mockery, and insults to the things by which you endeavour to do so. There never was more flagrant nor impertinent folly than the smallest portion of ornament in anything concerned with railroads or near them. Keep them out of the way, take them through the ugliest country you can find, confess them the miserable things they are, and spend nothing upon them but for safety and speed. Give large salaries to efficient servants, large prices to good manufacturers, large wages to able workmen; let the iron be tough, and the brickwork solid, and the carriages strong. The time is perhaps not distant when these first necessities may not be easily met: and to increase expense in any other direction is madness. Better bury gold in the embankments, than put it in ornaments in the stations. Will a single traveller be willing to pay an increased fare on the South Western because the columns of the terminus are covered with patterns from Nineveh?—he will only care less for the Ninevite ivories in the British Museum: or on the North Western, because there are old English-looking spandrels to the roof of the station at Crewe?—he will only have less pleasure in their prototypes at Crewe House. Railroad architecture has, or would have, a dignity of its own if it were only left to its work. You would not put rings on the fingers of a smith at his anvil. . . .

From *The Seven Lamps*, Ch. IV, ¶ 21.

The Lamp of Beauty

MUST NOT beauty, then, it will be asked, be sought for in the form which we associate with our every-day life? Yes, if you do it consistently, and in places where it can be calmly seen; but not if you use the beautiful form only as a mask and covering of the proper conditions and uses of things, nor if you thrust it into the places set apart for toil. Put it in the drawing-room, not into the workshop; put it upon domestic furniture, not upon tools of handicraft. All men have sense of what is right in this matter, if they would only use and apply that sense; every man knows where and how beauty gives him pleasure, if he would only ask for it when it does so, and not allow it to be forced upon him when he does not want it. Ask any one of the passengers over London Bridge at this instant whether he cares about the forms of the bronze leaves on its lamps, and he will tell you, No. Modify these forms of leaves to a less scale, and put them on his milk-jug at breakfast, and ask him whether he likes them, and he will tell you, Yes. People have no need of teaching if they could only think and

speak truth, and ask for what they like and want, and for nothing else: nor can a right disposition of beauty be ever arrived at except by this common sense, and allowance for the circumstances of the time and place. It does not follow, because bronze leafage is in bad taste on the lamps of London Bridge, that it would be so on those of the Ponte della Trinità; [1] nor, because it would be a folly to decorate the house fronts of Gracechurch Street, that it would be equally so to adorn those of some quiet provincial town. The question of greatest external or internal decoration depends entirely on the conditions of probable repose. It was a wise feeling which made the streets of Venice so rich in external ornament, for there is no couch of rest like the gondola. So, again, there is no subject of street ornament so wisely chosen as the fountain, where it is a fountain of use; for it is just there that perhaps the happiest pause takes place in the labour of the day, when the pitcher is rested on the edge of it, and the breath of the bearer is drawn deeply, and the hair swept from the forehead, and the uprightness of the form declined against the marble ledge, and the sound of the kind word or light laugh mixes with the trickle of the falling water, heard shriller and shriller as the pitcher fills. What pause is so sweet as that —so full of the depth of ancient days, so softened with the calm of pastoral solitude?

From *The Seven Lamps of Architecture*, Ch. IV, 'The Lamp of Beauty'.

The Lamp of Life

FRANKNESS . . . is in itself no excuse for repetition, nor Audacity for innovation, when the one is indolent and the other unwise. Nobler and surer signs of vitality must be sought,—signs independent alike of the decorative or original character of the style, and constant in every style that is determinedly progressive.

Of these, one of the most important I believe to be a certain neglect or contempt of refinement in execution, or, at all events, a visible subordination of execution to conception commonly involuntary, but not unfrequently intentional. . . . I would insist upon perfect and most delicate finish in its right place as a characteristic of all the highest schools of architecture, as much as it is of those of painting. But on the other hand, as perfect finish belongs to the perfected art, a progressive finish belongs to progressive art; and I do not think that any more fatal sign of a stupor or numbness settling upon that undeveloped art could possibly be detected, than that it had been *taken aback* by its own execution, and that the workmanship had gone ahead of the design; while, even in my admission of absolute finish in the right

[1] At Florence.

place, as an attribute of the perfected school, I must reserve to myself the right of answering in my own way the two very important questions— what *is* finish? and what *is* its right place?

¶ But in illustrating either of these points, we must remember that the correspondence of workmanship with thought is, in existent examples, interfered with by the adoption of the designs of an advanced period by the workmen of a rude one. All the beginnings of Christian architecture are of this kind, and the necessary consequence is of course an increase of the visible interval between the power of realization and the beauty of the idea. We have at first an intimation, almost savage in its rudeness, of a classical design; as the art advances, the design is modified by a mixture of Gothic grotesqueness, and the execution more complete, until a harmony is established between the two, in which balance they advance to new perfection. Now during the whole period in which the ground is being recovered, there will be found in the living architecture marks, not to be mistaken, of intense impatience; a struggle towards something unattained, which causes all minor points of handling to be neglected; and a restless disdain of all qualities which appear either to confess contentment, or to require a time and care which might be better spent. And, exactly as a good and earnest student of drawing will not lose time in ruling lines or finishing backgrounds about studies which, while they have answered his immediate purpose, he knows to be imperfect and inferior to what he will do hereafter,—so the vigour of a true school of early architecture, which is either working under the influence of high example or which is itself in a state of rapid development, is very curiously traceable, among other signs, in the contempt of exact symmetry and measurement, which in dead architecture are the most painful necessities.

¶ . . . I think that impatience is a glorious character in an advancing school: and I love the Romanesque and early Gothic especially, because they afford so much room for it; accidental carelessness of measurement or of execution being mingled undistinguishably with the purposed departures from symmetrical regularity, and the luxuriousness of perpetually variable fancy, which are eminently characteristic of both styles. How great, how frequent they are, and how brightly the severity of architectural law is relieved by their grace and suddenness, has not, I think, been enough observed; still less, the unequal measurements of even important features professing to be absolutely symmetrical. I am not so familiar with modern practice as to speak with confidence respecting its ordinary precision; but I imagine that the following measures of the western front of the cathedral of Pisa,[1] would be looked upon by present architects as very blundering approximations. That front is divided into seven arched compartments, of

[1] Ill. 55 facing page 200.

which the second, fourth or central, and sixth contain doors; the seven are in a most subtle alternating proportion; the central being the largest, next to it the second and sixth, then the first and seventh, lastly the third and fifth. By this arrangement, of course, these three pairs should be equal; and they are so to the eye, but I found their actual measures to be the following, taken from pillar to pillar, in Italian braccia, palmi (four inches each), and inches:

	Braccia	Palmi	Inches		Total in inches
1. Central door	8	0	0	=	192
2. Northern door ⎱	6	3	$1\frac{1}{2}$	=	$157\frac{1}{2}$
3. Southern door ⎰	6	4	3	=	163
4. Extreme northern space ⎱	5	5	$3\frac{1}{2}$	=	$143\frac{1}{2}$
5. Extreme southern space ⎰	6	1	$0\frac{1}{2}$	=	$148\frac{1}{2}$
6. Northern intervals between the doors ⎱	5	2	1	=	129
7. Southern intervals between the doors ⎰	5	2	$1\frac{1}{2}$	=	$129\frac{1}{2}$

There is thus a difference, severally, between 2, 3 and 4, 5 of five inches and a half in the one case, and five inches in the other. . . .

¶ There is another very curious instance of distortion above the central door of the west front. All the intervals between the seven arches are filled with black marble, each containing in its centre a white parallelogram filled with animal mosaics, and the whole surmounted by a broad white band, which, generally, does not touch the parallelogram below. But the parallelogram on the north of the central arch has been forced into an oblique position, and touches the white band; and, as if the architect was determined to show that he did not care whether it did or not, the white band suddenly gets thicker at that place, and remains so over the next two arches. And these differences are the more curious because the workmanship of them all is most finished and masterly, and the distorted stones are fitted with as much neatness as if they tallied to a hair's breadth. There is no look of slurring or blundering about it; it is all coolly filled in, as if the builder had no sense of anything being wrong or extraordinary; I only wish we had a little of his impudence.

¶ Still, the reader will say that all these variations are probably dependent more on the bad foundation than on the architect's feelings. Not so the exquisite delicacies of change in the proportions and dimensions of the apparently symmetrical arcades of the west front. It will be remembered that I said the tower of Pisa was the only ugly tower in Italy, because its tiers were equal, or nearly so, in height, a fault this, so contrary to the spirit of the builders of the time, that it can be considered only as an unlucky caprice. Perhaps the general aspect of the west front of the cathedral may then have occurred to the reader's mind, as seemingly another contradiction of the rule I had advanced. It would not have been so, however, even had

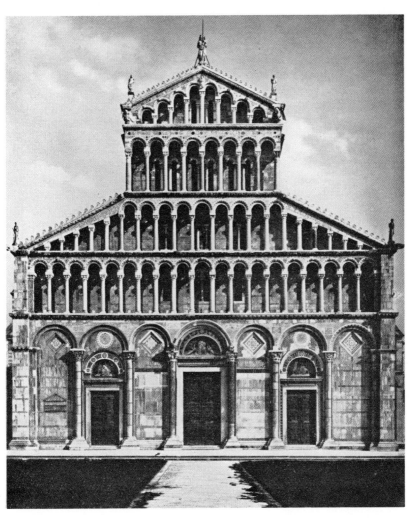

55. FAÇADE OF THE CATHEDRAL AT PISA

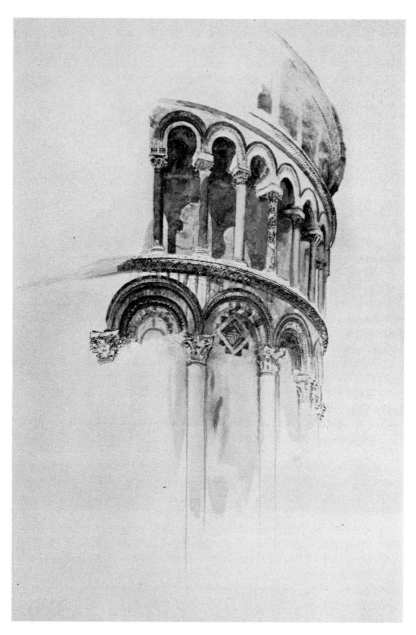

56. **APSE OF THE CATHEDRAL AT PISA.** Drawing by Ruskin. *Oxford, Ashmolean Museum*

its four upper arcades been actually equal; as they are subordinated to the great seven-arched lower storey, in the manner before noticed respecting the spire of Salisbury, and as is actually the case in the Duomo of Lucca and Tower of Pistoja. But the Pisan front is far more subtly proportioned. Not one of its four arcades is of like height with another. The highest is the third, counting upwards; and they diminish in nearly arithmetical proportion alternately; in the order 3rd, 1st, 2nd, 4th. The inequalities in their arches are not less remarkable: they at first strike the eye as all equal; but there is a grace about them which equality never obtained: on closer observation, it is perceived that in the first row of nineteen arches, eighteen are equal, and the central one larger than the rest; in the second arcade, the nine central arches stand over the nine below, having, like them, the ninth central one largest. But on their flanks, where is the slope of the shoulder-like pediment, the arches vanish, and a wedge-shaped frieze takes their place, tapering outwards, in order to allow the columns to be carried to the extremity of the pediment; and here, where the heights of the shafts are so fast shortened, they are set thicker; five shafts, or rather four and a capital, above, to four of the arcade below, giving twenty-one intervals instead of nineteen. In the next or third arcade,—which, remember, is the highest, eight arches, all equal, are given in the space of the nine below, so that there is now a central shaft instead of a central arch and the span of the arches is increased in proportion to their increased height. Finally, in the uppermost arcade, which is the lowest of all, the arches, the same in number as those below, are narrower than any of the façade; and the whole eight going very nearly above the six below them, while the terminal arches of the lower arcade are surmounted by flanking masses of decorated wall with projecting figures.

¶ Now I call *that* Living Architecture. There is sensation in every inch of it, and an accommodation to every architectural necessity, with a determined variation in arrangement, which is exactly like the related proportions and provisions in the structure of organic form. . . .

¶ I believe the right question to ask, respecting all ornament, is simply this: Was it done with enjoyment—was the carver happy while he was about it? It may be the hardest work possible, and the harder because so much pleasure was taken in it; but it must have been happy too, or it will not be living. How much of the stone mason's toil this condition would exclude I hardly venture to consider, but the condition is absolute. There is a Gothic church lately built near Rouen, vile enough, indeed, in its general composition, but excessively rich in detail; many of the details are designed with taste, and all evidently by a man who has studied old work closely. But it is all as dead as leaves in December; there is not one tender touch, not one warm stroke on the whole façade. The men who did it hated it,

and were thankful when it was done. And so long as they do so they are merely loading your walls with shapes of clay: the garlands of everlastings in Père la Chaise are more cheerful ornaments. You cannot get the feeling by paying for it—money will not buy life. I am not sure even that you can get it by watching or waiting for it. It is true that here and there a workman may be found who has it in him, but he does not rest contented in the inferior work—he struggles forward into an Academician; and from the mass of available handicraftsmen the power is gone—how recoverable I know not: this only I know, that all expense devoted to sculptural ornament, in the present condition of that power, comes literally under the head of Sacrifice for the sacrifice's sake, or worse. I believe the only manner of rich ornament that is open to us is the geometrical colour-mosaic, and that much might result from our strenuously taking up this mode of design. But, at all events, one thing we have in our power—the doing without machine ornament and cast-iron work. All the stamped metals, and artificial stones, and imitation woods and bronzes, over the invention of which we hear daily exultation—all the short, and cheap, and easy ways of doing that whose difficulty is its honour—are just so many new obstacles in our already encumbered road. They will not make one of us happier or wiser —they will extend neither the pride of judgment nor the privilege of enjoyment. They will only make us shallower in our understandings, colder in our hearts, and feebler in our wits. And most justly. For we are not sent into this world to do any thing into which we cannot put our hearts.

We have certain work to do for our bread, and that is to be done strenuously; other work to do for our delight, and that is to be done heartily: neither is to be done by halves and shifts, but with a will; and what is not worth this effort is not to be done at all. Perhaps all that we have to do is meant for nothing more than an exercise of the heart and of the will, and is useless in itself; but, at all events, the little use it has may well be spared if it is not worth putting our hands and our strength to. It does not become our immortality to take an ease inconsistent with its authority, nor to suffer any instruments with which it can dispense, to come between it and the things it rules; and he who would form the creations of his own mind by any other instrument than his own hand, would also, if he might, give grinding organs to Heaven's angels, to make their music easier. There is dreaming enough, and earthiness enough, and sensuality enough in human existence, without our burning the few glowing moments of it into mechanism; and since our life must at the best be but a vapour that appears for a little time and then vanishes away, let it at least appear as a cloud in the height of heaven, not as the thick darkness that broods over the blast of the Furnace, and rolling of the Wheel.

From *The Seven Lamps of Architecture*, Ch. v, 'The Lamp of Life'.

The Lamp of Memory

IT IS AS the centralization and protectress of this sacred influence [of memory], that Architecture is to be regarded by us with the most serious thought. We may live without her, and worship without her, but we cannot remember without her. How cold is all history, how lifeless all imagery, compared to that which the living nation writes, and the uncorrupted marble bears!—how many pages of doubtful record might we not often spare, for a few stones left one upon another! The ambition of the old Babel builders was well directed for this world: there are but two strong conquerors of the forgetfulness of men, Poetry and Architecture; and the latter in some sort includes the former, and is mightier in its reality: it is well to have, not only what men have thought and felt, but what their hands have handled, and their strength wrought, and their eyes beheld, all the days of their life. The age of Homer is surrounded with darkness, his very personality with doubt. Not so that of Pericles: and the day is coming when we shall confess, that we have learned more of Greece out of the crumbled fragments of her sculpture than ever from her sweet singers or soldier historians. And if indeed there be any profit in our knowledge of the past, or any joy in the thought of being remembered hereafter, which can give strength to present exertion, or patience to present endurance, there are two duties respecting national architecture whose importance it is impossible to overrate: the first, to render the architecture of the day, historical; and the second, to preserve, as the most precious of inheritances, that of past ages.

¶ . . . As regards domestic buildings, there must always be a certain limitation to views of this kind in the power, as well as in the hearts, of men; still I cannot but think it an evil sign of a people when their houses are built to last for one generation only. There is a sanctity in a good man's house which cannot be renewed in every tenement that rises on its ruins. . . .

I say that if men lived like men indeed, their houses would be temples —temples which we should hardly dare to injure, and in which it would make us holy to be permitted to live; and there must be a strange dissolution of natural affection, a strange unthankfulness for all that homes have given and parents taught, a strange consciousness that we have been unfaithful to our father's honour, or that our own lives are not such as would make our dwellings sacred to our children, when each man would fain build to himself, and build for the little revolution of his own life only. And I look upon those pitiful concretions of lime and clay which spring up, in mildewed forwardness, out of the kneaded fields about our capital—upon those

thin, tottering, foundationless shells of splintered wood and imitated stone —upon those gloomy rows of formalized minuteness, alike without difference and without fellowship, as solitary as similar—not merely with the careless disgust of an offended eye, not merely with sorrow for a desecrated landscape, but with a painful foreboding that the roots of our national greatness must be deeply cankered when they are thus loosely struck in their native ground; that those comfortless and unhonoured dwellings are the signs of a great and spreading spirit of popular discontent; that they mark the time when every man's aim is to be in some more elevated sphere than his natural one, and every man's past life is his habitual scorn; when men build in the hope of leaving the places they have built, and live in the hope of forgetting the years that they have lived; when the comfort, the peace, the religion of home have ceased to be felt; and the crowded tenements of a struggling and restless population differ only from the tents of the Arab or the Gipsy by their less healthy openness to the air of heaven, and less happy choice of their spot of earth; by their sacrifice of liberty without the gain of rest, and of stability without the luxury of change. . . .

¶ I look to this spirit of honourable, proud, peaceful self-possession, this abiding wisdom of contented life, as probably one of the chief sources of great intellectual power in all ages, and beyond dispute as the very primal source of the great architecture of old Italy and France. To this day, the interest of their fairest cities depends, not on the isolated richness of palaces, but on the cherished and exquisite decoration of even the smallest tenements of their proud periods. The most elaborate piece of architecture in Venice is a small house at the head of the Grand Canal, consisting of a ground floor with two storeys above, three windows in the first, and two in the second. Many of the most exquisite buildings are on the narrower canals, and of no larger dimensions.[1] One of the most interesting pieces of fifteenth century architecture in North Italy, is a small house in a back street, behind the marketplace of Vicenza; it bears the date 1481, and the motto, Il . n'est . rose . sans . épine .; it has also only a ground floor and two storeys, with three windows in each, separated by rich flower-work, and with balconies, supported, the central one by an eagle with open wings, the lateral ones by winged griffins standing on cornucopiæ. The idea that a house must be large in order to be well built, is altogether of modern growth, and is parallel with the idea, that no picture can be historical, except of a size admitting figures larger than life.

¶ I would have, then, our ordinary dwelling-houses built to last, and built to be lovely; as rich and full of pleasantness as may be, within and without; with what degree of likeness to each other in style and manner, I will say presently, under another head;[2] but, at all events, with such

[1] Ill. 57 facing this page. [2] Ibid. Vol. VII, ¶ 3.

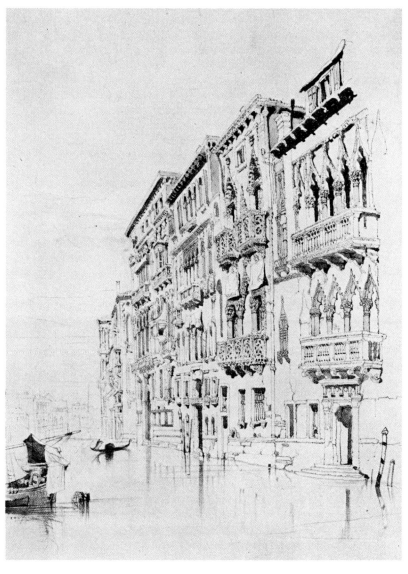

57. PALAZZO CONTARINI-FASAN IN VENICE. Drawing by Ruskin
Oxford, Ashmolean Museum

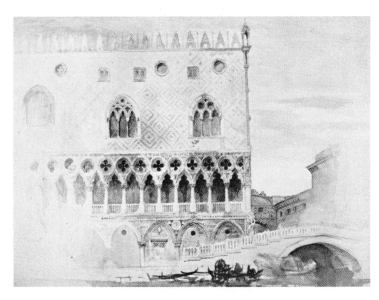

58. THE DUCAL PALACE, VENICE. Drawing by Ruskin. *Oxford, Ashmolean Museum*

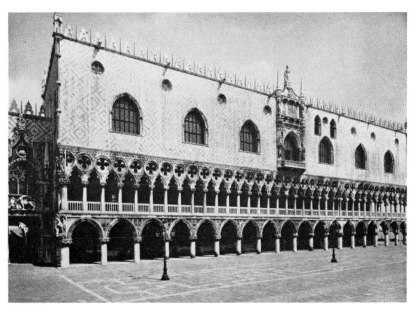

59. THE DUCAL PALACE, VENICE

differences as might suit and express each man's character and occupation, and partly his history. . . .[1]

¶ In public building the historical purpose should be still more definite. It is one of the advantages of Gothic architecture,—I use the word Gothic in the most extended sense as broadly opposed to classical,—that it admits of a richness of record altogether unlimited. Its minute and multitudinous sculptural decorations afford means of expressing, either symbolically or literally, all that needs to be known of natural feeling or achievement. . . . Take, for example, the management of the capitals of the ducal palace at Venice.[2] History, as such, was indeed entrusted to the painters of its interior, but every capital of its arcades was filled with meaning. . . .

¶ Now, not to speak of any more important public building, let us imagine our own India House [3] adorned in this way, by historical or symbolical sculpture: massively built in the first place; then chased with bas-reliefs of our Indian battles, and fretted with carvings of Oriental foliage, or inlaid with Oriental stones; and the more important members of its decoration composed of groups of Indian life and landscape, and prominently expressing the phantasms of Hindoo worship in their subjection to the Cross. Would not one such work be better than a thousand histories?

¶ That peculiar character . . . which separates the picturesque from the characters of subject belonging to the higher walks of art (and this is all that it is necessary for our present purpose to define), may be shortly and decisively expressed. Picturesqueness, in this sense, is *Parasitical Sublimity*. Of course all sublimity, as well as all beauty, is, in the simple etymological sense, picturesque, that is to say, fit to become the subject of a picture; and all sublimity is, even in the peculiar sense which I am endeavouring to develope, picturesque, as opposed to beauty; that is to say, there is more picturesqueness in the subject of Michael Angelo than of Perugino, in proportion to the prevalence of the sublime element over the beautiful. But that character, of which the extreme pursuit is generally admitted to be degrading to art, is *parasitical* sublimity; *i.e.* a sublimity dependent on the accidents, or on the least essential characters, of the objects to which it belongs; and the picturesque is *developed distinctively exactly in proportion to the distance from the centre of thought of those points of character in which the sublimity is found.* Two ideas, therefore, are essential to picturesqueness,—

[1] The MS. continues:

'Everything under such circumstances depends upon the beauty, and much on the simplicity of the emblem itself. The giglio rosso of Florence may be set as thick over a wall surface as lilies in their own field; so might our own rose, as richly as it studs its native briar, but we must beware of multiplying a Queen's Arms.'

[2] Ill. 58 and 59 facing this page.

[3] The old East India House in Leadenhall Street (pulled down in 1862) had a classical portico with a pediment carved with figures symbolizing oriental commerce protected by the King of England.

the first, that of sublimity (for pure beauty is not picturesque at all, and becomes so only as the sublime element mixes with it), and the second, the subordinate or parasitical position of that sublimity. Of course, therefore, whatever characters of line or shade or expression are productive of sublimity, will become productive of picturesqueness Among those [characters] . . . I may name angular and broken lines, vigorous oppositions of light and shadow, and grave deep, or boldly contrasted colour; and all these are in a still higher degree effective, when by resemblance or association, they remind us of objects on which a true and essential sublimity exists, as of rocks or mountains, or stormy clouds or waves. Now if these characters, or any others of a higher and more abstract sublimity, be found in the very heart and substance of what we contemplate, as the sublimity of Michael Angelo depends on the expression of mental character in his figures far more than even on the noble lines of their arrangement, the art which represents such characters cannot be properly called picturesque: but, if they be found in the accidental or external qualities, the distinctive picturesque will be the result. . . .

¶ Again, in the management of the sculptures of the Parthenon, shadow is frequently employed as a dark field on which the forms are drawn. This is visibly the case in the metopes, and must have been nearly as much so in the pediment. But the use of that shadow is entirely to show the confines of the figures; and it is to *their lines*, and not to the shapes of the shadows behind them, that the art and the eye are addressed. The figures themselves are conceived, as much as possible, in full light, aided by bright reflections; they are drawn exactly as, on vases, white figures on a dark ground; and the sculptors have dispensed with, or even struggled to avoid, all shadows which were not absolutely necessary to the explaining of the form. On the contrary, in Gothic sculpture, the shadow becomes itself a subject of thought. It is considered as a dark colour, to be arranged in certain agreeable masses; the figures are very frequently made even subordinate to the placing of its divisions: and their costume is enriched at the expense of the forms underneath, in order to increase the complexity and variety of the points of shade. There are thus, both in sculpture and painting, two, in some sort, opposite schools, of which the one follows for its subject the essential forms of things, and the other the accidental lights and shades upon them.

¶ . . . It so happens that, in architecture, the superinduced and accidental beauty is most commonly inconsistent with the preservation of original character, and the picturesque is therefore sought in ruin, and supposed to consist in decay. Whereas, even when so sought, it consists in the mere sublimity of the rents, or fractures, or stains, or vegetation, which assimilate the architecture with the work of Nature, and bestow upon it those circumstances of colour and form which are universally beloved by

the eye of man. So far as this is done, to the extinction of the true characters of the architecture, it is picturesque, and the artist who looks to the stem of the ivy instead of the shaft of the pillar, is carrying out in more daring freedom the debased sculptor's choice of the hair instead of the countenance. But so far as it can be rendered consistent with the inherent character, the picturesque or extraneous sublimity of architecture has just this of nobler function in it than that of any other object whatsoever, that it is an exponent of age, of that in which, as has been said, the greatest glory of the building consists; and, therefore, the external signs of this glory, having power and purpose greater than any belonging to their mere sensible beauty, may be considered as taking rank among pure and essential characters; so essential to my mind, that I think a building cannot be considered as in its prime until four or five centuries have passed over it; and that the entire choice and arrangement of its details should have reference to their appearance after that period, so that none should be admitted, which would suffer material injury either by the weather-staining, or the mechanical degradation which the lapse of such a period would necessitate. . . .

Restoration

. . . Neither by the public, nor by those who have the care of public monuments, is the true meaning of the word *restoration* understood. It means the most total destruction which a building can suffer: a destruction out of which no remnants can be gathered: a destruction accompanied with false description of the thing destroyed. Do not let us deceive ourselves in this important matter; it is *impossible*, as impossible as to raise the dead, to restore anything that has ever been great or beautiful in architecture. That which I have above insisted upon as the life of the whole, that spirit which is given only by the hand and eye of the workman, can never be recalled. Another spirit may be given by another time, and it is then a new building; but the spirit of the dead workman cannot be summoned up, and commanded to direct other hands, and other thoughts. And as for direct and simple copying, it is palpably impossible. What copying can there be of surfaces that have been worn half an inch down? The whole finish of the work was in the half inch that is gone; if you attempt to restore that finihs, you do it conjecturally; if you copy what is left, granting fidelity to be possible (and what care, or watchfulness, or cost can secure it,) how is the new work better than the old? There was yet in the old *some* life, some mysterious suggestion of what it had been, and of what it had lost; some sweetness in the gentle lines which rain and sun had wrought. There can be none in the brute hardness of the new carving. . . .

¶ Do not let us talk then of restoration. The thing is a Lie from beginning to end. You may make a model of a building as you may of a corpse, and your model may have the shell of the old walls within it as your cast might have the skeleton, with what advantage I neither see nor care: but the old building is destroyed, and that more totally and mercilessly than if it had sunk into a heap of dust, or melted into a mass of clay: more has been gleaned out of desolated Nineveh than ever will be out of re-built Milan. But, it is said, there may come a necessity for restoration! Granted. Look the necessity full in the face, and understand it on its own terms. It is a necessity for destruction. Accept it as such, pull the building down, throw its stones into neglected corners, make ballast of them, or mortar, if you will; but do it honestly, and do not set up a Lie in their place. And look that necessity in the face before it comes, and you may prevent it. The principle of modern times (a principle which, I believe, at least in France, to be *systematically acted on by the masons*, in order to find themselves work, as the abbey of St. Ouen was pulled down by the magistrates of the town by way of giving work to some vagrants), is to neglect buildings first, and restore them afterwards. Take proper care of your monuments, and you will not need to restore them. A few sheets of lead put in time upon a roof, a few dead leaves and sticks swept in time out of a water-course, will save both roof and walls from ruin. Watch an old building with an anxious care; guard it as best you may, and at *any* cost, from every influence of dilapidation. Count its stones as you would jewels of a crown; set watches about it as if at the gates of a besieged city; bind it together with iron where it loosens; stay it with timber where it declines; do not care about the unsightliness of the aid: better a crutch than a lost limb; and do this tenderly, and reverently, and continually, and many a generation will still be born and pass away beneath its shadow. Its evil day must come at last; but let it come declaredly and openly and let no dishonouring and false substitute deprive it of the funeral offices of memory.

From *The Seven Lamps of Architecture*, Ch. VI, 'The Lamp of Memory'.

The Lamp of Obedience

. . . If there be any one condition which, in watching the progress of architecture, we see distinct and general; if, amidst the counter-evidence of success attending opposite accidents of character and circumstance, any one conclusion may be constantly and indisputably drawn, it is this; that the architecture of a nation is great only when it is as universal and as established as its language; and when provincial differences of style are nothing more than so many dialects. Other necessities are matters of doubt:

nations have been alike successful in their architecture in times of poverty and of wealth; in times of war and of peace; in times of barbarism and of refinement; under governments the most liberal or the most arbitrary; but this one condition has been constant, this one requirement clear in all places and at all times, that the work shall be that of a *school*, that no individual caprice shall dispense with, or materially vary, accepted types and customary decorations; and that from the cottage to the palace, and from the chapel to the basilica, and from the garden fence to the fortress wall, every member and feature of the architecture of the nation shall be as commonly current, as frankly accepted, as its language or its coin.

¶ A day never passes without our hearing our English architects called upon to be original, and to invent a new style: about as sensible and necessary an exhortation as to ask of a man who has never had rags enough on his back to keep out cold, to invent a new mode of cutting a coat. Give him a whole coat first, and let him concern himself about the fashion of it afterwards. We want no new style of architecture. Who wants a new style of painting or sculpture? But we want *some* style. It is of marvellously little importance, if we have a code of laws and they be good laws, whether they be new or old, foreign or native, Roman or Saxon, or Norman, or English laws. But it is of considerable importance that we should have a code of laws of one kind or another, and that code accepted and enforced from one side of the island to another, and not one law made ground of judgment at York and another in Exeter. And in like manner it does not matter one marble splinter whether we have an old or new architecture, but it matters everything whether we have an architecture truly so called or not; that is, whether an architecture whose laws might be taught at our schools from Cornwall to Northumberland, as we teach English spelling and English grammar, or an architecture which is to be invented fresh every time we build a workhouse or a parish school. . . .

¶ . . . We must first determine what buildings are to be considered Augustan in their authority; their modes of construction and laws of proportion are to be studied with the most penetrating care; then the different forms and uses of their decorations are to be classed and catalogued, as a German grammarian classes the power of prepositions; and under this absolute, irrefragable authority, we are to begin to work: admitting not so much as an alteration in the depth of a cavetto, or the breadth of a fillet. Then, when our sight is once accustomed to the grammatical forms and arrangements, and our thoughts familiar with the expression of them all; when we can speak this dead language naturally, and apply it to whatever ideas we have to render, that is to say, to every practical purpose of life; then, and not till then, a licence might be permitted, and individual authority allowed to change or to add to the received forms, always within certain

limits; the decorations, especially, might be made subjects of variable fancy, and enriched with ideas either original or taken from other schools. And thus, in process of time, and by a great national movement, it might come to pass that a new style should arise, as language itself changes; we might perhaps come to speak Italian instead of Latin, or to speak Modern instead of Old English; but this would be a matter of entire indifference, and a matter, besides, which no determination or desire could either hasten or prevent. That alone which it is in our power to obtain, and which it is our duty to desire, is an unanimous style of some kind, and such comprehension and practice of it as would enable us to adapt its features to the peculiar character of every several building, large or small, domestic, civil, or ecclesiastical. I have said that it was immaterial what style was adopted, so far as regards the room for originality which its development would admit: it is not so, however, when we take into consideration the far more important questions of the facility of adaptation to general purposes, and of the sympathy with which, this or that style would be popularly regarded. The choice of Classical or Gothic, again using the latter term in its broadest sense, may be questionable when it regards some single and considerable public building; but I cannot conceive it questionable, for an instant, when it regards modern uses in general: I cannot conceive any architect insane enough to project the vulgarization of Greek architecture. Neither can it be rationally questionable whether we should adopt early or late, original or derivative Gothic; if the latter were chosen, it must be either some impotent and ugly degradation, like our own Tudor, or else a style whose grammatical laws it would be nearly impossible to limit or arrange, like the French Flamboyant. We are equally precluded from adopting styles essentially infantine or barbarous, however Herculean their infancy, or majestic their outlawry, such as our own Norman, or the Lombard Romanesque. The choice would lie I think between four styles: 1. The Pisan Romanesque; 2. The early Gothic of the Western Italian Republics, advanced as far and as fast as our art would enable us to the Gothic of Giotto;[1] 3. The Venetian Gothic in its purest development; 4. The English earliest decorated. The most natural, perhaps the safest choice, would be of the last, well fenced from chance of again stiffening into the perpendicular; and perhaps enriched by some mingling of decorative elements from the exquisite decorated Gothic of France, of which, in such cases, it would be needful to accept some well-known examples, as the North Door of Rouen[2] and the Church of St. Urbain at Troyes, for final and limiting authorities on the side of decoration.

From *The Seven Lamps of Architecture*, Ch. VII, 'The Lamp of Obedience'.

[1] Ill. 60 facing this page. [2] Ill. 61 facing page 211.

60. CAMPANILE OF FLORENCE CATHEDRAL designed by Giotto

61. PORTAL OF THE NORTH TRANSEPT OF ROUEN CATHEDRAL

The Orders

ALL EUROPEAN architecture, bad and good, old and new, is derived from Greece through Rome, and coloured and perfected from the East. The history of architecture is nothing but the tracing of the various modes and directions of this derivation. Understand this, once for all: if you hold fast this great connecting clue, you may string all the types of successive architectural invention upon it like so many beads. The Doric and the Corinthian orders are the roots, the one of all Romanesque, massy-capitaled buildings—Norman, Lombard, Byzantine, and what else you can name of the kind; and the Corinthian of all Gothic, Early English, French, German, and Tuscan. Now observe, those old Greeks gave the shaft; Rome gave the arch; the Arabs pointed and foliated the arch. The shaft and arch, the framework and strength of architecture, are from the race of Japheth: the spirituality and sanctity of it from Ismael, Abraham, and Shem. . . .

¶ I have said that the two orders, Doric and Corinthian, are the roots of all European architecture. You have, perhaps, heard of five orders: but there are only two real orders; and there never can be any more until doomsday. On one of these orders the ornament is convex: those are Doric, Norman, and what else you recollect of the kind. On the other the ornament is concave; those are Corinthian, Early English, Decorated, and what else you recollect of that kind. The transitional form, in which the ornamental line is straight, is the centre or root of both. All other orders are varieties of these, or phantasms and grotesques, altogether indefinite in number and species.

¶ This Greek architecture, then, with its two orders, was clumsily copied and varied by the Romans with no particular result, until they began to bring the arch into extensive practical service; except only that the Doric capital was spoiled in endeavours to mend it, and the Corinthian much varied and enriched with fanciful, and often very beautiful imagery. And in this state of things came Christianity: seized upon the arch as her own: decorated it, and delighted in it: invented a new Doric capital to replace the spoiled Roman one: and all over the Roman empire set to work, with such materials as were nearest at hand, to express and adorn herself as best she could. This Roman Christian architecture is the exact expression of the Christianity of the time, very fervid and beautiful—but very imperfect; in many respects ignorant, and yet radiant with a strong, childlike light of imagination, which flames up under Constantine, illumines all the shores of the Bosphorus and the Ægean and the Adriatic Sea, and then gradually, as the people give themselves up to idolatry, becomes

corpse-light. The architecture sinks into a settled form—a strange, gilded, and embalmed repose: it, with the religion it expressed; and so would have remained for ever,—so *does* remain, where its languor has been undisturbed. But rough wakening was ordained for it.

¶ This Christian art of the declining empire is divided into two great branches, western and eastern; one centred at Rome, the other at Byzantium, of which the one is the early Christian Romanesque, properly so called, and the other, carried to higher imaginative perfection by Greek work-men, is distinguished from it as Byzantine. But I wish the reader, for the present, to class these two branches of art together in his mind, they being, in points of main importance, the same; that is to say, both of them a true continuance and sequence of the art of old Rome itself, flowing un-interruptedly down from the fountain-head, and entrusted always to the best workmen who could be found—Latins in Italy and Greeks in Greece; and thus both branches may be ranged under the general term of Christian Romanesque, an architecture which had lost the refinement of Pagan art in the degradation of the empire, but which was elevated by Christianity to higher aims, and by the fancy of the Greek workmen endowed with brighter forms. And this art the reader may conceive as extending in its various branches over all the central provinces of the empire, taking aspects more or less refined, according to its proximity to the seats of government; dependent for all its power on the vigour and freshness of the religion which animated it; and as that vigour and purity departed, losing its own vitality, and sinking into nerveless rest, not deprived of its beauty, but benumbed, and incapable of advance or change. . . .

From *Stones of Venice*, Vol. I, Ch. ¶ XVII–XX.

[For this work I have followed the text of the first edition.]

Roman, Lombard and Arab

. . . The Ducal palace of Venice[1] contains the three elements in exactly equal proportions—the Roman, Lombard and Arab. It is the central building of the world. . . .

¶ The glacier stream of the Lombards, and the following one of the Normans, left their erratic blocks wherever they had flowed; but without influencing, I think, the Southern nations beyond the sphere of their own presence. But the lava stream of the Arab, even after it ceased to flow, warmed the whole of the Northern air; and the history of Gothic archi-tecture is the history of the refinement and spiritualization of Northern

[1] Ill. 59 facing page 205.

work under its influence. The noblest buildings of the world, the Pisan-Romanesque, Tuscan (Giottésque) Gothic, and Veronese Gothic, are those of the Lombard schools themselves, under its close and direct influence; the various Gothics of the North are the original forms of the architecture which the Lombards brought into Italy, changing under the less direct influence of the Arab. . . .

From *Stones of Venice*, Vol. I, Ch. I, ¶ XXIV–XXIX.

Renaissance Architecture

I HAVE NOT written in vain if I have heretofore done anything towards diminishing the reputation of the Renaissance landscape painting. But the harm which has been done by Claude and the Poussins is as nothing when compared to the mischief effected by Palladio, Scamozzi, and Sansovino. Claude and the Poussins were weak men, and have had no serious influence on the general mind. There is little harm in their works being purchased at high prices: their real influence is very slight, and they may be left without grave indignation to their poor mission of furnishing drawing-rooms and assisting stranded conversation. Not so the Renaissance architecture. Raised at once into all the magnificence of which it was capable by Michael Angelo, then taken up by men of real intellect and imagination, such as Scamozzi, Sansovino, Inigo Jones, and Wren, it is impossible to estimate the extent of its influence on the European mind; and that the more, because few persons are concerned with painting, and, of those few, the larger number regard it with slight attention; but all men are concerned with architecture, and have at some time of their lives serious business with it. It does not much matter that an individual loses two or three hundred pounds in buying a bad picture, but it is to be regretted that a nation should lose two or three hundred thousand in raising a ridiculous building. Nor is it merely wasted wealth or distempered conception which we have to regret in this Renaissance architecture: but we shall find in it partly the root, partly the expression, of certain dominant evils of modern times—over-sophistication and ignorant classicalism; the one destroying the healthfulness of general society, the other rendering our schools and universities useless to a large number of the men who pass through them.

Now Venice, as she was once the most religious, was in her fall the most corrupt, of European states; and as she was in her strength the centre of the pure currents of Christian architecture, so she is in her decline the source of the Renaissance. It was the originality and splendour of the palaces of Vicenza and Venice which gave this school its eminence in the

eyes of Europe; and the dying city, magnificent in her dissipation, and graceful in her follies, obtained wider worship in her decrepitude than in her youth, and sank from the midst of her admirers into the grave. . . .

¶ My opponents in matters of painting always assume that there *is* such a thing as a law of right, and that I do not understand it: but my architectural adversaries appeal to no law, they simply set their opinion against mine; and indeed there is no law at present to which either they or I can appeal. No man can speak with rational decision of the merits or demerits of buildings: he may with obstinacy; he may with resolved adherence to previous prejudices; but never as if the matter could be otherwise decided than by majority of votes, or pertinacity of partizanship. I had always, however, a clear conviction that there *was* a law in this matter: that good architecture might be indisputably discerned and divided from the bad; that the opposition in their very nature and essence was clearly visible; and that we were all of us just as unwise in disputing about the matter without reference to principle, as we should be for debating about the genuineness of a coin without ringing it. I felt also assured that this law must be universal if it were conclusive; that it must enable us to reject all foolish and base work, and to accept all noble and wise work, without reference to style or national feeling; that it must sanction the design of all truly great nations and times, Gothic or Greek or Arab; that it must cast off and reprobate the design of all foolish nations and times, Chinese or Mexican or modern European; and that it must be easily applicable to all possible architectural inventions of human mind. I set myself, therefore, to establish such a law, in full belief that men are intended, without excessive difficulty, and by use of their general common sense, to know good things from bad; and that it is only because they will not be at the pains required for the discernment, that the world is so widely encumbered with forgeries and basenesses. I found the work simpler than I had hoped; the reasonable things ranged themselves in the order I required, and the foolish things fell aside, and took themselves away so soon as they were looked in the face. . . .

. . . If I should succeed, as I hope, in making the Stones of Venice touchstones, and detecting, by the mouldering of her marble, poison more subtle than ever was betrayed by the rending of her crystal; and if thus I am enabled to show the baseness of the schools of architecture and nearly every other art, which have for three centuries been predominant in Europe I believe the result of the inquiry may be serviceable for proof of a more vital truth than any at which I have hitherto hinted. For observe: I said the Protestant had despised the arts, and the Rationalist corrupted them. But what has the Romanist done meanwhile? He boasts that it was the papacy which raised the arts; why could it not support them when it was left to its own strength? How came it to yield to the Classicalism which

was based on infidelity, and to oppose no barrier to innovations, which
have reduced the once faithfully conceived imagery of its worship to stage
decoration? Shall we not rather find that Romanism, instead of being a
promoter of the arts, has never shown itself capable of a single great con-
ception since the separation of Protestantism from its side. So long as,
corrupt though it might be, no clear witness had been borne against it, so
that it still included in its ranks a vast number of faithful Christians, so long
its arts were noble. But the witness was borne—the error made apparent;
and Rome, refusing to hear the testimony or forsake the falsehood, has been
struck from that instant with an intellectual palsy, which has not only
incapacitated her from any further use of the arts which once were her
ministers, but has made her worship the shame of its own shrines, and her
worshippers their destroyers.

From *Stones of Venice*, Vol. I, Ch. I. ¶ XXXVIII–XLIX.

Architects

IN NO ART is there closer connection between our delight in the work, and
our admiration of the workman's mind, than in architecture, and yet we
rarely ask for a builder's name. The patron at whose cost, the monk through
whose dreaming the foundation was laid, we remember occasionally;
never the man who verily did the work. Did the reader ever hear of
William of Sens as having had anything to do with Canterbury Cathedral?
or of Pietro Basegio as in anywise connected with the Ducal palace of
Venice? There is much ingratitude and injustice in this; and therefore I
desire my reader to observe carefully how much of his pleasure in building
is derived, or should be derived, from admiration of the intellect of men
whose names he knows not.

From *Stones of Venice*, Vol. I, Ch. I, ¶ V.

Strength and Beauty

THE TWO virtues of architecture which we can justly weigh, are, we said,
its strength or good construction, and its beauty or good decoration.
Consider first, therefore, what you mean when you say a building is well
constructed or well built; you do not merely mean that it answers its
purpose,—this is much, and many modern buildings fail of this much; but
if it be verily well built, it must answer this purpose in the simplest way,

and with no over-expenditure of means. We require of a light-house, for instance, that it shall stand firm and carry a light; if it do not this, assuredly it has been ill built; but it may do it to the end of time, and yet not be well built. It may have hundreds of tons of stone in it more than were needed, and have cost thousands of pounds more than it ought. To pronounce it well or ill built, we must know the utmost forces it can have to resist, and the best arrangements of stone for encountering them, and the men liked wrong things; but that they either cared nothing about any, or pretended to like what they did not. Do you suppose that any modern architect likes what he builds, or enjoys it? Not in the least. He builds it because he has been told that such and such things are fine, and that he *should* like them. He pretends to like them, and gives them a false relish of vanity. Do you seriously imagine, reader, that any living soul in London likes triglyphs? ★ —or gets any hearty enjoyment out of pediments? † You are much mistaken. Greeks did: English people never did,—never will. Do you fancy that the architect of old Burlington Mews, in Regent Street, had any particular satisfaction in putting the blank triangle over the archway, instead of a useful garret window? By no manner of means. He had been told it was right to do so, and thought he should be admired for doing it. Very few faults of architecture are mistakes of honest choice: they are almost always hypocrisies.

From *Stones of Venice*, Vol. I, Ch. II, ¶ I.

Enjoyment

SO, THEN, the first thing we have to ask of the decoration is that it should indicate strong liking, and that honestly. It matters not so much what the thing is, as that the builder should really love it and enjoy it, and say so plainly. The architect of Bourges Cathedral liked hawthorns; so he has covered his porch with hawthorn,—it is a perfect Niobe of May. Never was such hawthorn; you would try to gather it forthwith, but for fear of being pricked. The old Lombard architects liked hunting; so they covered their work with horses and hounds, and men blowing trumpets two yards long. The base Renaissance architects of Venice liked masquing and fiddling; so they covered their work with comic masks and musical instruments. Even that was better than our English way of liking nothing, and professing to like triglyphs.

★ Triglyph. Literally, 'Three Cut'. The awkward upright ornament with two notches in it, and a cut at each side, to be seen everywhere at the tops of Doric colonnades, ancient and modern.

† Pediment. The triangular space above Greek porticos, as on the Mansion House or Royal Exchange.

¶ But the second requirement in decoration, is sign of our liking the right thing. And the right thing to be liked is God's work, which He made for our delight and contentment in this world. And all noble ornamentation is the expression of man's delight in God's work.

¶ So, then, these are the two virtues of building: first, the signs of man's own good work; secondly, the expression of man's delight in better work than his own. And these are the two virtues of which I desire my reader to be able quickly to judge, at least in some measure; to have a definite opinion up to a certain point. Beyond a certain point he cannot form one. When the science of the building is great, great science is of course required to comprehend it; and, therefore, of difficult bridges, and light-houses, and harbour walls, and river dykes, and railway tunnels, no judgment may be rapidly formed. But of common buildings, built in common circumstances, it is very possible for every man, or woman, or child, to form judgment both rational and rapid. Their necessary, or even possible, features are but few; the laws of their construction are as simple as they are interesting. The labour of a few hours is enough to render the reader master of their main points; and from that moment he will find in himself a power of judgment which can neither be escaped nor deceived, and discover subjects of interest where everything before had appeared barren. For though the laws are few and simple, the modes of obedience to them are not so. Every building presents its own requirements and difficulties; and every good building has peculiar appliances or contrivances to meet them. Understand the laws of structure, and you will feel the special difficulty in every new building which you approach; and you will know also, or feel instinctively, whether it has been wisely met or otherwise. And an enormous number of buildings, and of styles of building, you will be able to cast aside at once, as at variance with these constant laws of structure, and therefore unnatural and monstrous.

¶ Then, as regards decoration, I want you only to consult your own natural choice and liking. There is a right and wrong in it; but you will assuredly like the right if you suffer your natural instinct to lead you. Half the evil in this world comes from people not knowing what they do like, not deliberately setting themselves to find out what they really enjoy. All people enjoy giving away money, for instance: they don't know *that*, —they rather think they like keeping it; and they *do* keep it under this false impression, often to their great discomfort. Every body likes to do good; but not one in a hundred finds *this* out. Multitudes think they like to do evil; yet no man ever really enjoyed doing evil since God made the world.

So in this lesser matter of ornament. It needs some little care to try experiments upon yourself; it needs deliberate question and upright answer. But there is no difficulty to be overcome, no abstruse reasoning to be gone

into; only a little watchfulness needed, and thoughtfulness, and so much honesty as will enable you to confess to yourself, and to all men, that you enjoy things, though great authorities say you should not.

From *Stones of Venice*, Vol. I, Ch. II, ¶ XIII–XVI.

Naturalism

I CONCLUDE, then, with the reader's leave, that all ornament is base which takes for its subject human work, that it is utterly base,—painful to every rightly-toned mind, without perhaps immediate sense of the reason, but for a reason palpable enough when we *do* think of it. For to carve our own work, and set it up for admiration, is a miserable self-complacency, a contentment in our own wretched doings, when we might have been looking at God's doings. And all noble ornament is the exact reverse of this. It is the expression of man's delight in God's work.

¶ For observe, the function of ornament is to make you happy. Now in what are you rightly happy? Not in thinking of what you have done yourself; not in your own pride; not your own birth; not in your own being, or your own will, but in looking at God; watching what He does, what He is; and obeying His law, and yielding yourself to His will.

You are to be made happy by ornaments; therefore they must be the expression of all this. Not copies of your own handiwork; not boastings of your own grandeur; not heraldries; not king's arms, nor any creature's arms, but God's arm, seen in His work. Not manifestation of your delight in your own laws, or your own liberties, or your own inventions; but in divine laws, constant, daily, common laws;—not Composite laws, nor Doric laws, nor laws of the five orders, but of the Ten Commandments.

From *Stones of Venice*, Vol. I, Ch. XX, ¶ XV–XVI.

Sculptured Decoration

. . . If, to produce a good or beautiful ornament, it were only necessary to produce a perfect piece of sculpture, and if a well-cut group of flowers or animals were indeed an ornament wherever it might be placed, the work of the architect would be comparatively easy. Sculpture and archi-tecture would become separate arts: and the architect would order so many pieces of such subject and size as he needed, without troubling himself with any questions but those of disposition and proportion. But

this is not so. *No perfect piece either of painting or sculpture is an architectural ornament at all,* except in that vague sense in which any beautiful thing is said to ornament the place it is in. Thus we say that pictures ornament a room; but we should not thank an architect who told us that his design, to be complete, required a Titian to be put in one corner of it, and a Velasquez in the other; and it is just as unreasonable to call perfect sculpture, niched in, or encrusted on a building, a portion of the ornament of that building, as it would be to hang pictures by way of ornament on the outside of it. It is very possible that the sculptured work may be harmoniously associated with the building, or the building executed with reference to it; but in this latter case the architecture is subordinate to the sculpture, as in the Medicean chapel, and I believe also in the Parthenon. And so far from the perfection of the work conducing to its ornamental purpose, we may say, with entire security, that its perfection, in some degree, unfits it for its purpose, and that no absolutely complete sculpture can be decoratively right. We have a familiar instance in the flower-work of St. Paul's, which is probably, in the abstract, as perfect flower sculpture as could be produced at the time; and which is just as rational an ornament of the building as so many valuable Van Huysums, framed and glazed, and hung up over each window.

¶ The especial condition of true ornament is, that it be beautiful in its place, and nowhere else, and that it aid the effect of every portion of the building over which it has influence; that it does not, by its richness, make other parts bald, or, by its delicacy, make other parts coarse. Every one of its qualities has reference to its place and use: *and it is fitted for its service by what would be faults and deficiencies if it had no special duty.* Ornament, the servant, is often formal, where sculpture, the master, would have been free; the servant is often silent where the master would have been eloquent; or hurried, where the master would have been serene. . . .

¶ . . . Architecture is the work of nations; but we cannot have nations of great sculptors. Every house in every street of every city ought to be good architecture, but we cannot have Flaxman or Thorwaldsen at work upon it: nor, even if we chose only to devote ourselves to our public buildings, could the mass and majesty of them be great, if we required all to be executed by great men; greatness is not to be had in the required quantity. Giotto may design a campanile, but he cannot carve it; he can only carve one or two of the bas-reliefs at the base of it. And with every increase of your fastidiousness in the execution of your ornament, you diminish the possible number and grandeur of your buildings. Do not think you can educate your workmen, or that the demand for perfection will increase the supply: educated imbecility and finessed foolishness are the worst of all imbecilities and foolishnesses; and there is no free-trade

measure which will ever lower the price of brains,—there is no California of common sense. Exactly in the degree in which you require your decoration to be wrought by thoughtful men, you diminish the extent and number of architectural works. Your business as an architect, is to calculate only on the co-operation of inferior men, to think for them, and to indicate for them such expressions of your thoughts as the weakest capacity can comprehend and the feeblest hand can execute. This is the definition of the purest architectural abstractions. They are the deep and laborious thoughts of the greatest men, put into such easy letters that they can be written by the simplest. *They are expressions of the mind of manhood by the hands of childhood.* . . .

From *Stones of Venice*, Vol. i, Ch. xxi, ¶ iii–xi.

Incrustation

. . . The whole early architecture of Venice is architecture of incrustation: this has not been enough noticed in its peculiar relation to that of the rest of Italy. There is, indeed, much incrusted architecture throughout Italy, in elaborate ecclesiastical work, but there is more which is frankly of brick, or thoroughly of stone. But the Venetian habitually incrusted his work with nacre; he built his houses, even the meanest, as if he had been a shell-fish,—roughly inside, mother-of-pearl on the surface: he was content, perforce, to gather the clay of the Brenta banks, and bake it into brick for his substance of wall; but he overlaid it with the wealth of ocean, with the most precious foreign marbles. You might fancy early Venice one wilderness of brick, which a petrifying sea had beaten upon till it coated it with marble: at first a dark city—washed white by the sea foam. And I told you before that it was also a city of shafts and arches, and that its dwellings were raised upon continuous arcades, among which the sea waves wandered. Hence the thoughts of its builders were early and constantly directed to the incrustation of arches.

From *Stones of Venice*, Vol. i, Ch. xxiii, ¶ xi.

Roofs

I HAVE a . . . confirmed opinion . . . respecting the decoration of curved surfaces. The majesty of a roof is never, I think, so great, as when the eye can pass undisturbed over the course of all its curvatures, and trace

the dying of the shadows along its smooth and sweeping vaults. And I would rather, myself, have a plain ridged Gothic vault, with all its rough stones visible, to keep the sleet and wind out of a cathedral aisle, than all the fanning and pendanting and foliation that ever bewildered Tudor weight. But mosaic or fresco may of course be used as far as we can afford or obtain them; for these do not break the curvature. Perhaps the most solemn roofs in the world are the apse conchas of the Romanesque basilicas, with their golden ground and severe figures. Exactly opposed to these are the decorations which disturb the serenity of the curve without giving it interest, like the vulgar panelling of St. Peter's and the Pantheon; both, I think, in the last degree detestable.

¶ As roofs internally may be divided into surfaces and ribs, externally they may be divided into surfaces, and points, or ridges; these latter often receiving very bold and distinctive ornament. The outside surface is of small importance in central Europe, being almost universally low in slope, and tiled, throughout Spain, South France, and North Italy: of still less importance where it is flat, as a terrace; as often in South Italy and the East, mingled with low domes; but the larger Eastern and Arabian domes become elaborate in ornamentation: I cannot speak of them with confidence; to the mind of an inhabitant of the north, a roof is a guard against wild weather; not a surface which is for ever to bask in serene heat, and gleam across deserts like a rising moon. I can only say, that I have never seen any drawing of a richly decorated Eastern dome that made me desire to see the original.

From *Stones of Venice*, Vol. i, Ch. xxix, ¶ iv-v.

Human Art

Is THERE, then, nothing to be done by man's art? Have we only to copy, and again copy, for ever, the imagery of the universe? Not so. We have work to do upon it; there is not any one of us so simple, nor so feeble, but he has work to do upon it. But the work is not to improve, but to explain. This infinite universe is unfathomable, inconceivable, in its whole; every human creature must slowly spell out, and long contemplate, such part of it as may be possible for him to reach; then set forth what he has learned of it for those beneath him; extricating it from infinity, as one gathers a violet out of grass; one does not improve either violet or grass in gathering it, but one makes the flower visible; and then the human being has to make its power upon his own heart visible also, and to give it the honour of the good thoughts it has raised up in him, and to write upon it the history of

his own soul. And sometimes he may be able to do more than this, and to set it in strange lights, and display it in a thousand ways before unknown: ways specially directed to necessary and noble purposes, for which he had to choose instruments out of the wide armoury of God. All this he may do: and in this he is only doing what every Christian has to do with the written, as well as the created word, 'rightly *dividing* the word of truth'. Out of the infinity of the written word, he has also to gather and set forth things new and old, to choose them for the season and the work that are before him, to explain and manifest them to others, with such illustration and enforcement as may be in his power, and to crown them with the history of what, by them, God has done for his soul. And, in doing this, is he improving the Word of God? Just such difference as there is between the sense in which a minister may be said to improve a text to the people's comfort, and the sense in which an atheist might declare that he could improve the Book, which, if any man shall add unto, there shall be added unto him the plagues that are written therein; just such difference is there between that which, with respect to Nature, man is, in his humbleness, called upon to do, and that which, in his insolence, he imagines himself capable of doing.

From *Stones of Venice*, Vol. i, Ch. xxx, ¶ v.

Torcello

THE INLET which runs nearest to the base of the campanile is not that by which Torcello is commonly approached. Another, somewhat broader, and overhung by alder copse, winds out of the main channel of the lagoon up to the very edge of the little meadow which was once the Piazza of the city, and there, stayed by a few grey stones which present some semblance of a quay, forms its boundary at one extremity. Hardly larger than an ordinary English farmyard, and roughly enclosed on each side by broken palings and hedges of honeysuckle and briar, the narrow field retires from the water's edge, traversed by a scarcely traceable footpath, for some forty or fifty paces, and then expanding into the form of a small square, with buildings on three sides of it, the fourth being that which opens to the water. Two of these, that on our left and that in front of us as we approach from the canal, are so small that they might well be taken for the outhouses of the farm, though the first is a conventual building, and the other aspires to the title of the 'Palazzo publico', both dating as far back as the beginning of the fourteenth century; the third, the octagonal church of Santa Fosca, is far more ancient than either, yet hardly on a larger scale. Though the pillars of the portico which surrounds it are of pure Greek

62. PANEL OF THE FONT IN THE CATHEDRAL AT PISA. Drawing by Ruskin. *Oxford, Ashmolean Museum*

63. THE PULPIT IN THE CATHEDRAL OF TORCELLO

marble, and their capitals are enriched with delicate sculpture, they, and the arches they sustain, together only raise the roof to the height of a cattle-shed; and the first strong impression which the spectator receives from the whole scene is, that whatever sin it may have been which has on this spot been visited with so utter a desolation, it could not at least have been ambition. Nor will this impression be diminished as we approach, or enter, the larger church to which the whole group of building is subordinate. It has evidently been built by men in flight and distress, who sought in the hurried erection of their island church such a shelter for their earnest and sorrowful worship as, on the one hand, could not attract the eyes of their enemies by its splendour, and yet, on the other, might not awaken too bitter feelings by its contrast with the churches which they had seen destroyed. There is visible everywhere a simple and tender effort to recover some of the form of the temples which they had loved, and to do honour to God by that which they were erecting, while distress and humiliation prevented the desire, and prudence precluded the admission, either of luxury of ornament or magnificence of plan. The exterior is absolutely devoid of decoration, with the exception only of the western entrance and the lateral door, of which the former has carved sideposts and architrave, and the latter, crosses of rich sculpture; while the massy stone shutters of the windows, turning on huge rings of stone, which answer the double purpose of stanchions and brackets, cause the whole building rather to resemble a refuge from Alpine storm than the cathedral of a populous city; and, internally, the two solemn mosaics of the eastern and western extremities, —one representing the Last Judgment, the other the Madonna, her tears falling as her hands are raised to bless,—and the noble range of pillars which enclose the space between, terminated by the high throne for the pastor and the semicircular raised seats for the superior clergy, are expressive at once of the deep sorrow and the sacred courage of men who had no home left them upon earth, but who looked for one to come, of men 'persecuted but not forsaken, cast down but not destroyed'. . . .

[The pulpit at Torcello[1] is supported] on a group of four slender shafts; itself of a slightly oval form, extending nearly from one pillar of the nave to the next, so as to give the preacher free room for the action of the entire person, which always gives an unaffected impressiveness to the eloquence of the southern nations. In the centre of its curved front, a small bracket and detached shaft sustain the projection of a narrow marble desk (occupying the place of a cushion in a modern pulpit), which is hollowed out into a shallow curve on the upper surface, leaving a ledge at the bottom of the slab, so that a book laid upon it, or rather into it, settles itself there, opening as if by instinct, but without the least chance of slipping to the

[1] Ill. 63 facing this page.

side, or in any way moving beneath the preacher's hands. Six balls, or rather almonds, of purple marble veined with white are set round the edge of the pulpit, and form its only decoration. Perfectly graceful, but severe and almost cold in its simplicity, built for permanence and service, so that no single member, no stone of it, could be spared, and yet all are firm and uninjured as when they were first set together, it stands in venerable contrast both with the fantastic pulpits of mediæval cathedrals and with the rich furniture of those of our modern churches. . . .

From *Stones of Venice*, Vol. II, Ch. II, ¶ III–VII.

[I have followed the text of the first edition.]

Venice

A YARD or two farther, we pass the hostelry of the Black Eagle, and, glancing as we pass through the square door of marble, deeply moulded, in the outer wall, we see the shadows of its pergola of vines resting on an ancient well, with a pointed shield carved on its side; and so presently emerge on the bridge and Campo San Moisè, whence to the entrance into St. Mark's Place, called the Bocca di Piazza (mouth of the square), the Venetian character is nearly destroyed, first by the frightful façade of San Moisè, which we will pause at another time to examine, and then by the modernizing of the shops as they near the piazza, and the mingling with the lower Venetian populace of lounging groups of English and Austrians. We will push fast through them into the shadow of the pillars at the end of the 'Bocca di Piazza', and then we forget them all; for between those pillars there opens a great light, and, in the midst of it, as we advance slowly, the vast tower of St. Mark seems to lift itself visibly forth from the level field of chequered stones; and, on each side, the countless arches prolong themselves into ranged symmetry, as if the rugged and irregular houses that pressed together above us in the dark alley had been struck back into sudden obedience and lovely order, and all their rude casements and broken walls had been transformed into arches charged with goodly sculpture, and fluted shafts of delicate stone.

¶ And well may they fall back, for beyond those troops of ordered arches there rises a vision out of the earth, and all the great square seems to have opened from it in a kind of awe, that we may see it far away;—a multitude of pillars and white domes, clustered into a long low pyramid of coloured light; a treasure-heap, it seems, partly of gold, and partly of opal and mother-of-pearl, hollowed beneath into five great vaulted porches, ceiled with fair mosaic, and beset with sculpture of alabaster, clear as amber and delicate as ivory,—sculpture fantastic and involved, of palm leaves and

lilies, and grapes and pomegranates, and birds clinging and fluttering among the branches, all twined together into an endless network of buds and plumes; and, in the midst of it, the solemn forms of angels, sceptred, and robed to the feet, and leaning to each other across the gates, their figures indistinct among the gleaming of the golden ground through the leaves beside them, interrupted and dim, like the morning light as it faded back among the branches of Eden, when first its gates were angel-guarded long ago. And round the walls of the porches there are set pillars of variegated stones, jasper and porphyry, and deep-green serpentine spotted with flakes of snow, and marbles, that half refuse and half yield to the sunshine, Cleopatra-like, 'their bluest veins to kiss'—the shadow, as it steals back from them, revealing line after line of azure undulation, as a receding tide leaves the waved sand; their capitals rich with interwoven tracery, rooted knots of herbage, and drifting leaves of acanthus and vine, and mystical signs, all beginning and ending in the Cross; and above them, in the broad archivolts, a continuous chain of language and of life—angels, and the signs of heaven, and the labours of men, each in its appointed season upon the earth; and above these, another range of glittering pinnacles, mixed with white arches edged with scarlet flowers,—a confusion of delight, amidst which the breasts of the Greek horses are seen blazing in their breadth of golden strength, and the St. Mark's Lion, lifted on a blue field covered with stars, until at last, as if in ecstacy, the crests of the arches break into a marble foam, and toss themselves far into the blue sky in flashes and wreaths of sculptured spray, as if the breakers on the Lido shore had been frostbound before they fell, and the sea-nymphs had inlaid them with coral and amethyst.

Between that grim cathedral of England and this, what an interval! There is a type of it in the very birds that haunt them; for, instead of the restless crowd, hoarse-voiced and sable-winged, drifting on the bleak upper air, the St. Mark's porches are full of doves, that nestle among the marble foliage, and mingle the soft iridescence of their living plumes, changing at every motion, with the tints, hardly less lovely, that have stood unchanged for seven hundred years.

¶ And what effect has this splendour on those who pass beneath it? You may walk from sunrise to sunset, to and fro, before the gateway of St. Mark's, and you will not see an eye lifted to it, nor a countenance brightened by it. Priest and layman, soldier and civilian, rich and poor, pass by it alike regardlessly. Up to the very recesses of the porches, the meanest tradesmen of the city push their counters; nay, the foundations of its pillars are themselves the seats—not 'of them that sell doves' for sacrifice, but of the vendors of toys and caricatures. Round the whole square in front of the church there is almost a continuous line of cafés, where the

idle Venetians of the middle classes lounge, and read empty journals; in its centre the Austrian bands play during the time of vespers, their martial music jarring with the organ notes,—the march drowning the miserere, and the sullen crowd thickening round them,—a crowd, which, if it had its will, would stiletto every soldier that pipes to it. And in the recesses of the porches, all day long, knots of men of the lowest classes, unemployed and listless, lie basking in the sun like lizards; and unregarded children,—every heavy glance of their young eyes full of desperation and stony depravity, and their throats hoarse with cursing,—gamble, and fight, and snarl, and sleep, hour after hour, clashing their bruised centesimi upon the marble ledges of the church porch. And the images of Christ and His angels look down upon it continually.

From *Stones of Venice*, Vol. II. Ch. II, ¶ XIII–XX.

Architectural Colour

I BELIEVE that from the beginning of the world there has never been a true or fine school of art in which colour was despised. It has often been imperfectly attained and injudiciously applied, but I believe it to be one of the essential signs of life in a school of art, that it loves colour; and I know it to be one of the first signs of death in the Renaissance schools, that they despised colour.

Observe, it is not now the question whether our Northern cathedrals are better with colour or without. Perhaps the great monotone grey of Nature and of Time is a better colour than any that the human hand can give; but that is nothing to our present business. The simple fact is, that the builders of those cathedrals laid upon them the brightest colours they could obtain, and that there is not, as far as I am aware, in Europe, any monument of a truly noble school which has not been either painted all over, or vigorously touched with paint, mosaic, and gilding in its prominent parts. . . .

¶ In the second chapter of the first volume,[1] it was noticed that the architect of Bourges Cathedral liked hawthorn, and that the porch of his cathedral was therefore decorated with a rich wreath of it; but another of the predilections of that architect was there unnoticed, namely, that he did not at all like *grey* hawthorn, but preferred it green, and he painted it green accordingly, as bright as he could. The colour is still left in every sheltered interstice of the foliage. He had, in fact, hardly the choice of any other colour; he might have gilded the thorns, by way of allegorizing

[1] Of the *Stones of Venice*.

human life, but if they were to be painted at all, they could hardly be painted anything but green, and green all over. People would have been apt to object to any pursuit of abstract harmonies of colour, which might have induced him to paint his hawthorn blue.

¶ In the same way, whenever the subject of the sculpture was definite, its colour was of necessity definite also; and, in the hands of the Northern builders, it often became, in consequence, rather the means of explaining and animating the stories of their stone-work, than a matter of abstract decorative science. Flowers were painted red, trees green, and faces flesh-colour; the result of the whole being often far more entertaining than beautiful. And also, though in the lines of the mouldings and the decorations of shafts or vaults, a richer and more abstract method of colouring was adopted (aided by the rapid development of the best principles of colour in early glass-painting), the vigorous depths of shadow in the Northern sculpture confused the architect's eye, compelling him to use violent colours in the recesses, if these were to be seen as colour at all, and thus injured his perception of more delicate colour harmonies; so that in innumerable instances it becomes very disputable whether monuments even of the best times were improved by the colour bestowed upon them, or the contrary. But, in the South, the flatness and comparatively vague forms of the sculpture, while they appeared to call for colour in order to enhance their interest, presented exactly the conditions which would set it off to the greatest advantage; breadth of surface displaying even the most delicate tints in the lights, and faintness of shadow joining with the most delicate and pearly greys of colour harmony; while the subject of the design being in nearly all cases reduced to mere intricacy of ornamental line, might be coloured in any way the architect chose without any loss of rationality. Where oak leaves and roses were carved into fresh relief and perfect bloom, it was necessary to paint the one green and the other red; but in portions of ornamentation where there was nothing which could be definitely construed into either an oak-leaf or a rose, but a mere labyrinth of beautiful lines, becoming here something like a leaf, and there something like a flower, the whole tracery of the sculpture might be left white, and grounded with gold or blue, or treated in any other manner best harmonizing with the colours around it. And as the necessarily feeble character of the sculpture called for and was ready to display the best arrangements of colour, so the precious marbles in the architect's hands give him at once the best examples and the best means of colour. The best examples, for the tints of all natural stones are as exquisite in quality as endless in change; and the best means, for they are all permanent.

¶ Every motive thus concurred in urging him to the study of chromatic decoration, and every advantage was given him in the pursuit of it; and

this at the very moment when, as presently to be noticed, the *naïveté* of barbaric Christianity could only be forcibly appealed to by the help of coloured pictures: so that, both externally and internally, the architectural construction became partly merged in pictorial effect; and the whole edifice is to be regarded less as a temple wherein to pray, than as itself a Book of Common Prayer, a vast illuminated missal, bound with alabaster instead of parchment, studded with porphyry pillars instead of jewels, and written within and without in letters of enamel and gold. . . .

From *Stones of Venice*, Vol. II, Ch. IV, ¶ XLIII–XLVI.

The Nature of Gothic

THE PRINCIPAL difficulty in [finding out how far Venetian architecture reached the universal or perfect type of Gothic] arises from the fact that every building of the Gothic period differs in some important respect from every other; and many include features which, if they occurred in other buildings, would not be considered Gothic at all; so that all we have to reason upon is merely, if I may be allowed so to express it, a greater or less degree of *Gothicness* in each building we examine. And it is this Gothicness, —the character which, according as it is found more or less in a building, makes it more or less Gothic,—of which I want to define the nature; and I feel the same kind of difficulty in doing so which would be encountered by any one who undertook to explain, for instance, the nature of Redness, without any actually red thing to point to, but only orange and purple things. Suppose he had only a piece of heather and a dead oak-leaf to do it with. He might say, the colour which is mixed with the yellow in this oak-leaf, and with the blue in this heather, would be red, if you had it separate; but it would be difficult, nevertheless, to make the abstraction perfectly intelligible: and it is so in a far greater degree to make the abstraction of the Gothic character intelligible, because that character itself is made up of many mingled ideas, and can consist only in their union. That is to say, pointed arches do not constitute Gothic, nor vaulted roofs, nor flying buttresses, nor grotesque sculptures; but all or some of these things, and many other things with them, when they come together so as to have life.

¶ Observe also, that, in the definition proposed, I shall only endeavour to analyze the idea which I suppose already to exist in the reader's mind. We all have some notion, most of us a very determined one, of the meaning of the term Gothic; but I know that many persons have this idea in their minds without being able to define it: that is to say, understanding generally that Westminster Abbey is Gothic, and St. Paul's is not, that Strasburg

Cathedral is Gothic, and St. Peter's is not, they have, nevertheless, no clear notion of what it is that they recognize in the one or miss in the other, such as would enable them to say how far the work at Westminster or Strasburg is good and pure of its kind; still less to say of any nondescript building, like St. James's Palace or Windsor Castle, how much right Gothic element there is in it, and how much wanting. And I believe this inquiry to be a pleasant and profitable one; and that there will be found something more than usually interesting in tracing out this grey, shadowy, many-pinnacled image of the Gothic spirit within us; and discerning what fellowship there is between it and our Northern hearts. And if, at any point of the inquiry, I should interfere with any of the reader's previously formed conceptions, and use the term Gothic in any sense which he would not willingly attach to it, I do not ask him to accept, but only to examine and understand, my interpretation, as necessary to the intelligibility of what follows in the rest of the work.

¶ We have, then, the Gothic character submitted to our analysis, just as the rough mineral is submitted to that of the chemist, entangled with many other foreign substances, itself perhaps in no place pure, or ever to be obtained or seen in purity for more than an instant; but nevertheless a thing of definite and separate nature, however inextricable or confused in appearance. Now observe: the chemist defines his mineral by two separate kinds of character; one external, its crystalline form, hardness, lustre, &c.; the other internal, the proportions and nature of its constituent atoms. Exactly in the same manner, we shall find that Gothic architecture has external forms, and internal elements. Its elements are certain mental tendencies of the builders, legibly expressed in it; as fancifulness, love of variety, love of richness, and such others. Its external forms are pointed arches, vaulted roofs, &c. And unless both the elements and the forms are there, we have no right to call the style Gothic. It is not enough that it has the Form, if it have not also the power and life. It is not enough that it has the Power, if it have not the form. We must therefore inquire into each of these characters successively; and determine first, what is the Mental Expression, and secondly, what the Material Form, of Gothic architecture, properly so called.

1st. Mental Power or Expression. What characters, we have to discover, did the Gothic builders love, or instinctively express in their work, as distinguished from all other builders?

¶ Let us go back for a moment to our chemistry, and note that, in defining a mineral by its constituent parts, it is not one nor another of them, that can make up the mineral, but the union of all: for instance, it is neither in charcoal, nor in oxygen, nor in lime, that there is the making of chalk, but in the combination of all three in certain measures; they are all found

in very different things from chalk, and there is nothing like chalk either in charcoal or in oxygen, but they are nevertheless necessary to its existence.

So in the various mental characters which make up the soul of Gothic. It is not one nor another that produces it; but their union in certain measures. Each one of them is found in many other architectures besides Gothic; but Gothic cannot exist where they are not found, or, at least, where their place is not in some way supplied. Only there is this great difference between the composition of the mineral, and of the architectural style, that if we withdraw one of its elements from the stone, its form is utterly changed, and its existence as such and such a mineral is destroyed; but if we withdraw one of its mental elements from the Gothic style, it is only a little less Gothic than it was before, and the union of two or three of its elements is enough already to bestow a certain Gothicness of character, which gains in intensity as we add the others, and loses as we again withdraw them.

¶ I believe, then, that the characteristic or moral elements of Gothic are the following, placed in the order of their importance:

1. Savageness.
2. Changefulness.
3. Naturalism.
4. Grotesqueness.
5. Rigidity.
6. Redundance.

These characters are here expressed as belonging to the building; as belonging to the builder, they would be expressed thus: 1. Savageness, or Rudeness. 2. Love of Change. 3. Love of Nature. 4. Disturbed Imagination. 5. Obstinacy. 6. Generosity. And I repeat, that the withdrawal of any one, or any two, will not at once destroy the Gothic character of a building, but the removal of a majority of them will. . . .

¶ Savageness. . . . We should err grievously in refusing either to recognize as an essential character of the existing architecture of the North, or to admit as a desirable character in that which it yet may be, this wildness of thought, and roughness of work; this look of mountain brotherhood between the cathedral and the Alp; this magnificence of sturdy power, put forth only the more energetically because the fine finger-touch was chilled away by the frosty wind, and the eye dimmed by the moor-mist, or blinded by the hail; this outspeaking of the strong spirit of men who may not gather redundant fruitage from the earth, nor bask in dreamy benignity of sunshine, but must break the rock for bread, and cleave the forest for fire, and show, even in what they did for their delight, some of the hard habits of the arm and heart that grew on them as they swung the axe or pressed the plough.

¶ If, however, the savageness of Gothic architecture, merely as an expression of its origin among Northern nations, may be considered, in some sort, a noble character, it possesses a higher nobility still, when considered as an index, not of climate, but of religious principle.

[I have earlier said] that the systems of architectural ornament, properly so called, might be divided into three:—1. Servile ornament, in which the execution or power of the inferior workman is entirely subjected to the intellect of the higher;—2. Constitutional ornament, in which the executive inferior power is, to a certain point, emancipated and independent, having a will of its own, yet confessing its inferiority and rendering obedience to higher powers;—and 3. Revolutionary ornament, in which no executive inferiority is admitted at all. I must here explain the nature of these divisions at somewhat greater length.

Of Servile ornament, the principal schools are the Greek, Ninevite, and Egyptian; but their servility is of different kinds. The Greek master-workman was far advanced in knowledge and power above the Assyrian or Egyptian. Neither he nor those for whom he worked could endure the appearance of imperfection in anything; and, therefore, what ornament he appointed to be done by those beneath him was composed of mere geometrical forms,—balls, ridges, and perfectly symmetrical foliage,—which could be executed with absolute precision by line and rule, and were as perfect in their way, when completed, as his own figure sculpture. The Assyrian and Egyptian, on the contrary, less cognizant of accurate form in anything, were content to allow their figure sculpture to be executed by inferior workmen, but lowered the method of its treatment to a standard which every workman could reach, and then trained him by discipline so rigid, that there was no chance of his falling beneath the standard appointed. The Greek gave to the lower workman no subject which he could not perfectly execute. The Assyrian gave him subjects which he could only execute imperfectly, but fixed a legal standard for his imperfection. The workman was, in both systems, a slave.*

¶ But in the mediæval, or especially Christian, system of ornament, this slavery is done away with altogether; Christianity having recognized, in small things as well as great, the individual value of every soul. But it not only recognizes its value; it confesses its imperfection, in only bestowing dignity upon the acknowledgement of unworthiness. That admission of lost power and fallen nature, which the Greek or Ninevite felt to be

* The third kind of ornament, the Renaissance, is that in which the inferior detail becomes principal, the executor of every minor portion being required to exhibit skill and possess knowledge as great as that which is possessed by the master of the design; and in the endeavour to endow him with this skill and knowledge, his own original power is overwhelmed, and the whole building becomes a wearisome exhibition of well-educated imbecility. We must fully inquire into the nature of this form of error, when we arrive at the examination of the Renaissance schools.

intensely painful, and, as far as might be, altogether refused, the Christian makes daily and hourly, contemplating the fact of it without fear, as tending, in the end, to God's greater glory. Therefore, to every spirit which Christianity summons to her service, her exhortation is: Do what you can, and confess frankly what you are unable to do; neither let your effort be shortened for fear of failure, nor your confession silenced for fear of shame. And it is, perhaps, the principal admirableness of the Gothic schools of architecture, that they thus receive the results of the labour of inferior minds; and out of fragments full of imperfection, and betraying that imperfection in every touch, indulgently raise up a stately and unaccusable whole.

¶ But the modern English mind has this much in common with that of the Greek, that it intensely desires, in all things, the utmost completion or perfection compatible with their nature. This is a noble character in the abstract, but becomes ignoble when it causes us to forget the relative dignities of that nature itself, and to prefer the perfectness of the lower nature to the imperfection of the higher; not considering that as, judged by such a rule, all the brute animals would be preferable to man, because more perfect in their functions and kind, and yet are always held inferior to him, so also in the works of man, those which are more perfect in their kind are always inferior to those which are, in their nature, liable to more faults and shortcomings. For the finer the nature, the more flaws it will show through the clearness of it; and it is a law of this universe, that the best things shall be seldomest seen in their best form. The wild grass grows well and strongly, one year with another; but the wheat is, according to the greater nobleness of its nature, liable to the bitterer blight. And therefore, while in all things that we see, or do, we are to desire perfection, and strive for it, we are nevertheless not to set the meaner thing, in its narrow accomplishment, above the nobler thing, in its mighty progress; not to esteem smooth minuteness above shattered majesty; not to prefer mean victory to honourable defeat; not to lower the level of our aim, that we may the more surely enjoy the complacency of success. But, above all, in our dealings with the souls of other men, we are to take care how we check, by severe requirement or narrow caution, efforts which might otherwise lead to a noble issue; and, still more, how we withhold our admiration from great excellencies, because they are mingled with rough faults. Now, in the make and nature of every man, however rude or simple, whom we employ in manual labour, there are some powers for better things: some tardy imagination, torpid capacity of emotion, tottering steps of thought, there are, even at the worst; and in most cases it is all our own fault that they *are* tardy or torpid. But they cannot be strengthened, unless we are content to take them in their feebleness, and unless we prize and honour them in their imperfection above the best and most perfect manual skill.

And this is what we have to do with all our labourers; to look for the *thoughtful* part of them, and get that out of them, whatever we lose for it, whatever faults and errors we are obliged to take with it. For the best that is in them cannot manifest itself, but in company with much error. Understand this clearly: You can teach a man to draw a straight line, and to cut one; to strike a curved line, and to carve it; and to copy and carve any number of given lines or forms, with admirable speed and perfect precision; and you find his work perfect of its kind: but if you ask him to think about any of those forms, to consider if he cannot find any better in his own head, he stops; his execution becomes hesitating; he thinks, and ten to one he thinks wrong; ten to one he makes a mistake in the first touch he gives to his work as a thinking being. But you have made a man of him for all that. He was only a machine before, an animated tool.

¶ And observe, you are put to stern choice in this matter. You must either make a tool of the creature, or a man of him. You cannot make both. Men were not intended to work with the accuracy of tools, to be precise and perfect in all their actions. If you will have that precision out of them, and make their fingers measure degrees like cog-wheels, and their arms strike curves like compasses, you must unhumanize them. All the energy of their spirits must be given to make cogs and compasses of themselves. All their attention and strength must go to the accomplishment of the mean act. The eye of the soul must be bent upon the finger-point, and the soul's force must fill all the invisible nerves that guide it, ten hours a day, that it may not err from its steely precision, and so soul and sight be worn away, and the whole human being be lost at last—a heap of sawdust, so far as its intellectual work in this world is concerned; saved only by its Heart, which cannot go into the form of cogs and compasses, but expands, after the ten hours are over, into fireside humanity. On the other hand, if you will make a man of the working creature, you cannot make a tool. Let him but begin to imagine, to think, to try to do anything worth doing; and the engine-turned precision is lost at once. Out come all his roughness, all his dullness, all his incapability; shame upon shame, failure upon failure, pause after pause: but out comes the whole majesty of him also; and we know the height of it only, when we see the clouds settling upon him. And whether the clouds be bright or dark, there will be transfiguration behind and within them.

¶ And now, reader, look round this English room of yours, about which you have been proud so often, because the work of it was so good and strong, and the ornaments of it so finished. Examine again all those accurate mouldings, and perfect polishings, and unerring adjustments of the seasoned wood and tempered steel. Many a time you have exulted over them, and thought how great England was, because her slightest

work was done so thoroughly. Alas! if read rightly, these perfectnesses are signs of a slavery in our England a thousand times more bitter and more degrading than that of the scourged African, or helot Greek. Men may be beaten, chained, tormented, yoked like cattle, slaughtered like summer flies, and yet remain in one sense, and the best sense, free. But to smother their souls within them, to blight and hew into rotting pollards the suckling branches of their human intelligence, to make the flesh and skin which, after the worm's work on it, is to see God, into leathern thongs to yoke machinery with,—this it is to be slave-masters indeed; and there might be more freedom in England, though her feudal lords' lightest words were worth men's lives, and though the blood of the vexed husband-man dropped in the furrows of her fields, than there is while the animation of her multitudes is sent like fuel to feed the factory smoke, and the strength of them is given daily to be wasted into the fineness of a web, or racked into the exactness of a line.

¶ And, on the other hand, go forth again to gaze upon the old cathedral front, where you have smiled so often at the fantastic ignorance of the old sculptors: examine once more those ugly goblins, and formless monsters, and stern statues, anatomiless and rigid; but do not mock at them, for they are signs of the life and liberty of every workman who struck the stone; a freedom of thought, and rank in scale of being, such as no laws, no charters, no charities can secure; but which it must be the first aim of all Europe at this day to regain for her children. . . .

From *Stones of Venice*, Vol. ii, Ch. vi, 'The Nature of Gothic', ¶ ii–xiv.

Values

WE HAVE much studied and much perfected, of late, the great civilized invention of the division of labour; only we give it a false name. It is not, truly speaking, the labour that is divided, but the men;—Divided into mere segments of men—broken into small fragments and crumbs of life; so that all the little piece of intelligence that is left in a man is not enough to make a pin or a nail, but exhausts itself in making the point of a pin or the head of a nail. Now it is a good and desirable thing, truly, to make many pins in a day; but if we could only see with what crystal sand their points were polished,—sand of human soul, much to be magnified before it can be discerned for what it is,—we should think there might be some loss in it also. And the great cry that rises from all our manufacturing cities, louder than their furnace blast, is all in very deed for this,—that we manufacture everything there except men. . . . It can be met only by a

right understanding, on the part of all classes, of what kinds of labour are good for men, raising them, and making them happy; by a determined sacrifice of such convenience, or beauty, or cheapness as is to be got only by the degradation of the workman; and by equally determined demand for the products and results of healthy and ennobling labour.

¶ And how, it will be asked, are these products to be recognized, and this demand to be regulated? Easily: by the observance of three broad and simple rules:

1. Never encourage the manufacture of any article not absolutely necessary, in the production of which *Invention* has no share.

2. Never demand an exact finish for its own sake, but only for some practical or noble end.

3. Never encourage imitation or copying of any kind, except for the sake of preserving record of great works.

The second of these principles is the only one which directly rises out of the consideration of our immediate subject; but I shall briefly explain the meaning and extent of the first also, reserving the enforcement of the third for another place.

1. Never encourage the manufacture of anything not necessary, in the production of which invention has no share.

For instance. Glass beads are utterly unnecessary, and there is no design or thought employed in their manufacture. They are formed by first drawing out the glass into rods; these rods are chopped up into fragments of the size of beads by the human hand, and the fragments are then rounded in the furnace. The men who chop up the rods sit at their work all day, their hands vibrating with a perpetual and exquisitely timed palsy, and the beads dropping beneath their vibration like hail. Neither they, nor the men who draw out the rods or fuse the fragments, have the smallest occasion for the use of any single human faculty; and every young lady, therefore, who buys glass beads is engaged in the slave-trade, and in a much more cruel one than that which we have so long been endeavouring to put down.

But glass cups and vessels may become the subjects of exquisite invention; and if in buying these we pay for the invention, that is to say for the beautiful form, or colour, or engraving, and not for mere finish of execution, we are doing good to humanity. . . .

¶ I shall only give one example, which however will show the reader what I mean, from the manufacture already alluded to, that of glass. Our modern glass is exquisitely clear in its substance, true in its form, accurate in its cutting. We are proud of this. We ought to be ashamed of it. The old Venice glass was muddy, inaccurate in all its forms, and clumsily

cut, if at all. And the old Venetian was justly proud of it. For there is this difference between the English and Venetian workman, that the former thinks only of accurately matching his patterns, and getting his curves perfectly true and his edges perfectly sharp, and becomes a mere machine for rounding curves and sharpening edges, while the old Venetian cared not a whit whether his edges were sharp or not, but he invented a new design for every glass that he made, and never moulded a handle or a lip without a new fancy in it. And therefore, though some Venetian glass is ugly and clumsy enough, when made by clumsy and uninventive work-men, other Venetian glass is so lovely in its forms that no price is too great for it; and we never see the same form in it twice. Now you cannot have the finish and the varied form too. If the workman is thinking about his edges, he cannot be thinking of his design; if of his design, he cannot think of his edges. Choose whether you will pay for the lovely form or the perfect finish, and choose at the same moment whether you will make the worker a man or a grindstone.

¶ Nay, but the reader interrupts me,—'If the workman can design beautifully, I would not have him kept at the furnace. Let him be taken away and made a gentleman, and have a studio, and design his glass there, and I will have it blown and cut for him by common workmen, and so I will have my design and my finish too.'

All ideas of this kind are founded upon two mistaken suppositions: the first, that one man's thoughts can be, or ought to be, executed by another man's hands; the second, that manual labour is a degradation, when it is governed by intellect.

On a large scale, and in work determinable by line and rule, it is indeed both possible and necessary that the thoughts of one man should be carried out by the labour of others; in this sense I have already defined the best architecture to be the expression of the mind of manhood by the hands of childhood. But on a smaller scale, and in a design which cannot be mathematically defined, one man's thoughts can never be expressed by another: and the difference between the spirit of touch of the man who is inventing, and of the man who is obeying directions, is often all the difference between a great and a common work of art. How wide the separation is between original and second-hand execution, I shall endeavour to show elsewhere; it is not so much to our purpose here as to mark the other and more fatal error of despising manual labour when governed by intellect; for it is no less fatal an error to despise it when thus regulated by intellect, than to value it for its own sake. We are always in these days endeavouring to separate the two; we want one man to be always thinking, and another to be always working, and we call one a gentleman, and the other an operative; whereas the workman ought often to be thinking, and the

thinker often to be working, and both should be gentlemen, in the best sense. As it is, we make both ungentle, the one envying, the other despising, his brother; and the mass of society is made up of morbid thinkers, and miserable workers. Now it is only by labour that thought can be made healthy, and only by thought that labour can be made happy, and the two cannot be separated with impunity. It would be well if all of us were good handicraftsmen in some kind, and the dishonour of manual labour done away with altogether; so that though there should still be a trenchant distinction of race between nobles and commoners, there should not, among the latter, be a trenchant distinction of employment, as between idle and working men, or between men of liberal and illiberal professions. All professions should be liberal, and there should be less pride felt in peculiarity of employment, and more in excellence of achievement. And yet more, in each several profession, no master should be too proud to do its hardest work. The painter should grind his own colours; the architect work in the mason's yard with his men; the master-manufacturer be himself a more skilful operative than any man in his mills; and the distinction between one man and another be only in experience and skill, and the authority and wealth which these must naturally and justly obtain.

¶ I should be led far from the matter in hand, if I were to pursue this interesting subject. Enough, I trust, has been said to show the reader that the rudeness or imperfection which at first rendered the term 'Gothic' one of reproach is indeed, when rightly understood, one of the most noble characters of Christian architecture, and not only a noble but an *essential* one. It seems a fantastic paradox, but it is nevertheless a most important truth, that no architecture can be truly noble which is *not* imperfect. And this is easily demonstrable. For since the architect, whom we will suppose capable of doing all in perfection, cannot execute the whole with his own hands, he must either make slaves of his workmen in the old Greek, and present English fashion, and level his work to a slave's capacities, which is to degrade it; or else he must take his workmen as he finds them, and let them show their weaknesses together with their strength, which will involve the Gothic imperfection, but render the whole work as noble as the intellect of the age can make it.

¶ But the principle may be stated more broadly still. I have confined the illustration of it to architecture, but I must not leave it as if true of architecture only. Hitherto I have used the words imperfect and perfect merely to distinguish between work grossly unskilful, and work executed with average precision and science; and I have been pleading that any degree of unskilfulness should be admitted, so only that the labourer's mind had room for expression. But, accurately speaking, no good work

whatever can be perfect, and *the demand for perfection is always a sign of a misunderstanding of the ends of art.*

¶ This for two reasons, both based on everlasting laws. The first, that no great man ever stops working till he has reached his point of failure: that is to say, his mind is always far in advance of his powers of execution, and the latter will now and then give way in trying to follow it; besides that he will always give to the inferior portions of his work only such inferior attention as they require; and according to his greatness he becomes so accustomed to the feeling of dissatisfaction with the best he can do, that in moments of lassitude or anger with himself he will not care though the beholder be dissatisfied also. I believe there has only been one man who would not acknowledge this necessity, and strove always to reach perfection, Leonardo; the end of his vain effort being merely that he would take ten years to a picture, and leave it unfinished. And therefore, if we are to have great men working at all, or less men doing their best, the work will be imperfect, however beautiful. Of human work none but what is bad can be perfect, in its own bad way.*

¶ The second reason is, that imperfection is in some sort essential to all that we know of life. It is the sign of life in a mortal body, that is to say, of a state of progress and change. Nothing that lives is, or can be, rigidly perfect; part of it is decaying, part nascent. The foxglove blossom, —a third part bud, a third part past, a third part in full bloom,—is a type of the life of this world. And in all things that live there are certain irregularities and deficiencies which are not only signs of life, but sources of beauty. No human face is exactly the same in its lines on each side, no leaf perfect in its lobes, no branch in its symmetry. All admit irregularity as they imply change; and to banish imperfection is to destroy expression, to check exertion, to paralyze vitality. All things are literally better, lovelier, and more beloved for the imperfections which have been divinely appointed, that the law of human life may be Effort, and the law of human judgment, Mercy.

Accept this then for a universal law, that neither architecture nor any other noble work of man can be good unless it be imperfect; and let us be prepared for the otherwise strange fact, which we shall discern clearly as we approach the period of the Renaissance, that the first cause of the fall of the arts of Europe was a relentless requirement of perfection, incapable alike either of being silenced by veneration for greatness, or softened into forgiveness of simplicity.

Thus far then of the Rudeness or Savageness, which is the first mental

* The Elgin marbles are supposed by many persons to be 'perfect'. In the most important portions they indeed approach perfection, but only there. The draperies are unfinished, the hair and wool of the animals are unfinished, and the entire bas-reliefs of the frieze are roughly cut.

element of Gothic architecture. It is an element in many other healthy architectures also, as in Byzantine and Romanesque; but true Gothic cannot exist without it.

¶ The second mental element above named was CHANGEFULNESS, or Variety.

I have already enforced the allowing independent operation to the inferior workman, simply as a duty to *him*, and as ennobling the architecture by rendering it more Christian. We have now to consider what reward we obtain for the performance of this duty, namely, the perpetual variety of every feature of the building.

Wherever the workman is utterly enslaved, the parts of the building must of course be absolutely like each other; for the perfection of his execution can only be reached by exercising him in doing one thing, and giving him nothing else to do. The degree in which the workman is degraded may be thus known at a glance, by observing whether the several parts of the building are similar or not; and if, as in Greek work, all the capitals are alike, and all the mouldings unvaried, then the degradation is complete; if, as in Egyptian or Ninevite work, though the manner of executing certain figures is always the same, the order of design is perpetually varied, the degradation is less total; if, as in Gothic work, there is perpetual change both in design and execution, the workman must have been altogether set free. . . .

¶ From these facts we may gather generally that Monotony is, and ought to be, painful to us, just as darkness is; that an architecture which is altogether monotonous is a dark or dead architecture; and of those who love it, it may be truly said, 'they love darkness rather than light'. But monotony in certain measure, used in order to give value to change, and, above all, that *transparent* monotony which, like the shadows of a great painter, suffers all manner of dimly suggested form to be seen through the body of it, is an essential in architectural as in all other composition; and the endurance of monotony has about the same place in a healthy mind that the endurance of darkness has: that is to say, as a strong intellect will have pleasure in the solemnities of storm and twilight, and in the broken and mysterious lights that gleam among them, rather than in mere brilliancy and glare, while a frivolous mind will dread the shadow and the storm; and as a great man will be ready to endure much darkness of fortune in order to reach greater eminence of power or felicity, while an inferior man will not pay the price; exactly in like manner a great mind will accept, or even delight in, monotony which would be wearisome to an inferior intellect, because it has more patience and power of expectation, and is ready to pay the full price for the great future pleasure of change. But in all cases it is not that the noble nature loves monotony, any more than it

loves darkness or pain. But it can bear with it, and receives a high pleasure in the endurance or patience, a pleasure necessary to the well-being of this world; while those who will not submit to the temporary sameness, but rush from one change to another, gradually dull the edge of change itself, and bring a shadow and weariness over the whole world from which there is no more escape. . . .

¶ . . . The Gothic ornament stands out in prickly independence, and frosty fortitude, jutting into crockets, and freezing into pinnacles; here starting up into a monster, there germinating into a blossom; anon knitting itself into a branch, alternately thorny, bossy, and bristly, or writhed into every form of nervous entanglement; but, even when most graceful, never for an instant languid, always quickset; erring, if at all, ever on the side of brusquerie.

¶ The feelings or habits in the workman which give rise to this character in the work, are more complicated and various than those indicated by any other sculptural expression hitherto named. There is, first, the habit of hard and rapid working; the industry of the tribes of the North, quickened by the coldness of the climate, and giving an expression of sharp energy to all they do . . . as opposed to the languor of the Southern tribes, however much of fire there may be in the heart of that langour, for lava itself may flow languidly. There is also the habit of finding enjoyment in the signs of cold, which is never found, I believe, in the inhabitants of countries south of the Alps. Cold is to them an unredeemed evil, to be suffered, and forgotten as soon as may be; but the long winter of the North forces the Goth (I mean the Englishman, Frenchman, Dane, or German), if he would lead a happy life at all, to find sources of happiness in foul weather as well as fair, and to rejoice in the leafless as well as in the shady forest. And this we do with all our hearts; finding perhaps nearly as much contentment by the Christmas fire as in the summer sunshine, and gaining health and strength on the ice-fields of winter, as well as among the meadows of spring. So that there is nothing adverse or painful to our feelings in the cramped and stiffened structure of vegetation checked by cold; and instead of seeking, like the Southern sculptor, to express only the softness of leafage nourished in all tenderness, and tempted into all luxuriance by warm winds and glowing rays, we find pleasure in dwelling upon the crabbed, perverse, and morose ani-mation of plants that have known little kindness from earth or heaven, but, season after season, have had their best efforts palsied by frost, their brightest buds buried under snow, and their goodliest limbs lopped by tempest.

¶ There are many subtle sympathies and affections which join to con-firm the Gothic mind in this peculiar choice of subject; and when we add

to the influence of these, the necessities consequent upon the employ-
ment of a rougher material, compelling the workman to seek for vigour of
effect, rather than refinement of texture or accuracy of form, we have
direct and manifest causes for much of the difference between the northern
and southern cast of conception: but there are indirect causes holding a far
more important place in the Gothic heart, though less immediate in their
influence on design. Strength of will, independence of character, resolute-
ness of purpose, impatience of undue control, and that general tendency to
set the individual reason against authority, and the individual deed against
destiny, which, in the Northern tribes, has opposed itself throughout all
ages to the languid submission, in the Southern, of thought to tradition,
and purpose to fatality, are all more or less traceable in the rigid lines,
vigorous and various masses, and daringly projecting and independent struc-
ture of the Northern Gothic ornament: while the opposite feelings are in
like manner legible in the graceful and softly guided waves and wreathed
bands, in which Southern decoration is constantly disposed; in its tendency
to lose its independence, and fuse itself into the surface of the masses upon
which it is traced; and in the expression seen so often, in the arrangement
of those masses themselves, of an abandonment of their strength to an
inevitable necessity, or a listless repose. . . .

¶ Last, because the least essential of the constituent elements of this
noble school, was placed that of REDUNDANCE,—the uncalculating be-
stowal of the wealth of its labour. There is, indeed, much Gothic, and that
of the best period, in which this element is hardly traceable, and which
depends for its effect almost exclusively on loveliness of simple design and
grace of uninvolved proportion: still, in the most characteristic buildings,
a certain portion of their effect depends upon accumulation of ornament;
and many of those which have most influence on the minds of men, have
attained it by means of this attribute alone. And although, by careful study
of the school, it is possible to arrive at a condition of taste which shall be
better contented by a few perfect lines than by a whole façade covered
with fretwork, the building which only satisfies such a taste is not to be
considered the best. For the very first requirement of Gothic architecture
being, as we saw above, that it shall both admit the aid, and appeal to the
admiration, of the rudest as well as the most refined minds, the richness
of the work is, paradoxical as the statement may appear, a part of its
humility. No architecture is so haughty as that which is simple; which
refuses to address the eye, except in a few clear and forceful lines; which
implies, in offering so little to our regards, that all it has offered is perfect;
and disdains, either by the complexity or the attractiveness of its features,
to embarrass our investigation, or betray us into delight. That humility,
which is the very life of the Gothic school, is shown not only in the

imperfection, but in the accumulation, of ornament. The inferior rank of the workman is often shown as much in the richness, as the roughness, of his work; and if the co-operation of every hand, and the sympathy of every heart, are to be received, we must be content to allow the redundance which disguises the failure of the feeble, and wins the regard of the in-attentive. There are, however, far nobler interests mingling, in the Gothic heart, with the rude love of decorative accumulation: a magnificent en-thusiasm, which feels as if it never could do enough to reach the fulness of its ideal; an unselfishness of sacrifice, which would rather cast fruitless labour before the altar than stand idle in the market; and, finally, a profound sympathy with the fulness and wealth of the material universe, rising out of that Naturalism whose operation we have already endeavoured to define. The sculptor who sought for his models among the forest leaves, could not but quickly and deeply feel that complexity need not involve the loss of grace, nor richness that of repose; and every hour which he spent in the study of the minute and various work of Nature, made him feel more forcibly the barrenness of what was best in that of man: nor is to to be wondered at, that, seeing her perfect and exquisite creations poured forth in a profusion which conception could not grasp nor calculation sum, he should think that it ill became him to be niggardly of his own rude crafts-manship; and where he saw throughout the universe a faultless beauty lavished on measureless spaces of broidered field and blooming mountain, to grudge his poor and imperfect labour to the few stones that he had raised one upon another, for habitation or memorial. The years of his life passed away before his task was accomplished; but generation succeeded generation with unwearied enthusiasm, and the cathedral front was at last lost in the tapestry of its traceries, like a rock among the thickets and herbage of spring.

¶ We have now, I believe, obtained a view approaching to com-pleteness of the various moral or imaginative elements which composed the inner spirit of Gothic architecture. We have, in the second place, to define its outward form.

Now, as the Gothic spirit is made up of several elements, some of which may, in particular examples, be wanting, so the Gothic form is made up of minor conditions of form, some of which may, in particular examples, be imperfectly developed.

We cannot say, therefore, that a building is either Gothic or not Gothic in form, any more than we can in spirit. We can only say that it is more or less Gothic, in proportion to the number of Gothic forms which it unites.

From *Stones of Venice*, Vol. ii, Ch. vi, 'The Nature of Gothic' ¶ ii–LXXIX.

Gothic Windows

WHETHER noble, or merchant, or, as frequently happened, both, every Venetian appears, at this time [1] to have raised his palace or dwelling-house upon one type. Under every condition of import.nce, through every variation of size, the forms and mode of decoration of all the features were universally alike; not servilely alike, but fraternally; not with the sameness of coins cast from one mould, but with the likeness of the members of one family. No fragment of the period is preserved, in which the windows, be they few or many, a group of three or an arcade of thirty, have not the noble cusped arch of the fifth order. And they are especially to be noted by us at this day, because these refined and richly ornamented forms were used in the habitations of a nation as laborious, as practical, as brave, and as prudent as ourselves; and they were built at a time when that nation was struggling with calamities and changes threatening its existence almost every hour. And, farther, they are interesting because perfectly applicable to modern habitation. The refinement of domestic life appears to have been far advanced in Venice from her earliest days; and the remains of her Gothic palaces are, at this day, the most delightful residences in the city, having undergone no change in external form, and probably having been rather injured and rendered more convenient by the modifications which poverty and Renaissance taste, contending with the ravages of time, have introduced in the interiors. So that, at Venice and the cities grouped around it, Vicenza, Padua, and Verona, the traveller may ascertain, by actual experience, the effect which would be produced upon the comfort or luxury of daily life by the revival of the Gothic school of architecture. He can still stand upon the marble balcony in the soft summer air, and feel its smooth surface warm from the noontide as he leans on it in the twilight; he can still see the strong sweep of the unruined traceries drawn on the deep serenity of the starry sky, and watch the fantastic shadows of the clustered arches shorten in the moonlight on the chequered floor; or he may close the casements fitted to their unshaken shafts against such wintry winds as would have made an English house vibrate to its foundation, and, in either case, compare their influence on his daily home feeling with that of the square openings in his English wall.

¶ And let him be assured, if he find there is more to be enjoyed in the Gothic window, there is also more to be trusted. It is the best and strongest building, as it is the most beautiful. I am not now speaking of the particular form of Venetian Gothic, but of the general strength of the pointed arch as opposed to that of the level lintel of the square window;

[1] The thirteenth century.

and I plead for the introduction of the Gothic form into our domestic architecture, not merely because it is lovely, but because it is the only form of faithful, strong, enduring, and honourable building, in such materials as come daily to our hands. By increase of scale and cost, it is possible to build, in any style, what will last for ages; but only in the Gothic is it possible to give security and dignity to work wrought with imperfect means and materials. And I trust that there will come a time when the English people may see the folly of building basely and insecurely. It is common with those architects against whose practice my writings have hitherto been directed, to call them merely theoretical and imaginative. I answer, that there is not a single principle asserted either in the 'Seven Lamps' or here, but is of the simplest, sternest veracity, and the easiest practicability; that buildings, raised as I would have them, would stand unshaken for a thousand years; and the buildings raised by the architects who oppose them will not stand for one hundred and fifty, they sometimes do not stand for an hour. There is hardly a week passes without some catastrophe brought about by the base principles of modern building: some vaultless floor that drops the staggering crowd through the jagged rents of its rotten timbers; some baseless bridge that is washed away by the first wave of a summer flood; some fungous wall of nascent rottenness that a thunder-shower soaks down with its workmen into a heap of slime and death. These we hear of, day by day; yet these indicate but the thousandth part of the evil. The portion of the national income sacrificed in mere bad building, in the perpetual repairs, and swift condemnation and pulling down of ill-built shells of houses, passes all calculation. And the weight of the penalty is not yet felt; it will tell upon our children some fifty years hence, when the cheap work, and contract work, and stucco and plaster work, and bad iron work, and all the other expedients of modern rivalry, vanity, and dishonesty, begin to show themselves for what they are.

From *Stones of Venice*, Vol. II, Ch. VII, ¶ XLVI–XLVII.

Northern Gothic

. . . In the North of Europe, civilization was less advanced, and the knowledge of the arts was more confined to the ecclesiastical orders [than in Venice], so that, for domestic architecture, the period of perfection must be there placed much later than in Italy, and considered as extending to the middle of the fifteenth century; yet, as each city reached a certain point in civilization, its streets became decorated with the same magnificence, varied only in style according to the materials at hand, and temper of the people.

And I am not aware of any town of wealth and importance in the middle ages, in which some proof does not exist, that, at its period of greatest energy and prosperity, its streets were inwrought with rich sculpture, and even (though in this, as before noticed, Venice always stood supreme) glowing with colour and with gold. Now, therefore, let the reader,— forming for himself as vivid and real a conception as he is able, either of a group of Venetian palaces in the fourteenth century, or, if he likes better, of one of the more fantastic but even richer street scenes of Rouen, Antwerp, Cologne, or Nuremberg, and keeping this gorgeous image before him,— go out into any thoroughfare, representative, in a general and characteristic way, of the feeling for domestic architecture in modern times; let him, for instance, if in London, walk once up and down Harley Street, or Baker Street, or Gower Street; and then, looking upon this picture and on this, set himself to consider (for this is to be the subject of our following and final inquiry) what have been the causes which have induced so vast a change in the European mind.

¶ Renaissance architecture is the school which has conducted men's inventive and constructive faculties from the Grand Canal to Gower Street; from the marble shaft, and the lancet arch, and the wreathed leafage, and the glowing and melting harmony of gold and azure, to the square cavity in the brick wall. We have now to consider the causes and the steps of this change; and, as we endeavoured above to investigate the nature of Gothic, here to investigate also the nature of Renaissance. . . .

<div align="right">From Stones of Venice, Vol. III, Ch. I, ¶ 1-2.</div>

Pride of Science

THE MORAL, or immoral, elements which unite to form the spirit of Central Renaissance architecture are, I believe, in the main, two,— Pride and Infidelity; but the pride resolves itself into three main branches, —Pride of Science, Pride of State, and Pride of System: and thus we have four separate mental conditions which must be examined successively.

I. PRIDE OF SCIENCE. It would have been more charitable, but more confusing, to have added another element to our list, namely the *Love* of Science; but the love is included in the pride, and is usually so very subordinate an element that it does not deserve equality of nomenclature. But whether pursued in pride or in affection (how far by either we shall see presently), the first notable characteristic of the Renaissance central school is its introduction of accurate knowledge into all its work, so far as it possesses such knowledge; and its evident conviction, that such science is

necessary to the excellence of the work, and is the first thing to be expressed therein. So that all the forms introduced, even in its minor ornament, are studied with the utmost care; the anatomy of all animal structure is thoroughly understood and elaborately expressed, and the whole of the execution skilful and practised in the highest degree. Perspective, linear and aerial, perfect drawing and accurate light and shade in painting, and true anatomy in all representations of the human form, drawn or sculptured, are the first requirements in all the work of this school. . . .

¶ . . . [It being the truth not of fact but of phenomena] with which art is exclusively concerned, how is such truth as this to be ascertained and accumulated? Evidently, and only, by perception and feeling. Never either by reasoning, or report. Nothing must come between Nature and the artist's sight; nothing between God and the artist's soul. Neither calculation nor hearsay,—be it the most subtle of calculations, or the wisest of sayings, —may be allowed to come between the universe, and the witness which art bears to its visible nature. The whole value of that witness depends on its being *eye*-witness; the whole genuineness, acceptableness, and dominion of it depend on the personal assurance of the man who utters it. All its victory depends on the veracity of the one preceding word, 'Vidi'.

The whole function of the artist in the world is to be a seeing and feeling creature; to be an instrument of such tenderness and sensitiveness, that no shadow, no hue, no line, no instantaneous and evanescent expression of the visible things around him, nor any of the emotions which they are capable of conveying to the spirit which has been given him, shall either be left unrecorded, or fade from the book of record. It is not his business either to think, to judge, to argue, or to know. His place is neither in the closet, nor on the bench, nor at the bar, nor in the library. They are for other men and other work. He may think, in a by-way; reason, now and then, when he has nothing better to do; know, such fragments of knowledge as he can gather without stooping, or reach without pains; but none of these things are to be his care. The work of his life is to be two-fold only; to see, to feel. . . .

¶ . . . For one visible truth to which knowledge . . . opens the eyes, it seals them to a thousand; that is to say, if the knowledge occur to the mind so as to occupy its powers of contemplation at the moment when sight-work is to be done, the mind retires inward, fixes itself upon the known fact, and forgets the passing visible ones; and a *moment* of such forgetfulness loses more to the painter than a day's thought can gain. This is no new or strange assertion. Every person accustomed to careful reflection of any kind, knows that its natural operation is to close his eyes to the external world. While he is thinking deeply, he neither sees nor feels, even though naturally he may possess strong powers of sight and emotion. He

who, having journeyed all day beside the Leman Lake, asked of his companions, at evening, where it was,* probably was not wanting in sensibility; but he was generally a thinker, not a perceiver. And this instance is only an extreme one of the effect which, in all cases, knowledge, becoming a subject of reflection, produces upon the sensitive faculties. It must be but poor and lifeless knowledge, if it has no tendency to force itself forward, and become ground for reflection, in despite of the succession of external objects. It will not obey their succession. The first that comes gives it food enough for its day's work; it is its habit, its duty, to case the rest aside, and fasten upon that. The first thing that a thinking and knowing man sees in the course of the day, he will not easily quit. It is not his way to quit anything without getting to the bottom of it, if possible. But the artist is bound to receive all things on the broad, white, lucid field of his soul, not to grasp at one. For instance, as the knowing and thinking man watches the sunrise, he sees something in the colour of a ray, or the change of a cloud, that is new to him; and this he follows out forthwith into a labyrinth of optical and pneumatical laws, perceiving no more clouds nor rays all the morning. But the painter must catch all the rays, all the colours that come, and see them all truly, all in their real relations and succession; therefore, everything that occupies room in his mind he must cast aside for the time, as completely as may be. The thoughtful man is gone far away to seek; but the perceiving man must sit still, and open his heart to receive. The thoughtful man is knitting and sharpening himself into a two-edged sword, wherewith to pierce. The perceiving man is stretching himself into a four-cornered sheet, wherewith to catch. And all the breadth to which he can expand himself, and all the white emptiness into which he can blanch himself, will not be enough to receive what God has to give him.

¶ What, then, it will be indignantly asked, is an utterly ignorant and unthinking man likely to make the best artist? No, not so neither. Knowledge is good for him so long as he can keep it utterly, servilely, subordinate to his own divine work, and trample it under his feet, and out of his way, the moment it is likely to entangle him.

And in this respect, observe, there is an enormous difference between knowledge and education. An artist need not be a *learned* man, in all probability it will be a disadvantage to him to become so; but he ought, if possible, always to be an *educated* man: that is, one who has understanding of his own uses and duties in the world, and therefore of the general nature of the things done and existing in the world; and who has so trained himself, or been trained, as to turn to the best and most courteous account whatever faculties or knowledge he has. The mind of an educated man is greater than the knowledge it possesses; it is like the vault of heaven, encompassing

* St. Bernard.

the earth which lives and flourishes beneath it: but the mind of an uneducated and learned man is like a caoutchouc band, with an everlasting spirit of contraction in it, fastening together papers which it cannot open, and keeps others from opening. . . .

<div align="right">From Stones of Venice, Vol. III, Ch. II, ¶ V–XIII.</div>

Pride of State

PRIDE OF STATE. It was noticed, in the second volume of *Modern Painters*, . . . that the principle which had most power in retarding the modern school of portraiture was its constant expression of individual vanity and pride. And the reader cannot fail to have observed that one of the readiest and commonest ways in which the painter ministers to this vanity, is by introducing the pedestal or shaft of a column, or some fragment, however simple, of Renaissance architecture, in the background of the portrait. And this is not merely because such architecture is bolder or grander than, in general, that of the apartments of a private house. No other architecture would produce the same effect in the same degree. The richest Gothic, the most massive Norman, would not produce the same sense of exaltation as the simple and meagre lines of the Renaissance.

¶ And if we think over this matter a little, we shall soon feel that in those meagre lines there is indeed an expression of aristocracy in its worst characters; coldness, perfectness of training, incapability of emotion, want of sympathy with the weakness of lower men, blank, hopeless, haughty self-sufficiency. All these characters are written in the Renaissance architecture as plainly as if they were graven on it in words. For, observe, all other architectures have something in them that common men can enjoy; some concession to the simplicities of humanity, some daily bread for the hunger of the multitude. Quaint fancy, rich ornament, bright colour, something that shows a sympathy with men of ordinary minds and hearts; and this wrought out, at least in the Gothic, with a rudeness showing that the workman did not mind exposing his own ignorance if he could please others. But the Renaissance is exactly the contrary of all this. It is rigid, cold, inhuman; incapable of glowing, of stooping, of conceding for an instant. Whatever excellence it has is refined, high-trained, and deeply erudite; a kind which the architect well knows no common mind can taste. He proclaims it to us aloud. 'You cannot feel my work unless you study Vitruvius. I will give you no gay colour, no pleasant sculpture, nothing to make you happy; for I am a learned man. All the pleasure you can have in anything I do is in its proud breeding, its rigid

formalism, its perfect finish, its cold tranquility. I do not work for the vulgar, only for the men of the academy and the court.'

¶ And the instinct of the world felt this in a moment. In the new precision and accurate law of the classical forms, they perceived something peculiarly adapted to the setting forth of state in an appalling manner: Princes delighted in it, and courtiers. The Gothic was good for God's worship, but this was good for man's worship. The Gothic had fellowship with all hearts, and was universal, like nature: it could frame a temple for the prayer of nations, or shrink into the poor man's winding stair. But here was an architecture that would not shrink, that had in it no submission, no mercy. The proud princes and lords rejoiced in it. It was full of insult to the poor in its every line. It would not be built of the materials at the poor man's hand; it would not roof itself with thatch or shingle, and black oak beams; it would not wall itself with rough stone or brick; it would not pierce itself with small windows where they were needed; it would not niche itself, wherever there was room for it, in the street corners. It would be of hewn stone; it would have its windows and its doors, and its stairs and its pillars, in lordly order, and of stately size; it would have its wings and its corridors, and its halls and its gardens, as if all the earth were its own. And the rugged cottages of the mountaineers, and the fantastic sheets of the labouring burgher, were to be thrust out of its way, as of a lower species. . . .

From *Stones of Venice*, Vol. III, Ch. II, ¶ XXXVII–XXXIX.

Pride of System

PRIDE OF SYSTEM. . . . I must pass to the third element above named, the Pride of System. It need not detain us so long as either of the others, for it is at once more palpable and less dangerous. The manner in which the pride of the fifteenth century corrupted the sources of knowledge, and diminished the majesty, while it multiplied the trappings, of state, is in general little observed; but the reader is probably already well and sufficiently aware of the curious tendency to formulization and system which, under the name of philosophy, encumbered the minds of the Renaissance schoolmen. As it was above stated, grammar became the first of sciences; and whatever subject had to be treated, the first aim of the philosopher was to subject its principles to a code of laws, in the observation of which the merit of the speaker, thinker, or worker, in or on that subject, was thereafter to consist; so that the whole mind of the world was occupied by the exclusive study of Restraints. The sound of the forging of fetters was heard from sea to sea. The doctors of all the arts and sciences set

themselves daily to the invention of new varieties of cages and manacles; they themselves wore, instead of gowns, a chain mail, whose purpose was not so much to avert the weapon of the adversary as to restrain the motions of the wearer; and all the acts, thoughts, and workings of mankind,—poetry, painting, architecture, and philosophy,—were reduced by them merely to so many different forms of fetter-dance. . . .

¶ Wheresoever we find the system and formality of rules much dwelt upon, and spoken of as anything else than a help for children, there we may be sure that noble art is not even understood, far less reached. And thus it was with all the common and public mind in the fifteenth and sixteenth centuries. The greater men, indeed, broke through the thorn hedges; and, though much time was lost by the learned among them in writing Latin verses and anagrams, and arranging the framework of quaint sonnets and dexterous syllogisms, still they tore their way through the sapless thicket by force of intellect or of piety; for it was not possible that, either in literature or in painting, rules could be received by any strong mind, so as materially to interfere with its originality: and the crabbed discipline and exact scholarship became an advantage to the men who could pass through and despise them; so that in spite of the rules of the drama we had Shakespeare, and in spite of the rules of art we had Tintoret,—both of them, to this day, doing perpetual violence to the vulgar scholarship and dim-eyed proprieties of the multitude.

¶ But in architecture it was not so; for that was the art of the multitude, and was affected by all their errors; and the great men who entered its field, like Michael Angelo, found expression for all the best part of their minds in sculpture, and made the architecture merely its shell. So the simpletons and sophists had their way with it: and the reader can have no conception of the inanities and puerilities of the writers, who, with the help of Vitruvius, reestablished its 'five orders', determined the proportions of each, and gave the various recipes for sublimity and beauty, which have been thenceforward followed to this day, but which may, I believe, in this age of perfect machinery, be followed out still farther. If, indeed, there are only five perfect forms of columns and architraves, and there be a fixed proportion to each, it is certainly possible, with a little ingenuity, so to regulate a stone-cutting machine, as that it shall furnish pillars and friezes to the size ordered, of any of the five orders, on the most perfect Greek models, in any quantity; an epitome, also, of Vitruvius, may be made so simple, as to enable any bricklayer to set them up at their proper distances, and we may dispense with our architects altogether.

¶ But if this be not so, and there be any truth in the faint persuasion which still lurks in men's minds that architecture *is* an art, and that it requires some gleam of intellect to practise it, then let the whole system of the orders

and their proportions be cast out and trampled down as the most vain, barbarous, and paltry deception that was ever stamped on human prejudice; and let us understand this plain truth, common to all work of man, that, if it be good work, it is not a copy, nor any thing done by rule, but a freshly and divinely imagined thing. Five orders! There is not a side chapel in any Gothic cathedral but it has fifty orders, the worst of them better than the best of the Greek ones, and all new; and a single inventive human soul could create a thousand orders in an hour.* And this would have been discovered even in the worst times, but that, as I said, the greatest men of the age found expression for their invention in the other arts, and the best of those who devoted themselves to architecture were in great part occupied in adapting the construction of buildings to new necessities, such as those developed by the invention of gunpowder (introducing a totally new and most interesting science of fortification, which directed the ingenuity of Sanmicheli and many others from its proper channel), and found interest of a meaner kind in the difficulties of reconciling the obsolete architectural laws they had consented to revive, and the forms of Roman architecture which they agreed to copy, with the requirements of the daily life of the sixteenth century.

<div style="text-align: right">From Stones of Venice, Vol. III, Ch. II, ¶ LXXXVI–XCI.</div>

Grotesque

FIRST, THEN, it seems to me that the grotesque is, in almost all cases, composed of two elements, one ludicrous, the other fearful; that, as one or other of these elements prevails, the grotesque falls into two branches, sportive grotesque, and terrible grotesque; but that we cannot legitimately consider it under these two aspects, because there are hardly any examples which do not in some degree combine both elements; there are few grotesques so utterly playful as to be overcast with no shade of fearfulness, and few so fearful as absolutely to exclude all ideas of jest. But although we cannot separate the grotesque itself into two branches, we may easily examine separately the two conditions of mind which it seems to combine; and consider successively what are the kinds of jest, and what the kinds of fearfulness, which may be legitimately expressed in the various walks of art, and how their expressions actually occur in the Gothic and Renaissance schools.

* That is to say, orders separated by such distinctions as the old Greek ones; considered with reference to the bearing power of the capital, all orders may be referred to two, as long ago stated; just as trees may be referred to the two great classes, monocotyledonous and dicotyledonous.

First, then, what are the conditions of playfulness which we may fitly express in noble art, or which (for this is the same thing) are consistent with nobleness in humanity? In other words, what is the proper function of play, with respect not to youth merely, but to all mankind?

¶ It is a much more serious question than may be at first supposed; for a healthy manner of play is necessary in order to a healthy manner of work: and because the choice of our recreation is, in most cases, left to ourselves, while the nature of our work is as generally fixed by necessity or authority, it may well be doubted whether more distressful consequences may not have resulted from mistaken choice in play than from mistaken direction in labour.

¶ Observe, however, that we are only concerned, here, with that kind of play which causes laughter or implies recreation, not with that which consists in the excitement of the energies whether of body or mind. Muscular exertion is, indeed, in youth, one of the conditions of recreation; 'but neither the violent bodily labour which children of all ages agree to call play', nor the grave excitement of the mental faculties in games of skill or chance, are in anywise connected with the state of feeling we have here to investigate, namely, that sportiveness which man possesses in common with many inferior creatures, but to which his higher faculties give nobler expression in the various manifestations of wit, humour, and fancy.

With respect to the manner in which this instinct of playfulness is indulged or repressed, mankind are broadly distinguishable into four classes: the men who play wisely; who play necessarily; who play inordinately; and who play not at all.

¶ First: Those who play wisely. It is evident that the idea of any kind of play can only be associated with the idea of an imperfect, childish, and fatigable nature. As far as men can raise that nature, so that it shall no longer be interested by trifles or exhausted by toils, they raise it above play; he whose heart is at once fixed upon heaven, and open to the earth, so as to apprehend the importance of heavenly doctrines, and the compass of human sorrow, will have little disposition for jest; and exactly in proportion to the breadth and depth of his character and intellect, will be, in general, the incapability of surprise, or exuberant and sudden emotion, which must render play impossible. It is, however, evidently not intended that many men should even reach, far less pass their lives in, that solemn state of thoughtfulness, which brings them into the nearest brotherhood with their Divine Master; and the highest and healthiest state which is competent to ordinary humanity appears to be that which, accepting the necessity of recreation, and yielding to the impulses of natural delight springing out of health and innocence, does, indeed, condescend often to playfulness,

but never without such deep love of God, of truth, and of humanity, as shall make even its lightest words reverent, its idlest fancies profitable, and its keenest satire indulgent. Wordsworth and Plato furnish us with, perhaps the finest and highest examples of this playfulness: in the one case, unmixed with satire, the perfectly simple effusion of that spirit

> 'Which gives to all the self-same bent,
> Whose life is wise, and innocent;'

—in Plato, and, by the by, in a very wise book of our own times, not unworthy of being named in such companionship, 'Friends in Council' mingled with an exquisite and loving satire. . . .

¶ Now all the forms of art which result from the comparatively re-creative exertion of minds more or less blunted or encumbered by other cares and toils, the art which we may call generally art of the wayside, as opposed to that which is the business of men's lives, is, in the best sense of the word, Grotesque. And it is noble or inferior, first, according to the tone of the minds which have produced it, and in proportion to their knowledge, wit, love of truth, and kindness; secondly, according to the degree of strength they have been able to give forth; but yet, however much we may find in it needing to be forgiven, always delightful so long as it is the work of good and ordinarily intelligent men. And its delightfulness ought mainly to consist *in those very imperfections* which mark it for work done in times of rest. It is not its own merit so much as the enjoyment of him who produced it, which is to be the source of the spectator's pleasure; it is to the strength of his sympathy, not to the accuracy of his criticism, that it makes appeal; and no man can indeed be a lover of what is best in the higher walks of art, who has not feeling and charity enough to rejoice with the rude sportiveness of hearts that have escaped out of prison, and to be thankful for the flowers which men have laid their burdens down to sow by the wayside.

¶ And are we never, then, it will be asked, to possess a refined or perfect ornamentation? Must all decoration be the work of the ignorant and the rude? Not so; but exactly in proportion as the ignorance and rudeness diminish, must the ornamentation become rational, and the grotesqueness disappear. The noblest lessons may be taught in ornamentation, the most solemn truths compressed into it. The Book of Genesis, in all the fulness of its incidents, in all the depth of its meaning, is bound within the leaf-borders of the gates of Ghiberti. But Raphael's arabesque is mere elaborate idleness. It has neither meaning nor heart in it; it is an unnatural and monstrous abortion.

From *Stones of Venice*, Vol. III, Ch. III, ¶ XXIII–L.

Values

HERE, . . . let me finally and firmly enunciate the great principle to which all that has hitherto been stated is subservient: that art is valuable or otherwise, only as it expresses the personality, activity, and living perception of a good and great human soul; that it may express and contain this with little help from execution, and less from science; and that if it have not this, if it show not the vigour, perception, and invention of a mighty human spirit, it is worthless. Worthless, I mean, as *art*; it may be precious in some other way, but, as art, it is nugatory. Once let this be well understood among us, and magnificent consequences will soon follow. Let me repeat it in other terms, so that I may not be misunderstood. All art is great, and good, and true, only so far as it is distinctively the work of *manhood* in its entire and highest sense; that is to say, not the work of limbs and fingers, but of the soul, aided, according to her necessities, by the inferior powers; and therefore distinguished in essence from all products of those inferior powers unhelped by the soul. For as a photograph is not a work of art, though it requires certain delicate manipulations of paper and acid, and subtle calculations of time, in order to bring out a good result; so, neither would a drawing *like* a photograph, made directly from nature, be a work of art, although it would imply many delicate manipulations of the pencil and subtle calculations of effects of colour and shade. It is no more art★ to manipulate a camel's-hair pencil, than to manipulate a china tray and a glass vial. It is no more art to lay on colour delicately, than to lay on acid delicately. It is no more art to use the cornea and retina for the reception of an image, than to use a lens and a piece of silvered paper. But the moment that inner part of the man, or rather that entire and only being of the man, of which cornea and retina, fingers and hands, pencils and colours, are all the mere servants and instruments; that manhood which has light in itself, though the eyeball be sightless, and can gain in strength when the hand and the foot are hewn off and cast into the fire; the moment this part of the man stands forth with its solemn 'Behold, it is I', then the work becomes art indeed, perfect in honour, priceless in value, boundless in power.

¶ Yet observe, I do not mean to speak of the body and soul as separable. The man is made up of both: they are to be raised and glorified together, and all art is an expression of the one, by and through the other.

★ I mean art in its highest sense. All that men do ingeniously is art, in one sense. In fact, we want a definition of the word 'art' much more accurate than any in our minds at present. For, strictly speaking, there is no such thing as 'fine' or 'high' art. All *art* is a low and common thing, and what we indeed respect is not art at all, but *instinct* or *inspiration* expressed by the help of art.

64. VIEW OF EDINBURGH. Engraving after Turner

65. ST. GEORGE'S CHURCH, EDINBURGH

All that I would insist upon is, the necessity of the whole man being in his work; the body *must* be in it. Hands and habits must be in it, whether we will or not; but the nobler part of the man may often not be in it. And that nobler part acts principally in love, reverence, and admiration, together with those conditions of thought which arise out of them. For we usually fall into much error by considering the intellectual powers as having dignity in themselves, and separable from the heart; whereas the truth is, that the intellect becomes noble or ignoble according to the food we give it, and the kind of subjects with which it is conversant. It is not the reasoning power which, of itself, is noble, but the reasoning power occupied with its proper objects. Half of the mistakes of metaphysicians have arisen from their not observing this; namely, that the intellect, going through the same processes, is yet mean or noble according to the matter it deals with, and wastes itself away in mere rotatory motion, if it be set to grind straws and dust. If we reason only respecting words, or lines, or any trifling and finite things, the reason becomes a contemptible faculty; but reason employed on holy and infinite things, becomes herself holy and infinite. So that, by work of the soul, I mean the reader always to understand the work of the entire immortal creature, proceeding from a quick, perceptive, and eager heart, perfected by the intellect, and finally dealt with by the hands, under the direct guidance of these higher powers.

¶ If . . . any of my readers should determine, according to their means, to set themselves to the revival of a healthy school of architecture in England, and wish to know in few words how this may be done, the answer is clear and simple. First, let us cast out utterly whatever is connected with the Greek, Roman, or Renaissance architecture, in principle or in form. We have seen above, that the whole mass of the architecture, founded on Greek and Roman models, which we have been in the habit of building for the last three centuries, is utterly devoid of all life, virtue, honourableness, or power of doing good. It is base, unnatural, unfruitful, unenjoyable, and impious. Pagan in its origin, proud and unholy in its revival, paralyzed in its old age, yet making prey in its dotage of all the good and living things that were springing around it in their youth, as the dying and desperate king, who had long fenced himself so strongly with the towers of it, is said to have filled his failing veins with the blood of children; * an architecture invented, as it seems, to make plagiarists of its architects, slaves of its workmen, and Sybarites of its inhabitants; an

* Louis the Eleventh. 'In the month of March, 1481, Louis was seized with a fit of apoplexy at *St. Bénoit-du-lac-mort*, near Chinon. He remained speechless and bereft of reason three days; and then, but very imperfectly restored, he languished in a miserable state. . . . To cure him,' says a contemporary historian, 'wonderful and terrible medicines were compounded. It was reported among the people that his physicians opened the veins of little children, and made him drink their blood, to correct the poorness of his own.'—*Bussey's History of France*. London, 1850.

architecture in which intellect is idle, invention impossible, but in which all luxury is gratified, and all insolence fortified;—the first thing we have to do is to cast it out, and shake the dust of it from our feet for ever. Whatever has any connection with the five orders, or with any one of the orders, —whatever is Doric, or Ionic, or Tuscan, or Corinthian, or Composite, or in any wise Grecized or Romanized; whatever betrays the smallest respect for Vitruvian laws, or conformity with Palladian work,—that we are to endure no more. To cleanse ourselves of these 'cast clouts and rotten rags' is the first thing to be done in the court of our prison.

From *Stones of Venice*, Vol. III, Ch. IV, ¶ VI–XXXV.

Edinburgh

. . . You, [citizens of Edinburgh], are all proud of your city; surely you must feel it a duty in some sort to justify your pride; that is to say, to give yourself a *right* to be proud of it. That you were born under the shadow of its two fantastic mountains—that you live where from your room windows you can trace the shores of its glittering Firth, are no rightful subjects of pride. You did not raise the mountains, nor shape the shores; and the historical houses of your Canongate, and the broad battlements of your castle, reflect honour upon you only through your ancestors. Before you boast of your city, before even you venture to call it *yours*, ought you not scrupulously to weigh the exact share you have had in adding to it or adorning it, to calculate seriously the influence upon its aspect which the work of your own hands has exercised? I do not say that, even when you regard your city in this scrupulous and testing spirit, you have not considerable ground for exultation. As far as I am acquainted with modern architecture, I am aware of no streets which, in simplicity and manliness of style, or general breadth and brightness of effect, equal those of the New Town of Edinburgh. But yet I am well persuaded that as you traverse those streets, your feelings of pleasure and pride in them are much complicated with those which are excited entirely by the surrounding scenery. As you walk up or down George Street, for instance, do you not look eagerly for every opening to the north and south, which lets in the lustre of the Firth of Forth, or the rugged outline of the Castle Rock? Take away the sea-waves, and the dark basalt, and I fear you would find little to interest you in George Street by itself. Now I remember a city, more nobly placed even than your Edinburgh, which, instead of the valley that you have now filled by lines of railroad, has a broad and rushing river of blue water sweeping through the heart of it; which, for the dark and solitary rocks that bears your castle,

has an amphitheatre of cliffs crested with cypresses and olive; which, for the two masses of Arthur's Seat and the ranges of the Pentlands, has a chain of blue mountains higher than the haughtiest peaks of your Highlands; and which, for your far-away Ben Ledi and Ben More, has the great central chain of the St. Gothard Alps; and yet, as you go out of the gates, and walk in the suburban streets of that city—I mean Verona—the eye never seeks to rest on that external scenery, however gorgeous; it does not look for the gaps between the houses, as you do here; it may for a few moments follow the broken line of the great Alpine battlements; but it is only where they form a background for other battlements, built by the hand of man. There is no necessity felt to dwell on the blue river or the burning hills. The heart and eye have enough to do in the streets of the city itself; they are contented there; nay, they sometimes turn from the natural scenery, as if too savage and solitary, to dwell with a deeper interest on the palace walls that cast their shade upon the streets, and the crowd of towers that rise out of that shadow into the depths of the sky.

¶ *That* is a city to be proud of, indeed; and it is this kind of architectural dignity which you should aim at, in what you add to Edinburgh or rebuild in it. For remember, you must either help your scenery or destroy it; whatever you do has an effect of one kind or another; it is never indifferent. But, above all, remember that it is chiefly by private, not by public, effort that your city must be adorned. It does not matter how many beautiful public buildings you possess, if they are not supported by, and in harmony with, the private houses of the town. Neither the mind nor the eye will accept a new college, or a new hospital, or a new institution, for a city. It is the Canongate, and the Princes Street, and the High Street that are Edinburgh. It is in your own private houses that the real majesty of Edinburgh must consist; and, what is more, it must be by your own personal interest that the style of the architecture which rises around you must be principally guided. Do not think that you can have good architecture merely by paying for it. It is not by subscribing liberally for a large building once in forty years that you can call up architects and inspiration. It is only by active and sympathetic attention to the domestic and every-day work which is done for each of you, that you can educate either yourselves to the feeling, or your builders to the doing, of what is truly great.

¶ Well, but, you will answer, you cannot feel interested in architecture: you do not care about it, and *cannot* care about it. I know you cannot. About such architecture as is built nowadays, no mortal ever did or could care. You do not feel interested in *hearing* the same thing over and over again;—why do you suppose you can feel interested in *seeing* the same thing over and over again, were that thing even the best and most beautiful in the world? Now, you all know the kind of window which you usually

build in Edinburgh: a massy lintel of a single stone, laid across from side to side, with bold square-cut jambs—in fact, the simplest form it is possible to build. It is by no means a bad form; on the contrary, it is very manly and vigorous, and has a certain dignity in its utter refusal of ornament. But I cannot say it is entertaining. How many windows precisely of this form do you suppose there are in the New Town of Edinburgh? I have not counted them all through the town, but I counted them this morning along . . . Queen Street . . . and on the one side of that street, there are of these windows, absolutely similar . . ., and altogether devoid of any relief by decoration, six hundred and seventy-eight. And your decorations are just as monotonous as your simplicities. How many Corinthian and Doric columns do you think there are in your banks, and post offices, institutions, and I know not what else, one exactly like another?—and yet you expect to be interested! . . . Why, if I were to say the same thing over and over again, for the single hour you are going to let me talk to you, would you listen to me? and yet you let your architects *do* the same thing over and over again for three centuries, and expect to be interested by their architecture; with a farther disdavantage on the side of the builder, as compared with the speaker, that my wasted words would cost you but little, but his wasted stones have cost you no small part of your incomes.

¶ 'Well, but', you still think within yourselves, 'it is not *right* that architecture should be interesting. It is a very grand thing, this architecture, but essentially unentertaining. It is its duty to be dull, it is monotonous by law: it cannot be correct and yet amusing.'

Believe me, it is not so. All things that are worth doing in art, are interesting and attractive when they are done. There is no law of right which consecrates dulness. The proof of a thing's being right is, that it has power over the heart; that it excites us, wins us, or helps us. I do not say that it has influence over all, but it has over a large class, one kind of art being fit for one class, and another for another; and there is no goodness in art which is independent of the power of pleasing. Yet, do not mistake me; I do not mean that there is no such thing as neglect of the best art, or delight in the worst, just as many men neglect nature, and feed upon what is artificial and base; but I mean, that all good art has the *capacity of pleasing*, if people will attend to it; that there is no law against its pleasing; but, on the contrary, something wrong either in the spectator or the art, when it ceases to please. . . .

¶ 'Well, but what are we to do?' you will say to me; 'we cannot make architects of ourselves'. Pardon me, you can—and you ought. Architecture is an art for all men to learn, because all are concerned with it; and it is so simple, that there is no excuse for not being acquainted with its primary rules, any more than for ignorance of grammar or of spelling, which are

both of them far more difficult sciences. Far less trouble than is necessary to learn how to play chess, or whist, or golf, tolerably,—far less than a schoolboy takes to win the meanest prize of the passing year, would acquaint you with all the main principles of the construction of a Gothic cathedral, and I believe you would hardly find the study less amusing. . . .

¶ . . . There is hardly a day passes but you may see some rent or flow in bad buildings. . . . You may see one whenever you choose, in one of your most costly, and most ugly buildings, the great church with the dome, at the end of George Street.[1] I think I never saw a building with a principal entrance so utterly ghastly and oppressive; and it is as weak as it is ghastly. The huge horizontal lintel above the door is already split right through. But you are not aware of a thousandth part of the evil: the pieces of building that you see are all carefully done; it is in the parts that are to be concealed by paint and plaster that the bad building of the day is thoroughly committed. The main mischief lies in the strange devices that are used to support the long horizontal cross beams of our larger apartments and shops, and the framework of unseen walls; girders and ties of cast iron, and props and wedges, and laths nailed and bolted together, on marvellously scientific principles; so scientific, that every now and then, when some tender repara-tion is undertaken by the unconscious householder, the whole house crashes into a heap of ruin, so total, that the jury which sits on the bodies of the inhabitants cannot tell what has been the matter with it, and returns a dim verdict of accidental death. . . .

¶ You . . . for instance, you know that, for an immense time back, all your public buildings have been built with a row of pillars supporting a triangular thing called a pediment. You see this form every day in your banks and clubhouses, and churches and chapels; you are told that it is the perfection of architectural beauty; and yet suppose Sir Walter Scott, instead of writing, 'Each purple peak, each flinty spire', had written, 'Each purple peak, each flinty "pediment",'—would you have thought the poem im-proved? And if not, why would it be spoiled? Simply because the idea is no longer of any value to you; the thing spoken of is a nonentity. These pediments, and stylobates, and architraves never excited a single pleasur-able feeling in you—never will, to the end of time. They are evermore dead, lifeless, and useless, in art as in poetry, and though you built as many of them as there are slates on your house-roofs, you will never care for them. They will only remain to later ages as monuments of the patience and pliability with which the people of the nineteenth century sacrificed their feelings to fashions, and their intellects to forms. But on the other hand, that strange and thrilling interest with which such words strike you as are in any wise connected with Gothic architecture—as for instance,

[1] St. George's Church, designed by Robert Reid, finished 1814. [Ill. 65 facing page 255].

Vault, Arch, Spire, Pinnacle, Battlement, Barbican, Porch, and myriads of such others, words everlastingly poetical and powerful whenever they occur,—is a most true and certain index that the things themselves are delightful to you, and will ever continue to be so. Believe me, you do indeed love these things, so far as you care about art at all, so far as you are not ashamed to confess what you feel about them.

¶ . . . You will all admit that there is neither romance nor comfort in waiting at your own or at any one else's door on a windy and rainy day, till the servant comes from the end of the house to open it. You all know the critical nature of that opening—the drift of wind into the passage, the impossibility of putting down the umbrella at the proper moment without getting a cupful of water dropped down the back of your neck from the top of the doorway; and you know how little these inconveniences are abated by the common Greek portico at the top of the steps. You know how the east winds blow through those unlucky couples of pillars, which are all that your architects find consistent with due observance of the Doric order. Then, away with these absurdities; and the next house you build, insist upon having the pure old Gothic porch, walled in on both sides, with its pointed arch entrance and gable roof above. Under that, you can put down your umbrella at your leisure, and, if you will, stop a moment to talk with your friend as you give him the parting shake of the hand. And if now and then a wayfarer found a moment's rest on a stone seat on each side of it, I believe you would find the insides of your houses not one whit the less comfortable; and, if you answer me, that were such refuges built in the open streets, they would become mere nests of filthy vagrants, I reply that I do not despair of such a change in the administration of the poor laws of this country, as shall no longer leave any of our fellow-creatures in a state in which they would pollute the steps of our houses by resting upon them for a night.

¶ This, then, is the first use to which your pointed arches and gable roofs are to be put. The second is of more personal pleasurableness. You surely must all of you feel and admit the delightfulness of a bow window; I can hardly fancy a room can be perfect without one. Now you have nothing to do but to resolve that every one of your principal rooms shall have a bow window, either large or small. Sustain the projection of it on a bracket, crown it above with a little peaked roof, and give a massy piece of stone sculpture to the pointed arch in each of its casements, and you will have as inexhaustible a source of quaint richness in your street architecture, as of additional comfort and delight in the interiors of your rooms.

Thirdly, as respects windows which do not project. You will find that the proposal to build them with pointed arches is met by an objection on the part of your architects, that you cannot fit them with comfortable

sashes. I beg leave to tell you that such an objection is utterly futile and ridiculous. I have lived for months in Gothic palaces, with pointed windows of the most complicated forms, fitted with modern sashes; and with the most perfect comfort. But granting that the objection were a true one— and I suppose it is true to just this extent, that it may cost some few shillings more per window in the first instance to set the fittings to a pointed arch than to a square one—there is not the smallest necessity for the *aperture* of the window being of the pointed shape. . . .

¶ Meanwhile, I have but one word to say, in conclusion. Whatever has been advanced in the course of this evening, has rested on the assumption that all architecture was to be of brick and stone; and may meet with some hesitation in its acceptance, on account of the probable use of iron, glass, and such other materials in our future edifices. I cannot now enter into any statement of the possible uses of iron or glass, but I will give you one reason, which I think will weigh strongly with most here, why it is not likely that they will ever become important elements in architectural effect. I know that I am speaking to a company of philosophers, but you are not philosophers of the kind who suppose that the Bible is a super- annuated book; neither are you of those who think the Bible is dishonoured by being referred to for judgment in small matters. The very divinity of the Book seems to me, on the contrary, to justify us in referring *every* thing to it, with respect to which any conclusion can be gathered from its pages. Assuming then that the Bible is neither superannuated now, nor ever likely to be so, it will follow that the illustrations which the Bible employs are likely to be *clear and intelligible illustrations* to the end of time. . . .

. . . Now, I find that iron architecture is indeed spoken of in the Bible. You know how it is said to Jeremiah, 'Behold, I have made thee this day a defenced city, and an iron pillar, and brazen walls, against the whole land'.[1] But I do not find that iron building is ever alluded to as likely to become *familiar* to the minds of men; but, on the contrary, that an archi- tecture of carved stone is continually employed as a source of the most important illustrations. A simple instance must occur to all of you at once. The force of the image of the Corner Stone as used throughout Scripture, would completely be lost, if the Christian and civilized world were ever extensively to employ any other material than earth and rock in their domestic dwellings: I firmly believe that they never will; but that as the laws of beauty are more perfectly established, we shall be content to build as our forefathers built, and still to receive the same great lessons which such building is calculated to convey. . . .

From *Edinburgh Lectures*, Vol. I.

[1] Jeremiah, I. 18.

The Cost of Architecture

. . . You perhaps fancied that architectural beauty was a very costly thing. Far from it. It is architectural ugliness that is costly. In the modern system of architecture, decoration is immoderately expensive, because it is both wrongly placed and wrongly finished. I say first, wrongly placed. Modern architects decorate the tops of their buildings. Mediaeval ones decorated the bottom. That makes all the difference between seeing the ornament and not seeing it. If you bought some pictures to decorate such a room as this, where would you put them? On a level with the eye, I suppose, or nearly so? Not on a level with the chandelier? If you were determined to put them up there, round the cornice, it would be better for you not to buy them at all. You would merely throw your money away. And the fact is, that your money *is* being thrown away continually, by wholesale; and while you are dissuaded, on the ground of expense, from building beautiful windows and beautiful doors, you are continually made to pay for ornaments at the tops of your houses, which, for all the use they are of, might as well be in the moon. For instance, there is not, on the whole, a more studied piece of domestic architecture in Edinburgh than the street in which so many of your excellent physicians live—Rutland Street. I do not know if you have observed its architecture; but if you will look at it to-morrow, you will see that a heavy and close balustrade is put all along the eaves of the houses. Your physicians are not, I suppose, in the habit of taking academic and meditative walks on the roofs of their houses; and, if not, this balustrade is altogether useless,—not merely useless, for you will find it runs directly in front of all the garret windows, thus interfering with their light, and blocking out their view of the street. . . .

¶ But this is a very slight waste of money, compared to the constant habit of putting careful sculpture at the tops of houses. A temple of luxury has just been built in London for the Army and Navy Club.[1] It cost £40,000, exclusive of purchase of ground. It has upon it an enormous quantity of sculpture, representing the gentlemen of the navy as little boys riding upon dolphins, and the gentlemen of the army—I couldn't see as what— nor can anybody; for all this sculpture is put up at the top of the house, where the gutter should be, under the cornice. I know that this was a Greek way of doing things. I can't help it; that does not make it a wise one. Greeks might be willing to pay for what they couldn't see, but Scotchmen and Englishmen shouldn't. . . .

¶ You must expect at first that there will be difficulties and inconsistencies in carrying out the new style; but they will soon be conquered if

[1] By Parnell, built between 1846 and 1857.

you attempt not too much at once. Do not be afraid of incongruities—do not think of unities of effect. Introduce your Gothic line by line and stone by stone; never mind mixing it with your present architecture; your existing houses will be none the worse for having little bits of better work fitted to them; build a porch, or point a window, if you can do nothing else; and remember that it is the glory of Gothic architecture that it can do *anything*. Whatever you really and seriously want, Gothic will do for you; but it must be an *earnest* want. It is its pride to accommodate itself to your needs, and the one general law under which it acts is simply this,—find out what will make you comfortable, build that in the strongest and boldest way, and then set your fancy free in the decoration of it. Don't do anything to imitate this cathedral or that, however beautiful. Do what is convenient; and if the form be a new one, so much the better; then set your mason's wits to work, to find out some new way of treating it. Only be steadily determined that, even if you cannot get the best Gothic, at least you will have no Greek; and in a few years' time—in less time that you could learn a new science or a new language thoroughly—the whole art of your native country will be reanimated.

From *Edinburgh Lectures*, Vol. II.

Fine Art

A L L H I G H art consists in the carving or painting natural objects, chiefly figures: it has always subject and meaning, never consisting solely in arrangement of lines, or even of colours. It always paints or carves something that it sees or believes in; nothing ideal or uncredited. For the most part, it paints and carves the men and things that are visible around it. And as soon as we possess a body of sculptors able, and willing, and having leave from the English public, to carve on the façades of our cathedrals portraits of the living bishops, deans, canons and choristers, who are to minister in the said cathedrals; and on the façades of our public building, portraits of the men chiefly moving or acting in the same; and on our buildings, generally, the birds and flowers which are singing and budding in the fields around them, we shall have a school of English architecture. Not till then.

From *The Seven Lamps of Architecture*, Preface, 2nd edn., ¶ 7.

Calais

. . . I cannot find words to express the intense pleasure I have always in first finding myself, after some prolonged stay in England, at the foot

of the old Tower of Calais church. The large neglect, the noble unsightli-
ness of it; the record of its years written so visibly, yet without sign of
weakness or decay; its stern wasteness and gloom, eaten away by the
Channel winds, and overgrown with the bitter sea grasses; its slates and
tiles all shaken and rent, and yet not falling; its desert of brick-work full
of bolts, and holes, and ugly fissures, and yet strong, like a bare brown
rock; its carelessness of what anyone thinks or feels about it, putting forth
no claim, having no beauty or desirableness, pride, nor grace; yet neither
asking for pity; not, as ruins are, useless and piteous, feebly or fondly
garrulous of better days; but useful still, going through its own daily work,
—as some old fisherman beaten grey by storm, yet drawing his daily nets;
so it stands, with no complaint about its past youth, in blanched and meagre
massiveness and serviceableness, gathering human souls together under-
neath it: the sound of its bells for prayer still rolling through its rents; and
the grey peak of it seen far across the sea, principal of the three that rise
above the waste of surfy sand and hillocked shore,—the lighthouse for life,
and the belfry for labour, and this for patience and praise.

From *Modern Painters*, Vol. IV, Part V, Ch. I, ¶ 2.

Imagination

[THE] QUALITY of industry is essential to an artist, [but] it does not in
any wise make an artist; many people are busy, whose doings are little
worth; neither does sensibility make an artist; since, as I hope, many can
feel both strongly and nobly, who yet care nothing about art. But the
gifts which distinctively mark the artist—*without* which he must be feeble in
life, forgotten in death—*with* which he may become one of the shakers
of the earth, and one of the signal lights in heaven—are those of sympathy
and imagination. . . .
 ¶ Perhaps the first idea which a young architect is apt to be allured by,
as a head-problem in these experimental days, is its being incumbent upon
him to invent a 'new style' worthy of modern civilization in general,
and of England in particular; a style worthy of our engines and telegraphs;
as expansive as steam, and as sparkling as electricity. But, if there are any
of my hearers who have been impressed with this sense of inventive duty,
may I ask them, first, whether their plan is that every inventive architect
among us shall invent a new style for himself, and have a county set aside
for his conceptions, or a province for his practice? Or, must every architect
invent a little piece of the new style, and all put it together at last like a
dissected map? And if so, when the new style is invented, what is to be done

next? I will grant you this Eldorado of imagination—but can you have more than one Columbus? Or, if you sail in company, and divide the prize of your discovery and the honour thereof, who is to come after your clustered Columbuses? to what fortunate islands of style are your architectural descendants to sail, avaricious of new lands? When our desired style is invented, will not the best we can all do be simply—to build in it? —and cannot you now do that in styles that are known? Observe, I grant, for the sake of your argument, what perhaps many of you know that I would not grant otherwise—that a new style *can* be invented. I grant you not only this, but that it shall be wholly different from any that was ever practised before. We will suppose that capitals are to be at the bottom of pillars instead of the top; and that buttresses shall be on the tops of pinnacles instead of at the bottom; that you roof your apertures with stones which shall neither be arched nor horizontal; and that you compose your decoration of lines which shall neither be crooked nor straight. The furnace and the forge shall be at your service: you shall draw out your plates of glass and beat out your bars of iron till you have encompassed us all,—if your style is of the practical kind,—with endless perspective of black skeleton and blinding square,—or if your style is to be of the ideal kind,—you shall wreathe your streets with ductile leafage, and roof them with variegated crystal—you shall put, if you will, all London under one blazing dome of many colours that shall light the clouds round it with its flashing, as far as to the sea. And still, I ask you, What after this? Do you suppose those imaginations of yours will ever lie down there asleep beneath the shade of your iron leafage, or within the coloured light of your enchanted dome? Not so. Those souls, and fancies, and ambitions of yours, are wholly infinite; and, whatever may be done by others, you will still want to do something for yourselves; if you cannot rest content with Palladio, neither will you with Paxton: all the metal and glass that ever were melted have not so much weight in them as will clog the wings of one human spirit's aspiration.

¶ If you will think over this quietly by yourselves, and can get the noise out of your ears of the perpetual, empty, idle, incomparably idiotic talk about the necessity of some novelty in architecture, you will soon see that the very essence of a Style, properly so called, is that it should be practised *for ages*, and applied to all purposes; and that so long as any given style is in practice, all that is left for individual imagination to accomplish must be within the scope of that style, not in the invention of a new one. If there are any here, therefore, who hope to obtain celebrity by the invention of some strange way of building which must convince all Europe into its adoption, to them, for the moment, I must not be understood to address myself, but only to those who would be content with that degree of

celebrity which an artist may enjoy who works in the manner of his fore-fathers;—which the builder of Salisbury Cathedral might enjoy in England, though he did not invent Gothic; and which Titian might enjoy at Venice, though he did not invent oil painting. Addressing myself then to those humbler, but wiser, or rather, only wise students who are content to avail themselves of some system of building already understood, let us consider together what room for the exercise of the imagination may be left to us under such conditions. And, first, I suppose it will be said, or thought, that the architect's principal field for exercise of his invention must be in the disposition of lines, mouldings, and masses, in agreeable proportions. Indeed, if you adopt some styles of architecture, you cannot exercise invention in any other way. And I admit that it requires genius and special gift to do this rightly. Not by rule, nor by study, can the gift of graceful proportionate design be obtained; only by the intuition of genius can so much as a single tier of façade be beautifully arranged; and the man has just cause for pride, as far as our gifts can ever be a cause for pride, who finds himself able, in a design of his own, to rival even the simplest arrangement of parts in one by Sanmicheli, Inigo Jones, or Christopher Wren. . . .

¶ Observe, nearly every other liberal art or profession has some intense pleasure connected with it, irrespective of any good to others. As lawyers, or physicians, or clergymen, you would have the pleasure of investigation, and of historical reading, as part of your work: as men of science you would be rejoicing in curiosity perpetually gratified respecting the laws and facts of nature: as artists you would have delight in watching the external forms of nature: as day labourers or petty tradesmen, supposing you to undertake such work with as much intellect as you are going to devote to your designing, you would find continued subjects of interest in the manufacture or the agriculture which you helped to improve; or in the problems of commerce which bore on your business. But your architectural designing leads you into no pleasant journeys,—into no seeing of lovely things,—no discerning of just laws,—no warmths of compassion, no humilities of veneration, no progressive state of sight or soul. Our conclusion is—must be—that you will not amuse, nor inform, nor help anybody; you will not amuse, nor better, nor inform yourselves: you will sink into a state in which you can neither show, nor feel, nor see anything, but that one is to two as three is to six. And in that state what should we call ourselves? Men? I think not. The right name for us would be—numerators and denominators. Vulgar Fractions.

¶ Shall we, then, abandon this theory of the soul of architecture being in proportional lines, and look whether we can find anything better to exert our fancies upon?

¶ May we not, to begin with, accept this great principle—that, as our bodies, to be in health, must be *generally* exercised, so our minds, to be in health, must be *generally* cultivated? You would not call a man healthy who had strong but was paralytic in his feet; nor one who could walk well, but had no use of his hands; nor one who could see well, if he could not hear. You would not voluntarily reduce your bodies to any such partially developed state. Much more, then, you would not, if you could help it, reduce your minds to it. Now, your minds are endowed with a vast number of gifts of totally different uses—limbs of mind as it were, which, if you don't exercise, you cripple. One is curiosity; that is a gift, a capacity of pleasure in knowing; which if you destroy, you make yourselves cold and dull. Another is sympathy; the power of sharing in the feelings of living creatures; which if you destroy, you make yourselves hard and cruel. Another of your limbs of mind is admiration; the power of enjoying beauty or ingenuity; which if you destroy, you make yourselves base and irreverent. Another is wit; or the power of playing with the lights on the many sides of truth; which if you destroy, you make yourselves gloomy, and less useful and cheering to others than you might be. So that in choosing your way of work it should be your aim, as far as possible, to bring out all these faculties, as far as they exist in you; not one merely, nor another, but all of them. And the way to bring them out, is simply to concern yourselves attentively with the subjects of each faculty. To cultivate sympathy you must be among living creatures, and thinking about them; and to cultivate admiration, you must be among beautiful things and looking at them.

From *The Influence of Imagination on Architecture*, Vol. VI, p. 346.

The Valley of the Somme

YOU STOPPED at the brow of the hill to put the drag on, and looked up to see where you were:—and there lay beneath you, far as eye could reach on either side, this wonderful valley of the Somme,—with line on line of tufted aspen and tall poplar, making the blue distances more exquisite in bloom by the gleam of their leaves; and in the midst of it, by the glittering of the divided streams of its river, lay the clustered mossy roofs of Abbeville, like a purple flake of cloud, with the precipitous mass of the Cathedral towers rising mountainous through them, and here and there, in the midst of them, spaces of garden close set with pure green trees, bossy and perfect. So you trotted down the hill between bright chalk banks, with a cottage or two nestled into their recesses, and little round children rolling about like apples before the doors, and at the bottom you came into a space of open park ground, divided by stately avenues of chestnut and acacia,—

with long banks of outwork and massive walls of bastion seen beyond—
then came the hollow thunder of the drawbridge and shadow of the gate
—and in an instant, you were in the gay street of a populous yet peaceful
city—a fellowship of ancient houses set beside each other, with all the active
companionship of business and sociableness of old friends, and yet each with
the staid and self-possessed look of country houses surrounded by hereditary
fields—or country cottages nested in forgotten glens,—each with its own
character and fearlessly independent ways—its own steep gable, narrow or
wide—its special little peaked windows set this way and that as the fancy
took them,—its most particular odd corners, and outs and ins of wall to
make the most of the ground and sunshine,—its own turret staircase, in the
inner angle of the courtyard,—its own designs and fancies in carving of
bracket and beam—its own only bridge over the clear branchlet of the
Somme that rippled at its garden gate.

¶ All that's gone,—and most of Abbeville is like most of London—
rows of houses, all alike, with an heap of brickbats at the end of it. But St.
Vulfran[1] is still left, and it and the other churches have this special interest
—they are the last of their race. The last—that is a bold word, and one
which I would not press too far in the implied absoluteness of its negation.
I don't mean that you may not by close search find here and there a frag-
ment of good Gothic later than St. Vulfran of Abbeville, but I do mean
that there is no other important building, nor even an unimportant one of
beauty, belonging to the true Gothic school, and of later date than this.
Roughly, it belongs to the last quarter of the fifteenth century,—1475 to
1500—and the Gothic of Flanders was hopelessly corrupt fifty years before
that, the Gothic of Italy had given way to classicalism a hundred years
before, and the Gothic spirit of England, though not yet dead, was fastened
down and helpless under stern geometrical construction, and frigid law of
vertical line, so that it is walled up like a condemned nun, and you cannot
see it die. But here, in France, it passes away in your sight; driven from all
other scenes of its ancient power, it came to this narrow valley of the Somme,
and passed away.

¶ I have no doubt that if any architects are present, they are shocked
at my calling this pure. Not ten buildings in the world, pure: Verona tombs
grand, but not pure; Giotto's Gothic, not pure; our Early English is thin
and cut to pieces in its mouldings. Gothic is developed, in one form young,
and in another old. This is not central Gothic, but it is still *altogether* Gothic,
—florid, but still essential, coherent. While, as I said, the Flemish is corrupt,
and the English both corrupt and dead, here [it is] living and in all essential
character incorrupt, while the Spire of Antwerp is only a Renaissance
building in the shape of a Gothic one.

[1] Ill. 66 facing page 270.

¶ Now are you not inclined to ask, in the presence of this last fragment of a series of beautiful human work that had lasted through five hundred years,—how it came to pass that in this [place] it perished?—what was the meaning of its fate?—by what power it had risen?—by what fault it fell?

Now, observe:—this is a most strangely complex question. Gothic architecture perished before two great influences,—the Reformation, and the revival of literature. We usually think of those influences as allied,—but they were not allied at all.

¶ The Reformation was an illiterate movement—it was the rising of ignorant persons, who had been deceived, against the arts that had deceived them; its immediate tendency was to destroy Gothic as an art, with all the fine arts. But revived literature rose against it as not fine enough art. It destroyed Gothic, because it thought it had found something better than Gothic. These two adversaries were directly opposed,—they attacked from opposite flanks, and were as hostile to each other as to what they destroyed. Now,—you see—here is one most interesting question. Suppose these enemies had not attacked together. Suppose Luther had attacked it alone, on one flank, and Raphael alone, on the other. Suppose you had had reformation over Europe,—confiscation of priests' revenues in Rome as well as in England,—an Elizabeth on the throne of Madrid and a Cromwell at the gates of the Vatican. What form would the arts then have taken, as the Gothic expired? Or on the other hand,—suppose you had had Classic literature revived without religious reformation, and that a still imperious and fervid Catholicism had built its temples to the Madonna,—its shrines to the Saints,—at Whitby and Tynemouth—at Bolton and Melrose—on the dust of their despised aisles,—in the form of the temples of the Lacinian Juno and the Ephesian Diana,—what would have been the course of art, and human thought then? You see how interesting this double question would be,—and how carefully we must distinguish the effect of a popular emotion which broke down images because it hated images, from one which removed them only to make them fairer and more like heathen gods. And again,—how careful to distinguish a movement which destroyed legendary art because it detested legend, from a movement which no longer needed legendary art because its legends could now be in books instead of pictures.

¶ But both these questions, interesting as they are, are subordinate to a greater one. Suppose either, or both, of those adversaries had risen against Gothic two centuries earlier, and that printing had been discovered, and classic literature revived, in the reign of Saint Louis. Quite easily that might have chanced. There was nothing to hinder it in the nature of things, —and in that case, the two adversaries would have attacked the Gothic in youth, and met the main rush of its power. What would have happened then? Well, I can tell you what would have happened. That would have

taken place universally, which did take place partially in the leading minds of the thirteenth century. The strong Gothic would have received the classical element everywhere, as it did at Florence. That architecture of Florence did receive classical forms, as the mind of Dante received classical legends, incorporating them with its own life, and making that life more varied and more vivid. But in the sixteenth century the Gothic itself was dying—the stock of the tree was rotten to its root, no grafting was any more possible on any branch of it. It sank at the first touch of the axe; and a new thing was planted instead of it, foreign to the soil, and which will never flourish there. Therefore, what I have to show you to-night is the form of this Christian architecture in its last time—not yet dead—but with its hours numbered, and numbered not by any enemy's will, but by its own weakness,—not by external calamity, but by native corruption. . . .

¶ . . . In reading this architecture, you will read infallibly the faults of its builders. And yet you must observe carefully that the higher arts, which involve the action of the whole intellect, tell the story of the entire national character; but the constructive and mechanical arts tell only part. From a nation's painting, you know everything concerning it; from a nation's architecture, only half. . . .

¶ So we proceed to read [the Church of Saint Wulfran at Abbeville] as well as we can. Well—first there are its more physical and material qualities. What is it made of—built of? That's the first thing to ask of all building. Egyptian building is essentially of porphyry,—Greek of marble,— St. Mark's at Venice of glass and alabaster,—and this is—built of chalk, common chalk—chalk with the flints in it left in, and sticking out here and there. Well, that the first point to think about. All flamboyant architecture is essentially chalk architecture,—it is built of some light, soft, greasy stone, which you can cut like cheese, which you can drive a furrow into with your chisel an inch deep, as a ploughman furrows his field. Well, of course, with this sort of stuff the workman goes instinctively in for deep cutting; he *can* cut deep,—and he does cut deep;—and he can cut fast, and he does cut fast;—and he can cut fantastically,—and he goes in for fancy. What is more, the white surface itself has no preciousness in it, but it becomes piquant when opposed with black shadow, and this flamboyant chiselling is therefore exactly, compared to a fine sculpture, what a Prout sketch is to a painting:—black and white,—against gentle and true colour.

¶ Now what this Abbeville work is typically, all late northern work is broadly:—black and white sketching against perfect form; and what there is of good and bad in that method is all mingled in it. On the one hand there is not a greater distinction between vital sculpture for building, and dead sculpture, than that a true workman paints with his chisel,—does not carve the form of a thing, but cuts the effect of its form. In the great

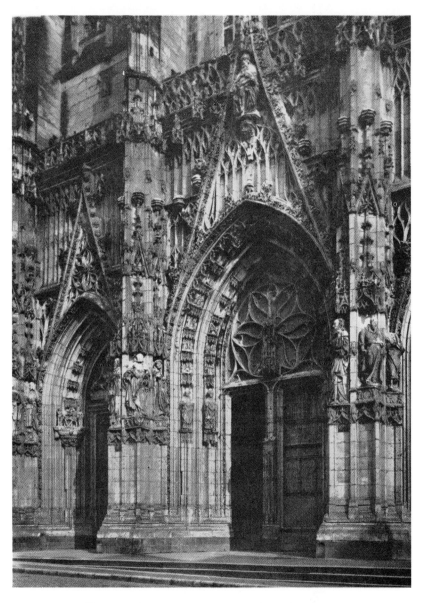

66. CENTRAL PORTAL OF ST. WULFRAN IN ABBEVILLE

67. STUDY OF DEAD LEAVES. Drawing by Ruskin. *Oxford, Ashmolean Museum*

statue of Voltaire at the French Academy,[1]—a miracle of such work—the light in the eye is obtained by a projecting piece of marble. All Donatello's work—all Mino of Fiesole's—all the loveliest Italian cinque-cento—is literally chisel-painting; and it is continually apt to run into too much trick and under-cutting. I can't go into that, now—it begins with the use of the drill in Byzantium capitals. But the issue of it is that you have at last too much superficial effect,—too much trickery,—not enough knowledge of real form. But then you have a knowledge of effect which is quite consummate, and I know nothing in the whole range of art in which the touch is so exquisitely measured to its distance as in this flamboyant. Not one accent is ever lost,—it looks equally fine all over; but at forty feet above the eye you find it is actually so coarse that you cannot believe it is the work you saw from below.

But broadly;—here is the final corruption:—that it becomes a design of lace in white, on a black ground; not a true or intelligent rendering of organic form.

¶ And now we come to another physical condition. Flamboyant architecture is of stone in churches,—but contemporaneously of wood in houses.

So you see—the workman's life practice is all in chalk,—or all in oak, —either in a soft effaceable thing, or a tough fibrous thing. His design becomes sketchy, for one cause;—and fibrous, nervous, and edgy for the other. For observe;—in carving wooden beams, you can always get an effect cheaply by bringing out your edges, but it is difficult to get a sharp edge out of marble without breaking it;—and impossible to cut a thin edge out of granite,—but in wood, up come the edges whether you like them or not, at every blow. That's the reason why dead game is so often carved in wood. You have only to jag at the feathers, and there they are. So, again, the grain of wood is tormenting if one has to cut forms across it, but it lends itself at once to a current curve with the grain. So that this sort of line becomes necessarily characteristic, and goes into the stone-work, till at last you have it insisted on, as in the 'prentice pillar at Roslin. But more than this: working in wood, and living among woods, the carver was continually dealing with branches of trees, and he saw the beauty of leaves as connected with branches, more than any one ever did before; and he saw especially quantities of dead leaves, and got to like the way they twisted, from being used to it. Now I luckily happen once to have made a careful study of a cluster of dead oak leaves, and more luckily still, I kept the cluster I drew it from. There's a Flamboyant crocket for you! [2]

[1] This is a slip of the pen for the Théâtre Français, in the *foyer* of which stands the celebrated statue of Voltaire by Houdon (1741-1828).
[2] Ill. 67 facing this page.

¶ Now for the moral part of it. So far as the workman knew what dead leaves were and loved them, the work is beautiful. But so far as he liked dead leaves better than living ones, and twigs of oak better than living creatures, it is a degraded one. Now see. Here at Abbeville, the leaves are either shrivelled and dead, or wrinkled as cabbage is wrinkled; but here at Bourges is strong Gothic,—the leaves are all alive, smooth, glossy, elastic, and tender with youth. Here is the glow and the bloom of an unstinted vitality. Here literally is the frost,—here literally the wrinkles—of age.

¶ Now the next character of this architecture is curiously mingled in physical and moral causes. Physically, it is architecture for a damp climate, in soft stone, which needed to be protected in the most delicate and important parts of the carving, as far as possible from rain, that it might not moulder, and that the faces might not be deformed by stains. So each statue, instead of being freely exposed to sun and storm, as in Greece,—has its little canopy well projecting over it, and the niche becomes as important as the statue. But note the moral part of this change. As people began to gain more civilized domestic habits, each man's house became of greater importance to him: each statue has a house of its own. And further,—as the world became more luxurious people began to think solitude more sacred; each saint, instead of joining in choir or procession, must have his own little den and cave, all to himself. So each holy statue has its own oratory, and every saint has his special tabernacle; and at last the saint-ship disappears in the seclusion; and all over England and France you have tabernacle work instead of sculpture, Shrines instead of Saints, and Canopies instead of Kings.

And I cannot—and I suppose I need not—follow out the relative moral change which that means,—of which before the last French Revolution we had seen enough.[1]

¶ Now the next point of decline is not physical at all; it is wholly a mental matter—excess, namely, of ingenuity in construction. There is always a steady increase in this particular kind of skill in every school of building, from its birth to its fall. It builds more and more ingeniously every day, and at last expires in small mathematical conceits.

The first idea of construction is the simplest possible; two stones set on end, and another set on the top. That is Stonehenge construction,—it is Egyptian construction,—it is Greek construction. Not ingenious,—but very secure, if your stone is good. And with that simplest of constructions are connected, without any exception, all the best schools of sculpture; for there is no great sculpturesque school even of advanced Gothic, after the horizontal lintel has quite vanished into the vault. Well, next to this horizontal stone, come two stones, giving a gable;—then the arch, and then

[1] The coup d'état of 1851.

endless systems of narrower shafts and higher arches, until the mind of the builder is mainly occupied in finding new ways of making his work stand, and look as if it couldn't stand. Now there is nothing more delightful in their own way than these subtle contrivances of later Gothic, through which Strassburg tower stands up five hundred feet transparent as a cloud, —and Salisbury spire springs like the foam jet over a hollow wave,— foundationless.

¶ But, exactly in proportion as the builder's mind is occupied with these mechanical conditions, it is necessarily unoccupied by thoughts connected with human passion or historical event.

Mathematics are delightful and absorbing, but they are not pathetic; good mason's work, or good engineer's, is intensely satisfactory to the person doing it, and leaves him no time for sentiment, or for what it is now the somewhat vulgar fashion to call sentimentality. And in exactly measured and inevitable degree, as architecture is more ingenious, it is less passionate. Only the other day I was speaking to one of our quite leading Gothic architects about the relative value of southern work and northern—equally good of their period,—and especially of the early school of Pisa as compared with that of France. My friend (we owe so much to him that he will pardon me for naming him,—Mr. Street) alleged against the Pisan work that there was no construction in it, which is literally true —so true that I could make no defence at the time. It is rather pinned together than built;—but there are two reasons for this. Architecture which is built with little bits of precious stone, must always be more like mosaic than that which is built of big bits of coarse stone;—but also, the builder's mind is far too busy in other and higher directions to care about construction. It is full of theology, of philosophy, of thoughts about fate, about love, about death,—about heaven and hell. It is not at all an interesting question with him how to make stones balance each other; but it is, how to reconcile doctrines;—the centre of gravity of vaults is of little moment with him,—but the centre of Fortitude in spirits is much;—not but that his arches and stones, however rudely balanced, did stick together somehow; there is no defiance of construction in them, only no attention is paid to it; if the thing stands, that is all that is wanted. But I think you must see at once what a vital difference it must make at last in schools of building, whether their designer has his head full of mathematical puzzles, or of eager passions;—whether he is only a dextrous joiner, manufacturing hollow stone boxes,—or a poet, writing his book on pages of marble, and not much caring about the binding of them.

¶ And herein, I am therefore able to give you an infallible test of the relative dignity of schools in all time. Some may be more learned than others, —some more graceful,—some more ingenious,—and others more severe;

but the infallible test is,—the prevalence of the human element in their sculpture. Where the sculpture leads, and its passions, the school is great and living; where the masonry leads, and its problems,—there the school is mean and dying. . . .

¶ Now with this great moral change in the temper from passionate to mechanical, there is associated a most curious change in method of construction. When humanity and history were the main things in the architect's mind, his broad surfaces were everything to him, and his limiting lines unimportant. But when construction became principal with him, and story subordinate,—the shaft and the arch rib became everything, and the wall nothing,—until it was found that, in fact, a building might be constructed by nothing but ribs, a mere osseous thorax of a building, instead of a living body. And the critical moment,—the turn of fate,—the fastening of a disease that might be conquered, into disease that was mortal to Gothic architecture,—was what I long ago defined in the *Stones of Venice*, as the substitution of the line for the mass as the element of decoration. For early work had walls covered with sculpture, and windows divided by pillars. Late work has its walls covered with lace, and its windows spun across with cobwebs. And this is not a mere increase in subtlety or excess in quantity. It is total and fatal change in principle. Look here,—here's a picture, —and here's a frame. Early architecture decorated with this;—late architecture decorates with that. Literally,—and to the fullest extent,—this is true. In early work, you have a tablet covered with sculpture, and a decorated moulding round it;—that is all right; but in late work, you have no sculpture,—but are to enjoy the moulding.

¶ But now observe, secondly: it is interwoven Architecture. Not merely linear,—but flexibly linear, twisted and wreathed so as to make the stone look ductile. Herein is its great distinction from the English perpendicular; and it is an entirely essential distinction. And to an architect it would necessarily appear that in this it was inferior to the English school,—and that pretending to make stone look not like stone, and defying many of the laws of mechanical structure, it had forfeited all title to be ranked with the rigid legitimacy of buildings. And that is in the main, true; this system of interweaving is an abandonment of the principle, which is, that every material should have its qualities insisted on, not disguised; and that all ornament is wrong which contradicts or conceals the laws of stable masonry. But it is necessary that the true root and cause of this character should be understood, before we can judge it justly. . . .

¶ . . . I was showing you a few minutes ago the difference between the elastic lines of early sculpture, and the crisped, contracted lines of late sculpture. But there is a worse character of lines than crispness. There is the character of relaxation. You may lose the spring of youth in two ways.

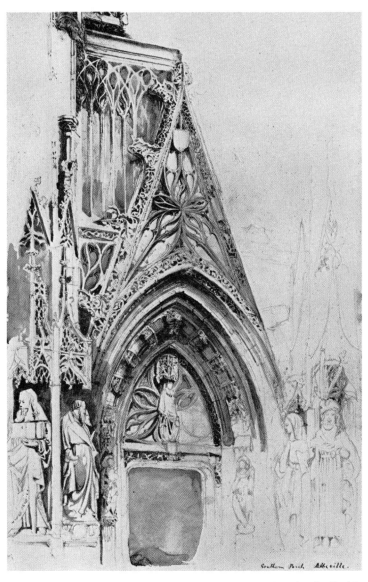

68. SOUTHERN PORCH OF ST. WULFRAN, ABBEVILLE. Drawing by Ruskin
Oxford, Ashmolean Museum

69. NORTH ARCH OF THE WEST ENTRANCE OF AMIENS CATHEDRAL
Drawing by Ruskin. *Oxford, Ashmolean Museum*

By stiffening of age, or by languor,—and the languor is the worse of the two. And that is the way in which the lines of ornamental design corrupted themselves at this period everywhere, not in Gothic only,—nay, not so much in Gothic as in the Renaissance that was superseding it. Everywhere loose lines of fillets, ribands, and weakly or wildly undulatory drapery, were beginning to be chosen in preference to the elastic lines of organic form; and thus, to the smallest particular, the forms of art echoed the temper of their age; the fluttered line announced the feeble will, and the unbound robe, the licentious temper.

¶ But in the Northern Gothic, and especially in this flamboyant school, there was another and a quite nobler influence at work; there *was* this licentiousness; but with it there was a strange fear and melancholy, which had descended unbroken from the gloom of Scandinavian religion,—which was associated always with the labour, the darkness, and the hardships of the North, and which in its resistance to the increasing luxury of the time, took now a feverish and frantic tendency towards the contemplation of death,—clinging to this as its only rebuke and safety, tempted by luxury on one side, and tormented by remorse upon the other,—and most of all by the great baseness of illiterate Christianity in the fear of a physical hell —mingled with indignation against the vices of the priests,—which brought a bitter mockery and low grotesque into the art that had once breathed in affectionate faith and childish obedience. So that you have the pensiveness of Albert Dürer's Melancholia, and the majesty of his Knight walking with Death,—and the fantasy and fever of his Apocalypse,—and the luxury of his wanton and floating Fortune,—and the insatiable intensity of redundant minuteness, and as it were an avarice of nothing in his pebbles and leaves; and you have the mixed mockery and despair of Holbein's Dance of Death, —and a thousand such others,—and all the powers and instincts of which these were the sign, thrilling and contending in the breasts of men, and forcing themselves into every line of the last forms of the shrines of their expiring religion. So that the very threads of the now thin and nervous stone work catch the ague of mixed wantonness and terror, and—weak with unwholesome and ominous fire—flamboyant with a fatal glow— tremble in their ascent as if they were seen through troubled and heated air, over a desert horizon;—and lose themselves at last in the likeness,—no more as the ancient marbles, of the snows of Olympus,—but of the fires of condemnation.

¶ I have hitherto traced for you only the weaknesses and errors of this architecture, or its vain beauty. I have not yet told you the great one fault by which it fell. Commonly it is said of all Gothic, that it rose in simplicity, that it declined by becoming too florid and too rich.

Put that error at once out of your minds. All beautiful and perfect

art, literature or nature, is rich. Titian is rich, Beethoven is rich, Shakespeare is rich, and the forests, and the fields, and the clouds are richest of all. And the two most beautiful Gothic pieces of work in the world,—the South door of the Cathedral of Florence, and the North transept door of the Cathedral of Rouen,—were both in the thirteenth century covered with sculpture as closely as a fretted morning sky with sands of cloud.

But the Gothic fell, because its wealth was empty and its profusion heartless; it fell, because men had become meanly fanciful and vainly sad, or viciously gay,—because it had ceased to be earnest, and ceased to be sincere.

¶ I observe that lately among our artists there has been a singular crusade against the word 'Sentiment'. In the very meeting of the Architects' Institute, to which I have already referred, another of its members declared that he never could see anything but absurdity in the idea that Gothic architecture owed any of its merits to the Sentimentality of the People at large. That the idea appeared absurd to him, I do not wonder; but the fact,—singular as it may be,—was actually so, that in these days the people at large had sentiments, and acted upon them,—and that their architecture owed to these, not only its merits, but even its existence; for, to take one central and characteristic instance: 'One saw at the re-erection of the front of Chartres in 1145'—these are the words of an eyewitness: 'One saw people of wealth and power, accustomed to a life of ease, harness themselves in crowds to the carts that carried the stones; and though sometimes a thousand persons, men and women,—so vast were the weights that had to be drawn —were harnessed to one chariot, there reigned so great a silence that no murmur was heard; only when they stopped to rest, they spoke: making confession of their sins with prayers and tears.' Very absurd, doubtless— but an entirely practical business;—and perhaps, in another seven hundred years, we may also seem absurd to those who shall come after us,—though our sentiments, such as they are, and the burdens we have laid on ourselves, and the chariots we have dragged, may leave behind them no monument of imbecility like the towers of Chartres Cathedral.

But be that as it may, this was the reason that the Gothic fell,—that it had lost to the core its faith, its truth, and its sensibility, and was incapable alike of being grafted with the grace of a Pagan religion, or communicating, even to one generation more, the humility—or the glory—of its own.

¶ Finally. Architecture can only be built by a Thoughtful Nation, and a Pure Nation, living up to its conscience,—who have a Common Pride, and a Common-Wealth.

By a Thoughtful Nation. It cannot be built by clowns, or by people who are generally low in sphere of thought and power of intellect. It does not matter how good they are, if they are foolish or simple, or busied chiefly and earnestly in vulgar business. It is right in Cheshire to care for

cheese,—right in Newcastle to be occupied in coals,—right in the Highlands to be interested in grouse;—but a nation interested only in cheese or coal or grouse cannot be architects. You can only have great buildings when the rulers or guides of the people are eagerly occupied—unselfishly—in the highest spheres of intellect open to them in their age.

¶ Then, secondly, I said, by a Pure people. That is to say, the arts being intensely the work of Human creatures, can only be attained by them in the measure of their humanity, in the degree of their separation from brutes, both in thought and character. Cathedrals can't be built by lambs, and they can't be built by serpents or swine. However loving you are, you must have brains—or you can't build; and however clever you are, you must be affectionate and self-commandant,—or you can't build. I don't say how far we are, or are not this,—but only,—that just so far, we can have art, and no farther. So much as there is in us of serpent or of swine, of malice or of greed,—so much less there is of art capacity; and so far as we are affectionate and temperate, or self-commandant,—so much more we have of art-capacity.

¶ Thirdly: Architecture is possible only to a people who have a Common Pride, and a Common-Wealth,—whose Pride is Civic,—and is the Pride of All.

Good architecture can't be built by Modest people; you must be very saucy, and think yourselves very fine people before you can build,—but your pride must be in what you *all do*, and all *are*. Among us, I notice that it is always individual. We want to do a thing by ourselves, to say a thing that other people have not said,—to get it allowed by them that we did it or we said it. Now when people have real faculty for art, they never care much about putting their names to what they have done. You hardly ever get at a Greek workman's name; hardly ever at a Gothic workman's; but there is always the strongest and brightest National or Civic pride,—the determination that they will have the noblest temple or the highest tower for a thousand miles round.

¶ Fourthly. No architecture can be built but by a nation which has a common wealth,—a common well-being. And this first in a most literal way. There must be perfect freemasonry and unity among all the workmen, from highest to lowest; and the salaries of the highest must not be high, and of the lowest not mean or miserable. There must be gradations of authority, according to faculty,—and that will always be naturally and necessarily given to the man who can design most brilliantly; all the others will look for government and for working drawings;—he will be the master mason,—but he must be nothing more: difference of authority— yes; difference of pay,—no—or at least in very small degree. It is the greatest glory of a King, or General, or a Master of Craft,—to be poor. Not only

their greatest glory, but their greatest power. No rich king—no rich captain—no rich craftsman—ever has his arm free. You will find that a notable lantern to take with you in reading history. Look—if you want to know where nations are in power—Look if their kings are poor—there, their kings are strong. Look where masters have low wages—there, they are masters indeed.

¶ And for the practical application of this, I will give you a direct and sharp one. And there is nothing, of all I have had to tell you, *more* certain,—nothing for us at present so immediately needing to be told.

No architecture will ever be possible where the *master workman has a commission on the cost*. Pay him a salary—a high one if you choose—though you had better not,—but always salary, not commission. Pay your masters only as working men; but masters and men together as gentlemen,—and you may yet see a chisel handled again by an English hand, as in the days of old.

¶ But, further—and last of lastest. There must be commonwealth, as regards those for whom you build, as well as by whom you build. We shall never make our houses for the rich beautiful, till we have begun by making our houses for the poor beautiful. As it is a common and diffused pride, so it is a common and diffused delight on which alone our future arts can be founded.

Delight—observe. We have seen that Gothic architecture fell, not by its luxury, but its despondency. You may have as much luxury as you like, when everybody is at ease,—and as much mirth as you can win, so that everybody be cheerful. I don't ask you to drag carts full of stones, nor to think all day long of Death. Nay, you must think less of Death—in play —and not have so much cause to think of it in earnest. You must not build for pleasure in the front of the house, while there is despair at the back of it. . . .

Never mind the outside. Never mind the houses that look to the Park. Mind the houses that look into Seven Dials. You have just heard authentically from Dr. Hawksley, that you are paying seven millions a year for your London poor, and that Pauperism is on the increase. You fancy perhaps that by giving so much, you show how much you care for them. Ah, no; that is the fine you pay for not caring for them. Give the half of that, in love; you need not give the other half in money. Register them—look after them—let the air and sun in among them;—instead of thinking it pious to light candles by daylight, think it pious to light windows where there's only candlelight; and you will find you soon will have the best half of your seven millions to spare, that you may spend in magnificence what you wasted in misery,—and bringing back the true Saints to their shrines, and building a tabernacle work that shall keep out the wind and

the rain from shivering bodies,—carve a victorious St. George and a prostrate Flamboyant Dragon over every poor man's door.

From *The Flamboyant Architecture of the Valley of the Somme*, Vol. XIX, p. 243.

Assisi

AT THE TWO extremities of the tower of Assisi stand buildings which seem to have been set there by fate with the distinct object of making manifest the opposition [between the Lombard and the Gothic].

The Duomo, at the upper end of the city, retains its Lombardic façade absolutely uninjured. It is a perfect architectural composition, with three wheel windows and three richly sculptured doors, separated from each other by a bold cornice and beautifully proportioned arcade. Rich decoration by external sculpture is the builder's object; and in spirit and fineness of chiselling, or in force of cruel life, it cannot be surpassed. Whatever bites, rends, devours, or destroys, these builders can represent; of the Madonna, their only idea is that she is a powerful animal giving suck. Although the apse of this building is simple, it is still an architectural composition, having the same general intention as the elaborate apse of the Duomo of Verona; the power of the building is in sculpture, in proportion, in use of rich niche and shaft—not in subject sculpture, still less in painting.

¶ One walks down the hill to San Francesco; and in what remains there of the original building, the principles are exactly reversed. Bare walls, hastily put together and held in shape by richest appliances of arch and buttress, are enough for the church outside. There is no sculpture of any importance. Rude waggon vaults, arches built anyhow, walls anyhow; the apse, a mere vertical hexagon on a cylinder, with no care for proportion, for delicacy of masonry, for anything but blank resistance to the elements; the whole spirit of the building is in its interior painting, and painted glass sustained in simplest tracery. The Catherine-wheel window, and rude tracery below it, is the only portion clumsily adopted from the Lombards. For the extreme simplicity,—the absolute negation of architectural charm, —I can only account by supposing the original church built with a definite idea of obeying St. Francis' command of poverty, and that its painting is a *cheap* decoration. It is a sepulchral urn of common Etruscan earth, painted by its religious potter, as of old in Greece, but inside instead of outside. This opposition between the Duomo and San Francesco is perfectly clear and tenable, even taking San Francesco with all its chapels and finer vaultings, as it at present stands,—divesting it only of the clearly later porch.

From *The Schools of Art in Florence*, Vol. XXIII, p. 194.

Mathematical Art

WE ENTER to-day on the study of the group of artists whom I wish you to think of as characteristically mathematic in their temper of work—desirous, that is to say, of correcting the impressions of sense by the appliance of the laws of reason, and the measurement or other sure determination of the facts—so that their minds instead of being in a habitual state of αἴσθησις, or perception, are in a habitual state of μάθησις, or learning and demonstration. . . .

¶ For instance, Michael Angelo, who is the culminating power of the Mathematic school, paints his angels without wings. The masters of the Æsthetic school always had seen them with wings, and painted them so without asking any questions; but Michael Angelo, who never saw any, but only reasoned them out, and produced them by mathematic processes, necessarily felt, as an anatomist, the impossibility of their having wings, and could not, therefore, either logically or with any pleasure, represent them. And as it appears almost equally unreasonable to suppose that human bodies should float in the air without wings,—although in some cases, especially that of the Creation of Adam, he gives entire buoyancy by the help of drapery and cloud, and in others by gesture,—on the whole he likes to have his figure well down on the ground, and will always take more pains with a reeling Bacchus, a dying Adonis, or a recumbent Leda, than a flying Victory. . . .

The Mathematic school begins with Niccola Pisano; culminates in Michael Angelo; its central captain is Brunelleschi.

All three men of gigantic power, and of apparently universal faculty; all three sculptors and architects, Michael Angelo, a painter also; all three recognized in their time as absolute masters and lawful authorities—men not merely to be admired, but obeyed. . . . All these three men, then, had a special power in Italy. Niccola Pisano taught her physical truth and trustworthiness in all things; Brunelleschi the dignity of abstract mathematical law; Michael Angelo the majesty of the human frame. To Niccola you owe the veracity, to Brunelleschi the harmony, and to Michael Angelo the humanity, of mathematic art.

¶ To Brunelleschi, I say, you owe its harmony, he being a man of entirely harmonious, exalted, and refined nature, no less intense than scrupulous, no less strong than patient, and no less daring than subtle. He is the discerner of all that has been recovered, and the founder of all that has been done, in classical architecture justly and honourably so called. Michael Angelo, San Micheli, Sansovino, Palladio, Inigo Jones, and Wren are all his scholars; to him you, in reality, owe whatever is good and pure,

whatever is delicate and learned, in the architecture of modern Europe. But above all things you especially owe to him—what perhaps some of my audience may be more grateful to him for than I am—the three great domes of Florence, Rome, and London.

¶ I should much like to test the feeling of my audience on this matter. Of course, if I were to ask everybody who had seen with admiration the dome of Florence[1] to hold up their hands, everybody would lift hand who had been there. But what I should like to know is whether, on slow self-examination, they look forward to another sight of the dome of Florence, as they do to seeing, after a year or two's interval, the spire of Strassburg again, or the towers of the west front of Rouen.

And for the general public—would not the glimpses of Florence be just as brilliant if the dome were not there—provided only the mosaic shops were? I don't mean that one would not miss the dominant mass of it in distant views of the city, just as one would miss St. Paul's from London; but only that the enjoyment of one's Florentine or London life does not depend on those objects, however admittedly sublime; and I think that when amateurs express themselves with enthusiasm about that Florentine cupola, they are in reality only patting the dome of Florence to appease their own consciences, like Sydney Smith's little girl caressing the tortoise, when her father told her she might as well pat the dome of St. Paul's to please the Dean and Chapter.

¶ Observe, in saying so much as this, I carefully hold apart all influence of association or historical sentiment. If you introduce that element of emotion, it does not much matter, supposing the historical or pathetic interest equal, whether your approach to any great city or ruin of city is announced by the outline on the horizon of a tower, a dome, or a pyramid. But counting only the enduring pleasure we take in the sight of a beautiful thing, I believe that in a healthy and naturally æsthetic mind one does heartily enjoy seeing Coventry spires again as one drives down the hill into the town, or the three gables of Peterborough over the flats, or the long-ridged back of the roof of Amiens, with its sharp arrow of a belfry, but that in driving about Florence it is a matter of extreme indifference whether at the end of a street we see the dome or not.

¶ For my own part I am free to confess that I have not the slightest idea what Michael Angelo meant when he said, 'Like thee I will not build one, better than thee I cannot'. I don't even know what he is supposed to have meant—whether to have been thinking only of the skill of construction, or perceiving a grace of proportion which he could only spoil by altering. So far as he meant the first, no professional person can give any admiration on the same grounds. The merit of structure in a dome depends

[1] Ill. 70 facing page 282.

on relations of weight in the shell and buttresses of it—which to admire, you must first know a great deal of high mathematics—and then the thickness and material of the walls, and shell all the way up. No general spectator can have the slightest idea whether a dome is ill built or well in such particulars.

¶ For the general grace of its outline a dome is merely to be considered as a cup turned upside down; and as on any shelf of the Etruscan Room of the British Museum, or of the Florentine Uffizi, I can see twenty cups in a row, every one of them of a different outline, and every one of them equally pretty, I confess myself utterly unable to understand why Michael Angelo should have felt himself unequal to drawing another cup that should be just as agreeable in outline as that of his Florentine friend, and stand just as steadily bottom upwards.

¶ I think that you may in like manner receive his praise of the dome of Florence as indicating primarily his sense of its safety and economical stability, qualities which it had, as it proved afterwards, in a degree inimitable by him. And you will find in the records of the thought given to it by its builder the same idea prevalent above others. It is not the beauty of the dome, but its unexampled size, of which Brunelleschi intends Florence to be proud; and his own skill is to be shown in the scientific and mechanical functions of designing a safe dome so big, and then of building it with safety to the workman. And herein you find the first clear indication of the new feeling characteristic of the mechanic and mathematic age, that there is a merit deserving primary consideration in mere and simple magnitude, and mere and simple overcoming of physical difficulty. . . .

From *The Schools of Art in Florence*, Vol. xxiii, p. 211.

Ilaria di Caretto

. . . Many [have probably never heard of Jacopo della Quercia], of whose works I have very seldom hitherto spoken, nor indeed are there now many remaining to be spoken of. His fountain at Siena is destroyed, and a modern copy of it put up instead; his bas-relief on the north side of the Duomo of Florence has been blanched by a process of purification which has apparently changed into chalk from marble; his two fonts at Lucca have been scraped thoroughly down with sand-paper; while of his tomb of the wife of Paul Guinigi [1] there, one side has been carried to Florence, and the canopy or other decoration adjunct long ago destroyed by the mob; [2] so that there remains of it now only one side of the sarcophagus, and happily untouched except by time, though unprotected but by the repentant kindness of fortune, the recumbent figure of its dead.

[1] See above p. 180. [2] In 1429. See Vasari.

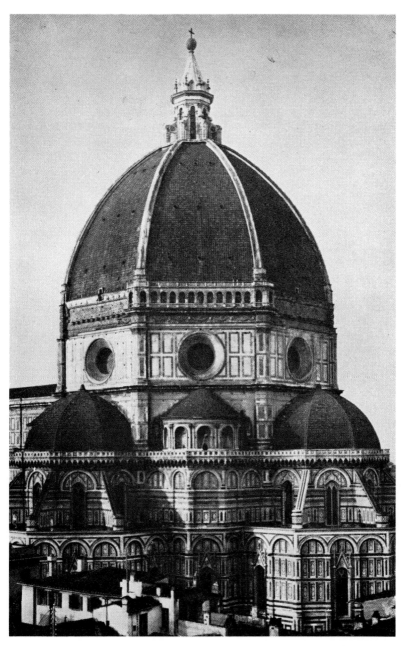

70. THE CUPOLA OF FLORENCE CATHEDRAL designed by Brunelleschi

71. TOMB OF ILARIA DI CARRETTO. Drawing by Ruskin. *Oxford, Ashmolean Museum*

72. TOMB OF ILARIA DI CARRETTO by Jacopo della Quercia. *Lucca Cathedral*

¶ Nevertheless, on the ground of the excellence of that one work, of the position he held among the sculptors of Italy at the time of the competition for the gates of Florence, and of the facts of his life recorded by Vasari, you will find that I have justly placed him among the highest representatives of the mathematic sculpture of 1400; and you will not, I think, impugn my having done so when I tell you that this statue of the lady of Caretto [1] is the only piece of monumental work I know in the world which unites in perfect and errorless balance the softest mysteries of emotion with the implacable severities of science, and that, if any of my pupils had time to see only one statue in Italy, and permitted me to choose for them, out of all her churches and all her galleries, the one which would teach them most, I should name to them no ideal statue of God or Goddess, Saint or Athlete, but this perfect image of the early dead wife of an Etruscan noble.

¶ Yet observe I do not praise it to you as a supremely wonderful thing at all, but only as a supremely right one; nay, the singly quite right one which you can see in all Italy. There are many which come near it, many which in artistic skill equal it; none which, as a standard of art, judgment, and feeling, matches it. And, for the present at least, you can perfectly see it. Its canopy, as I said, is gone; the sarcophagus with its recumbent figure stands as simply by the transept wall of Lucca Cathedral as a table at the side of your room,[2] and just at the height of your hand, if you wished to raise the head on its pillow which will never move more. Fortunately, again, the wall behind is of dark brown marble, relieving the white form; and a cross and circle, cut deep into its stone, before the tomb was placed there, sign her resting-place with sweet fortuitous sacredness.

¶ . . . And this statue of the lady of Caretto marks for you not only the time of perfect law in art, but of perfect law in life; only such a woman can ever have had such a tomb.

¶ Precisely in equipoise between [the] two conditions of imperfection and of extravagance, between the cold severity which cannot reach the tenderness of death, and the vivid insolence which forgets its power, is placed this perfect tomb—a sacred portraiture of an infinite peace—laid, as it were, between the living and the dead—Christ's word spoken in perpetual marble: 'She is not dead—but sleepeth.'

¶ And now let me ask you to note one by one the conditions in the mind of the sculptor, and the modes in which he must use reserve, or forbid his own imagination, skill, and pride, to obtain such a result as this. Above all things, first, he must subdue his pride, or, at least, his love of applause. He must derive no praise from the unfeeling. Every decoration that can be

[1] Ilaria, wife of Carlo, Marchese di Caretto. Ill. 71 and 72 facing this page.
[2] In 1891 removed to the centre of the transept and protected by an iron railing.

parted with he refuses: there is no fringe or embroidery here to be played with in presence of death. All *terror* also he refuses: there is no ghastliness of winding-sheet, no wasting of sickness on the features. All *curiosity* he refuses: there is no fine impressing of the pillow by the head, no subtle crumpling of the wrinkles of the dress about the limbs. Nay, all too attractive extreme of the fairest truth he refuses: a lock of the hair escapes from its fillet and trembles loosely down upon the cheek with a perfect tenderness, and had Ghiberti or Luca della Robbia touched it, it would have been so soft, so finishedly like hair, that the eye might have been caught by it, and the meaner thought intended—how wonderful. Not so with Quercia. A few quiet resolute touches, ineffably subtle and unperceived in their skill, and the lock lies on the cheek indeed, but you do not look at it—only at the face.

¶ Again, he is as much master of all the laws of balance and weight in the human body as Michael Angelo himself. But he does not want you to think of balances or weight. In Michael Angelo's Adonis, or David, or Twilight, or Bound Slave you instantly think how languid the Adonis, how balanced in youthful strength the David, how deep in dream the Twilight, how bowed in toil the Slave; and had Michael Angelo cut this, you would have felt instantly how heavily she lies—how dead. Not so Quercia. He will not let you think of anything secondary for an instant—not of flesh, not of death, and least of all, of him or his knowledge. The young matron lies at rest, like a fallen flower. Her hands are crossed as they fall, not on her breast—that would have been too emotional for Quercia; only so. Any other sculptor would have made them daintily beautiful; not he. They are just natural, even not tapered to the finger-ends a bit, but bluntish, though small and soft; just a simple lady's hands, laid one on the other as easily as if she had but that moment put them so. You don't think of saying 'What pretty hands'; still less, 'How exquisitely they are cut.' But try to draw them, and you will find dimpled Nature herself not more inimitable.

¶ Again, with all this reserve and restraint of power, all is done with such consummate point that, had he disposed the folds of the drapery entirely by natural laws, the statue would have been deceptive, and every fool would have gaped at it for its deception. Quercia will not have it so. I must not have the mob coming here, he thinks, to see how like marble can be to clothes: he arranges the dress over the breast in perfectly natural but close-drawn folds, and thus permits the soft outline of the form beneath, but from the shoulder he draws these terminal folds straight to the feet. They would be only possible if the statue was erect, nor then in this continuousness; no drapery unless under tension could take so unbroken lines, whereas these are not even absolutely straight, but curves of extreme subtlety.

¶ For the final point, then. Hitherto we have seen Quercia thinking only of his chief subject, admitting no secondary motive for a moment. One at last he admits. He has given humanity in its perfectness, accepting the glory of death; beside it he will put the lower creature in its obedience, watching the mystery of death. He has put Ilaria's dog at her feet, which rest upon him. A bull terrier he is; as far as I know dogs, rightly chosen, whether by Ilaria herself or by Quercia for her, as the most faithful. He takes the place here of the old heraldic hound or other merely symbolic creature. But this dog of Quercia's is living; he lays his paws on the outer fold of his mistress's dress, lies utterly quiet under her feet, the hem of the dress just sweeping past his breast and down over one of his paws. His head only is turned to watch the face: Will she not wake, then?

From *The Schools of Art in Florence*, Vol XXIII, p. 221.

THE ORGANIZATION
AND THE STUDY OF ART

THE ORGANIZATION
AND THE STUDY
OF ART

The Hanging of Pictures

. . . It would be interesting if we could obtain a return of the sum which the English nation pays annually for park walls to enclose game, stable walls to separate horses, and garden walls to ripen peaches; and if we could compare this ascertained sum with what it pays for walls to show its art upon. How soon it may desire to quit itself of the dishonour which would result from the comparison I do not know; but as the public appear to be seriously taking some interest in the pending questions respecting their new National Gallery, it is, perhaps, worth while to state the following general principles of good picture exhibitions.

1st. All large pictures should be on walls lighted from above; because light from whatever point it enters, must be gradually subdued as it passes further into the room. Now if it enters at either side of the picture the gradation of diminishing light to the other side is generally unnatural; but if the light falls from above, its gradation from the sky of the picture down to the foreground is never unnatural, even in a figure piece, and is often a great help to the effect of a landscape. Even the interiors, in which lateral light is represented as entering a room, and none as falling from the ceiling, are yet best seen by light from above; for a lateral light contrary to the supposed direction of that in the picture will greatly neutralize its effect; and a lateral light in the same direction will exaggerate it. The artist's real intention can only be seen fairly by light from above.

2nd. Every picture should be hung so as to admit of its horizon being brought on a level with the eye of the spectator, without difficulty, or stooping. When pictures are small, one line may be disposed so as to be seen by a sitting spectator, and one to be seen standing, but more than two lines should never be admitted. A *model* gallery should have one line only; and some interval between each picture, to prevent the interference of the

colours of one piece with those of the rest—a most serious source of deterioration of effect.

3rd. If pictures were placed thus, only in one low line, the gorgeousness of large rooms and galleries would be lost, and it would be useless to endeavour to obtain any imposing architectural effect by the arrangement or extent of the rooms. But the far more important objects might be attained, of making them perfectly comfortable, securing good light in the darkest days and ventilation without draughts in the warmest and coldest.

4th. And if hope of architectural effect were thus surrendered, there would be a great advantage in giving large upright pictures a room to themselves. For as the perspective horizon of such pictures cannot always be brought low enough even for a standing spectator, and as, whether it can or not, the upper parts of great designs are often more interesting than the lower, the floor at the further extremity of the room might be raised by the number of steps necessary to give full command of the composition; and a narrow lateral gallery carried from this elevated daïs; to its sides. Such a gallery of close access to the flanks of pictures like Titian's Assumption or Peter Martyr would be of the greatest service to artists.

5th. It is of the highest importance that the works of each master should be kept together. No great master can be thoroughly enjoyed but by getting into his humour, and remaining long enough under his influence to understand his whole mode and cast of thought. The contrast of works by different masters never brings out their merits; but their defects: the spectator's effort (if he is kind enough to make any) to throw his mind into their various tempers, materially increases his fatigue—and the fatigue of examining a series of pictures carefully is always great, even under the most favourable circumstances. The advantage thus gained in peace of mind and power of understanding, by the assemblage of the works of each master, is connected with another, hardly less important, in the light thrown on the painter's own progress of intellect and methods of study.

6th. Whatever sketches and studies for any picture exist by its master's hand, should be collected at any sacrifice; a little reciprocal courtesy among governments might easily bring this about: such studies should be shown under glass . . . in the centre of the room in which the picture itself is placed. The existing engravings from it, whatever their merit or demerit (it is often a great point in art education to demonstrate the *last*) should be collected and exhibited in a similar manner.

7th. Although the rooms, if thus disposed, would never, as aforesaid, produce any bold architectural effect (the tables just proposed in the centre of each room being especially adverse to such effect), they might be rendered separately beautiful, by decoration so arranged as not to interfere with the colour of the pictures. The blankness and poverty of colour are, in such

adjuncts, much more to be dreaded than its power; the discordance of a dead colour is more painful than the discordance of a glowing one: and it is better slightly to eclipse a picture by pleasantness of adjunct, than to bring the spectator to it disgusted by collateral deformities.

8th. Though the idea of a single line of pictures, seen by light from above, involves externally, as well as internally, the sacrifice of the ordinary elements of architectural splendour, I am certain the exterior even of this long and low gallery could be rendered not only impressive, but a most interesting school of art. I would dispose it in long arcades; if the space were limited, returning upon itself like a labyrinth; the walls to be double, with passages of various access between them, in order to secure the pictures from the variations of temperature in the external air; the outer walls to be of the most beautiful British building stones—chiefly our whitest limestone, black marble, and Cornish serpentine, variously shafted and inlaid; between each two arches a white marble niche, containing a statue of some great artist; the whole approximating, in effect, to the lower arcades of the Baptistery of Pisa, continued into an extent like that of the Pisan Campo Santo. Courts should be left between its returns, with porches at the outer angles, leading one into each division of the building appropriated to a particular school; so as to save the visitor from the trouble of hunting for his field of study through the length of the labyrinth; and the smaller chambers appropriated to separate pictures should branch out into these courts from the main body of the building.

9th. As the condition that the pictures should be placed at the level of sight would do away with all objections to glass as an impediment of vision (who is there who cannot see the Perugino in the National Gallery?) *all* pictures should be put under glass, firmly secured and made air-tight behind. The glass is an important protection not only from dust, but from chance injury. I have seen a student in the Vernon Gallery [1] mixing his colours on his pallet knife, and holding the knife, full charged, within half an inch or less, of the surface of the picture he was copying, to see if he had matched the colour. The slightest accidental jar given to the hand would have added a new and spirited touch to the masterpiece.

10th. Supposing the pictures thus protected, it matters very little to what atmosphere their frames and glasses may be exposed. The most central situation for a National Gallery would be the most serviceable, and therefore the best. . . .

11th. No drawing is worth a nation's keeping if it be not either good, or documentarily precious. If it be either of these, it is worth a bit of glass and a wooden frame. All drawings should be glazed, simply framed in

[1] The Vernon collection was presented to the National Gallery in 1847, and for many years was shown in a room known as the Vernon Gallery.

wood, and enclosed in sliding grooves in portable cases. . . . The department for the drawings should be, of course, separate, and like a beautiful and spacious library, with its cases of drawings ranged on the walls (as those of the coins are in the Coin-room of the British Museum), and convenient recesses with pleasant lateral light, for the visitors to take each his case of drawings into. Lateral light is best for drawings, because the variation in intensity is small, and of little consequence to a small work; but the shadow of the head is inconvenient in looking close at them, when the light falls from above.

12th. I think the collections of Natural History should be kept separate from those of Art.[1] . . .

From *On the Hanging of Pictures*, 'Notes on the Turner Exhibition'.

A Joy for Ever

. . . To begin, then, with one of these necessary truisms: all economy, whether of states, households, or individuals, may be defined to be the art of managing labour. The world is so regulated by the laws of Providence, that a man's labour, well applied, is always amply sufficient to provide him during his life with all things needful to him, and not only with those, but with many pleasant objects of luxury; and yet farther, to procure him large intervals of healthful rest and serviceable leisure. And a nation's labour well applied, is, in like manner, amply sufficient to provide its whole population with good food and comfortable habitation; and not with those only, but with good education besides, and objects of luxury, art treasures, such as these you have around you now.[2] But by those same laws of Nature and Providence, if the labour of the nation or of the individual be misapplied, and much more if it be insufficient,—if the nation or man be indolent and unwise,—suffering and want result, exactly in proportion to the indolence and improvidence—to the refusal of labour, or to the misapplication of it. Wherever you see want, or misery, or degradation, in this world about you, there, be sure, either industry has been wanting, or industry has been in error. It is not accident, it is not Heaven-commanded calamity, it is not the original and inevitable evil of man's nature, which fill your streets with lamentation, and your graves with prey. It is only that, when there should have been providence, there has been waste; when there should have been

[1] The Natural History collections of the British Museum were removed to a separate building at South Kensington only in 1880-83.

[2] *A Joy For Ever* represents the substance of two lectures given in connection with the Art Treasures Exhibition at Manchester.

labour, there has been lasciviousness and wilfulness, when there should have been subordination. . . .

¶ Now, we have warped the word "economy" in our English language into a meaning which it has no business whatever to bear. In our use of it, it constantly signifies merely sparing or saving; economy of money means saving money—economy of time, sparing time, and so on. But that is a wholly barbarous use of the word—barbarous in a double sense, for it is not English, and it is bad Greek; barbarous in a treble sense, for it is not English, it is bad Greek, and it is worse sense. Economy no more means saving money than it means spending money. It means the administration of a house, its stewardship; spending or saving, that is whether money or time, or anything else, to the best possible advantage. In the simplest and clearest definition of it, economy whether public or private, means the wise management of labour; and it means this mainly in three senses: namely, first, *applying* your labour rationally, and secondly *preserving* its produce carefully; lastly, *distributing* its produce seasonably.

¶ I say first, applying your labour rationally; that is, so as to obtain the most precious things you can, and the most lasting things, by it: not growing oats in land where you can grow wheat, nor putting fine embroidery on a stuff that will not wear. Secondly, preserving its produce carefully; that is to say, laying up your wheat wisely in store-houses for the time of famine, and keeping your embroidery watchfully from the moth: and lastly, distributing its produce seasonably; that is to say, being able to carry your corn at once to the place where the people are hungry, and your embroideries to the places where they are gay; so fulfilling in all ways the Wise Man's description, whether of the queenly housewife or queenly nation: 'She riseth while it is yet night, and giveth meat to her household, and a portion to her maidens. She maketh herself coverings of tapestry, her clothing is silk and purple. Strength and honour are in her clothing, and she shall rejoice in time to come.' . . .

I. DISCOVERY.—How are we to get our men of genius: that is to say, by what means may we produce among us, at any given time, the greatest quantity of effective art-intellect? A wide question, you say, involving an account of all the best means of art education. Yes, but I do not mean to go into the consideration of those; I want only to state the few principles which lie at the foundation of the matter. Of these, the first is that you have always to find your artist, not to make him; you can't manufacture him, any more than you can manufacture gold. You can find him, and refine him: you dig him out as he lies nugget-fashion in the mountain-stream; you bring him home; and you make him into current coin, or household plate, but not one grain of him can you originally

produce. A certain quantity of art-intellect is born annually in every nation, greater or less according to the nature and cultivation of the nation, or race of men; but a perfectly fixed quantity annually, not increasable by one grain. You may lose it, or you may gather it; you may let it lie loose in the ravine, and buried in the sands, or you may make king's thrones of it, and overlay temple gates with it, as you choose: but the best you can do with it is always merely sifting, melting, hammering, purifying—never creating.

¶ And there is another thing notable about this artistical gold; not only is it limited in quantity, but in use. You need not make thrones or golden gates with it unless you like, but assuredly you can't do anything else with it. You can't make knives of it, nor armour, nor railroads. The gold won't cut you, and it won't carry you: put it to a mechanical use, and you destroy it at once. It is quite true that, in the greatest artists, their proper artistical faculty is united with every other; and you may make use of the other faculties, and let the artistical one lie dormant. For aught I know, there may be two or three Leonardo da Vincis employed at this moment in your harbours and railroads: but you are not employing their Leonardesque or golden faculty there,—you are only oppressing and destroying it. And the artistical gift in average men is not joined with others: your born painter, if you don't make a painter of him, won't be a first-rate merchant, or lawyer; at all events, whatever he turns out, his own special gift is unemployed by you; and in no wise helps him in that other business. So here you have a certain quantity of a particular sort of intelligence, produced for you annually by providential laws, which you can only make use of by setting it to its own proper work, and which any attempt to use otherwise involves the dead loss of so much human energy.

¶ Well then, supposing we wish to employ it, how is it to be best discovered and refined? It is easily enough discovered. To wish to employ it is to discover it. All that you need is, a school of trial in every important town, in which those idle farmers' lads whom their masters never can keep out of mischief, and those stupid tailors' 'prentices who are always stitching the sleeves in wrong way upwards, may have a try at this other trade; only this school of trial must not be entirely regulated by formal laws of art education, but must ultimately be the workshop of a good master painter, who will try the lads with one kind of art and another, till he finds out what they are fit for.

¶ Next, after your trial school, you want your easy and secure employment, which is the matter of chief importance. For, even on the present system, the boys who have really intense art capacity, generally make painters of themselves; but then, the best half of their early energy is lost in the battle of life. Before a good painter can get employment, his mind has always been embittered, and his genius distorted. A common mind

usually stoops, in plastic chill, to whatever is asked of it, and scrapes or daubs its way complacently into public favour. But your great men quarrel with you, and you revenge yourselves by starving them for the first half of their lives. Precisely in the degree in which any painter possesses original genius, is at present the increase of moral certainty that during his early years he will have a hard battle to fight; and that just at the time when his conceptions ought to be full and happy, his temper gentle, and his hopes enthusiastic—just at that most critical period, his heart is full of anxieties and household cares; he is chilled by disappointments, and vexed by injustice; he becomes obstinate in his errors, no less than in his virtues, and the arrows of his aims are blunted, as the reeds of his trust are broken.

¶ What we mainly want, therefore, is a means of sufficient and unagitated employment: not holding out great prizes for which young painters are to scramble; but furnishing all with adequate support, and opportunity to display such power as they possess without rejection or mortification. I need not say that the best field of labour of this kind would be presented by the constant progress of public works involving various decoration; and we will presently examine what kind of public works may thus, advantageously for the nation, be in constant progress. But a more important matter even than this of steady employment, is the kind of criticism with which you, the public, receive the works of the young men submitted to you. You may do much harm by indiscreet praise and by indiscreet blame; but remember the chief harm is always done by blame. It stands to reason that a young man's work cannot be perfect. It *must* be more or less ignorant; it must be more or less feeble; it is likely that it may be more or less experimental, and if experimental, here and there mistaken. If, therefore, you allow yourself to launch out into sudden barking at the first faults you see, the probability is that you are abusing the youth for some defect naturally and inevitably belonging to that stage of his progress; and that you might just as rationally find fault with a child for not being as prudent as a privy councillor, or with a kitten for not being as grave as a cat.

¶ But there is one fault which you may be quite sure is unnecessary, and therefore a real and blamable fault: that is haste, involving negligence. Whenever you see that a young man's work is either bold or slovenly, then you may attack it firmly; sure of being right. If his work is bold, it is insolent; repress his insolence: if it is slovenly, it is indolent; spur his indolence. So long as he works in that dashing or impetuous way, the best hope for him is in your contempt: and it is only by the fact of his seeming not to seek your approbation that you may conjecture he deserves it.

¶ But if he does deserve it, be sure that you give it him, else you not only run a chance of driving him from the right road by want of encouragement, but you deprive yourselves of the happiest privilege you will ever

have of rewarding his labour. For it is only the young who can receive much reward from men's praise: the old, when they are great, get too far beyond and above you to care what you think of them. You may urge them then with sympathy, and surround them then with acclamation; but they will doubt your pleasure, and despise your praise. You might have cheered them in their race through the asphodel meadows of their youth; you might have brought the proud, bright scarlet into their faces, if you had but cried once to them 'Well done', as they dashed up to the first goal of their early ambition. But now, their pleasure is in memory, and their ambition is in heaven. They can be kind to you, but you nevermore can be kind to them. You may be fed with the fruit and fulness of their old age, but you were as the nipping blight to them in their blossoming, and your praise is only as the warm winds of autumn to the dying branches.

¶ There is one thought still, the saddest of all, bearing on this with-holding of early help. It is possible, in some noble natures, that the warmth and the affections of childhood may remain unchilled, though unanswered; and that the old man's heart may still be capable of gladness, when the long-withheld sympathy is given at last. But in these noble natures it nearly always happens that the chief motive of earthly ambition has not been to give delight to themselves, but to their parents. Every noble youth looks back, as to the chiefest joy which this world's honour ever gave him, to the moment when first he saw his father's eyes flash with pride, and his mother turn away her head, lest he should take her tears for tears of sorrow. Even the lover's joy, when some worthiness of his is acknowledged before his mistress, is not so great as that, for it is not so pure—the desire to exalt himself in her eyes mixes with that of giving her delight; but he does not need to exalt himself in his parents' eyes: it is with the pure hope of giving them pleasure that he comes to tell them what he has done, or what has been said of him; and therefore he has a purer pleasure of his own. And this purest and best of rewards you keep from him if you can: you feed him in his tender youth with ashes and dishonour; and then you come to him, obsequious, but too late, with your sharp laurel crown, the dew all dried from off its leaves; and you thrust it into his languid hand, and he looks at you wistfully. What shall he do with it? What can he do, but go and lay it on his mother's grave?

¶ Thus, then, you see that you have to provide for your young men: first, the searching or discovering school; then the calm employment; then the justice of praise: one thing more you have to do for them in preparing them for full service—namely, to make, in the noble sense of the word, gentlemen of them; that is to say, to take care that their minds receive such training, that in all they paint they shall see and feel the noblest things. I am sorry to say that, of all parts of an artist's education, this is the most

neglected among us; and that even where the natural taste and feeling of the youth have been pure and true, where there was the right stuff in him to make a gentleman of, you may too frequently discern some jarring rents in his mind, and elements of degradation in his treatment of subject, owing to want of gentle training, and of the liberal influence of literature. This is quite visible in our greatest artists, even in men like Turner and Gainsborough; while in the common grade of our second-rate painters the evil attains a pitch which is far too sadly manifest to need my dwelling upon it. Now, no branch of art economy is more important than that of making the intellect at your disposal pure as well as powerful; so that it may always gather for you the sweetest and fairest things. The same quantity of labour from the same man's hand, will, according as you have trained him, produce a lovely and useful work, or a base and hurtful one; and depend upon it, whatever value it may possess, by reason of the painter's skill, its chief and final value, to any nation, depends upon its being able to exalt and refine, as well as to please; and that the picture which most truly deserves the name of an art-treasure is that which has been painted by a good man.

¶ You cannot but see how far this would lead, if I were to enlarge upon it. I must take it up as a separate subject some other time: only noticing at present that no money could be better spent by a nation than in providing a liberal and disciplined education for its painters, as they advance into the critical period of their youth; and that, also, a large part of their power during life depends upon the kind of subjects which you, the public, ask them for, and therefore the kind of thoughts with which you require them to be habitually familiar. I shall have more to say on this head when we come to consider what employment they should have in public buildings. . . .

II. APPLICATION.—There are three main points the economist has to attend to in this.

> First, To set his men to various work.
> Secondly, To easy work.
> Thirdly, To lasting work.

I shall briefly touch on the first two, for I want to arrest your attention on the last.

¶ I say first to various work. Supposing you have two men of equal power as landscape painters—and both of them have an hour at your disposal. You would not set them both to paint the same piece of landscape. You would, of course, rather have two subjects than a repetition of one.

Well, supposing them sculptors, will not the same rule hold? You naturally conclude at once that it will; but you will have hard work to convince your modern architects of that. They will put twenty men to work, to carve twenty capitals; and all shall be the same. If I could show

you the architects' yards in England just now, all open at once, perhaps you might see a thousand clever men, all employed in carving the same design. Of the degradation and deathfulness to the art-intellect of the country involved in such a habit, I have more or less been led to speak before now; but I have not hitherto marked its definite tendency to increase the price of *work*, as such. When men are employed continually in carving the same ornaments, they get into a monotonous and methodical habit of labour—precisely correspondent to that in which they would break stones, or paint house-walls. Of course, what they do so constantly, they do easily; and if you excite them temporarily by an increase of wages, you may get much work done by them in a little time. But, unless so stimulated, men condemned to a monotonous exertion, work—and always, by the laws of human nature, *must* work—only at a tranquil rate, not producing by any means a maximum result in a given time. But if you allow them to vary their designs, and thus interest their heads and hearts in what they are doing, you will find them become eager first, to get their ideas expressed, and then to finish the expression of them; and the moral energy thus brought to bear on the matter quickens, and therefore cheapens, the production in a most important degree. Sir Thomas Deane, the architect of the new Museum at Oxford, told me, as I passed through Oxford on my way here, that he found that, owing to this cause alone, capitals of various design could be executed cheaper than capitals of similar design (the amount of hand labour in each being the same) by about 30 per cent.

¶ Well, that is the first way, then, in which you will employ your intellect well; and the simple observance of this plain rule of political economy will effect a noble revolution in your architecture, such as you cannot at present so much as conceive. Then the second way in which we are to guard against waste is by setting our men to the easiest, and therefore the quickest, work which will answer the purpose. Marble, for instance, lasts quite as long as granite, and is much softer to work; therefore, when you get hold of a good sculptor, give him marble to carve—not granite.

¶ That, you say, is obvious enough. Yes; but it is not so obvious how much of your workmen's time you waste annually in making them cut glass, after it has got hard, when you ought to make them mould it while it is soft. It is not so obvious how much expense you waste in cutting diamonds and rubies, which are the hardest things you can find, into shapes that mean nothing, when the same men might be cutting sandstone and freestone into shapes that meant something. It is not so obvious how much of the artists' time in Italy you waste, by forcing them to make wretched little pictures for you out of crumbs of stone glued together at enormous cost, when the tenth of the time would make good and noble pictures for you out of water-colour.

¶ I could go on giving you almost numberless instances of this great commercial mistake; but I should only weary and confuse you. I therefore commend also this head of our subject to your own meditation, and proceed to the last I named—the last I shall task your patience with to-night. You know we are now considering how to apply our genius; and we were to do it as economists, in three ways:

To *various* work;

To *easy* work;

To *lasting* work.

¶ This lasting of the work, then, is our final question.

Many of you may perhaps remember that Michael Angelo was once commanded by Pietro di Medici to mould a statue out of snow, and that he obeyed the command. I am glad, and we have all reason to be glad, that such a fancy ever came into the mind of the unworthy prince, and for this cause: that Pietro di Medici then gave, at the period of one great epoch of consummate power in the arts, the perfect, accurate, and intensest possible type of the greatest error which nations and princes can commit, respecting the power of genius entrusted to their guidance. You had there, observe, the strongest genius in the most perfect obedience; capable of iron independence, yet wholly submissive to the patron's will; at once the most highly accomplished and the most original, capable of doing as much as man could do, in any direction that man could ask. And its governor, and guide, and patron sets it to build a statue in snow—to put itself into the service of annihilation—to make a cloud of itself, and pass away from the earth.

¶ Now this, so precisely and completely done by Pietro di Medici, is what we are all doing, exactly in the degree in which we direct the genius under our patronage to work in more or less perishable materials. So far as we induce painters to work in fading colours, or architects to build with imperfect structure, or in any other way consult only immediate ease and cheapness in the production of what we want, to the exclusion of provident thought as to its permanence and serviceableness in after ages; so far we are forcing our Michael Angelos to carve in snow. The first duty of the economist in art is, to see that no intellect shall thus glitter merely in the manner of hoar-frost; but that it shall be well vitrified, like a painted window, and shall be set so between shafts of stone and bands of iron, that it shall bear the sunshine upon it, and send the sunshine through it, from generation to generation.

¶ I can conceive, however, some political economist to interrupt me here, and say, 'If you make your art wear too well, you will soon have too much of it; you will throw your artists quite out of work. Better allow

for a little wholesome evanescence—beneficent destruction: let each age provide art for itself, or we shall soon have so many good pictures that we shall not know what to do with them.'

Remember, my dear hearers, who are thus thinking, that political economy, like every other subject, cannot be dealt with effectively if we try to solve two questions at a time instead of one. It is one question, how to get plenty of a thing; and another, whether plenty of it will be good for us. Consider these two matters separately; never confuse yourself by interweaving one with the other. It is one question, how to treat your fields so as to get a good harvest; another, whether you wish to have a good harvest, or would rather like to keep up the price of corn. It is one question, how to graft your trees so as to grow most apples; and quite another, whether having such a heap of apples in the storeroom will not make them all rot.

¶ Now, therefore, that we are talking only about grafting and grow-ing, pray do not vex yourselves with thinking what you are to do with the pippins. It may be desirable for us to have much art, or little—we will examine that by-and-bye; but just now, let us keep to the simple con-sideration how to get plenty of good art if we want it. Perhaps it might be just as well that a man of moderate income should be able to possess a good picture, as that any work of real merit should cost £500 or £1,000; at all events, it is certainly one of the branches of political economy to ascertain how, if we like, we can get things in quantities—plenty of corn, plenty of wine, plenty of gold, or plenty of pictures.

It has just been said, that the first great secret is to produce work that will last. Now, the conditions of work lasting are twofold: it must not only be in materials that will last, but it must be itself of a quality that will last—it must be good enough to bear the test of time. If it is not good, we shall tire of it quickly, and throw it aside—we shall have no pleasure in the accumulation of it. So that the first question of a good art-economist re-specting any work is, Will it lose its flavour by keeping? It may be very amusing now, and look much like a work of genius; but what will be its value a hundred years hence?

You cannot always ascertain this. You may get what you fancy to be work of the best quality, and yet find to your astonishment that it won't keep. But of one thing you may be sure, that art which is produced hastily will also perish hastily; and that what is cheapest to you now, is likely to be dearest in the end.

¶ I am sorry to say, the great tendency of this age is to expend its genius in perishable art of this kind, as if it were a triumph to burn its thoughts away in bonfires. There is a vast quantity of intellect and of labour consumed annually in our cheap illustrated publications; you triumph in them; and

you think it so grand a thing to get so many woodcuts for a penny. Why, woodcuts, penny and all, are as much lost to you as if you had invested your money in gossamer. More lost, for the gossamer could only tickle your face, and glitter in your eyes; it could not catch your feet and trip you up: but the bad art can, and does; for you can't like good woodcuts as long as you look at the bad ones. If we were at this moment to come across a Titian woodcut, or a Dürer woodcut, we should not like it—those of us at least who are accustomed to the cheap work of the day. We don't like, and can't like, *that* long; but when we are tired of one bad cheap thing, we throw it aside and buy another bad cheap thing; and so keep looking at bad things all our lives. Now, the very men who do all that quick bad work for us are capable of doing perfect work. Only, perfect work can't be hurried, and therefore it can't be cheap beyond a certain point. But suppose you pay twelve times as much as you do now, and you have one woodcut for a shilling instead of twelve; and the one woodcut for a shilling is as good as art can be, so that you will never tire of looking at it; and is struck on good paper with good ink, so that you will never wear it out by handling it; while you are sick of your penny-each cuts by the end of the week, and have torn them mostly in half too. Isn't your shilling's worth the best bargain?

¶ It is not, however, only in getting prints or woodcuts of the best kind that you will practise economy. There is a certain quality about an original drawing which you cannot get in a woodcut, and the best part of the genius of many men is only expressible in original work, whether with pen or ink—pencil or colours. This is not always the case; but in general, the best men are those who can only express themselves on paper or canvas; and you will therefore, in the long run, get most for your money by buying original work; proceeding on the principle already laid down, that the best is likely to be the cheapest in the end. Of course, original work cannot be produced under a certain cost. If you want a man to make you a drawing which takes him six days, you must, at all events, keep him for six days in bread and water, fire and lodging; that is the lowest price at which he can do it for you, but that is not very dear: and the best bargain which can possibly be made honestly in art—the very ideal of a cheap purchase to the purchaser—is the original work of a great man fed for as many days as are necessary on bread and water, or perhaps we may say with as many onions as will keep him in good humour. That is the way by which you will always get most for your money; no mechanical multiplication or ingenuity of commercial arrangements will ever get you a better penny's worth of art than that.

¶ Without, however, pushing our calculations quite to this prison-discipline extreme, we may lay it down as a rule in art-economy, that original work is, on the whole, cheapest and best worth having. But

precisely in proportion to the value of it as a production, becomes the importance of having it executed in permanent materials. And here we come to note the second main error of the day, that we not only ask our workmen for bad art, but we make them put it into bad substance. We have, for example, put a great quantity of genius, within the last twenty years, into water-colour drawing, and we have done this with the most reckless disregard whether either the colours or the paper will stand. In most instances, neither will. By accident, it may happen that the colours in a given drawing have been of good quality, and its paper uninjured by chemical processes. But you take not the least care to ensure these being so; I have myself seen the most destructive changes take place in water-colour drawings within twenty years after they were painted; and from all I can gather respecting the recklessness of modern paper manufacture, my belief is, that though you may still handle an Albert Dürer engraving, two hundred years old, fearlessly, not one-half of that time will have passed over your modern water-colours, before most of them will be reduced to mere white or brown rags; and your descendants, twitching them contemptuously into fragments between finger and thumb, will mutter against you, half in scorn and half in anger, 'Those wretched nineteenth century people! they kept vapouring and fuming about the world, doing what they called business, and they couldn't make a sheet of paper that wasn't rotten.' . . .

¶ But I cannot pass without some brief notice our habit—continually, as it seems to me, gaining strength—of putting a large quantity of thought and work, annually, into things which are either in their nature necessarily perishable, as dress; or else into compliances with the fashion of the day, in things not necessarily perishable, as plate. I am afraid almost the first idea of a young rich couple setting up house in London, is, that they must have new plate. Their father's plate may be very handsome, but the fashion is changed. They will have a new service from the leading manufacturer, and the old plate, except a few apostle spoons, and a cup which Charles the Second drank a health in to their pretty ancestress, is sent to be melted down, and made up with new flourishes and fresh lustre. Now, so long as this is the case—so long, observe, as fashion has influence on the manufacture of plate—so long *you cannot have a goldsmith's art in this country.* Do you suppose any workman worthy the name will put his brains into a cup, or an urn, which he knows is to go to the melting-pot in half a score years? He will not; you don't ask or expect it of him. You ask of him nothing but a little quick handicraft—a clever twist of a handle here, and a foot there, a convolvulus from the newest school of design, a pheasant from Landseer's game cards; a couple of sentimental figures for supporters, in the style of the signs of insurance offices, then a clever touch with the burnisher, and there's your epergne, the admiration of all the footmen at the wedding-

breakfast, and the torment of some unfortunate youth who cannot see the pretty girl opposite to him, through its tyrannous branches.

¶ But you don't suppose that *that's* goldsmith's work? Goldsmith's work is made to last, and made with the men's whole heart and soul in it; true goldsmith's work, when it exists, is generally the means of education of the greatest painters and sculptors of the day. Francia was a goldsmith; Francia was not his own name, but that of his master the jeweller; and he signed his pictures almost always, 'Francia, the goldsmith', for love of his master; Ghirlandajo was a goldsmith, and was the master of Michael Angelo; Verrocchio was a goldsmith, and was the master of Leonardo da Vinci. Ghiberti was a goldsmith, and beat out the bronze gates which Michael Angelo said might serve for gates of Paradise.★ But if ever you want work like theirs again, you must keep it, though it should have the misfortune to become old-fashioned. You must not break it up, nor melt it any more. There is no economy in that; you could not easily waste intellect more grievously. Nature may melt her goldsmith's work at every sunset if she chooses; and beat it out into chased bars again at every sunrise; but you must not. The way to have a truly noble service of plate, is to keep adding to it, not melting it. At every marriage, and at every birth, get a new piece of gold or silver if you will, but with noble workmanship on it, done for all time, and put it among your treasures; that is one of the chief things which gold was made for, and made incorruptible for. When we know a little more of political economy, we shall find that none but partially savage nations need, imperatively, gold for their currency; but gold has been given us, among other things, that we might put beautiful work into its imperishable splendour, and that the artists who have the most wilful fancies may have a material which will drag out, and beat out, as their dreams require, and will hold itself together with fantastic tenacity, whatever rare and delicate service they set it upon.

¶ So here is one branch of decorative art in which rich people may indulge themselves unselfishly; if they ask for good art in it, they may be sure in buying gold and silver plate that they are enforcing useful education on young artists. But there is another branch of decorative art in which I am sorry to say we cannot, at least under existing circumstances, indulge ourselves, with the hope of doing good to anybody: I mean the great and subtle art of dress.

★ Several reasons may account for the fact that goldsmith's work is so wholesome for young artists: first, that it gives great firmness of hand to deal for some time with a solid substance; again, that it induces caution and steadiness—a boy trusted with chalk and paper suffers an immediate temptation to scrawl upon it and play with it, but he dares not scrawl on gold, and he cannot play with it; and, lastly, that it gives great delicacy and precision of touch to work upon minute forms, and to aim at producing richness and finish of design correspondent to the preciousness of the material.

¶ And here I must interrupt the pursuit of our subject for a moment or two, in order to state one of the principles of political economy, which, though it is, I believe, now sufficiently understood and asserted by the leading masters of the science, is not yet, I grieve to say, acted upon by the plurality of those who have the management of riches. Whenever we spend money, we of course set people to work: that is the meaning of spending money; we may, indeed, lose it without employing anybody; but, whenever we spend it, we set a number of people to work, greater or less, of course, according to the rate of wages, but, in the long run, pro-portioned to the sum we spend. Well, your shallow people, because they see that however they spend money they are always employing somebody, and, therefore, doing some good, think and say to themselves, that it is all one *how* they spend it—that all their apparently selfish luxury is, in reality, unselfish, and is doing just as much good as if they gave all their money away, or perhaps more good; and I have heard foolish people even declare it as a principle of political economy, that whoever invented a new want conferred a good on the community. I have not words strong enough —at least, I could not, without shocking you, use the words which would be strong enough—to express my estimate of the absurdity and the mis-chievousness of this popular fallacy. So, putting a great restraint upon my-self, and using no hard words, I will simply try to state the nature of it, and the extent of its influence.

¶ Granted, that whenever we spend money for whatever purpose, we set people to work; and passing by, for the moment, the question whether the work we set them to is all equally healthy and good for them, we will assume that whenever we spend a guinea we provide an equal number of people with healthy maintenance for a given time. But, by the way in which we spend it, we entirely direct the labour of these people during that given time. We become their masters or mistresses, and we compel them to produce, within a certain period, a certain article. Now, that article may be a useful and lasting one, or it may be a useless and perishable one—it may be one useful to the whole community, or useful only to ourselves. And our selfishness and folly, or our virtue and prudence, are shown, not by our spending money, but by our spending it for the wrong or the right thing; and we are wise and kind, not in maintaining a certain number of people for a given period, but only in requiring them to produce during that period, the kind of things which shall be useful to society, instead of those which are only useful to ourselves.

¶ Thus, for instance: if you are a young lady, and employ a certain number of sempstresses for a given time, in making a given number of simple and serviceable dresses—suppose, seven; of which you can wear one yourself for half the winter, and give six away to poor girls who have

none, you are spending your money unselfishly. But if you employ the same number of sempstresses for the same number of days, in making four, or five, or six beautiful flounces for your own ball-dress—flounces which will clothe no one but yourself, and which you will yourself be unable to wear at more than one ball—you are employing your money selfishly. You have maintained, indeed, in each case, the same number of people; but in the one case you have directed their labour to the service of the community; in the other case you have consumed it wholly upon yourself. I don't say you are never to do so; I don't say you ought not sometimes to think of yourselves only, and to make yourselves as pretty as you can; only do not confuse coquettishness with benevolence, nor cheat yourselves into thinking that all the finery you can wear is so much put into the hungry mouths of those beneath you: it is not so; it is what you yourselves, whether you will or no, must sometimes instinctively feel it to be—it is what those who stand shivering in the streets, forming a line to watch you as you step out of your carriages, *know* it to be; those fine dresses do not mean that so much has been put into their mouths, but that so much has been taken out of their mouths.

¶ The real politico-economical signification of every one of those beautiful toilettes, is just this: that you have had a certain number of people put for a certain number of days wholly under your authority, by the sternest of slave-masters—hunger and cold; and you have said to them, 'I will feed you, indeed, and clothe you, and give you fuel for so many days; but during those days you shall work for me only: your little brothers need clothes, but you shall make none for them: your sick friend needs clothes, but you shall make none for her: you yourself will soon need another and a warmer dress, but you shall make none for yourself. You shall make nothing but lace and roses for me; for this fortnight to come, you shall work at the patterns and petals, and then I will crush and consume them away in an hour.' You will perhaps answer—'It may not be particularly benevolent to do this, and we won't call it so; but at any rate we do no wrong in taking their labour when we pay them their wages: if we pay for their work, we have a right to it.'

¶ No;—a thousand times no. The labour which you have paid for, does indeed become, by the act of purchase, your own labour: you have bought the hands and the time of those workers; they are, by right and justice, your own hands, your own time. But have you a right to spend your own time, to work with your own hands, only for your own advantage?—much more, when, by purchase, you have invested your own person with the strength of others; and added to your own life, a part of the life of others? You may, indeed, to a certain extent, use their labour for your delight: remember, I am making no general assertions against splendour

of dress, or pomp of accessories of life; on the contrary, there are many reasons for thinking that we do not at present attach enough importance to beautiful dress, as one of the means of influencing general taste and character. But I *do* say, that you must weigh the value of what you ask these workers to produce for you in its own distinct balance; that on its own worthiness or desirableness rests the question of your kindness, and not merely on the fact of your having employed people in producing it: and I say further, that as long as there are cold and nakedness in the land around you, so long there can be no question at all but that splendour of dress is a crime. In due time, when we have nothing better to set people to work at, it may be right to let them make lace and cut jewels; but as long as there are any who have no blankets for their beds, and no rags for their bodies, so long it is blanket-making and tailoring we must set people to work at —not lace. . . .

III. ACCUMULATION.—And now, in the outset, it will be well to face that objection which we put aside a little while ago; namely, that perhaps it is not well to have a great deal of good art; and that it should not be made too cheap.

'Nay', I can imagine some of the more generous among you exclaiming, 'we will not trouble you to disprove that objection; of course it is a selfish and base one: good art, as well as other good things, ought to be made as cheap as possible, and put as far as we can within the reach of everybody'.

¶ Pardon me, I am not prepared to admit that. I rather side with the selfish objectors, and believe that art ought not to be made cheap, beyond a certain point; for the amount of pleasure that you can receive from any great work, depends wholly on the quantity of attention and energy of mind you can bring to bear upon it. Now, that attention and energy depend much more on the freshness of the thing than you would at all suppose; unless you very carefully studied the movements of your own minds. If you see things of the same kind and of equal value very frequently, your reverence for them is infallibly diminished, your powers of attention get gradually wearied, and your interest and enthusiasm worn out; and you cannot in that state bring to any given work the energy necessary to enjoy it. If, indeed, the question were only between enjoying a great many pictures each a little, or one picture very much, the sum of enjoyment being in each case the same, you might rationally desire to possess rather the larger quantity than the small; both because one work of art always in some sort illustrates another, and because quantity diminishes the chances of destruction.

¶ But the question is not a merely arithmetical one of this kind. Your fragments of broken admirations will not, when they are put together,

make up one whole admiration; two and two, in this case, do not make four, nor anything like four. Your good picture, or book, or work of art of any kind, is always in some degree fenced and closed about with difficulty. You may think of it as of a kind of cocoanut, with very often rather an unseemly shell, but good milk and kernel inside. Now, if you possess twenty cocoanuts, and being thirsty, go impatiently from one to the other, giving only a single scratch with the point of your knife to the shell of each, you will get no milk from all the twenty. But if you leave nineteen of them alone, and give twenty cuts to the shell of one, you will get through it, and at the milk of it. And the tendency of the human mind is always to get tired before it has made its twenty cuts; and to try another nut: and moreover, even if it has perseverance enough to crack its nuts, it is sure to try to eat too many, and to choke itself. Hence, it is wisely appointed for us that few of the things we desire can be had without considerable labour, and at considerable intervals of time. We cannot generally get our dinner without working for it, and that gives us appetite for it; we cannot get our holiday without waiting for it, and that gives us zest for it; and we ought not to get our picture without paying for it, and that gives us a mind to look at it. . . .

¶ Meantime, returning to our immediate subject, I say to my generous hearers, who want to shower Titians and Turners upon us, like falling leaves, 'Pictures ought not to be too cheap'; but in much stronger tone I would say to those who want to keep up the prices of pictorial property, that pictures ought not to be too dear—that is to say, not as dear as they are. For, as matters at present stand, it is wholly impossible for any man in the ordinary circumstances of English life to possess himself of a piece of great art. A modern drawing of average merit, or a first-class engraving, may, perhaps, not without some self-reproach, be purchased out of his savings by a man of narrow income; but a satisfactory example of first-rate art—masterhands' work—is wholly out of his reach. And we are so accustomed to look upon this as the natural course and necessity of things, that we never set ourselves in any wise to diminish the evil; and yet it is an evil perfectly capable of diminution.

¶ It is an evil precisely similar in kind to that which existed in the Middle Ages, respecting good books, and which everybody then, I suppose, thought as natural as we do now our small supply of good pictures. You could not then study the work of a great historian, or great poet, any more than you can now study that of a great painter, but at heavy cost. If you wanted a book, you had to get it written out for you, or to write it out for yourself. But printing came, and the poor man may read his Dante and his Homer; and Dante and Homer are none the worse for that. But it is only in literature that private persons of moderate fortune can possess

and study greatness: they can study at home no greatness in art; and the object of that accumulation which we are at present aiming at, as our third object in political economy, is to bring great art in some degree within the reach of the multitude; and, both in larger and more numerous galleries than we now possess, and by distribution, according to his wealth and wish, in each man's home, to render the influence of art somewhat correspondent in extent to that of literature. Here, then, is the subtle balance which your economist has to strike: to accumulate so much art as to be able to give the whole nation a supply of it, according to its need, and yet to regulate its distribution so that there shall be no glut of it, nor contempt.

¶ A difficult balance, indeed, for us to hold, if it were left merely to our skill to poise; but the just point between poverty and profusion has been fixed for us accurately by the wise laws of Providence. If you carefully watch for all the genius you can detect, apply it to good service, and then reverently preserve what it produces, you will never have too little art; and if, on the other hand, you never force an artist to work hurriedly, for daily bread, nor imperfectly, because you would rather have showy works than complete ones, you will never have too much. Do not force the multiplication of art, and you will not have it too cheap; do not wantonly destroy it, and you will not have it too dear.

¶ 'But who wantonly destroys it?' you will ask. Why, we all do. Perhaps you thought, when I came to this part of our subject, corresponding to that set forth in our housewife's economy by the 'keeping her embroidery from the moth', that I was going to tell you only how to take better care of pictures, how to clean them, and varnish them, and where to put them away safely when you went out of town. Ah, not at all. The utmost I have to ask of you is, that you will not pull them to pieces, and trample them under your feet. 'What!' you will say, 'when do we do such things? Haven't we built a perfectly beautiful gallery for all the pictures we have to take care of?' Yes, you have, for the pictures which are definitely sent to Manchester to be taken care of. But there are quantities of pictures out of Manchester which it is your business, and mine too, to take care of no less than of these, and which we are at this moment employing ourselves in pulling to pieces by deputy. . . .

¶ . . . Consider, then, this similitude of ourselves. Suppose you saw (as I doubt not you often do see) a prudent and kind young lady sitting at work, in the corner of a quiet room, knitting comforters for her cousins, and that just outside, in the hall, you saw a cat and her kittens at play among the family pictures; amusing themselves especially with the best Vandykes, by getting on the tops of the frames, and then scrambling down the canvases by their claws; and on some one's informing the young lady of these proceedings of the cat and kittens, suppose she answered that it wasn't

her cat, but her sister's, and the pictures weren't hers, but her uncle's, and she couldn't leave her work, for she had to make so many pairs of comforters before dinner. Would you not say that the prudent and kind young lady was, on the whole, answerable for the additional touches of claw on the Vandykes?

¶ Now, that is precisely what we prudent and kind English are doing, only on a larger scale. Here we sit in Manchester, hard at work, very properly, making comforters for our cousins all over the world. Just outside there in the hall—that beautiful marble hall of Italy—the cats and kittens and monkeys are at play among the pictures: I assure you, in the course of the fifteen years in which I have been working in those places in which the most precious remnants of European art exist, a sensation, whether I would or no, was gradually made distinct and deep in my mind, that I was living and working in the midst of a den of monkeys;—sometimes amiable and affectionate monkeys, with all manner of winning ways and kind intentions,—more frequently selfish and malicious monkeys; but, whatever their disposition, squabbling continually about nuts, and the best places on the barren sticks of trees; and that all this monkeys' den was filled, by mischance, with precious pictures, and the witty and wilful beasts were always wrapping themselves up and going to sleep in pictures, or tearing holes in them to grin through; or tasting them and spitting them out again, or twisting them up into ropes and making swings of them; and that sometimes only, by watching one's opportunity, and bearing a scratch or a bite, one could rescue the corner of a Tintoret, or Paul Veronese, and push it through the bars into a place of safety.

¶ Literally, I assure you, this was, and this is, the fixed impression on my mind of the state of matters in Italy. And see how. The professors of art in Italy, having long followed a method of study peculiar to themselves, have at last arrived at a form of art peculiar to themselves; very different from that which was arrived at by Correggio and Titian. Naturally, the professors like their own form the best; and, as the old pictures are generally not so startling to the eye as the modern ones, the dukes and counts who possess them, and who like to see their galleries look new and fine (and are persuaded also that a celebrated chef-d'œuvre ought always to catch the eye at a quarter of a mile off), believe the professors who tell them their sober pictures are quite faded, and good for nothing, and should all be brought bright again; and, accordingly, give the sober pictures to the professors, to be put right by rules of art. Then, the professors repaint the old pictures in all the principal places, leaving perhaps only a bit of background to set off their own work. And thus the professors come to be generally figured, in my mind, as the monkeys who tear holes in the pictures, to grin through. Then the picture-dealers, who live by the pictures,

cannot sell them to the English in their old and pure state; all the good work must be covered with new paint, and varnished so as to look like one of the professorial pictures in the great gallery, before it is saleable. And thus the dealers come to be imaged, in my mind, as the monkeys who make ropes of the pictures, to swing by. Then, every now and then at some old stable, or wine-cellar, or timber-shed, behind some forgotten vats or faggots, somebody finds a fresco of Perugino's or Giotto's, but doesn't think much of it, and has no idea of having people coming into his cellar, or being obliged to move his faggots; and so he whitewashes the fresco, and puts the faggots back again; and these kind of persons, therefore, come generally to be imaged, in my mind, as the monkeys who taste the pictures, and spit them out, not finding them nice. While, finally, the squabbling for nuts and apples (called in Italy 'bella libertà') goes on all day long.

¶ Now, all this might soon be put an end to, if we English, who are so fond of travelling in the body, would also travel a little in soul! We think it a great triumph to get our packages and our persons carried at a fast pace, but we never take the slightest trouble to put any pace into our perceptions; we stay usually at home in thought, or if we ever mentally see the world, it is at the old stage-coach or waggon rate. Do but consider what an odd sight it would be, if it were only quite clear to you how things are really going on—how, here in England, we are making enormous and expensive efforts to produce new art of all kinds, knowing and confessing all the while that the greater part of it is bad; but struggling still to produce new patterns of wall-papers, and new shapes of teapots, and new pictures, and statues, and architecture; and pluming and cackling if ever a teapot or a picture has the least good in it;—all the while taking no thought whatever of the best possible pictures, and statues, and wall-patterns already in existence, which require nothing but to be taken common care of, and kept from damp and dust: but we let the walls fall that Giotto patterned, and the canvases rot that Tintoret painted, and the architecture be dashed to pieces that St. Louis built, while we are furnishing our drawing-rooms with prize upholstery, and writing accounts of our handsome warehouses to the country papers. Don't think I use my words vaguely or generally: I speak of literal facts. Giotto's frescoes at Assisi are perishing at this moment for want of decent care; Tintoret's pictures in San Sebastian, at Venice, are at this instant rotting piecemeal into grey rags; St. Louis's chapel, at Carcassonne, is at this moment lying in shattered fragments in the marketplace. And here we are all cawing and crowing, poor little half-fledged daws as we are, about the pretty sticks and wool in our own nests. There's hardly a day passes, when I am at home, but I get a letter from some well-meaning country clergyman, deeply anxious about the state of his parish church, and breaking his heart to get money together that he may hold

up some wretched remnant of Tudor tracery, with one niche in the corner
and no statue—when all the while the mightiest piles of religious archi-
tecture and sculpture that ever the world saw are being blasted and withered
away, without one glance of pity or regret. The country clergyman does
not care for *them*—he has a sea-sick imagination that cannot cross channel.
What is it to him, if the angels of Assisi fade from its vaults, or the queens
and kings of Chartres fall from their pedestals? They are not in his parish.

¶ 'What!' you will say, 'are we not to produce any new art, nor take
care of our parish churches?' No, certainly not, until you have taken proper
care of the art you have got already, and of the best churches out of the
parish. Your first and proper standing is not as church-wardens and parish
overseers, in an English county, but as members of the great Christian
community of Europe. And as members of that community (in which
alone, observe, pure and precious ancient art exists, for there is none in
America, none in Asia, none in Africa), you conduct yourselves precisely
as a manufacturer would, who attended to his looms, but left his warehouse
without a roof. The rain floods your warehouse, the rats frolic in it, the
spiders spin in it, the choughs build in it, the wall-plague frets and festers
in it; and still you keep weave, weave, weaving at your wretched webs,
and thinking you are growing rich, while more is gnawed out of your
warehouse in an hour than you can weave in a twelvemonth.

¶ Even this similitude is not absurd enough to set us rightly forth.
The weaver would, or might, at least, hope that his new woof was as stout
as the old ones, and that, therefore, in spite of rain and ravage, he would
have something to wrap himself in when he needed it. But *our* webs rot as
we spin. The very fact that we despise the great art of the past shows that
we cannot produce great art now. If we could do it, we should love it when
we saw it done—if we really cared for it, we should recognize it and keep
it; but we don't care for it. It is not art that we want; it is amusement,
gratification of pride, present gain—anything in the world but art: let it rot,
we shall always have enough to talk about and hang over our sideboards.

¶ You will (I hope) finally ask me what is the outcome of all this,
practicable to-morrow morning by us who are sitting here? These are the
main practical outcomes of it: In the first place, don't grumble when you
hear of a new picture being bought by Government at a large price. There
are many pictures in Europe now in danger of destruction which are, in
the true sense of the word, priceless; the proper price is simply that which
it is necessary to give to get and to save them. If you can get them for
fifty pounds, do; if not for less than a hundred, do; if not for less than five
thousand, do; if not for less than twenty thousand, do; never mind being
imposed upon: there is nothing disgraceful in being imposed upon; the only
disgrace is in imposing; and you can't in general get anything much worth

having, in the way of Continental art, but it must be with the help or connivance of numbers of people who, indeed, ought to have nothing to do with the matter, but who practically have, and always will have, everything to do with it; and if you don't choose to submit to be cheated by them out of a ducat here and a zecchin there, you will be cheated by them out of your picture; and whether you are most imposed upon in losing that, or the zecchins, I think I may leave you to judge; though I know there are many political economists, who would rather leave a bag of gold on a garret-table, than give a porter sixpence extra to carry it downstairs.

That, then, is the first practical outcome of the matter. Never grumble, but be glad when you hear of a new picture being bought at a large price. In the long run, the dearest pictures are always the best bargains; and, I repeat, (for else you might think I said it in mere hurry of talk, and not deliberately,) there are some pictures which are without price. You should stand, nationally, at the edge of Dover Cliffs—Shakespeare's—and wave blank cheques in the eyes of the nations on the other wide of the sea, freely offered, for such and such canvases of theirs.

¶ Then, the next practical outcome of it is—Never buy a copy of a picture, under any circumstances whatever. All copies are bad; because no painter who is worth a straw ever *will* copy. He will make a study of a picture he likes, for his own use, in his own way; but he won't and can't copy. Whenever you buy a copy, you buy so much misunderstanding of the original, and encourage a dull person in following a business he is not fit for, besides increasing ultimately chances of mistake and imposture, and farthering, as directly as money *can* farther, the cause of ignorance in all directions. You may, in fact, consider yourself as having purchased a certain quantity of mistakes; and, according to your power, being engaged in disseminating them.

¶ I do not mean, however, that copies should never be made. A certain number of dull persons should always be employed by a Government in making the most accurate copies possible of all good pictures; these copies, though artistically valueless, would be historically and documentarily valuable, in the event of the destruction of the original picture. The studies also made by great artists for their own use, should be sought after with the greatest eagerness; they are often to be bought cheap; and in connection with the mechanical copies, would become very precious: tracings from frescoes and other large works are also of great value; for though a tracing is liable to just as many mistakes as a copy, the mistakes in a tracing are of one kind only, which may be allowed for, but the mistakes of a common copyist are of all conceivable kinds: finally, engravings, in so far as they convey certain facts about the pictures, without pretending adequately to represent or give an idea of the pictures, are often serviceable and valuable.

I can't, of course, enter into details in these matters just now; only this main piece of advice I can safely give you—never to buy copies of pictures (for your private possession) which pretend to give a facsimile that shall be in any wise representative of, or equal to, the original. Whenever you do so, you are only lowering your taste, and wasting your money. And if you are generous and wise, you will be ready rather to subscribe as much as you would have given for a copy of a great picture towards its purchase, or the purchase of some other like it, by the nation. There ought to be a great National Society instituted for the purchase of pictures; [1] presenting them to the various galleries in our great cities, and watching there over their safety: but in the meantime, you can always act safely and beneficially by merely allowing your artist friends to buy pictures for you, when they see good ones. Never buy for yourselves, nor go to the foreign dealers; but let any painter whom you know be entrusted, when he finds a neglected old picture in an old house, to try if he cannot get it for you; then, if you like it, keep it; if not, send it to the hammer, and you will find that you do not lose money on pictures so purchased.

¶ And the third and chief practical outcome of the matter is this general one: Wherever you go, whatever you do, act more for *preservation* and less for *production.* I assure you, the world is, generally speaking, in calamitous disorder, and just because you have managed to thrust some of the lumber aside, and get an available corner for yourselves, you think you should do nothing but sit spinning in it all day long—while, as householders and economists, your first thought and effort should be, to set things more square all about you. Try to set the ground floors in order, and get the rottenness out of your granaries. *Then* sit and spin, but not till then.

IV. DISTRIBUTION.—And now, lastly, we come to the fourth great head of our inquiry, the question of the wise distribution of the art we have gathered and preserved. It must be evident to us, at a moment's thought, that the way in which works of art are on the whole most useful to the nation to which they belong, must be by their collection in public galleries, supposing those galleries properly managed. But there is one disadvantage attached necessarily to gallery exhibition—namely, the extent of mischief which may be done by one foolish curator. As long as the pictures which form the national wealth are disposed in private collections, the chance is always that the people who buy them will be just the people who are fond of them; and that the sense of exchangeable value in the commodity they possess, will induce them, even if they do not esteem it themselves, to take

[1] Ruskin's suggestion was carried out in 1903 by the formation of a 'National Art Collections Fund'; the object of the Society being 'to raise money by private subscription and donation in order to supplement the support given by the State to our national galleries and museums.'

such care of it as will preserve its value undiminished. At all events, so long as works of art are scattered through the nation, no universal destruction of them is possible; a certain average only are lost by accidents from time to time. But when they are once collected in a large public gallery, if the appointment of curator becomes in any way a matter of formality, or the post is so lucrative as to be disputed by place-hunters, let but one foolish or careless person get possession of it, and perhaps you may have all your fine pictures repainted, and the national property destroyed, in a month. That is actually the case at this moment, in several great foreign galleries. They are the places of execution of pictures: over their doors you only want the Dantesque inscription, 'Lasciate ogni speranza, voi che entrate'.

¶ Supposing, however, this danger properly guarded against, as it would be always by a nation which either knew the value, or understood the meaning, of painting,* arrangement in a public gallery is the safest, as well as the most serviceable, method of exhibiting pictures; and it is the only mode in which their historical value can be brought out, and their historical meaning made clear. But great good is also to be done by encouraging the private possession of pictures; partly as a means of study, (much more being always discovered in any work of art by a person who has it perpetually near him than by one who only sees it from time to time), and also as a means of refining the habits and touching the hearts of the masses of the nation in their domestic life.

¶ For these last purposes, the most serviceable art is the living art of the time; the particular tastes of the people will be best met, and their particular ignorances best corrected, by painters labouring in the midst of them, more or less guided to the knowledge of what is wanted by the degree of sympathy with which their work is received. So then, generally, it should be the object of government, and of all patrons of art, to collect, as far as may be, the works of dead masters in public galleries, arranging them so as to illustrate the history of nations, and the progress and influence of their arts; and to encourage the private possession of the works of *living* masters. And the first and best way in which to encourage such private possession is, of course, to keep down the prices of them as far as you can. . . .

¶ I know how many objections must arise in your minds at this moment to what I say; but you must be aware that it is not possible for me in an hour to explain all the moral and commercial bearings of such a principle as this. Only, believe me, I do not speak lightly; I think I have considered all the objections which could be rationally brought forward, though I have time at present only to glance at the main one—namely, the

* It would be a great point gained towards the preservation of pictures if it were made a rule that at every operation they underwent, the exact spots in which they have been repainted should be recorded in writing.

idea that the high prices paid for modern pictures are either honourable, or serviceable, to the painter. So far from this being so, I believe one of the principal obstacles to the progress of modern art to be the high prices given for good modern pictures. For observe first the action of this high remuneration on the artist's mind. If he 'gets on', as it is called, catches the eye of the public, and especially of the public of the upper classes, there is hardly any limit to the fortune he may acquire; so that, in his early years, his mind is naturally led to dwell on this worldly and wealthy eminence as the main thing to be reached by his art; if he finds that he is not gradually rising towards it, he thinks there is something wrong in his work; or, if he is too proud to think that, still the bribe of wealth and honour warps him from his honest labour into efforts to attract attention; and he gradually loses both his power of mind and his rectitude of purpose. This, according to the degree of avarice or ambition which exists in any painter's mind, is the necessary influence upon him of the hope of great wealth and reputation. But the harm is still greater, in so far as the possibility of attaining fortune of this kind tempts people continually to become painters who have no real gift for the work; and on whom these motives of mere worldly interest have exclusive influence;—men who torment and abuse the patient workers, eclipse or thrust aside all delicate and good pictures by their own gaudy and coarse ones, corrupt the taste of the public, and do the greatest amount of mischief to the schools of art in their day which it is possible for their capacities to effect; and it is quite wonderful how much mischief may be done even by small capacity. If you could by any means succeed in keeping the prices of pictures down, you would throw all these disturbers out of the way at once. . . .

¶ But, observe, it is not only the painter himself whom you injure, by giving him too high prices; you injure all the inferior painters of the day. If they are modest, they will be discouraged and depressed by the feeling that their doings are worth so little, comparatively, in your eyes;— if proud, all their worst passions will be aroused, and the insult or approbium which they will try to cast on their successful rival will not only afflict and wound him, but at last sour and harden him: he cannot pass through such a trial without grievous harm. . . .

¶ For remember always, that the price of a picture by a living artist never represents, never *can* represent, the quantity of labour or value in it. Its price represents, for the most part, the degree of desire which the rich people of the country have to possess it. Once get the wealthy classes to imagine that the possession of pictures by a given artist adds to their 'gentility', and there is no price which his work may not immediately reach, and for years maintain; and in buying at that price, you are not getting value for your money, but merely disputing for victory in a contest of

ostentation. And it is hardly possible to spend your money in a worse or more wasteful way; for though you may not be doing it for ostentation yourself, you are, by your pertinacity, nourishing the ostentation of others; you meet them in their game of wealth, and continue it for them; if they had not found an opposite player, the game would have been done; for a proud man can find no enjoyment in possessing himself of what nobody disputes with him. So that by every farthing you give for a picture beyond its fair price—that is to say, the price which will pay the painter for his time—you are not only cheating yourself and buying vanity, but you are stimulating the vanity of others; paying, literally, for the cultivation of pride. You may consider every pound that you spend above the just price of a work of art, as an investment in a cargo of a mental quick-lime or guano, which, being laid on the fields of human nature, is to grow a harvest of pride. You are in fact ploughing and harrowing, in a most valuable part of your land, in order to reap the whirlwind; you are setting your hand stoutly to Job's agriculture—'Let thistles grow instead of wheat, and cockle instead of barley'. . . .

¶ So far then of the motives which should induce us to keep down the prices of modern art, and thus render it, as a private possession, attainable by greater numbers of people than at present. But we should strive to render it accessible to them in other ways also—chiefly by the permanent decoration of public buildings. . . .

The first and most important kind of public buildings which we are always sure to want, are schools: and I would ask you to consider very carefully, whether we may not wisely introduce some great changes in the way of school decoration. Hitherto, as far as I know, it has either been so difficult to give all the education we wanted to our lads, that we have been obliged to do it, if at all, with cheap furniture and bare walls; or else we have considered that cheap furniture and bare walls are a proper part of the means of education; and supposed that boys learned best when they sat on hard forms, and had nothing but blank plaster about and above them whereupon to employ their spare attention; also, that it was as well they should be accustomed to rough and ugly conditions of things, partly by way of preparing them for the hardships of life, and partly that there might be the least possible damage done to floors and forms, in the event of their becoming, during the master's absence, the fields or instruments of battle. All this is so far well and necessary, as it relates to the training of country lads, and the first training of boys in general. But there certainly comes a period in the life of a well-educated youth, in which one of the principal elements of his education is, or ought to be, to give him refinement of habits; and not only to teach him the strong exercises of which his frame is capable, but also to increase his bodily sensibility and refinement, and

show him such small matters as the way of handling things properly, and treating them considerately.

¶ Not only so; but I believe the notion of fixing the attention by keeping the room empty, is a wholly mistaken one: I think it is just in the emptiest room that the mind wanders most; for it gets restless, like a bird, for want of a perch, and casts about for any possible means of getting out and away. And even if it be fixed, by an effort, on the business in hand, that business becomes itself repulsive, more than it need be, by the vileness of its associations; and many a study appears dull or painful to a boy, when it is pursued on a blotted deal desk, under a wall with nothing on it but scratches and pegs, which would have been pursued pleasantly enough in a curtained corner of his father's library, or at the lattice window of his cottage. Now, my own belief is, that the best study of all is the most beautiful; and that a quiet glade of forest, or the nook of a lake shore, are worth all the schoolrooms in Christendom, when once you are past the multiplication table; but be that as it may, there is no question at all but that a time ought to come in the life of a well-trained youth, when he can sit at a writing-table without wanting to throw the inkstand at his neighbour; and when also he will feel more capable of certain efforts of mind with beautiful and refined forms about him than with ugly ones. When that time comes, he ought to be advanced into the decorated schools; and this advance ought to be one of the important and honourable epochs of his life. . . .

¶ For you who have [the responsibility of guiding labour] in your hands are in reality the pilots of the power and effort of the State. It is entrusted to you as an authority to be used for good or evil, just as completely as kingly authority was ever given to a prince, or military command to a captain. And, according to the quantity of it that you have in your hands, you are the arbiters of the will and work of England; and the whole issue, whether the work of the State shall suffice for the State or not, depends upon you. You may stretch out your sceptre over the heads of the English labourers, and say to them, as they stoop to its waving, 'Subdue this obstacle that has baffled our fathers, put away this plague that consumes our children; water these dry places, plough these desert ones, carry this food to those who are in hunger; carry this light to those who are in darkness; carry this life to those who are in death'; or on the other side you may say to her labourers: 'Here am I; this power is in my hand; come, build a mound here for me to be throned upon, high and wide; come, make crowns for my head, that men may see them shine from far away; come, weave tapestries for my feet, that I may tread softly on the silk and purple; come, dance before me, that I may be gay; and sing sweetly to me, that I may slumber; so shall I live in joy, and die in honour.' And better than such an

honourable death it were that the day had perished wherein we were born, and the night in which it was said there is a child conceived.

¶ I trust that in a little while there will be few of our rich men who, through carelessness or covetousness, thus forfeit the glorious office which is intended for their hands. I said, just now, that wealth ill-used was as the net of the spider, entangling and destroying: but wealth well used is as the net of the sacred fisher who gathers souls of men out of the sleep. A time will come—I do not think even now it is far from us—when this golden net of the world's wealth will be spread abroad as the flaming meshes of morning cloud are over the sky; bearing with them the joy of light and the dew of the morning, as well as the summons to honourable and peaceful toil. What less can we hope from your wealth than this, rich men of England, when once you feel fully how, by the strength of your possessions—not, observe, by the exhaustion, but by the administration of them and the power,—you can direct the acts—command the energies—inform the ignorance—prolong the existence, of the whole human race; and how, even of worldly wisdom, which man employs faithfully, it is true, not only that her ways are pleasantness, but that her paths are peace; and that, for all the children of men, as well as for those to whom she is given, Length of days is in her right hand, as in her left hand Riches and Honour?

<div style="text-align: right">From A Joy for Ever: The Political Economy of Art.</div>

Education in the Arts [1]

. . . I think the art examination should have three objects:

1. To put the happiness and knowledge which the study of art conveys within the conception of the youth, so that he may in after-life pursue them, if he has the gift.

2. To enforce, as far as possible, such knowledge of art among those who are likely to become its patrons, or the guardians of its works, as may enable them usefully to fulfil those duties.

3. To distinguish pre-eminent gift for the production of works of art, so as to get hold of all the good artistical faculty born in the country, and leave no Giotto lost among hill-shepherds.

In order to accomplish the first object, I think that, according to Mr. Acland's proposal, preliminary knowledge of drawing and music should be asked for, in connection with writing and arithmetic; but not, in the pre-

[1] A letter to T. D. Acland for his book *Some Account of the Origin and Objects of the New Oxford Examinations for the Title of Associate in Arts and Certificates for the year* 1858.

liminary examination, made to count towards distinction in other schools. I think drawing is a necessary means of the expression of certain facts of form, and means of acquaintance with them, as arithmetic is the means of acquaintance with facts of number. I think the facts which an elementary knowledge of drawing enables a man to observe and note are often of as much importance to him as those which he can describe in words or calculate in numbers. And I think the cases in which mental deficiency would prevent the acquirement of a serviceable power of drawing would be found as rare as those in which no progress could be made in arithmetic. I would not desire this elementary knowledge to extend far, but the limits which I would propose are not here in question. While I feel the force of all the admirable observations of Mr. Hullah on the use of the study of music, I imagine that the cases of physical incapacity of distinguishing sounds would be too frequent to admit of musical knowledge being made a *requirement*; I would *ask* for it, in Mr. Acland's sense; but the drawing might, I think, be required, as arithmetic would be.

¶ To accomplish the second object is the main difficulty. Touching which I venture positively to state—

First. That sound criticism of art is impossible to young men, for it consists principally, and in a far more exclusive sense than has yet been felt, in the recognition of the facts represented by the art. A great artist represents many and abstruse facts; it is necessary, in order to judge of his works, that all those facts should be experimentally (not by hearsay) known to the observer; whose recognition of them constitutes his approving judgment. A young man *cannot* know them.

Criticism of art by young men must, therefore, consist either in the more or less apt retailing and application of received opinions, or in a more or less immediate and dexterous use of the knowledge they already possess, so as to be able to assert of given works of art that they are true up to a certain point; the probability being then that they are true farther than the young man sees.

The first kind of criticism, is in general, useless, if not harmful; the second is that which the youths will employ who are capable of becoming critics in after years.

Secondly. All criticism of art, at whatever period of life, must be partial; warped more or less by the feelings of the person endeavouring to judge. Certain merits of art (as energy, for instance) are pleasant only to certain temperaments; and certain tendencies of art (as, for instance, to religious sentiment) can only by sympathized with by one order of minds. It is almost impossible to conceive of any mode of examination which would set the students on anything like equitable footing in such respects; but their sensibility to art may be generally tested.

Thirdly. The history of art, or the study, in your accurate words, '*about the subject*', is in no wise directly connected with the studies which promote or detect art-capacity or art-judgment. It is quite possible to acquire the most extensive and useful knowledge of the forms of art existing in different ages, and among different nations, without thereby acquiring any power whatsoever of determining respecting any of them (much less respecting a modern work of art) whether it is good or bad.

These three facts being so, we had perhaps best consider, first, what direction the art studies of the youth should take, as that will at once regulate the mode of examination.

First. He should be encouraged to carry forward the practical power of drawing he has acquired in the elementary school. This should be done chiefly by using that power as a help in other work: precision of touch should be cultivated by map-drawing in his geography class; taste in form by flower-drawing in the botanical schools; and bone and limb drawing in the physiological schools. His art, kept thus to practical service, will always be right as far as it goes; there will be no affectation or shallowness in it. The work of the drawing-master would be at first little more than the exhibition of the best means and enforcement of the most perfect results in the collateral studies of form.

Secondly. His critical power should be developed by the presence around him of the best models, *into the excellence of which his knowledge permits him to enter.* He should be encouraged, above all things, to form and express judgment of his own; not as if his judgment were of any importance as related to the excellence of the thing, but that both his master and he may know precisely in what state his mind is. He should be told of an Albert Dürer engraving, 'That *is* good, whether you like it or not; but be sure to determine *whether* you do or do not, and why'. All formal expressions of reasons for opinion, such as a boy could catch up and repeat, should be withheld like poison; and all models which are too good for him should be kept out of his way. Contemplation of works of art without understanding them jades the faculties and enslaves the intelligence. A Rembrandt etching is a better example to a boy than a finished Titian, and a cast from a leaf than one of the Elgin Marbles.

Thirdly. I would no more involve the art-schools in the study of the history of art than surgical schools in that of the history of surgery. But a general idea of the influence of art on the human mind ought to be given by the study of history in the historical schools; the effect of a picture, and power of a painter, being examined just as carefully (in relation to its extent) as the effect of a battle and the power of a general. History, in its full sense, involves subordinate knowledge of all that influences the acts of mankind; it has hardly yet been written at all, owing to the want of such

subordinate knowledge in the historians; it has been confined either to the relation of events by eye-witnesses (the only valuable form of it), or the more or less ingenious collation of such relations. And it is especially desirable to give history a more archæological range at this period, so that the class of manufactures produced by a city at a given date should be made of more importance in the student's mind than the humours of the factions that governed, or details of the accidents that preserved it, because every day renders the destruction of historical memorials more complete in Europe owing to the total want of interest in them felt by its upper and middle classes.

Fourthly. Where the faculty for art was special, it ought to be carried forward to the study of design, first in practical application to manufacture, then in higher branches of composition. The general principles of the application of art to manufacture should be explained in all cases, whether of special or limited faculty. Under this head we may at once get rid of the third question stated in the first page—how to detect special gift. The power of drawing from a given form accurately would not be enough to prove this: the additional power of design, with that of eye for colour, which could be tested in the class concerned with manufacture, would justify the master in advising and encouraging the youth to undertake special pursuit of art as an object of life.

It seems easy, on the supposition of such a course of study, to conceive a mode of examination which would test relative excellence. I cannot suggest the kind of questions which ought to be put to the class occupied with sculpture; but in my own business of painting, I should put, in general, such tasks and questions as these:

1. 'Sketch such and such an object' (given a difficult one, as a bird, complicated piece of drapery, or foliage) 'as completely as you can in light and shade in half an hour.'

2. 'Finish such and such a portion of it' (given a very small portion) 'as perfectly as you can, irrespective of time.'

3. 'Sketch it in colour in half an hour.'

4. 'Design an ornament for a given place and purpose.'

5. 'Sketch a picture of a given historical event in pen and ink.'

6. 'Sketch it in colours.'

7. 'Name the picture you were most interested in in the Royal Academy Exhibition of this year. State in writing what you suppose to be its principal merits—faults—the reasons of the *interest* you took in it.'

I think it is only the fourth of these questions which would admit of much change; and the seventh, in the name of the exhibition; the question being asked, without previous knowledge by the students, respecting some

one of four or five given exhibitions which should be visited before the Examination.

This being my general notion of what an Art-Examination should be, the second great question remains of the division of schools and connection of studies.

Now I have not yet considered—I have not, indeed, knowledge enough to enable me to consider—what the practical convenience or results of given arrangements would be. But the logical and harmonious arrangement is surely a simple one; and it seems to me as if it would not be inconvenient, namely, (requiring elementary drawing with arithmetic in the preliminary Examination), that there should then be three advanced schools:

A. The School of Literature (occupied chiefly in the study of human emotion and history).

B. The School of Science (occupied chiefly in the study of external facts and existences of constant kind).

C. The School of Art (occupied in the development of active and productive human faculties).

In the school A, I would include Composition in all languages, Poetry, History, Archæology, Ethics.

In the school B, Mathematics, Political Economy, the Physical Sciences (including Geography and Medicine).

In the school C, Painting, Sculpture, including Architecture, Agriculture, Manufacture, War, Music, Bodily Exercises (Navigation in seaport schools), including laws of health.

I should require, for a first class, proficiency in two schools; not, of course, in all the subjects of each chosen school, but in a well-chosen and combined group of them. Thus, I should call a very good first-class man one who had got some such range of subjects, and such proficiency in each, as this:

English, Greek, and Mediæval-Italian Literature. High.
English and French History, and Archæology. Average.
Conic Sections. Thorough, as far as learnt.
Political Economy. Thorough, as far as learnt.
Botany, *or* Chemistry, *or* Physiology. High.
Painting. Average.
Music. Average.
Bodily Exercises. High.

From *The Arts as a Branch of Education*, Vol. XVI, p. 449.

Museums

. . . The first function of a Museum . . . is to give example of perfect order and perfect elegance, in the true sense of the test word, to the disorderly and rude populace. Everything in its *own* place, everything looking its best because it is there, nothing crowded, nothing unnecessary, nothing puzzling. Therefore, after a room has been once arranged, there must be no change in it. For new possessions there must be new rooms. . . .

My requirement of 'elegance' . . . contemplates chiefly architecture and fittings. These should not only be perfect in stateliness, durability, and comfort, but beautiful to the utmost point, consistent with due subordination to the objects displayed. To enter a room in the Louvre is an education in itself; but two steps on the filthy floor and under the iron forks, half scaffold, half gallows, of the big Norwood glass bazaar, [the Crystal Palace] debase mind and eye at once below possibility of looking at anything with profit all the day afterwards. . . .

All idea of any 'payment' [in the sense of the gallery paying its way], must be utterly and scornfully abjured on the foundation stone of every National or Civic Museum. There must be neither companies to fill their own pockets out of it, nor Trustees who can cramp the management, or interfere with the officering, or shorten the supplies of it. Put one man of reputation and sense at its head; give him what staff he asks for, and a fixed annual sum for expenditure—specific accounts to be printed annually for all the world's seeing—and let him alone. The original expenditure for building and fitting must be magnificent, and the current expenditure for cleaning and refitting magnanimous; but a certain proportion of this current cost should be covered by small entrance fees, exacted, not for any miserly helping out of the floor-sweepers' salaries, but for the sake of the visitors themselves, that the rooms may not be encumbered by the idle, or disgraced by the disreputable. You must not make your Museum a refuge against rain or ennui, nor let into perfectly well-furnished, and even, in the true sense, palatial, rooms, the utterly squalid and ill-bred portion of the people. . . .

From *A Museum or Picture Gallery; Its Function and its Formation.*

LIST OF PLATES

I · DRAWINGS BY RUSKIN

All Ruskin's drawings reproduced in this volume
are in the Ashmolean Museum, Oxford

II · WORKS BY OTHER ARTISTS

In alphabetical order

III · ARCHITECTURE
In alphabetical order

ACKNOWLEDGEMENTS

LORD LEIGHTON's painting in the Royal Collection is reproduced by gracious permission of Her Majesty the Queen.

The publishers are grateful to all private owners who have kindly allowed their pictures to be reproduced, particularly Sir William Acland Bt., Sir William Cooper Bt., the Hon. Mrs. George Lambton, and Sir Roger Makins. Thanks are also due to the Warden of Keble College, Oxford and the Trustees of the Wallace Collection for permission to reproduce paintings in their possession, as well as to the authorities of the following Galleries: City Museum and Art Gallery, Birmingham; Museum of Fine Arts, Boston; Walker Art Gallery, Liverpool; National Gallery, Royal Academy of Arts, Tate Gallery and Victoria and Albert Museum, London; National Gallery of Canada, Ottawa; Ashmolean Museum, Oxford; Lady Lever Art Gallery, Port Sunlight.

Photographs were also obtained from Messrs. Alinari, Florence; Archives Photographiques, Paris; and The Radio Times Hulton Picture Library, London.

INDEX

I: NAMES

II : SUBJECTS

SUBJECTS 337

Art exhibitions: old Water Colour Society, 136, 171; Royal Academy, 74-8, 99-102, 135-7, 157
Art galleries: arrangement of, 52-3, 55-7, 289-92, 313-14; exteriors of, 291
Art-intellect: discovery of, 293; employment of, 294-5, 297; encouragement of, 295-6
Artists: duty of, 221-2; education of, 53-5, 247; essential gifts of, 264; function of, 246; three classes of, 132-3; two groups of, 85-6

Backgrounds: Giotto's, 71-2; Pre-Raphaelite, 64, 151
Beauty: common sense in, 197-8; elements of, in ugliness, 80; essential to true art, 72-3; foil of, 79-80; in architecture, 215-16; lamp of, 195-8; law of, 169-70
Body, human: different treatments of, by the masters, 122-4; for its own sake, 122-3; Greek treatment of, 122
Brick in ornament, 190-1
Burlesque, English love of, 138
Byzantine architecture, 147, 212, 239, 271

Canopies for statues, 272
Capitals, 192, 211, 251 n., 271, 298
Cathedrals, 166, 184, 187, 188, 194, 199-201, 225, 226, 276
Chalk architecture, 270-1
Chalk drawing, 165
Character, treatment of, by great painters, 112, 123, 165
Chiaroscuro, 71, 85-7, 132-3, 141, 144-5
Chivalry, 129-30, 169
Christian architecture, early, 199, 211-12, 213
Christian art, two great branches of, 212
Christian Classic school, 129
Christian Faithful school, 129
Christian Romantic school, 129-32
Christian system of ornament, 231-2
Cinque-cento, Italian, 271
Clarity and mystery, 87-8

Classic art: Classic and Gothic, 165-70; perpetual laws of, 169-70; summary of, 166-7
Clay, school of, 144
Colour: architectural, 226-8; blue, in painting, 28-9, 39, 109; brightness of, inadmissible without harmony, 31; Burne-Jones' use of, 165; distance and foreground, colour changes of, 38-9; English natural, 172; Flemish schools', 58; Gainsborough as a great colourist, 36; German schools' (modern), 32; Greek method, 142; Hunt's use of, 158; idealists' delicate hues, 32; importance of, in any picture, 60; light and, 85-7; Millais's use of, 91-4, 106; nobility of, 57-8; purple, in painting, 29, 38; Rossetti's system of, 158-60, 165; Rubens' system of, 29; schools of, 55, 140-5; shadow colours, 141; Tintoretto's use of, 71, 132; Titian's method, 29, 32, 71, 86; Turner's use of, see under Turner's work; Venetian school of painting, q.v.; walls in art galleries, 290-1; yellow, in painting, 29
Colourists and chiaroscurists, 71, 85-7, 132-3, 141
Colours, preparation of, by every artist, 54-5
Common-wealth in architecture, 277
Constant school of art, 116-17
Construction: good, 215-16; history of, 272-3; laws of, 217; relative value of, 274
Contemplation, love of, 72
Copies (of art), 235, 312-13
Corinthian style, 211, 256, 258
Corner stone, 261
Cottage architecture, 8, 177-8
Crystal, school of, 144-5

Dances, ancient, 168-9
Decorated style of architecture, 210, 211
Decoration, see Ornament
Decorative design, 137